SCULPTURE AND ENLIVENED SPACE

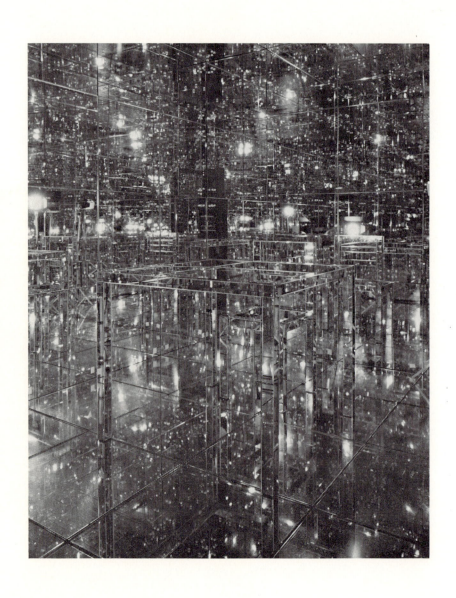

F. David Martin

SCULPTURE
AND
ENLIVENED SPACE

Aesthetics and History

THE UNIVERSITY PRESS OF KENTUCKY

circ
N/A

Frontispiece: Lucas Samaras, *Mirrored Room*, 1966
(Albright-Knox Art Gallery, Buffalo, N.Y.
Gift of Seymour H. Knox)

Library of Congress Cataloging in Publication Data

Martin, F. David, 1920-
 Sculpture and enlivened space.

 Includes bibliographical references and index.
 1. Sculpture—Philosophy. 2. Painting—Philosophy.
I. Title.
NB1137.M37 730'.1 79-4006
ISBN 0-8131-1386-5

Scholarly publisher for the Commonwealth
serving Berea College, Centre College of Kentucky,
Eastern Kentucky University, The Filson Club,
Georgetown College, Kentucky Historical Society,
Kentucky State University, Morehead State University,
Murray State University, Northern Kentucky University,
Transylvania University, University of Kentucky,
University of Louisville, and Western Kentucky University.

Editorial and Sales Offices: Lexington, Kentucky 40506

To My Children and Grandchildren

Contents

Illustrations follow page 116.

Acknowledgments

Many years ago my old friend Theodore M. Greene remarked that sculpture, except for music, was the least understood of the arts. He lamented that in *The Arts and the Art of Criticism* (1940) he was unable to distinguish satisfactorily sculpture from painting and architecture. And he was puzzled by the extraordinary absence of systematic investigations into the nature of sculpture.

A few years ago, partly because Greene's remarks still intrigued me but also because the so-called visual arts are my favorites, I began studying the aesthetics of sculpture. It did not take very long, for even since Greene's time little has been done. Avoiding for the most part the more general questions, I published a number of essays on specific questions about sculpture. Then this book gradually evolved, pushed by a sense of dissatisfaction with anything less than an attempt to understand the field of sculpture as a totality, from the prehistoric to the avant-garde.

I have been encouraged, advised, and warned. For the many faults that still remain, I am solely responsible. Virgil C. Aldrich of the University of Utah, Rudolf Arnheim of the University of Michigan, and Joyce Brodsky of the University of Connecticut criticized the whole manuscript. I am indebted to Jean Harrell of the University of California at Hayward for the segment on music in chapter five. Sections have been worked over by Joseph Fell, Mildred Martin, Gladys Cook, Harry Garvin, Frank Wilson, and Gerald Eager, colleagues of mine at Bucknell. Kevin Donovan, a graduate student, meticulously corrected the final draft. Mrs. Nancy Johnson cared for both the illustrations and the manuscript with its frequent overhauls. My wife protected me from interruption. Finally, this study could not have been undertaken without the benefit of several research grants from Bucknell University.

SCULPTURE AND ENLIVENED SPACE

Introduction

The partaker partakes of that which changes him.
The child that touches takes character from the thing.
The body, it touches.
 Wallace Stevens, "Notes towards a Supreme Fiction"

Sculpture has been conceived by most philosophers of art or aestheticians as the child of Mother Painting. When they have approached sculpture, either to enjoy or to study, most aestheticians have come with the eye of the lover of painting. Sculpture is viewed as a subsidiary art that merely translates the innovations of painting into three dimensions. Even those who have defended the autonomy of sculpture have not been able to articulate clear and comprehensive conceptions of what sculpture is. No aesthetician—or historian of art, critic, or anyone else—has attempted to uncover and, in turn, organize the vast and bewildering variety of sculpture into an intelligible field. Pure descriptions of sculpture, i.e., unadulterated with conceptual biases insofar as that is possible, are rare. Systematic examinations of basic questions about sculpture are rarer. The testing of the explanations, generated by these examinations, against "pure descriptions" is practically nonexistent. It seems justifiable to assert that this study is an exploration into terra incognita.

Born in Ancient Greece, cared for in its earliest days especially by Plato and Aristotle, the business of giving systematic explanations of art was not given a name until christened "Aesthetics" by Alexander Baumgarten in the eighteenth century. Even with a name, however, aesthetics has remained the poor relative of philosophy, regarded as not quite respectable and even worse boring. Speculative philosophers usually have first directed their attention to what have been regarded as the basic concerns of philosophy—metaphysics, epistemology, logic, and ethics—and then, if they live long enough, finish off with an essay on aesthetics. With considerable justification philosophers of the analytic school such as J. A. Passmore complain about the dreariness of

1

aesthetics, meaning mainly speculative aesthetics. Yet these philosophers usually analyze language about art rather than works themselves—surely livelier phenomena—and so the dreariness is often compounded. Phenomenological aesthetics, maturing in the twentieth century, provides a fruitful method for avoiding both fanciful generalities and pedantic analyses. Phenomenology can be a way back to the things themselves, the phenomena in this case being works of sculpture. Unfortunately, phenomenological aestheticians have been either so caught up in the web of methodological problems or so concerned about other arts that they rarely have sought out and tried to describe the phenomena of sculpture. I shall make the attempt.

Early in this century, Clive Bell prefaced his book on *Art* with the observation: "It is improbable that more nonsense has been written about aesthetics than about anything else: the literature is not large enough for that." Since then the literature has greatly expanded, and in the preface to his *Aesthetics: From Classical Greece to the Present* Monroe Beardsley remarks: "After writing this short history, I confess that Clive Bell's irony no longer seems to me historically fair, even in his day. And the half century since his words were published has brought solid achievement and even greater promise." If given special application to the aesthetics of sculpture, however, Bell's irony is not unfair. Despite the fact that sculpture in the West has always been a widely practiced art, and is today one of the more adventurous arts, there are only a very few systematic and sustained studies about the "how" and the "why" of sculpture. Historians of sculpture have written many detailed analyses, often of the highest quality, about particular works and styles, but like critics of sculpture they have rarely attempted to map out the field. Moreover, the historians usually have concentrated upon the "when" and the "what," i.e., upon such matters as dating, authenticity, iconography, and iconology. Their emphasis has been classificatory and philological. The critics have concentrated more upon description, interpretation, and evaluation of particular sculptures, usually ignoring any further questions. For the most part, the analyses of both historians and critics have touched only tangentially upon explanatory issues. By this I mean that they have not delved into such general questions as: How is sculpture perceived? Is sculpture perceived differently from painting? Does sculpture possess distinctive features? Why is sculpture distinguished from painting and architecture? Is sculpture an autonomous art? How does sculpture come to be? Why do artists create sculpture? Why is sculpture treasured and preserved? Does sculpture have a special role to play in a culture? More specific

questions are also ignored. Isamu Noguchi, for example, laments: "Today we are familiar with the spaces within sculpture but, apart from this, the concept of sculptural space has hardly been touched."[1] Is sculptural space, as is assumed by many, no more than a special kind of pictorial space? It is my purpose in this study to attempt to answer these kinds of general and specific questions.

In ancient writings, most references to sculpture were historical, technical, and critical (especially evaluative). According to the legend preserved in some verses by Tzetzes, the Byzantine writer, Pheidias made a statue of the goddess Athene for a niche high on a temple wall. In order to bring the head of Athene more directly in view from the floor below, Pheidias made it disproportionately large and slightly inclined. Some Athenians objected, and, presumably, Plato would have sided with the objectors. In the *Sophist* (235e-236d) Plato draws the distinction between an exact imitation of nature and an imitation that modifies the forms of nature for artistic effect. He has the Eleatic stranger observe that in large works, if the true proportions were given, "the upper part which is farther off, would appear to be out of proportion in comparison with the lower, which is nearer; and so they [the artists] give up the truth in their images and make only the proportions which appear to be beautiful, disregarding the real ones." In this context, Plato seemed to favor true proportions over the beautiful. Although such discussions were about sculpture and involved basic questions about the aesthetics of art, they stimulated very little discussion about the basic questions of the aesthetics of sculpture.[2] The same is true of Polyclitus's famous but lost writings about the proportions of sculpture, despite their much more specific reference to sculpture.[3] In the first century B.C. the Roman Vitruvius, the only ancient writer from whom we have numerical data on human proportions, claimed that "nature has so designed the human body that the skull, from the chin to the upper part of the forehead and the roots of the hair, should equal one-tenth of the length of the body." Similarly the rest of the parts of the human body were given very precise numerical relationships. But as Wladyslaw Tatarkiewicz points out: "The [ancient] sculptor's canon was really concerned with nature, not art. It measured the proportions appearing in nature, particularly in a well-built man, rather than the proportions which should appear in a statue."[4] No principles were set forth concerning whether the sculptor had the right to introduce corrections in anatomy and perspective to improve upon nature. The ancient sculptors exercised that right, of course, but aside from Plato there was little systematic examination (a basic characteristic of *aesthetics* as I am using the

3

term) of this artistic freedom. Although the ancients thoroughly examined the relation of some of the arts to nature—Aristotle on tragedy, for instance—they generally ignored that question with respect to sculpture or, for that matter, painting and architecture. No ancient philosopher, as Paul Oskar Kristeller points out, "wrote a systematic treatise on the visual arts or assigned them a prominent place in his scheme of knowledge."[5] Antiquity had no Muses for painting, sculpture, and architecture; they were invented by the allegorists of modern times.

That same neglect of the aesthetics of sculpture prevailed into the Middle Ages. Although much was written on poetics and the theory of music, apparently no general treatise on sculpture or any of the visual arts was produced. Painting, sculpture, and architecture belonged to the mechanical "vulgar arts."[6] Giotto's designs for some of the reliefs on the lowest story of the Campanile in Florence in the early fourteenth century are one of the first indications of change, for painting and sculpture are represented between the liberal and the mechanical arts. Finally in the Renaissance, painting, sculpture, and architecture were clearly distinguished from the technical crafts, as in the writings of Alberti, Leonardo, and Dürer. For the first time in the West explicit questions were raised about the nature of these arts, but the question of the autonomy of sculpture was never explored in depth, as is indicated, for example, by the answers to the poll of 1546 taken by Benedetto Varchi.[7] The leading painters and sculptors were asked to compare the merits of painting and sculpture. The sculptors, such as Michelangelo and Cellini, naturally rated sculpture above painting, but invariably they assumed that a sculpture was no more than a many-sided painting, viewed basically in the same way as a painting except that sometimes there was more than one side to see. This failure to establish firmly the autonomy of sculpture has persisted into this century. Even in our own day the studies that consider the question of the autonomy of sculpture, such as Herbert Read's *The Art of Sculpture*, are rarities. The *Journal of Aesthetics and Art Criticism* and the *British Journal of Aesthetics*, for example, have published only a handful of articles on the aesthetics of sculpture. No other major art, not even photography or film which are recent arts, has been so neglected. Why this silence?

There are two closely related reasons. In the first place, the vast range and complexity of sculpture discourage investigation. The basic questions are rarely raised because it is so difficult to define sculpture or even to delimit its scope. For example, relief sculpture sometimes differs remarkably from sculpture in

the round. Furthermore, the species of sculpture seem to have no end: mobile, stabile, sound, light, laser, space, earth, pop, junk, funk, environmental, shelter, tableaux, machine, minimal, process, cybernetic, conceptual, etc. It seems futile to attempt to enumerate a sufficient number of characteristics inclusive of all works that are or will be named and used as sculpture. And if we are unable to arrive at a definition as the basis for bringing together these manifold exemplifications, then any aesthetics of sculpture would seem to be impossible; we would not know what we are talking about. Morris Weitz's well-known theory of family resemblances, developed from Wittgenstein, might seem to be a solution. Thus sculpture presumably could be identified as an assemblage of things brought together by relations of resemblance, in such a way that every member of the group possesses some similarity to some other member but with no property common to all members of the group. Unfortunately the complexities of this approach are so forbidding in the field of sculpture that no one, as far as I know, has tried it. There seems to be such a maze of threads, of an intricacy perhaps unique among the arts, that there is little hope that a family pattern can be woven.[8] And even if it were, that success would not answer the more basic question of the family's origin. Apparently sculpture is not a kind of thing which differs from all other kinds of things in any one essential way.

In the second place, consequently, sculpture appears to lack autonomy. It has been assumed generally since ancient times that painting, sculpture, and architecture are species of visual art, since in all three vision is the primary sense of perception. The traditional view of the visual arts, furthermore, almost invariably regards painting as the basic art. "We have no difficulty," Adrian Stokes tells us, "in speaking of the painter as the artist *par excellence*, of painting as the representative of art in general."[9] In turn, if the questions about the aesthetics of painting are answered, then we have the keys to answering the questions about the aesthetics of sculpture. Painting is the two-dimensional matrix from which sculpture expands into a three-dimensional painting; and architecture is a large-scale sculpture—for architecture shares with sculpture the relations of skin to skeleton, surface to volume, and mass to void—that opens up a space we can enter and use for utilitarian purposes.

The usefulness of these traditional distinctions for differentiating painting, sculpture, and architecture is limited. The line between painting and sculpture, especially, is often difficult to draw. Some low-relief sculpture, for example, is hardly more three-dimensional than some paintings by Van Gogh or Jackson

5

Pollock in which the paint is piled on the canvas as high as a half inch. The paint on Richard Pousette-Dart's *Cavernous Earth with Twenty-seven Folds of Opaqueness* in the Hirshhorn Museum in Washington protrudes an inch from the canvas. Max Ernst developed the technique called "grattage" (as in *Swamp Angel*), grating or scratching wet paint with sharp tools, working it like sculptural material. Ben Nicholson's *Painted Relief* (Fig. 52)—painted synthetic board mounted on plywood—is an excellent example (as is suggested by the ambiguity of the title) of the difficulties in attempting to distinguish sculpture from painting solely on the basis of dimensionality. Or consider Alexander Archipenko's description of "Sculpto-Paintings," an innovation of 1912: "A panel painting uniting colors and forms having interdependencies of relief, concave or perforated forms, colors and textures. . . . Forms are intermixed with the patterns of color and the space between them."[10] Contemporary works, especially, are often difficult to classify. They exhibit a characteristic of our time by challenging the inherited practices and distinctions. For example, Lucio Fontana sometimes slashes through his painted canvas, showing depths of several inches, like open wounds. Lee Bontecou, conversely, sometimes uses wire to stretch her canvas and other materials out into space. Even some of the earliest known works, such as the bison of the Altamira cave paintings, often involve the bulges and hollows of the rock formations in a way that brings out three-dimensionality, and some of the outlines are incised as well as painted. And what about painted pottery? And mosaics? Three-dimensional objects such as tables and chairs are placed in front of their painted canvases by some pop painters (or sculptors?), such as James Rosenquist and Tom Wesselmann, in such a way that they are ingrown with the two-dimensional designs. Are these examples of sculpture or of painting?

Although it is usually easier to distinguish sculpture from architecture on the basis of whether an inner space for practical purposes exists, there are also difficulties with this criterion. For example, the Pyramids were intended to open up an interior space for the dead only. Antonio Gaudi's chimneys of the Casa Milá in Barcelona are powerfully sculptural in appearance, yet their interiors are a functional part of the building. Eero Saarinen's immense *Gateway Arch* in Saint Louis opens up inner space only for people on a small observation deck at the top and in the passageways and elevators that get them up there. Constantin Brancusi's *Gate of the Kiss* and Alexander Calder's *Gates of Spoleto* can be used as shelters. Kurt Schwitters in his *Merzbau* environment divided interior functional space by using fantastic combinations of refuse and

6

found objects as structural and decorative elements. Are these examples of sculpture or of architecture?

The usual answer, for good reasons, classifies such examples as mixed media. Painting, sculpture, and architecture at various times, as these examples clearly indicate, have tended toward or achieved merger rather than exclusion. No angel with a flaming sword stands between the painter, the sculptor, and the architect. To insist upon sharp divisions between painting, sculpture, and architecture which would deny their interactions and fusions is fruitless. Certainly (and fortunately) contemporary artists will not be intimidated by such theorizing, although, as in the nineteenth century, that kind of theoretical intimidation has occurred.[11] But, on the other hand, to classify works as mixed media is an answer that begs the question about the autonomy of sculpture. When sculpture mixes with painting or architecture, an adequate explanation of the result must include an understanding of what went into the mix.

Although in the Western tradition painting has usually been conceived as the mother of the visual arts, in the Medieval period, usually, architecture was so conceived, especially of sculpture. As Jurgis Baltrušaitis observes: "The relief destined to adorn an edifice, to emphasize and validate its various members, loses its plastic meaning if one isolates it from the monument that carries it. One may say that the architect guided the sculptor's chisel."[12] Thus in almost all Romanesque portals the tympanum and the lintel are not allowed to become separate sculptural fields. Moreover, the architecture provided for the most part the materials—usually stone—for the sculptor. Born from walls, sculpture was the child of architecture and remained under her protection.[13] The parentage of architecture is seemingly persuasive, for traditionally the most important function of relief sculpture was its adornment of architecture. Until this century, furthermore, practically all monumental sculpture in high relief or in the round was made for the architectural niche, the womb of Mother Architecture. John Dewey claims that it is "open to doubt whether the sculptural dissociated from the architectural ever will reach great aesthetic heights. It is difficult not to feel something incongruous in the single and isolated statue in the public square or park. Surely statues are most successful when they are massive, monumental, and have something approaching an architectural context."[14] But since claims for Mother Painting have been made for a longer time, especially insistent since the Renaissance, painting and sculpture are usually grouped together by contemporary theorists as clearly distinct from architecture. For example, Katherine Kuh argues that "because architecture, unlike painting and

sculpture, goes beyond the visual to involve us in physical realities, it demands both psychological projection and kinetic participation."[15] Such a division usually returns sculpture to the parentage of painting, as we see with Adolf von Hildebrand's very influential *On the Problem of Form in Painting and Sculpture* (1893).[16]

There are, of course, commonsense grounds for thinking of sculpture as simply a three-dimensional extension of painting rather than as an autonomous art. The differences between painting and sculpture, especially in the way they are perceived, seem superficial. Some sculptures cause us to move around more than most paintings, and some sculptures, as opposed to almost all paintings, solicit our touching. But even with such sculptures, sight seems, as the tradition has always maintained, to be the completely dominant sense. The following statement by Rhys Carpenter is representative of the long, almost completely unchallenged tradition that espouses the "eminence of the eye":

Sculpture is a visual and not a tactile art, because it is made for the eyes to contemplate and not for the fingers to feel. Moreover, just as it reaches us through the eyes and not through the finger tips, so it is created visually, no matter how the sculptor may use his hands to produce his work. . . sculptured form cannot be apprehended tactilely or evaluated by its tactual fidelity. . . . Any dissenting opinion is probably inspired by the heightened physical actuality of sculptural presentation: we cannot directly sense a painted texture by touching the canvas, whereas we can actually explore with our fingers the solid sculptural shape. But the logic is faulty if it is thence inferred that sculpture is more immediately involved in the tactile sense; for, at best, we can only touch the material medium and not the artistic representation which is intended and calculated for the eye's contemplative vision.[17]

Or consider the conclusion of Claire Golomb after studying the sculpture and drawing of very young children. "This study . . . resulted in the discovery of the evolution of *diverse* human figures in drawing and modeling, differences related to the effects of a two- and a three-dimensional medium."[18] But then she also concludes that "in drawing and modeling visual aspects of the object dominate."[19] When modeling, the children were kneading, rolling, patting, smoothing, stretching, and disjoining and joining their playdough. Their sense of touch, as Golomb's data clearly indicate, was far more involved in their modeling than in their drawing. Nevertheless, consistent with the eminence of the eye tradition, Golomb concludes that the visual aspects in the making and perceiving of sculpture dominate. No point is made of touch as being even an important factor.

8

This belief in the eminence of the eye is reinforced by the fact that most of us know sculptures primarily through photographs, and a photograph reduces a sculpture, which is a configuration of three-dimensional shapes, to a configuration of colored or toned two-dimensional shapes. In André Malraux's "museum without walls" we can see sculptures from all times and places. But, unfortunately, a photograph of a sculpture can only represent and cannot present three-dimensionality. And only rarely can a photograph avoid sharpening and emphasizing the silhouette at the expense of the three-dimensional shaping. A photograph of a painting is not so reductive, because it translates from one two-dimensional medium into another. That is why, after becoming familiar with both a sculpture and a painting through photographs, the first viewing of the actual sculpture is likely to be a fresher and more exciting experience than the first viewing of the actual painting. The fact that the camera provides us only with two-dimensional or pictorial views of sculpture not only encourages the overestimation of the eye in the perception of sculpture but also tightens the tyranny of the two-dimensional view of sculpture.

It is often the case, moreover, that we perceive a sculpture from a considerable distance, and distancing involves a progressive flattening of the appearance of a solid body. For example, if a person stands before Masaccio's *Trinity*, on the south wall of the third bay in Santa Maria Novella in Florence, and also observes in the distance Brunelleschi's *Crucifixion* in the first chapel of the south transept, Brunelleschi's sculpted Christ will probably be perceived as flat as a paper cutout, as being as two-dimensional as Masaccio's painted Christ. When one moves down the aisle toward the *Crucifixion*, however, its three-dimensionality becomes increasingly evident. Yet even then we may be convinced, along with Carpenter, that the ways we perceive the Masaccio and the Brunelleschi are basically the same. Furthermore, it might be argued, if we were paralyzed from the neck down we could still perceive sculpture as well as painting, whereas if we were blind we could perceive neither sculpture nor painting.

These points suggest that sight is indispensable for the perception of both sculpture and painting, whereas touch is dispensable. The tradition has been so dominated by the eminence of the eye that it never occurred to anyone before Marcel Duchamp and Constantin Brancusi in the twentieth century even to raise the question whether a blind person was able to perceive sculpture. They placed three-dimensional shapes with varying textures within opaque containers having openings at the top large enough to allow for passage of the

hands. The tactual and kinaesthetic sensations resulting from handling these shapes were intended to evoke pleasing feelings in people with or without vision. These works were to be perceived much like the Chinese touchstones that were meant to be held in one's hands and whose attraction is almost entirely tactual. (The terms *tactual, tactile, haptic,* and *kinaesthetic* are often used rather loosely. Under the *tactual* I include both tactile perceptions, i.e., feelings of things and events outside the skin, and haptic perceptions, i.e., feelings of things and events inside the skin. By kinaesthetic perceptions I mean the feelings of movements associated with tactual perceptions.) But the questions raised by these experiments received little attention. A painting and a sculpture side by side seem to be perceived mainly or solely by the eye, and our perceptual apparatus seems to function in essentially the same way for both objects. Although admittedly the sculpture has more corporeal substance, it is not obvious that something different is happening to us when we are perceiving a sculpture as contrasted with our perceiving a painting. So it seems to follow that if the perception of painting is adequately explained, then the perception of sculpture is also adequately explained. Furthermore, it also seems to follow that if the creation of painting is adequately explained, then the creation of sculpture is also adequately explained. For example, it is a widely accepted belief that the revolutionary advances in sculpture at the beginning of this century, especially by Brancusi, Umberto Boccioni, Archipenko, Duchamp-Villon, Ossip Zadkine, and Pablo Picasso, were essentially a transposition to three dimensions of the discoveries made by cubist painters.[20] In short, it is pervasively assumed that sculpture lacks autonomy. This assumption helps block investigation into basic questions about sculpture.

Even when basic questions about sculpture are investigated, there are two special difficulties. The first difficulty is shared by aestheticians describing painting as well as sculpture. Even if a person sets aside or brackets the traditional assumptions and tries objectively to describe what happens in the respective perceptions of painting and sculpture, there still remains the problem of perceptual types. Viktor Lowenfeld's experiments, following the explorations of Alois Riegl, indicate that roughly one-fourth of all individuals are tactually—or what Lowenfeld calls "haptically"—oriented, half are visually oriented, and the remaining one-fourth are not clearly one or the other: "An extreme haptical type of individual—by no means rare—is a normal-sighted person who uses his eyes only when he is compelled to do so; otherwise he reacts as would a blind person who is entirely dependent upon touch and kinesthesis.

An extreme visually minded person, on the other hand, is one who is entirely lost in the dark, one who depends completely on his visual experiences of the outside world."[21] This typology suggests that phenomenological descriptions of the perceptions of painting and sculpture—allowing them to show themselves from themselves without our perceptual idiosyncrasies intervening—are an ideal that can only be approximated. Visually oriented persons probably will prefer painting to sculpture and will tend to describe their perceptions of sculpture in pictorial terms. They are likely to admire pictorially oriented sculptors such as Ben Nicholson and Louise Nevelson more than Brancusi and Henry Moore. Their memories are mainly visual. Thus as tourists they find the camera indispensable, for their pictures prove to themselves that they were there. Tactually oriented persons probably will prefer sculpture to painting and will tend to describe their perceptions of painting in sculptural terms. They are likely to admire sculpturally oriented painters such as Paul Cézanne and Jackson Pollock more than Piet Mondrian and Mark Rothko. They find the camera dispensable. To put the point in other ways: tactually oriented persons will regret the loss of mass when they discover that what they took to be a range of mountains is only a line of clouds; when golfing, they will not only sight their putt but walk to the hole to get a feel of the distance; and they will want not only to view the sea but to swim in it. Judging by Lowenfeld's tests, which are at best only rough guides, I would place myself somewhere near the center between the visual and tactual types. In any case, I love both painting and sculpture, yet I find my perceptions of them significantly different. These differences, often admittedly subtle and difficult to articulate, have very important consequences, if I am correct, for the aesthetics of sculpture. These differences are important not because they suggest the superiority of either painting or sculpture (that dreary issue was worn out in the Renaissance), but rather because they suggest the autonomy of the two arts, and that is an exciting issue that rarely has been probed. My many comparisons of sculpture with painting are meant to bring out the distinguishing characteristics of sculpture, and any innuendoes about the superiority of sculpture should be ignored.

The second special difficulty is restricted to the aestheticians of sculpture. Conclusions about perception derived from experimental psychology are often helpful in understanding how we perceive the various arts, but usually they are far more relevant to painting than to sculpture, as the work of Rudolf Arnheim (Art and Visual Perception, for example) demonstrates. Scientific psychologists generally focus on visual rather than on tactual material. Moreover, this visual

material is usually highly artificial, such as dot patterns on two-dimensional surfaces, and this material is usually investigated in highly artificial situations, such as the motionless observer with a fixed head in the environment of the laboratory.[22] Such materials and situations are not so different from the perception of most paintings, but they are very different indeed from the perception of most sculptures. Vision in a moving head on a moving body of a three-dimensional thing—normally the situation with the perception of a sculpture—differs in crucial ways from vision in a fixed head on a still body of a two-dimensional surface—normally the situation with the perception of a painting. Thus figure and ground relationships on two-dimensional surfaces, one of the key phenomena investigated by Gestalt psychologists especially, appear quite differently on three-dimensional things. With sculpture, usually, "figure and ground" become "figure and surround." That does not mean that conclusions of experimental psychology are necessarily irrelevant to the aesthetics of sculpture, but rather that they need to be applied with special care.

To sum up, the traditional theory about sculpture, derived from the traditional theory about perception, is loaded with misconceptions. Only in recent times, especially with the development of phenomenology, have the misconceptions about perception begun to be radically attacked. Because of this movement, it is now possible to begin an aesthetics of sculpture based on firmer foundations, one that is able to be tested with reference to its ability to increase our understanding and, in turn, enrich our experience of sculpture. Generally the aesthetic experiences of sculpture have been left either without theoretical enlightenment or, more unfortunately, muddied up with theoretical error. No other art, I believe, has suffered more.

This study is divided into two parts. In Part I the basic question will be: How is sculpture perceived? In Part II: How does sculpture come to be? These questions require considerations of the distinctive features and autonomy of sculpture. In Heideggerian terminology, I am seeking the "essence" of sculpture. An essence, for Martin Heidegger, is not simply what a thing is—lending itself, presumably, to an analysis that results in a definition stating the necessary and sufficient properties of the thing. Rather, an essence is the manner in which something comes into being and remains as it is. An essence is not a thing but the generative power that makes a thing what it is. Thus the questions: What forces impel man to create sculpture? What forces impel man to cherish and preserve sculpture? Answers to these questions will, I believe, reveal features unique to sculpture, though they may not constitute necessary

12

and sufficient properties. If sculpture cannot be usefully defined, that does not mean either that sculptural examples cannot be convincingly selected or that we do not know what we are talking about. Both the features of, and the concepts about, sculpture obviously have blurred boundaries with other arts, but the centers of both the features and the concepts are clear enough.[23] In brief, I am seeking the reasons for the existence of sculpture. I am seeking both to describe accurately the phenomena of sculpture and to explain why they happen.

The questions about the perception of sculpture in Part I precede the questions about the origin of sculpture in Part II because the origin cannot be convincingly located and understood until the autonomy of sculpture is established. This establishment requires an analysis of how sculpture shows itself in our perceptions. Conversely, the location of the origin of sculpture grounds the perception of sculpture in its true context. In Chapter 1, I trace the way the aesthetics of sculpture in the West has been dominated by the presupposition of the eminence of the eye and, in turn, by the aesthetics of painting. In Chapter 2, I describe and compare the ways we perceive sculpture and painting. The method used in these descriptions here and throughout is phenomenological: allowing the sculptures to show themselves from themselves, i.e., as phenomena.* These descriptions and comparisons provide strong prima facie evidence that the perceptual dynamics of sculpture and painting are significantly different and, therefore, sculpture and painting are autonomous arts. In the first section of Chapter 3, I briefly review the traditional theory of perception which presupposes the eminence of the eye. In the second section, I consider revisions of that theory by psychologists as well as, and more importantly, by phenomenologists whose investigations radically attack the traditional theory. In Chapter 4, I show that sculpture is most adequately understood as an

* Phenomenology—the unprejudiced description of phenomena insofar as that is possible—is often burdened with neologisms, especially as practiced by Edmund Husserl, Heidegger, and Maurice Merleau-Ponty. Sometimes, however, what appear to be neologisms, especially to Anglo-American analytic philosophers unsympathetic to phenomenology, are actually new terms having new meanings. And this is necessary on occasion because Western languages from the time of Plato, both everyday and systematic, are trapped in assumptions—as Jacques Derrida has been so wittingly pointing out—that slant our understanding of our world, leading, for example, to the sharp and sometimes misleading distinction between ourselves as subjects and everything else as objects. These assumptions, as I will try to show, are partially responsible for the failure to recognize and understand the autonomy of sculpture. At times, therefore, I will use terms such as "being-in-the-world" and "being-with," not because they are used by phenomenologists but rather because they will not be as misleading as traditional terms.

autonomous art, based on such evidence as was described in Chapter 2. Support for this claim is aided by a more sophisticated understanding of perception, as reviewed in Chapter 3. I conclude that the most distinctive feature of any sculpture is its activation of its surrounding space—its enlivened space or "impacting between." The presence of this feature makes a work "sculptural" as distinguished from "pictorial." In Chapter 5, I examine the way the "between" functions in the major arts. Then in Chapter 6 I begin to explore in more detail how enlivened space functions in sculpture, specifically in the work of Brancusi, Moore, and Alberto Giacometti. The correctness of the conclusion that enlivened space is the most distinctive feature of sculpture will be confirmed, I hope, by the way the understanding of this feature helps illuminate and organize the vast variety of sculptural works.

Part II is about the origin of sculpture, not in the historical sense but rather in the sense of an examination of what forces impel man to create and treasure sculpture. In Chapter 7 I claim that the distinctive, underlying, and all-pervasive subject matter of sculpture is our togetherness or physical "withness" with things. The origin of sculpture, consequently, is located in the drive to reveal that mode of existence with a clarity that is usually lacking in everyday experience, for in everyday experience our unity with things usually is either confused or forgotten. In the following chapters and appendix, supporting evidence for these claims is presented.

HOW IS SCULPTURE PERCEIVED?

I

The Eminence
of the Eye

The vision of the mind authoritatively supplements the vision of the eye.
John Tyndall

One of the key presuppositions underlying the dominant weltanschauung of the Western philosophical tradition has been the eminence of the eye over the other senses. Sight is the firstborn and noblest sense. The mutilated eye, as with Oedipus, is the symbol of spiritual torture. "Theoria," the highest activity of the mind, is described mainly in visual metaphors, as is the face or visage, the highest feature of the body both physically and in importance. The eyes are thought to be more directly connected with the mind than the other senses. In turn, light is the most important power of our world. "For light," as Schopenhauer saw, "is the pleasantest and most gladdening of things. . . . the correlative and condition of the most perfect kind of knowledge of perception."[1] Even before philosophy, most myths of the Ur-situation (original creation) make "to-be-ness" depend upon the formative powers of Light. In the Beginning primeval matter was without shape. Darkness was upon the face of the Deep. But Spirit moved upon this face and there was Light, this Light being the organizing principle that brought order into what Milton called Chaos and Old Night. The Light of creative intelligence, whose cosmic structuring was the first work of visual art, formed the primeval, nondescript stuff into Heaven and Earth, making vision and knowledge possible. Since three-dimensional matter

17

was formed, sculpture conceivably might have been thought of as the art closest to the model of cosmic creation and hence the supreme visual art. Indeed, in Plato's *Timaeus* God is a kind of sculptor who fabricates the universe. But in thought if not in practice, it seems that sculpture from the beginning has always been dominated by painting. If nature is the art of God, then God is a painter.

In ancient writers generally, and Plato and Aristotle specifically, references to the distinctive features of painting and sculpture are infrequent and inconsequential. Painting, however, draws far more references than sculpture in ancient literature,[2] as in the writings of Galen and Philostratus, despite the great qualitative superiority of Greek sculpture (at least in the judgment of almost everyone since ancient times) as well as its apparent quantitative superiority. Furthermore, it was assumed, although never explicitly stated as far as I can discern, that if the distinctive features of painting were understood, then the distinctive features of sculpture would also be understood. Both painting and sculpture are revealed by light to the eye. Apollo, the father of the Olympian world according to Nietzsche, was "the god of all plastic energies . . . the 'shining one,' the deity of light."

For Plato, sight was the primary physical stimulus of reason and the soul to the Beautiful, the True, and the Good. Thus Plato speaks of "the light of reason" and of "the eye of the soul." Among the senses, Plato suggests that the eyes are least likely to mire the spirit in the messy world of the corporeal. He mocks those who think they can seize Being "with their bare hands." Sight, as in the Myth of the Cave, is the sense most likely to lead us toward Being; the other senses, it is implied, are more likely to lead us toward Becoming. Aristotle, in the opening lines of the *Metaphysics*, declares that vision among the senses yields the most knowledge, excels in differentiation, and is enjoyable for its own sake. "To see" in both Greek and Latin carried (and still carries in all Western languages) such connotations as: to understand, to have insight. Painting and sculpture (along with architecture) were classified as visual arts. If the other senses were involved in the creation and perception of painting and sculpture, they remained strictly subservient to vision. Philostratus, for example, claimed that before Pheidias sculpted Zeus he must have given himself "to viewing the world together with the sky and the stars." Nothing is said about the feel of the marble. Despite the fact that among Ancient Greek and Roman arts painting was dominated by sculpture, painting dominated the attention of the philosophers, critics, and historians.

In the Middle Ages, the visual exaltation that promotes the superiority of

painting over sculpture continues. The one surviving treatise on sculpture—*De Diversis Artibus*, probably written between 1110 and 1140 in northwest Germany by a Benedictine monk with the pseudonym of Theophilus—is almost completely about technical problems, especially metalwork. The work consists of three books: the first deals with painting, the second glass, and the third sculpture. Although a metalworker, Theophilus seems to take it for granted that sculpture is subordinate to painting. In any case, the purpose of both arts is to produce visual images, and whether two-dimensional or three-dimensional apparently makes no essential difference. That same point of view is found in the famous Album of Villard de Honnecourt, that well-traveled architect of the thirteenth century. Indeed, the term *sculptor* meaning someone who works only in three dimensions was almost unknown in the Middle Ages. Such workers were usually called masons, stonecutters, metalworkers, and so forth. Medieval Christianity, furthermore, had special problems with sculpture. The Old Testament proscribed: "Thou shalt not make unto thee any graven image, or likeness of any thing that is in heaven above, or that is in the earth beneath, or that is in the water under the earth." In the Eastern Church, especially, icons of the Divine were worrisome. The Council Hieria of 753–754 denounced artists who "with unclean hands would bestow a form upon that which ought only to be believed in the heart." A painted icon of the Divine sometimes was acceptable, but a sculpted icon of the Divine, particularly in the round, was a blasphemy. In the Western Church monumental sculpture in the round of the Divine also was generally avoided, for it was associated with the ancient sculpture of the pagan religions—errors in stone. On the other hand, little ancient painting had survived, and most of that painting was not linked with cult. Hence it seemed proper to represent the sacred in paint, but it took a long time before the sacred in stone was acceptable. From the fifth to the eleventh centuries, sculpture was restricted largely to relief carvings on sarcophagi, other memorials, and especially architectural decorations such as capitals of columns, tympanums, lintels, altars, pulpits, doors, and screens. Even as late as the twelfth century the nonpuritanical Peter Abelard, despite his protection by Abbot Suger from the puritanical Saint Bernard, was inveighing against graven images. Suger himself (and this was typical) accepted sculpture as stone painting, subordinate to and not basically different from painting on wood, a compromise imposed by the Iconoclasts. As Charles Biederman points out: "The Iconoclasts at first opposed sculpture but approved of painting, and . . . eventually they were able to impose restrictions upon the sculptural medium by

means of specific laws as to its use. Apparently they decided to admit sculpture (since they could not enforce their will by completely eliminating worship-images) on the condition that the painting medium, which did not possess the major reality characteristics of the third dimension, be given precedence over it. In the painting medium they evidently felt that images were freed as much as possible from the here-reality."[3] Relief sculptures on both the outside and the inside of the church were acceptable within the grammar of architecture as adjectives, not as substantives. The few examples of sculpture in the round, on the other hand, were almost always inside the church, placed in niches in such a way that they appeared as pictorial as possible.

For medieval thinkers, sight was the primary sense that could lead the ignorant, like those of Plato's cave, to God and the Good. The palpability of sculpture was either overlooked or faulted. Suger's Abbey Church of Saint Denis was saturated with sculptural splendor, but Suger rarely wrote about sculpture. Apparently he perceived only the pictorial in sculpture, often reducing sculptures to gems, like stained glass, which moved his spirit to transcendence.[4] Stained glass and stone pictures gain their glory from the sun. As Dante proclaimed: "There is no visible thing in the world more worthy to serve as a symbol of God than the sun." And as the Pseudo-Areopagite proclaimed in the opening of his major work, *De Caelesti Hierarchia*: "Every creature, visible or invisible, is a light brought into being by the Father of the lights. . . . This stone or that piece of wood is a light to me." It was only during and after the Renaissance, when light was no longer necessarily identified with God,[5] that sculptural autonomy even became an issue.

In the Renaissance the autonomy of sculpture was implied in the many discussions concerning the merits of painting versus sculpture. Leon Battista Alberti even argued, mainly because of his awe of antiquity, that sculpture in churches was preferable to painting.[6] Moreover, by about the year 1500 painting and sculpture along with architecture finally were ranked as liberal arts. Furthermore, while painting interested the theorists much more than sculpture,[7] treatises on sculpture, although less numerous than treatises on painting, at last appeared—for example, Alberti's *De Statua* (c. 1433) and Pomponio Gaurico's *De Sculptura* (1504). Although these treatises were technical rather than theoretical, their discussions generally took for granted the autonomy of sculpture. Yet even in the late fifteenth century, even after Donatello and Ghiberti, sculptors were disparaged. When the young Michelangelo an-

nounced that he wanted to be a sculptor, his father announced that he would never allow his son to become a stonecutter. Only the insistent intervention of Lorenzo the Magnificent succeeded in changing the father's mind. Even when sculpture was accepted as an autonomous and liberal art, it was usually kept inferior to painting. For example, Leonardo disparaged sculpture because it causes "much perspiration which mingling with the grit turns into mud." And Castiglione in his *Courtier* permitted poetry, music, and painting as proper pursuits for a gentleman. But like most ancient Roman writers such as Lucian, Castiglione maintained that although a gentleman should admire the works of great sculptors he should not, because of the heavy manual labor, be one himself. Furthermore, like most writers of his time, Castiglione downgraded the sense of touch, and so did the artists in their programs. Thus *The Lady of the Unicorn*—that exceptionally colorful series of tapestries of courtly life in the Cluny Museum in Paris, executed by the Flemish in the late fifteenth century from French cartoons—is an allegory of the five senses. Typically the place of honor is given to the representation of vision, first on the right, while the representation of touch is placed last on the left.

Leonardo on other occasions moved to firmer ground. He argued that both painting and sculpture are visual arts which aim at representing the visual scenes of nature, and that painting not only can represent some things better than sculpture, going back to Alberti's *On Painting*, but also can represent some things which sculpture cannot:

In the first place, sculpture is dependent on certain lights, namely those from above, while a picture carries everywhere its own light and shade; light and shade therefore are essential to sculpture. In this respect, the sculptor is aided by the nature of the relief, which produces these of its own accord, but the painter artifically creates them by his art in places where nature would normally do the like. The sculptor cannot render the difference in the varying natures of the colours of objects; painting does not fail to do so in any particular. The lines of perspective of sculptors do not seem in any way true; those of painters may appear to extend a hundred miles beyond the work itself. The effects of aerial perspective are outside the scope of sculptors' work; they can neither represent transparent bodies nor luminous bodies nor angles of reflection nor shining bodies such as mirrors and like things of glittering surface, nor mists, nor dull weather, nor an infinite number of things which I forbear to mention lest they should prove wearisome.[8]

In opposing this view of Leonardo, the defenders of sculpture stressed its ability to show more aspects of a figure than a painting. Giorgione, according to Vasari, had the answer to that assertion:

Giorgione was of the opinion that a painting could show at a single glance, without it being necessary to walk about, all the aspects that a man can present in a number of gestures, while sculpture can only do so if one walks about it. He offered in a single view to show the front and back and two sides of a figure in painting. . . . He accomplished this in the following way. He painted a nude figure turning its back; at its feet was a limpid fount of water, the reflection from which showed the front. On one side was a burnished corselet which had been taken off, and gave a side view, because the shining metal reflected everything. On the other side was a looking-glass, showing the other side of the figure, a beautiful and ingenious work to prove that painting demands more skill and pains, and shows to a single view more than sculpture does.[9]

No defender of sculpture was able to articulate principles for sculpture independent of those for painting. Michelangelo much preferred sculpture over painting, arguing that "painting should be considered excellent in proportion as it approaches the effect of relief, while relief should be considered bad in proportion as it approaches the effect of painting."[10] However, Michelangelo, through Ficino's philosophy especially, was deeply influenced by neo-Platonism, a "light metaphysics" tightly tied to the eminence of the eye. Plotinus claimed, "Beauty addresses itself chiefly to sight." The sun is the symbol of spiritual reality. The eyes, the windows of the soul, see the sun because they are themselves sunlike. The eyes mark the presence in the body of that radiant emanation of ideal extrasensory reality which hierarchically orders and sustains matter in being. Conversely, the other senses are inseparably enmeshed in the body, and, for Plotinus, "The body is brute, the true man is the other, going pure of body." Similarly, Ficino in *Liber de Sole* identifies the sun, light, and sight with spiritual reality:

Nothing reveals the nature of the Good more fully than the light [of the sun]. First, light is the most brilliant and clearest of sensible objects. Second, there is nothing which spreads out so easily, broadly, or rapidly as light. Third, like a caress, it penetrates all things harmlessly and most gently. Fourth, the heat which accompanies it fosters and nourishes all things and is the universal generator and mover. . . . Similarly the Good is itself spread everywhere, and it soothes and entices all things. It does not work by compulsion, but through the love which accompanies it, like heat [which accompanies light]. This love allures all objects so that they freely embrace the Good. . . . Perhaps light is itself the celestial spirit's sense of sight, or its act of seeing, operating from a distance, linking all things to heaven, yet never leaving heaven nor mixing with external things. . . . Just look at the skies, I pray you, citizens of heavenly fatherland. . . . The sun can signify God himself to you, and who shall dare to say the sun is false.[11]

This downgrading, by implication, of the tactual powers of the body may have been partially responsible for Michelangelo's inability to articulate the inde-

pendence of sculpture from painting. Benvenuto Cellini, the most enthusiastic champion of sculpture in Renaissance Italy, published two very informative treatises, one on goldsmith work and the other on sculpture (*I Trattati dell' oreficeria e della scultura*), but he also failed to establish the autonomy of sculpture. For Cellini the demands on the sculptor are greater than on the painter; therefore, the sculptor's talents must be superior. Nevertheless, the sculptor must produce a series of views or aspects, a set of cunningly related silhouettes. For Cellini sculpture is a many-sided painting "seven times the greater" because a statue must have eight viewing points.[12] And the same pictorial emphasis was continued by G. B. Armenini, who thought of sculpture as primarily an aid to painters, recommending, for example, that the painter study ancient sculpture as the best possible model for the study of proportions.[13] However much the autonomy of sculpture began to be presupposed in the Renaissance, there were neither any significant theoretical defenses of that presupposition nor any descriptions that pointed to features that essentially distinguish sculpture from painting.[14]

In the seventeenth century, the ranking of painting over sculpture is indicated by the numerous treatises, based on Horace's *Ut pictura poesis*, that compared painting with poetry, the latter usually being rated the superior art.[15] The debasing materiality of sculpture kept it out of such exalted discussions, except for a few scattered and usually demeaning references. Only very occasionally was the honor that painting derived from its comparisons with poetry extended to sculpture.[16] The debates concerning the merits of painting versus sculpture subsided. In this Age of Science not much work was done in the aesthetics of either painting or sculpture. But sculpture continued to be subordinated to painting. A painting by Gonzales Coques entitled *The Sense of Sight* (Fig. 27) is indicative of the eminence of the eye, the importance of light, and the subordination of sculpture of painting. Although portraying a sculptor's hands at work on his statuette, the title makes no reference to the sense of touch. And the sculptor's gaze, emphasized by his glasses and the angle of the powerful lighting, converges on a surface patch, as if he were working a two-dimensional surface.

In the eighteenth century, Sir Joshua Reynolds agreed with Cellini's basic assumption that the aim of both painting and sculpture is pictorial representation. Reynolds disagreed, however, about the more difficult art: "Painting . . . is much more extensive and complicated than sculpture, and affords therefore a more ample field for criticism; and as the greater includes the less, the leading

principles of sculpture are comprised in those of painting."[17] It never occurred to anyone in the Age of Enlightenment (note once again the connection of light with understanding) to defend the autonomy of sculpture. We might expect such a defense from Winckelmann—especially in his *Thoughts on the Imitation of Greek Works in Painting and Sculpture*—as well as Lessing, for both had a special love for sculpture. Yet there is hardly a hint. Indeed, Lessing on the last page of his preface to *Laocoon* states, "By 'painting' I mean the visual arts in general." Joseph Addison spoke for his time: "Our sight is the most perfect and most delightful of all our senses."[18] Hölderlin was ahead of his time when he wrote early in the nineteenth century that strange saying: "King Oedipus has an eye too many perhaps."[19]

In the nineteenth century the irony increases, for it was a sculptor who wrote one of the most important treatises on visual perception. Adolf von Hildebrand declares: "The aim—the presentation of a general idea of space by means of a visual perception—is the same for painter and sculptor, and the work of each is directed by the same subjective requirements, however different may be their means of representation."[20] For Hildebrand there is a disturbing, almost agonizing, quality about the three-dimensional which can be overcome only by the relief-view. Mass must be translated into the two-dimensional, for otherwise the object remains "real" and the artistic "idea" is lost. Thus low relief is held to be the basic sculptural form, and high relief and sculpture in the round are simply devices for presenting a series of low-relief pictures:

If the figure offers more than one plane picture, there will, of course, be more than one position from which to view it. The number of satisfactory aspects a work may have depends on the artist's conception; it may be two, front and rear, as in statues of a relief-like character; it may be three, or four, etc. . . . But among all the possible aspects there will always be one that dominates. This one is representative of the total plastic nature of the object, and, like a picture or relief, expresses it all in a single two-dimensional impression. It stands for the virtual visual idea underlying the plastic representation which dominated the artist's mind when he created the work. . . . The problem in a plastic *ensemble* consists in arranging a solid figure so that it can afford us such a picture.[21]

For example, the *Winged Bull with Five Legs*—ninth century B.C. from the Palace of Ashurnasirpal II, now in the New York Metropolitan Museum of Art—appears from the front with two standing legs, and from the side with four walking legs. There are the two basic pictures, although which one Hildebrand would have considered dominant is difficult to determine. In any case, the

oblique views show five legs, and Hildebrand would want us to subordinate or ignore those pictures, similar to the way we subordinate or ignore the interim pictures of an unwinding Chinese scroll before a frame of the composition rolls completely into view and stops. Hildebrand's theory possibly is consistent with the intention of the Assyrian sculptor. And it may be the case that the Assyrian viewer ignored the oblique views. But such a theory surely does violence to the fullest and, in turn, most satisfactory perception of the *Winged Bull*, for part of its fascination is precisely the intrinsic value of the oblique views before they eventually swing us to the front or side.

It is true that in the nineteenth century, especially in the aesthetics of Hegel, sculpture is finally investigated as an art with its own principles. According to Hegel, "Sculpture, to put the matter in general terms, conceives the astounding project of making Spirit imagine itself in an exclusively material medium, and so shape this external medium that it is presented to itself in such and recognizes the presentment to be the objective form adequate to its ideal substance."[22] Nevertheless, Hegel continues the tradition of espousing the superiority of painting. Sight is closer to Spirit than touch,[23] and painting, being two-dimensional, is more an art of sight than is sculpture. Therefore, painting approaches more closely the objectification of Spirit; and the apotheosis of painting, which came in the Renaissance, inevitably came later in the progressive historical realization of Spirit than the apotheosis of sculpture, which came in Ancient Greece. Furthermore the autonomy of sculpture, as well as that of the other arts, is derivative from Hegel's metaphysical System. Unless you accept the System (and only a very special breed of Idealist still does), you are not likely to accept the formulation of principles that secures the independence of sculpture. This kind of aesthetics "from on high"—practiced as well by other German Idealists, e.g., Schelling and Schopenhauer—established the autonomy of sculpture at the expense of distorting the phenomena "below," the showing forth of the things themselves, i.e., the sculptures. Although rejecting the metaphysical systems, Baudelaire accepted the autonomy of sculpture. But sculpture is "brutal and positive like nature" and "at the same time vague and intangible, because it shows too many sides at once." Unlike painting, sculpture to its disadvantage lacks a unique point of view, is subject to the accidents of illumination, and is a vulgar artisan reality.[24]

In the early years of the twentieth century the eminence of the eye tradition in aesthetics continued, except that the ear sometimes was given equal status. For example, in his famous essay on "Psychical Distance," Edward

Bullough argued that the objects of taste, smell, and touch cannot be "distanced" in the requisite way and hence can rarely induce the aesthetic experience:

It has been an old problem why the "arts of the eye and of the ear" should have reached the practically exclusive predominance over arts of the other senses. Attempts to raise "culinary art" to the level of a Fine Art have failed in spite of all propaganda, as completely as the creation of scent or liquor "symphonies." There is little doubt that, apart from other excellent reasons of a partly psychophysical, partly technical nature, the actual *spatial distance* separating objects of sight and hearing from the subject has contributed strongly to the development of this monopoly. [25]

Sculpture for Bullough, furthermore, was perceived essentially as a many-sided painting. [26] Santayana was even more emphatic about the eminence of the eye: "The birth of spirit is joyful when it is the dawn of light, disclosing a thousand movements and objects that evoke intuition and excite a discerning love, or even a discerning aversion." [27] Yet Santayana was strangely negative toward painting, clearly preferring sculpture. [28] Nevertheless for Santayana, also, sculpture was perceived essentially as a many-sided painting. [29] Without exception, as far as I can discover, the aestheticians of the early twentieth century shared Bullough's and Santayana's visual prejudices. Yet with the development of the myriad forms of avant-garde sculpture in the early part of the century, it became increasingly evident, especially to some sculptors, that there is much more to perceiving sculpture than meets the eye. Naum Gabo put it succinctly: "To think about sculpture as a succession of two-dimensional images would mean to think about something else, but not sculpture . . . sculpture is three-dimensional *eo ipso*." Furthermore, in recent years studies of perception by psychologists (Jean Piaget, James J. Gibson, and R. L. Gregory, for example) and even more importantly studies of the phenomenology of the human body (Edmund Husserl, Max Scheler, Jean-Paul Sartre, and Maurice Merleau-Ponty, for example) would seem to imply that sculpture and painting are perceived differently. Yet almost no one has attempted to apply what we now know about perception to the basic questions about sculpture. [30] The eminence of the eye continues in aesthetics.

Merleau-Ponty, more than anyone else, has challenged the eminence of the eye with penetrating analyses. He insists on sight as the feeling of distance, on the intimate synthesis of sight and touch, that "sight-space" and "touch-space" are of the same world, and that our bodies with all their senses are immersed in that world. Thus in "Eye and Mind" he writes: "My body

26

simultaneously sees and is seen. It touches itself touching. It feels itself moving through the inherence of sensing in the sensed. Because it moves itself and sees, it holds things in a circle around itself." "Everything I see is in principle within my reach, at least within reach of my sight, and is marked upon the map of 'I can'. . . . The visible world and the world of my motor projects are each total parts of the same Being." "Things have an internal equivalent in me; they arouse in me a carnal formula of their presence." In *Signs:* "A perception is an opening of our flesh which is immediately filled by the universal flesh of the world." In *The Phenomenology of Perception:* "Our bodies are our anchorage in the world." Also:

The senses lead over into one another by opening themselves up to the structures of the thing. One sees the rigidity and fragility of the glass when it is broken with a crystal sound, this sound is carried by the visible glass. . . . The form of objects is not their geometrical contour: It . . . speaks to all of our senses at the same time as to sight. . . . In the swaying of a branch from which a bird has just flown, one reads its flexibility or its elasticity, and it is in this way that a branch of an apple tree and one of a birch tree are immediately distinguished.

Compare now typical experiences of perceiving a painting and perceiving a sculpture, especially one in the round. It seems obvious, at least in a preliminary way, that with most sculptures there is a much stronger sense of their carnal presence than in the case of most paintings, of sight-space and touch-space as being of the same world, of our bodies being immersed in that world. We would expect Merleau-Ponty, therefore, to take sculpture as the art that best illustrates his conception of perception, for example, the sculptures of Degas. From the late 1880s on, Degas practically abandoned painting—despite his mastery and acknowledged success in that medium—in favor of sculpture, the volumetric reconstruction especially of the female dancer and the horse. The perspectives constructed on two-dimensional surfaces, however turned or twisted or cut off, could not bring out the carnal presence he was seeking (Compare Figs. 35 and 36). By 1921, four years after his death, the bronze dancers and horses cast from the wax models found in his studio were exhibited and received wide critical attention. They are perfect illustrations for Merleau-Ponty's theory, and surely he had seen them. But, consistent with the traditional superiority of painting, Merleau-Ponty turns to the landscapes of Cézanne as his principal examples.

Merleau-Ponty's devaluation of sculpture by default is reminiscent of Bernard Berenson, who by and large ignored sculpture: "Painting is the most comprehensive, the most inclusive of the arts of visual representation, vying

27

with sculpture in a way that leaves to it little advantage—except indeed its resistance to exposure and its consequent preeminence as an adjunct to architecture and other out-of-door needs of decoration or commemoration."[31] Yet, oddly, Berenson demanded from painting a visualization of tactility. The painter can accomplish his task only by giving tactile values to retinal impressions. The purpose of these "ideated sensations" is to make visible, as Cézanne neatly put it, "how the world touches us." However, Merleau-Ponty would not accept Berenson's explanation that the colors and structures of a painting by Giotto or Masaccio suggest tactility. Berenson is assuming a scientific abstraction that Merleau-Ponty considers remote from immediate or primordial perception: "Cézanne does not try to use color to suggest the tactile sensations which would give shape and depth. The distinctions between touch and sight are unknown in primordial perception. It is only as a result of a science of the human body that we finally learn to distinguish between our senses. The lived object is not rediscovered or constructed on the basis of the contributions of the senses; rather, it presents itself to us from the start as the center from which these contributions radiate."[32] If Merleau-Ponty's description of perception is accurate, and I believe it is, then surely a sculpture, especially in the round, illustrates the point far more convincingly than a painting, even the most powerful by Cézanne. Sculpture reveals our physical "withness" with things, our "being-with," much more vividly than painting, and this suggests that sculpture is autonomous. Merleau-Ponty, however, never made this claim explicit.

Susanne K. Langer and Herbert Read have been leaders in recognizing the autonomy of sculpture. Yet both fall far short of a full appreciation of the distinctiveness of sculpture. Langer continues to adhere to the eminence of the eye, and Read fails to explain how our visual and tactual perceptions of sculpture are synthesized. Langer, in disputing Hildebrand, emphasizes the perceptual consequences that follow from the three-dimensionality of sculpture: "Sculpture, even when it is wedded to a background as in true relief, is essentially 'volume,' not 'scene.'"[33] She was one of the first to recognize explicitly that the space around a sculpture is part of that sculpture: "The tangible form has a complement of . . . space that it absolutely commands, that is given with it and only with it, and is, in fact, part of the sculptural volume."[34] The material body of sculpture and its space create an illusion or semblance of organic life. Sculpture is "virtual kinetic volume," created by the semblance of living form. "Here we have the primary illusion, virtual space, created in a

mode quite different from that of painting, which is *scene*, the field of direct vision. Sculpture creates an equally visual space, but not a space of direct vision; for volume is really given originally to touch, both haptic touch and contact limiting bodily movement, and the business of sculpture is to translate its data into entirely visual terms, i.e., *to make tactual space visible.*[35] Tactual space is transformed by the sculptor into a visual semblance, into "entirely visual terms," although the magic of the transformation is not explained by Langer. Despite her criticisms of Hildebrand, Langer also makes vision completely supreme in the perception of sculpture. Tactual sensations are only the raw material of the sculptor; for after he has finished his transformations, his and our sight sensations take over.

Read's *The Art of Sculpture*, however deficient, is still one of the most important aesthetics of sculpture of the West. Unequivocally, he rejects the eminence of the eye: "Sculpture owes its individuality as an art to unique plastic qualities, to the possession and exploitation of a special kind of sensibility. Its uniqueness consists in its realization of an integral mass in actual space. The sensibility required for this effort of realization has nothing in common with visual perception, i.e., with the visual impression of a three-dimensional form on a two-dimensional plane."[36] Visual perception of sculpture must, therefore, be supplemented: "Sculpture is an art of *palpation*—an art that gives satisfaction in the touching and handling of objects. That, indeed, is the only way in which we can have direct sensation of the three-dimensional shape of an object. . . . If we merely 'look at' sculpture, even with our sophisticated vision, which is capable of reading into the visual image the conceptual knowledge we possess from previous experience of three-dimensional objects, still we get merely a two-dimensional impression of a three-dimensional object."[37] The supplemental mode of perceiving, Read continues, involves a specifically plastic sensibility that is "more complex than the specifically visual sensibility. It involves three factors: a sensation of the tactile quality of surfaces; a sensation of volume as denoted by plane surfaces; and a synthetic realization of the mass and ponderability of the object."[38]

How the visual and plastic sensibilities are synthesized in our perception of sculpture is not discussed. Apparently Read assumes the still widely accepted theory based on Berkeley (*Essay towards a New Theory of Vision* [1709]) and Helmholtz (*Physiological Optics* [1865]) that visual data are two-dimensional as registered by the retina. Visual data acquire their three-dimensional meaning by association with tactual data. The inadequacy of this theory has been con-

29

vincingly demonstrated by James J. Gibson. He shows that sight-space is seen in depth because the mechanical conversion of the three-dimensional world into its two-dimensional projection upon the retinal screen produces "gradient" appearances, a pattern that changes in a regular order rather than in a disorderly array of flickering regions such as can be observed in the snow of a mistuned television screen. The stepwise organization of these "gradients" according to texture, size, shape, hue, and luminosity provides the mind behind the eye with the material for their comprehension as three-dimensional. Because of our intuitive understanding of these "gradients," our experience of depth and distance is not a conceptual inference from retinal data but is directly given to us in visual perception. [39]

Lacking Gibson's conception of an original unity, Read's perceptual world is built additively and sequentially. Sight-space is one world; touch-space is another world; and these two worlds have no necessary congruence. When the stimulations of vision and touch are passed on to the mind they can be integrated through the association of ideas, and only then does space-in-depth result. For example, we see a flat field; we touch various thicknesses; we construct a depth field. If we associate tactual memories with our sight without actually touching, "we get," according to Read, "merely a two-dimensional impression of a three-dimensional object." Hence the tactual sensibility can be evoked only by the actual touching of the material body of a sculpture. Unfortunately, since the material bodies of many sculptures are beyond our reach, even outside museums, many sculptures are therefore beyond our perception as sculpture. Michelangelo's *Pietà* in Saint Peter's, recently enclosed by glass, presumably cannot now be experienced sculpturally. The glass is admittedly bothersome, for it stops our movement toward and around the *Pietà*, but even if we could, would we really want to touch the material body of this sculpture? The numinous power of the work is so awesome that to touch the Virgin or Christ may seem sacrilegious. Moreover, unlike most of the sculptures of Brancusi and Arp, the surfaces of the *Pietà* in some areas, for example the ruffles of the collar and the hem of the Virgin's robe, would probably feel fussy to our touch, thus confusing our perception of the overall monumental simplicity of the statue. Furthermore, many sculptures are not attractive to touch; for example, the jagged surfaces of most of Giacometti's later bronzes (Figs. 57, 58). It is strange that Read did not listen to his good friend Henry Moore on this point: "Some people, misunderstanding the nature of tactile values, and perhaps wishing to be fashionable, will often say, 'I love touching sculptures.'

That can be nonsense. One simply prefers to touch smooth forms rather than rough ones, whether these forms be natural or created by art. Nobody can seriously claim to enjoy touching a rough-cast sculpture, with its unpleasant prickly surface that may be nonetheless good sculpture."[40]

Despite the rich suggestiveness of many of Read's analyses and his defense of the autonomy of sculpture, something is fundamentally missing in a theory that requires the touching of the material body of a sculpture for it to be perceived sculpturally. The difficulty derives, I submit, from Read's acceptance of the traditional theory of perception. The autonomy of sculpture needs to be established on firmer grounds.

II

Perceiving Sculpture and Painting

A definition of sculpture: something you bump into when you back up to look at a painting.

Ad Reinhardt

Concepts about the picture or image—the object of sight—have been and still are the basis for the aesthetics of painting and sculpture. And Hans-Georg Gadamer even pessimistically predicts: "The aesthetic concept of a picture will always inevitably include sculpture, which is one of the plastic arts. This is no arbitrary generalization, but corresponds to an historical problem of philosophical aesthetic, which ultimately goes back to the role of the image in Platonism and is expressed in the usage of the word."[1] Even when the autonomy of sculpture has been vigorously asserted, as by Langer and Read, the explanation of that autonomy has been weakened by reliance on the traditional theory of perception, with its key presupposition of the eminence of the eye. Although broader and more adequate descriptions of perception have been developing in psychology and phenomenology, the suggestions inherent in these descriptions which are relevant to the question of the autonomy of sculpture have been largely ignored. But the "inevitability" claim in Gadamer's prediction is unwarranted, as I hope to demonstrate.

First, however, let us describe and compare the ways we perceive sculpture and painting. I believe it is quite evident, independent of theory, that when we examine our perceptions of sculpture and painting closely we find, perhaps to

our surprise, that they are significantly different. For the purpose of an adequate aesthetics of sculpture, it is important to establish clearly these differences at the outset. The prima facie evidence for the autonomy of sculpture cannot be brought forth convincingly by theory, for theory may be loaded with concepts that twist the perceptual evidence. The traditional ways of describing painting and sculpture have been confused by the intrusion of theoretical interpretations. These descriptions often have been determined less by the phenomena, i.e., the paintings and the sculptures, than by theoretical points of view that interpret the phenomena rather than describe them as they are actually experienced. Like a camera with set lens, such theoretical approaches tend to frame only that which fits their focus. Often these theoretically based descriptions have brought out facets of the phenomena that otherwise would have been overlooked. But, at the same time, the narrowness of focus has caused much to be missed. I maintain that this is especially true of some of the most important differences between painting and sculpture. I want to get back to the things themselves—that painting and that sculpture in their splendid singularity. The aesthetic experience is my access. In the aesthetic experience our undivided attention is sustained on the work. There is no subject/object dichotomy. We lose explicit self-consciousness, our sense of being separate, of standing apart from the work. Nevertheless, the aesthetic experience is very active. Concepts are initiated and controlled by our perceptions. Our conceptions are experienced as fused with our perceptions, as a unity with the work. Thus, as the later Heidegger urged, we allow the work to be a phenomenon, to unfold into its fullness, its thingliness, or individuality.

Then I want to describe what I find. And, when I do this, I do not find an external object, set forth and distanced from me in the mode of analytic thought, but a thing-as-felt-and-meant. Now I am as close to the thing in its thingliness as I can be. But how can I describe this thing without objectifying it, without twisting it into the frame of some conceptual point of view? I can do this by allowing my aesthetic experience of the thing suggest the concepts to be used in my descriptions. I will allow the conceptuality that was already involved in my aesthetic experience to initiate and control the concepts used in my descriptions: "think from" the aesthetic experience of the painting or the sculpture. Then my concepts will not be set presuppositions, as in the traditional way of describing, but an emerging context that helps mitigate the twisting of the perceptual evidence.

Pure description, unadulterated by conceptual biases, is an ideal that can

only be approached, of course, but it can be approached. In any case, I will attempt in the following descriptions to follow Charles Sanders Peirce's stricture regarding his own approach to phenomenology: "The student's great effort is not to be influenced by any tradition, any authority, any reason for supposing that such and such ought to be the facts, or any fancies of any kind, and to confine himself to honest single-minded observation of appearances." In turn, as Peirce also claims, "The reader, upon his side, must repeat the author's observations for himself, and decide from his own observations whether the author's account of the appearance is correct or not."[2] After such phenomenological description,[3] the explanatory interpretations generated by theory can then be tested with some assurance that they are being referred to "what really is."

As I walked into a room in the Philadelphia Museum of Art, my attention was drawn to an early Rembrandt portrait (Fig. 25)[4] on one of the walls and the bronze version of Arp's *Growth* (Fig. 51) near the center of the room. The Rembrandt seemed to stand up and stand back. The Arp seemed to bend toward me. The space in front of the Rembrandt appeared vacuous. The space around the Arp appeared dense. I perceived the Rembrandt from across what seemed to be an impassible divide. I perceived the Arp coming toward me, for it seemed to have been created from the inside out.

Concentrating first on the Rembrandt, I found an optimal viewpoint or privileged position—avoiding bumping into the Arp!—that eliminated the glare of its glass protection and allowed the painting to be seen most clearly within one basic view, all elements being simultaneously available.[5] From that position, awareness of real space (the space between the painting and me) disappeared, and I focused upon the imaginary space of the painting. As I stood before the painting, my body came to rest (if a chair had been available I would have surely sat down), and only slight movements of my eyes and head were necessary to perceive the details of the painting. My straight-in-the-face privileged position was the central commanding viewpoint.[6] Although I found myself shifting my stance occasionally in order to observe a color or shading or texture or line or shape from closer in or further back or from a slightly different angle, still I related and subordinated these observations to the privileged position, which generated that "luminous silent stasis" or epiphany, as Joyce described it in the *Portrait of the Artist as a Young Man*. In memory, I seem to be able to see the Rembrandt from only the privileged position. That position produces the image of the essential relationships—the "principle of constancy" in gestaltist terms—against which all other images of the Rembrandt are

34

counterpointed and completely subordinated. Moreover, perspective centers every region of space within the portrait, and, as R. L. Gregory points out, "Paintings are generally more compelling in depth when viewed with . . . the head held still."[7]

Nevertheless, it took considerable time to take in the Rembrandt. My eyes leisurely moved from one region of it to another. For in paintings, as Paul Klee pointed out, "Paths are made for the eye of the beholder which moves along from patch to patch like an animal grazing." With the Rembrandt there was a "rapt resting" on each region, an unhurried series of "nows," each of which had its own temporal spread. There was a sense of the "saddle-back present," as William James called it, of riding the present with a piece of the past and a piece of the future. There was no long stretch into the past and future as in the perception of most music. Each region had its own center of gravity and thus was a place of rest—of arrest. Each region was a calculated trap for sensuous meditation and consummation. Each region filled my eyes so completely that there was no desire to move on to the next region, at least for a while. Yet there was a feudal constitution in this organization of regions. Although each region maintained its personal rights and particularity, the totality of the regions—the painting as a whole as perceived from the privileged position—always made itself felt as a commanding and governing norm. The Rembrandt is like a face with one set expression.[8]

Turning to the Arp sculpture, I found a warm and friendly presence. I found myself reaching toward the statue rather than keeping my distance (if a chair had been available I would not have used it). Whereas my perceptual relationship to the Rembrandt required my getting to and settling in the privileged position, similar to choosing what I consider to be the best seat in a theater, my perceptual relationship to the Arp was much more mobile and flexible. I wanted to touch and caress the shining bronze, despite the "Do Not Touch" signs and the guards. The smooth rounded shapes with their swelling volumes moved gently out into space, turning my body around the figure and controlling the rhythm of my walking.

My perception of the Arp seemed to take much more time than my perception of the Rembrandt. This is an illusion, for in fact I probably spent as much time perceiving the Rembrandt. But the dominance of the view of the Rembrandt from the privileged position made it seem as if only the time spent at that view really counted, as if a single, timeless glance had sufficed. The power of that epiphany was so overwhelming that it made me forget "the spots of time"

35

(Wordsworth) spent in other views. Conversely, the Arp seemed not only three-dimensional but four-dimensional, because it brought in the element of time so discernibly—a cumulative drama, a temporal gestalt. Not only did each aspect of the sculpture make equal demands upon my contemplation but, at the same time, each aspect was incomplete, enticing me on to the next for fulfillment. As I moved, masses changed, and on their surfaces points became lines, lines became curves, and curves became shapes. As each new aspect unrolled, there was a shearing of textures, especially at the lateral borders. The bronze flowed. The leading border disclosed a new aspect and the textures of the old aspect changed. The light flamed. The trailing border eliminated the old aspect. The curving surface continuously revealed the emergence of volumes and masses in front, behind, and in depth. What was hidden behind the surfaces was still perceived, an example of what Gibson calls a "sensationless perception,"[9] for the textures indicated a mass behind them. Moreover, the surface shapes were in perspective, and as Merleau-Ponty points out, "perspective does not appear to me to be a subjective deformation of things but, on the contrary, to be one of their properties, perhaps their essential property. It is precisely because of it that the perceived possesses in itself a hidden and inexhaustible richness, that it is a 'thing.' "[10]

As I moved, what I had perceived and what I was going to perceive were immanent in what I was presently perceiving. My moving body linked these aspects. A continuous metamorphosis developed, as I remembered the aspects that were and anticipated the aspects to come, the varying reflected light glancing off the surfaces helping to blend the changing shapes. My perception of the Arp was alive with motion. Even the sounds in the museum room were caught, more or less, in the rhythm of my movements. As I returned to my starting point, I found the sculpture richer, as home seems after a journey. With the Rembrandt, on the other hand, there seemed to be no movement and thus no journey—also no sound. In the inner intimacy of that epiphany there was, instead, a silence that rang. "Give her a silence, that the soul may softly turn home into the flooding and fullness in which she lived" (Rilke).

Any photograph of the Arp is necessarily unsatisfactory, for it must isolate a single aspect, whereas a photograph of the Rembrandt taken from the privileged position may be satisfactory. The static camera cannot capture the three-dimensional world, especially when, as with the Arp, the sculpture is not set up in a pictorial manner, for example, in front of a flat wall at right angles to the perceiver. Unlike my participation with the Rembrandt, there was no privileged

position for responding to the Arp. I have no single memory image of the sculpture but a series of images, none of which is necessarily dominant, the shades of the various images passing into one another.[11] Moreover the drawing of my body around the sculpture, following the concavities and convexities, had an "in and out" quality, resembling breathing. Sometimes I wanted to touch its surfaces, and when I moved in, the reflected light diffused, and the textures, shapes, and volumes appeared larger. The range of my vision, however, became narrower, like a film scene taken with a zoom lens. When I moved back, the reflected light sharpened, and the other aspects appeared smaller. In close, the mass of *Growth* seemed heavier. On the other hand, I had no desire to touch the Rembrandt or even to get closer than the privileged position. The Rembrandt depiction discourages embrace. Nor can the painted man be grasped. If I had walked closer, at a certain point the portrait would have ceased to be a portrait and would have become blurred blotches. Nor could I have walked into the depth of the depicted space, for its surface would have resisted like a wall. Nor were there any holes in that surface that would have enabled me to reach into that painted space and touch the man or the chair. Even if I had put my nose on the surface, the painted depth, being imaginary, would have remained beyond my physical reach. And, furthermore, as Rembrandt remonstrated: "Don't poke your nose into my pictures; the smell of paint will poison you."

The imaginary space of the portrait and the real space of the museum room were discontinuous. Thus touching the Rembrandt was of no help in my perception of that painting. The enlivened space around the Arp, on the other hand, was continuous with the space of the museum room. Thus touching the Arp helped my perception of that sculpture by informing me about its surface. There was a variance, however, between the temperature as given to touch, which is cold, and the temperature as given to sight, which is hot. This was somewhat disconcerting. With the marble version of *Growth* in the Guggenheim Museum, New York, the sight perception is as cool as the touch perception, and in this respect I find the marble version aesthetically more effective. Whereas the bronze appears to warm the surrounding space with flamelike shapes, the marble appears to cool the surrounding space with soft shadows.

Grasping the Arp informed me about its shape, size, weight, and rigidity-plasticity. Conversely, it was impossible to grasp the Rembrandt depiction. With the Rembrandt my hands were usually clasped behind my back, whereas

with the Arp my hands were usually moving, even when I was not touching or grasping the sculpture. With the Rembrandt, the real three-dimensional structures of man and chair were completely abstracted and I had to reconstruct those structures from the clues of painted perspective. The painting gave me disembodied images of man and chair by means of shapes, light, colors, lines, and textures hermetically sealed off from real space. On the other hand, the shapes, light, colors, lines, and textures of the Arp were embedded in real volume and mass. Hence, not only the lines of the Arp but also its shapes and textures were perceived with reference to my hands imaginatively or actually traversing their surfaces. While the surface of the Arp is not visually dull, especially with the lights glancing off the bronze, that surface is not nearly as visually glorious as that of the Rembrandt. On the other hand, the surface of the Arp, unlike that of the Rembrandt, has impacting force. It seems to push out into the surrounding atmosphere or what I am calling the "between," propelled by the three-dimensional material structured like coiled springs. The forces of this mass seem to pierce through its surface, penetrating the between. The surface of the Arp is not an impenetrable container, as with the surface of the Rembrandt, but a porous skin composed of planes and points of departure for lines of force generated by both the solidity of the material body and the properties of its shape. The internal pressure of this sculpture creates a dynamic atmospheric extension. In turn, I felt my body as very tightly unified with this impacting between and the material body of the sculpture, and continual body adjustments were necessary. My tactile feelings and, in turn, my haptic and kinaesthetic feelings were much more strongly stimulated than with the Rembrandt. Consequently, with the Arp, unlike with the Rembrandt, there was considerable co-perception of my body. In this respect the Rembrandt made me a spectator, whereas the Arp made me a participant.

The space between the Rembrandt and me ideally should be transparent, a clear and motionless atmosphere. I felt entirely alone with the painting when this ideal was approximated. Sensory awareness of the space between, such as glare coming off the glass of the painting, or cigar smoke coming from a neighboring viewer, or any sounds or smells, distracted me from the painting. The space between was necessary, of course, but only as an empty opening, an unfelt access. With the Arp the space between was furrowed with forces; the shadows, for example, intruded into that space, stretching, shrinking, warping, and twisting, while the reflected light bounced off the bronze. The smoke of the neighboring viewer and the sounds and smells of the museum room were not

nearly so distracting as with the Rembrandt. To some extent they were absorbed into the space between the Arp and me as if they belonged there.

The Rembrandt appeared to have a light of its own, generated within its frame, simultaneously illuminating and dissolving the man and the chair within a rich engulfing darkness. My seeing was emphasized by the difficulty caused by the flickering inadequacy of the light rendered in chiaroscuro. This depicted light appeared to be entirely distinct from the real light in the museum room. The virtue of this real light was its transparency, its imperceptibility. This light was not something to be seen but rather the unseen condition making possible my seeing the man and the chair in the painting struggling with the painting's light, as if to capture its moving nature and make it static. Conversely, Arp's *Growth* had no light of its own, and its material body, like the flower to the sun, seemed to reach out for the light of the museum room. As it reached out, the bronze dramatically enhanced that light by reflection, seeming to make the light move.

If *Growth* were crowded into a corner, its vitality would be weakened, for *Growth* needs space all around to penetrate with its forces. Unlike the Rembrandt, *Growth* seems to breathe into its surrounding atmosphere. Its concavities seem to inhale; its convexities seem to exhale. The surrounding space of this sculpture is a perceptible part of it. As Henry Moore points out, sculpture needs "more care in its placing than paintings do. With a picture, the frame keeps you at a distance and the picture goes on living in its own world. But if a sculpture is placed against the light, if you come into a room for instance and see it against the window, you just see a silhouette with a glare around it. It can't mean anything. If a thing is three-dimensional and meant to have a sense of complete existence, it won't do to back it up against a wall like a child that's been put in the corner."[12]

Recently *Growth* has been devitalized in the Philadelphia Museum by being placed on a new and very high pedestal close against a wall. Like a picture frame, that wall flattens and sharpens the shape of *Growth*. Now more of a silhouette is seen. Now one tends to perceive lines and shapes, figure and ground, more than volumes and masses. No longer does the material body activate more space than it fills. I settle into a privileged position in front and at a right angle to the wall and the sculpture it is absorbing. Once again the tyranny of the eminence of the eye has triumphed. The sculptural has been made pictorial. The dynamics of a physical presence have been sacrificed to the stillness of an imaginary presence.

I find that when properly placed, as formerly in Philadelphia, Arp's bronze, like a magnet, sends out vectors that fill its surrounding space with directed paths. If an object were to enter that space, I would expect it to be drawn into some orbit around the bronze. And, indeed, I was pulled around the bronze as determined by those vectors. A sense of gravity united the sculpture and me in a common space. *Growth* articulates the emptiness around it, making what otherwise would be a void both visible and tactile. The surrounding space has a "curious curvature," seemingly a moving volume filled with currents. To perceive this pattern of forces along with the material body is to perceive the totality of this sculpture. The space between the Arp and me was not a mere adjunct, as in the case of the Rembrandt, but integral. Whereas the forces of the Rembrandt, determined by the relationships of light, shadings, lines, colors, shapes, and textures, stayed within its frame, the forces of the Arp, determined by the relationships of the parts of the material body of the sculpture, thrust out into its surrounding space and explicitly pushed and pulled into my perceptions.

The frame of the Rembrandt helps to contain the forces of the painting within an imaginary space, helping to bracket them, as it were, between quotation marks. The larger the frame around a painting, generally, the more it helps separate the imaginary space of the painting from the real space outside it. The massive frame of Correggio's *Four Saints: Peter, Martha, Mary Magdalen, and Leonard* in the Metropolitan Museum of Art in New York even creates a transition space, like the proscenium arch of the theater, to prepare us for another world. Yet even paintings without frames, for example, Mark Rothko's *Earth Greens* (Fig. 62), frame themselves with their edges. Claims, such as Dewitt Parker's, that "by placing the statue on a pedestal, we indicate its isolation from the space of the room, as by putting a frame around a picture we isolate it, too, from everything else in the world,"[13] fail to recognize the impact of a sculpture on its surrounding space. It is true that large pedestals may make the material bodies of their sculptures inaccessible to touch, and this sometimes may be appropriate, as with Michelangelo's *Pietà* in Saint Peter's. But generally a pedestal that separates the material body of a sculpture from the ground is very inappropriate.[14] For example, in the Museo Civico in Lucca, Italy, Matteo Civitale's marble *Ecce Homo* has recently been installed on a stand of transparent glass panes. The effect is disastrous, for the weighty bust appears to be suspended without support, and this pictorial other-worldliness deadens what otherwise could be a powerfully enlivened space. In another room close by, a

painting of the *Visitation* attributed to Francesco di Giorgio is also mounted on transparent glass panes. Here the appearance of separation from the ground works very effectively, reinforcing the separation of imaginary space from real space.

With the Arp, the original pedestal, like a stem of a plant leading to its flower, is continuous with and prepares for the spiraling form above. Thus the pedestal helps that form push out spiraling lines of force into its environment. Moreover, the pedestal added to my sense of the pull of gravity, which I shared with the sculpture, reinforcing the weight of forces in the surrounding atmosphere. As David Smith once remarked, "Gravitation is the only *logical* factor a sculptor has to contend with. The parts can't float, as in painting, but must be tied together."[15] Thus the pedestal works as an entering rather than a distancing device. Whereas the Arp possesses its environment (with or without a pedestal), the Rembrandt dispossesses itself of its environment (with or without a frame). Consequently, the Rembrandt has a "nonimpacting between," for the space between the painting and me had no significant perceptible forces; the Arp, conversely, has an "impacting between," for the space between the material body of the sculpture and me had significant perceptible forces. Or, to put it another way, the space in front of the Rembrandt is inert; the space around the Arp is enlivened.

If these perceptions of mine are not idiosyncratic and my descriptions accurate, these descriptions are compelling prima facie evidence for the autonomy of the two arts. Presumably, therefore, it is nonsense to subordinate sculpture to painting or painting to sculpture. Such subordinations follow from conceptual confusions that muddy up our perceptions of both arts. Painting and sculpture go hand in hand, for vision is obviously fundamental in the perception of both arts. Moreover, these arts undoubtedly will continue to marry and create half-breeds. These children are not properly baptized as either painting or sculpture. But to perceive the distinctiveness of these children, we must understand their parentage. I am claiming and hope to marshall convincing evidence that it is the impacting between that is the most distinctive feature that distinguishes the sculptural parent from the pictorial parent. That is why we perceive sculpture differently from painting.

III

Perception:
Traditional and
Phenomenological Accounts

Phenomenology has, generally speaking, revealed man ·to us not as an understanding which constructs the world but as a being thrown into the world and attached to it by a natural bond. As a result it re-educates us in how to see [perceive] this world which we touch at every point of our being, whereas classical psychology [and philosophy] abandoned the lived world for the one which scientific intelligence succeeded in constructing.

<div align="right">Maurice Merleau-Ponty, Sense and Non-sense</div>

According to the traditional theory of perception—in its most straightforward and simplest version—we do not directly perceive objects but only the sensations they cause in our sense receptors.[1] These receptors—eyes, ears, nose, tongue, and skin—are independent of one another. They are passive receptors that react to specific kinds of stimuli, these reactions or sensations being channeled through the nervous system to the brain. Only in the brain can these independent sensations be synthesized. In relatively recent formulations, there is an object X that happens to emit energy particles or waves that perchance stimulate the sense receptors of the body of a subject Y. These stimulated sense receptors, in turn, cause events to occur in the nervous system of Y, leading to neurological centers and finally in the case of a human Y to a brain or mind where the sensations terminate. These sensations are experienced as private or subjective in the sense that they cannot be directly shared. Hence, there is a

42

subject/object dichotomy. Each human mind is a private subject separate from objects as public, for the mind is capable of constructing objects out of its sensations and verifying these objects as existing or public when these objects cause predictable patterns of sensations that can be observed. Sensations that synthesize into verifiable patterns are indications or signs of objects "out there," different from and external to the mind. The objective world is—as Galileo, Descartes, and Newton supposed—a conglomeration of particles in motion. The sense receptors of the human body react to these moving particles as sensations which, in turn, enter the receptive mind. The sensations (or "impressions" and, in turn, copies of impressions or "ideas" in Humean terminology) come together by various means of association, controlled by a kind of mental law of gravity. The syntheses of consistent patterns of sensations make it possible for the mind to construct objects which, especially with the help of sight, are projected as "out there" as the cause of the sensations. So we do not directly perceive a chair as a thing or entity, as our common sense leads us to think, but rather the chair is a construction built out of our sensations. We infer back to the chair as the object that caused the pattern of sensations. Indeed, in Logical Positivism, one of the later schools in this tradition, it is sometimes even denied that the chair is a thing at all. As A. J. Ayer in his early work would have it,[2] terms such as *chair* are "logical constructions," shorthand expressions that stand for nothing more than consistent patterns of sensations. To infer that objects cause or lie behind these patterns is the invention of ghosts.

The traditional theory proclaims the eye to be the fundamental sense receptor that establishes the projection of a world of objects. If solipsism is to be avoided, there must be objects out there and a bridge from our minds to them. Sight spans and organizes that space. Sight lines up objects and fixes them spatially, giving them "presentational immediacy," in Alfred North Whitehead's terms, by neutralizing the awareness of "causal efficacy," i.e., the awareness of the objects as having stimulated our sense receptors and those sensations as having been channeled on to the brain.[3] Sight is the sense of the simultaneous and the extensive, many objects being juxtaposed instantly as coexistent objects spread out within our field of vision. Sight opens up the world. As visual, objects are represented to us, it would seem, without any direct contact with them. When we touch objects, on the other hand, we obviously have entered into direct intercourse with them. The properties of light with their normally diminutive disturbances in the eyes allow the dynamic genesis of the stimulation of the object on the eyes to disappear in the perceptual result.

43

Perception in the mode of presentational immediacy eclipses its dependency upon the prior perception in the mode of causal efficacy. This disappearance of awareness of causal efficacy is reinforced by our upright posture which both removes most of our bodies from direct contact with the ground and keeps us back from things so that we confront them, like cameras on tripods. Consequently, the sighted object seems to let us be as we let it be. The "looking at" of sight keeps us aloof from objects. There is no apparent bridging of the gap between the subject and the object. Furthermore, this very aloofness from objects and the simultaneity of their presentation allows for selectivity. Only certain aspects of the objects—depending on the subject's intention—are allowed to come into focus. Objects are set forward in front of the subject framed and fitted to the subject's sight. The distancing of sight also makes possible time to take action. Included in this action may even be an invasion into the "thereness" of the sighted object, even by sight itself. Paul Valéry observed, "If looks could kill, if the eye could impregnate, the streets would be filled with dead men and pregnant women." But although looks do not kill or impregnate, they can have powerful effects on others, as Sartre more than anyone else has noted. The invasion of sight into the "thereness" of an object may bring a "nearness," in the sense of drawing them from obscurity into light, into significance. Nevertheless, this collapsing of distance, whether by sight or the other senses, depends upon the prior establishment of distance by sight. The initial aloofness of sight makes possible a world which, in turn, makes possible the intimacy of sight and the other senses.

Hearing is also, according to traditional theory, a "distance sense," but hearing cannot locate and fix objects as precisely as sight. Furthermore, more obviously than sight, hearing is a temporal sense, for any present quality of sound is a duration of passage from before to after. The duration of a sound is the duration of hearing it. Anything outlasting the acoustic act can be known only by information other than the acoustic. Thus hearing cannot line up a field of objects "out there" to be perceived simultaneously.[4] If hearing were our only sense, we would be unable to distinguish either ourselves as subjects from objects or nearing from distancing.

The other senses—touch, taste, and smell—are all basically "near senses," tending toward intensity and clarity of perception by closing the range. Touch, like hearing, is more obviously temporal than sight. Of course the eyes like the hands also can "run" over objects, but generally only after first fixating

them. With touch and large objects, conversely, the fixation comes at the end of the "running." Thus touch can fixate objects "out there." We grasp a small ball and discover its texture, shape, weight, and identity. Although a very large object cannot be grasped, it can be touched, especially with our hands, and we can discover its texture, shape, identity, and have some idea about its weight. By running our hands over and between objects we can discover their spatial locations. Yet, according to Hans Jonas: "Only a creature that has the visual faculty characteristic of man can vicariously 'see' by touch. . . . Blind men can 'see' by means of their hands, not because they are devoid of eyes but because they are beings endowed with the general faculty of 'vision' and only happen to be deprived of the primary organ of sight."[5] Even the man blind from birth can envision a clearing, a space, and only a being who is essentially a "see-er" can be blind. According to traditional theory, it is this envisioning capacity, this power of pictorial imagination, that makes possible the power of touch to fixate objects as "out there." And the same holds for hearing, smell, and taste. The sensations from these receptors along with those from touch mix in the brain, by a process called "synesthesia," and associate with the sensations derived from sight. The sight sensations, it is assumed, form the frame or world within which these mixings synthesize.[6]

In this traditional scheme, which thinks of the sense receptors as the linkages between subjects and objects, sight is the primary and exceptional sense.[7] Sight is the only sense receptor—in direct connection and cooperation with the associative and constructive powers of the mind—that can systematically organize objects. Unlike the other sense receptors which are seemingly linked more directly with objects, sight "stands back" and thus is a distinct "here" that arranges things into "objects out there." The eyes can shut off objects more easily than the lidless senses, confirming the independence of the subject. I withdraw my hand from the scalding water or spit out the rotten apple, but such sensations leave their imprint—and thus their withness with us—much more strongly than the sensations of sight. The distancing of sight helps impose the subject/object dichotomy and the weltanschauung of the Western metaphysical tradition. No wonder that sight has been held to be the eminent sense, no wonder that there is a relative silence about the aesthetics of sculpture, for only since the pioneering efforts of Bergson, Husserl, Gabriel Marcel, Scheler, Heidegger, Sartre, and Merleau-Ponty have the presuppositions of the traditional theory of perception come under radical attack. Although this

literature is extremely complex and far from complete, there is considerable consensus about many of the phenomena of perception relevant to the aesthetics of sculpture.

Some psychologists, even of quite diverse schools, share this consensus in many respects with the above-mentioned philosophers. The Gestaltists, such as Rudolf Arnheim, the Developmentalists, such as Jean Piaget, the Ecologists, such as James J. Gibson, and the Cognitivists, such as R. L. Gregory and Ulric Neisser, also attack such traditional conceptions as: the sense receptors are independent, passive receptors; and sensations are the sole content of perception. There is agreement, moreover, that generally we perceive things directly, and that in doing so sensations, while necessary, are in the background of our awareness. The psychologists, however, have only attacked the "mechanics" of the traditional theory, for as experimentalists their method necessarily requires the presupposition of the subject/object dichotomy. The philosophers, on the other hand, have also attacked this presupposition. Thus the philosophers have been far more radical than the psychologists in their attacks. As Gadamer says of the Gestaltists: "Modern science . . . now introduces the idea of the Gestalt, as a supplementary principle of knowledge into the explanation of nature— chiefly into the explanation of living nature (biology and psychology). This does not mean that it abandons its fundamental attitude, but only that it seeks to reach its goal—the domination of being [nature]—in a more subtle way."[8] Most psychologists, therefore, continue to work within the framework of the traditional theory. Very few of them, so far as I have been able to discover, take the work of phenomenology seriously. And only a handful of them have even noted the tyranny of the eminence of the eye. For example, Gibson complains: "More than any other perceptual system, the haptic [tactual] apparatus incorporates receptors that are distributed all over the body and this diversity of anatomy makes it hard to understand the unity of function that nevertheless exists. Moreover, it is so obviously involved in the control of performance that we are introspectively not aware of its capability to yield perception; we allow the visual system to dominate our consciousness."[9] Only the study of hearing rivals the study of vision, as Neisser points out: "The sense of touch has received much less scientific attention than vision or hearing. Special journals are devoted to optics and to acoustics, to research in vision and to disorders of hearing; entire laboratories specialize in psychoacoustics or in visual research; Nobel Prizes have been awarded for the discovery of basic mechanisms in both modalities.

46

Touch has far less glamour and prestige, and we know correspondingly less about it."[10] Data of touch are much more difficult to investigate scientifically than data of sight and sound. The tactual receptors lack a specific organ, such as the eye or the ear. In turn, it is much more difficult to isolate or define the stimulus for the tactual. Nevertheless, the psychologists have succeeded in making much more intelligible many aspects of the mechanics of perception, for example, Gibson's formulation of the senses as perceptual systems. These clarifications supplement the work of the phenomenologists and are useful to an aesthetics of sculpture. In general, the philosophers have concentrated upon explaining what in the following discussion I call "primary perception." The psychologists, on the other hand, have concentrated upon explaining "secondary perception."

If we bracket out, as Husserl so constantly urged, the traditional presuppositions and allow things to show forth from themselves as far as possible, i.e., allow them to emerge as phenomena instead of twisting them into our preconceptions, we find ourselves *with* things. The relation of ourselves with things is primary. We are not subjects over against objects. We are beings attached by a natural bond to things. Subjects and objects are poles contained within and dependent upon the relation or bond, the pregiven unity. The relation is prior to the relata. Thus we discover, to begin with, that we directly perceive the palpable presence of a thing, a door, for example, not a subjective image of a door nor an inferred object nor a logical construction fashioned out of sensations but the door as a thing. If we touch a door with a stick, we perceive that door at the end of the stick, not in the hand. We nail the stick to the door, not to a brown rectangular patch. Or if the door slams shut, as Heidegger reports, "We never really first perceive a throng of sensations, e.g., tones and noises, in the appearance of things. . . . We hear the door shut in the house and never hear acoustical sensations or even mere sounds. In order to hear a bare sound we have to listen-away from things, divert our ear from them, i.e., listen abstractly."[11] Even if, for some reason, we abstain from explicitly thinking of the thing as a door, we are aware of being immediately presented with something as a thing—corporeal, unique. We are placed in the first instance with the "concrete suchness" or "thingliness" of a thing directly, with no intermediary, presentatively rather than representatively. Almost always we are perceiving things, our awareness of accompanying sensations, such as the tactual and kinaesthetic, remaining in the background. Only rarely, because of exceptional

47

pain or pleasure or a special effort of attention, do sensations move to the foreground. This direct bestowal of things in our awareness can only occur if we are, in Heidegger's terminology, "beings-in-the-world."

"World" does not signify the whole of beings or entities placed in an envelope of vacuous space, as claimed by Democritus and Newton. "World" is rather the whole as a context in which we find ourselves already immersed, surrounded by a limited range of things in their thingliness or individuality as revealed through pre-abstractive or "primary perception." Space is the positioned interrelationships of things as we perceive them in our world. We are not in space; we inhabit space. We are not egos wrapped in skin, distinct from things and space. We are open bodies with things sojourning through space. As Merleau-Ponty puts it: "The ego as a center from which his intentions radiate, the body which carries them and the beings and things to which they are addressed are not confused: but they are only three sectors of a unique field."[12] In primary perception, our bodies, things, and space are a community, a pregiven unity, separable only by reflective analysis. That community is the context or world in which we find ourselves "already there." Although the connecting links of things with our bodies are not as tight as the connecting links of our bodily parts, the network of these interconnections make up our world. Our bodies are extensions of our minds, and things exist for us as extensions of our bodies. Even when by means of introspection we are explicitly aware of only our bodies, we are also implicitly aware of gravity and a substratum to which our bodily poses are oriented. Thus space is directly given, not inferred as the traditional theory would have it. "When I go toward the door of the lecture hall," Heidegger insists, "I am already there, and I could not get to it at all if I were not such that I am there. I am never here only, as this encapsulated body; rather I am there, that is, I already pervade the room, and only thus can I go through it."[13] We could not take a step if the perception of our goal did not activate in our bodies the natural capacity for transforming the space between into action-space that belongs both to ourselves and to the goal. In other words, unless the goal were a unity with us in the same world, we could not move toward the goal. We do not perceive in primary perception space as separate from us; rather, space is the positioned interrelationships of things forcing themselves upon us and our reaction to that forcing. As beings-in-the-world, we are space-saturated. Space is part of our being. To be is for us to be with things—to interact with things—and this withness necessarily involves positioned interrelationships (space) in a context (world). Our bodies are not walls

48

separating us from things but are either active or passive mediators: active, for example, when we move toward or away from things or seek information about them; passive, for example, when things seep into our bodies more or less osmotically. We feel our bodies as having no distinct boundaries, as being interlaced with things. Our bodies extend into things and they extend into us. Our worlds are masses without gaps that penetrate our pores. Our bodies are the inside of our worlds, and our worlds are the outside of our bodies. We are always here and there, and our awareness of here depends upon our awareness of there. We are, before we are anything else, a continuum, bonded to things, all of a piece.

That continuum may include, of course, the atmosphere, the expanse of air between us and other things. The atmosphere is both a thing and a medium which permits not only the more or less unhindered movement of other things and their displacement but also our withness with these things. The atmosphere permits our direct contact with a thing, as when we rub up against or taste some thing. The atmosphere permits also our indirect contact with a thing, as when we see or hear or smell some thing, for the atmosphere allows the flux of light, transmits vibrations, and mediates the diffusion of volatile substances. One of the meanings of the term *space* in ordinary language is "atmosphere." At times I will use this meaning. Nevertheless, this usage should always be understood within the bounds of the general meaning of "space," namely, the positioned interrelationships of things forcing themselves upon us and our reaction to that forcing.

We perceive things directly as they extend to us and we extend to them. Artists understand this better than most of us because artists live more explicitly in "primary perception," the awareness of being physically with things. The painter Paul Klee, for example, wrote: "In a forest, I have felt many times over that it was not I who looked at the forest. Some days I felt that the trees were looking at me, were speaking to me. . . . I was there, listening. . . . I think that the painter must be penetrated by the universe and not want to penetrate it. . . . I expect to be inwardly submerged, buried. Perhaps I paint to break out."[14] But the sculptor, perhaps more than any other artist, is aware of being-in-the-world. For instance, Julio Gonzalez was a second-rate painter until his fifties, and then he found his destiny. The three-dimensional materiality of sculpture released his sense of being-in-the-world into structures that finally satisfied him as his paintings had not, giving us some of the finest sculptures of our time. He declared: "The important problem to solve . . . is not only to wish to make a

work which is harmonious and perfectly balanced—No! but to get this result by the marriage of *material and space*."[15] Henry Moore said: "The understanding of three-dimensional form involves all points of view about form—space, interior, and exterior form, pressure from within; they're all one and the same big problem. They're all mixed up with the human thing, with one's own body."[16]

Subjects and objects and the space of the physicists are abstractions from or re-presentations of our primary perception of our lived world, the unity of being-in-the-world. In primary perception, things present or unfold themselves in our awareness. Re-presentations of these things, obviously necessary for practice and theory, are the functions of reflective analysis or "secondary perception." Primary perception is awareness by acquaintance; secondary perception is awareness by abstraction. Although primary perception can occur without secondary perception, secondary perception cannot occur without primary perception, however minimal. Without the presencing of things in primary perception, secondary perception would have no preexisting or coexisting background to abstract from. Without something "showing forth" in our awareness, there could be no questions such as "What is it?" or "What can be done about it?" Pure primary perception is possible, although it rarely occurs, whereas pure secondary perception is impossible. Unless the door as a thing presenced itself in my primary perception, I could not re-present that presentation and think of it as an object. In this sense, a thing is a verb before it is a noun. Although secondary perception always presupposes primary perception, it is not difficult to distinguish whether our perception is "primary in orientation," as when we *think from* a thing in the aesthetic experience, or "secondary in orientation, as when we *think at* a practical or theoretical problem.

Some things "presence" themselves without our initiative, as when accidentally something painfully hot touches us. We immediately withdraw before we have any explicit concepts or ideas about the thing. A second or two later we classify that thing as an object—burning metal. In that first instant of withdrawal—assuming that consciousness of the stimulus has occurred—our primary perception is pure, unmixed with explicit concepts. But in the second instant, as we think about what caused that primary perception, our perception becomes secondary. We *think at* the thing, objectify it. In this example, pure primary perception precedes secondary perception. Similarly, we may at first be aware only of something presencing "out there," without naming or classifying it, and then in secondary perception we become aware of its pattern charac-

teristics and name the thing a mountain, likening it to the class of comparable patterns not present to our primary perception. Some things, on the other hand, presence themselves because of our initiative, as when we turn the spigot to bring forth the water. In this example, we are thinking at the water from the beginning. Secondary perception occurs simultaneously with primary perception. Although we are not thinking about the water as a thing but as an object to be used, nevertheless, the water as a thing—however minimally—must be presencing in primary perception, showing itself from itself. The water to some extent is simply given, something beyond our control. It may even be that this water begins to fascinate and sustain our attention, and we begin to allow the water to unfold into its fullness. Then we *think from* the water, and the water returns to being a thing, for it initiates and controls the concepts that come into our awareness. These concepts function to help bring forth the thingliness of the thing—its individuality—rather than to dominate the thing and reduce it to an object. Cézanne: "The landscape thinks in me, and I am its consciousness." This kind of primary perception is not pure, of course, for explicit concepts are mixed into our awareness, yet this perception is primary in orientation because the concepts are initiated and controlled by the thing. Because explicit concepts help us focus on the individuality of a thing—provided we are thinking from that thing—perception that is primary in orientation is far more effective than pure primary perception in helping a thing unfold into its fullness.

In primary perception, whether pure or oriented, we find ourselves in direct and active engagement with things. Because it "lays concepts on" things, secondary perception is more indirect. Moreover secondary perception, by separating us more or less from things, slows down our engagement with things, twisting them around to face us "out there" as objects and making them more or less static by imposing a frame upon them. Whereas space as the positioned interrelationships of things appears as dynamic in primary perception, space appears as inert in secondary perception. "Analytic thought" [or what I am calling secondary perception], as Merleau-Ponty points out, "interrupts the perceptual transition from one moment to another, and then seeks in the mind the guarantee of a unity which is already there when we perceive."[17] Francis Bacon: "We put nature to the rack to wring out the answers to our questions." In perception that is primary in orientation, however, the "concrete suchness" of things penetrates, permeates, and thus controls our awareness. Furthermore, if this awareness is sustained, the experience becomes aesthetic. Then we become aware of being one with these things. Conversely, in secondary perception we

abstract from the "concrete suchness" of things and thus gain some control over them. This is "customary perception," as Rilke names it, for without it we could not survive for very long. Through controlling, we are aware of being other than the things controlled. In the aesthetic experience we participate with things, our awareness freed from the explicit presence of the "I." In secondary perception either the unfolding of things is cut short or the fullness is missed by a shift in the direction of generality. We reduce things to objects and stand apart from them as subjects—the subject/object dichotomy. The aesthetic experience is a kind of midwifery that allows the given to come forth, that helps bear the thing into its fullness. The presencing or the coming forth of a thing is slowed down in secondary perception by the distancing of reflective analysis. Thus secondary perception, relatively speaking, is static, allowing a separating, whereas the aesthetic experience is dynamic, allowing a gathering. The aesthetic experience permits the opening up of the qualities of things which secondary perception circumscribes, classifies, and often quantifies. In conclusion, the traditional theory of perception, however adequate it may be for describing and explaining secondary perception, either is oblivious of or forgets the establishing ground of primary perception—whether pure, oriented, or sustained (aesthetic)—which makes possible the emergence of things in our awareness. In turn, theories based on this tradition have developed distorted descriptions and explanations of the aesthetic experience and its relation to the things of our world.

In the aesthetic experience of anything, the perceived and the perceiver lose their separate static identities and emerge as polarities within the process of perception. But as I shall try to explicate, the aesthetic experience of sculpture—more than with any other thing—involves an emergence of a physical presencing that is unique. The aesthetic experience of sculpture brings out our being with things physically in an exceptionally vivid way. This special kind of emergence is possible because on the most fundamental level we are always a unity with things, beings-in-the-world. To understand the uniqueness of sculpture, we need a better understanding of how our bodies perceive the things they are with. The inadequacies of the traditional theory of perception have been based on inadequate descriptions of the body's role in perception.

We do not *have* bodies; we *are* our bodies. As opposed to the traditional view, our bodies are neither objects over against our minds as subjects nor instruments at the disposal of our willing. Our minds are incarnate, embodied, a unity of awareness of body with things within a world so tightly interwoven in

primary perception that the threads can be separated only by the abstractive knives of secondary perception. But since the abstractions that result are so omnipresent and indispensably useful, we become so accustomed to them that we often forget the unity of being-in-the-world from which the abstractions are drawn. Moreover, the presencing of primary perception withdraws when the re-presentation of secondary perception dominates, and so primary perception easily gets covered up despite the fact that the withdrawal of primary perception is never total. Primary perception, furthermore, is uniquely elusive, despite its pervasiveness in every awareness, because to describe a primary perception inevitably involves abstractions which may lead us into thinking at rather than thinking from. Wittgenstein suggested a solution: "Don't think, look!"

How can we make clear what is meant by "I am my body" without reducing the body to an object, precisely what it is not in primary perception? Gabriel Marcel struggled with this problem all his life: "It is essential to disentangle the exact meaning of the ambiguous formula: 'I am my body.' It can be seen straight away that *my* body is *mine* inasmuch as, however confusedly, it is felt. The radical abolition of coenesthesia, supposing it were possible, would mean the destruction of my body in so far as it is mine. . . . I only am my body more absolutely than I am anything else because to be anything else whatsoever I need first of all to make use of my body."[18] Unfortunately, this language is somewhat misleading, for it suggests that the body is only an instrument of the mind. Husserl hit upon a succinct formula that Marcel, I believe, would have accepted: "In every experience of spatial objects the body, as the perceptual organ of the experiencing subject, is co-perceived."[19] However much in the background, it is the constant co-perception of my body with things that gives the meaning to "I am my body."

To use my body is to co-perceive my body—especially my tactual and kinaesthetic sensations—along with whatever else is being perceived. Although I usually do not explicitly see myself as seeing and touching, I am always implicitly aware of myself as seeing and touching. These activities manifest themselves, however dimly in awareness, along with the things being seen and touched. This perception of the witness of the body with other things is the ground of our self-identity, the "I am" which means, more precisely, "I am my body," or, even more precisely, "I am my body with things within a world." What I always perceive of my body is its power and limits—the feelings of "I am or am not able to"—the animation that underlies its functioning. The body manifests itself with things because its power allows things to manifest them-

selves. Our bodies are centers of action in the midst of things that are "poles of action" (Merleau-Ponty), these things being correlates of our body action on them (Piaget). But the body action in the first instance, i.e., in primary perception, should not be understood as instrumental action, such as pushing things around. Rather, primary perception allows things to show forth, for only then can they be pushed around. As beings-in-the-world we are centers of gravity toward which all things turn their sides. And we can be sure that things have more than one side only because we can go around them. We are points of reference by which things show forth as three-dimensional and achieve location. Things are perceived because our bodies act to help them manifest themselves. Hence there is no such event as a perception without body action, as the studies of Piaget and Inhelder conclusively prove.[20] Even the eye in an unmoving head must move to see. The eye, as Gibson observes, "is a self-focusing, self-setting, and self-orienting camera whose image becomes optimal because the system compensates for blur, for extremes of illumination, and for being aimed at something uninteresting."[21] Perceived space—our positioned interrelationships with things—is always action-space with ourselves at the center. Our worlds are all around us, not just in front of us. The possession of a body in space, itself part of the space to be apprehended, and that body capable of self-motion in counterplay with other things are the preconditions of our awareness of a world. Thus our continuous effort to keep ourselves balanced upright, in defiance of the pull of gravity, as well as the rhythm of our breathing and the beat of our hearts affect our perception of everything. The things in our worlds are attuned to our awareness and become manifest because they are already with us in a pregiven unity.

Our awareness of acting on things to help their presencing unfold is the origin of possessive experience, of our experience of "mine." We say of most things that they are moved, but we move ourselves. While we have the freedom to change our places in respect to other things and thus vary their appearance, we lack the power to place our bodies at a distance. Our bodies are always near, for they are the indispensable centers from which our awareness—since it is inextricably embodied—cannot escape. We can see most of our body members only from restricted perspectival positions, and some members, for example, our heads, are visible only by the use of such things as mirrors. Our bodies, which are involved in all perception, stand in the way of being seen. Although our bodily sense is always there, unlike our sense of most other things, the

bodily sense, however intimate, pervasive, mobile, and massive, is usually not as distinct as our sense of other things. The very omnipresence of our bodily sense makes it difficult for us to notice and focus our attention upon it. Intense pleasures and pains are the major exceptions, for they are very noticeable and they are surely "ours," but even intense pleasure and pains are usually diffused and become clearly located only by touching things.

As things come forth and are touched, especially very solid things, the feeling of our bodies becomes more distinct and takes on a sense of solidity. Moreover, that touching sharpens our sense of the boundaries of both the things and our bodies, as knives are sharpened by being rubbed against each other. "Construction of the boundaries of the body image," as Matthew Lipman puts it, "is based upon the obstruction encountered from those objects which 'object' to being included in it."[22] However, there are no sharp borderlines between the outside world and our bodies. For instance, can you distinctly feel where your skin stops and other things begin? The skin is a boundary, according to Gibson, but it "is not always or everywhere as clean-cut as the hairless human philosopher tends to think."[23] Especially near the openings, our skin is the most sensitive area of the body. Yet the sense of our skin, even in such tightly drawn areas as the cheekbones, is a blurred outline unless bumped or caressed. And as depth within our bodies increases, this lack of definition increases. At the depth of an inch or two, except in the case of severe pain, all we have is a vague sense of mass and heaviness, fairly homogeneous in quality and constant in character except during illness or at certain periods such as puberty or old age. Better than any mirror in reflecting the "mineness" of our bodies is contact with things. As we grasp a stick, we perceive not only the shape of the stick but the shape of our grasping hand. As we sit down in a chair, we perceive not only the shape of the chair but the shape of our bodies. Indeed it may be that the need for perceiving our bodily "mineness" is the primal or ontological basis of our sexual needs. (e. e. cummings: "I like my body when it is with your body. It is so quite new a thing."[24]) In any case, we perceive our bodies mainly through other things, especially other human bodies. That is why we get a clearer perception of our bodies when we move than when we are at rest. The more distinct the contact with things, the more distinct our awareness of "mine." When we remain motionless with our eyes shut and no certain grip on anything, our body seems to slip away. Still all awareness has some sense of possessiveness, for we never escape, except by ceasing to be, from being-in-the-world. When we explicitly

perceive ourselves in primary perception (for implicitly primary perception of ourselves is always present in awareness), we also perceive the fabric of our world.

No thing, including ourselves, manifests itself in isolation. Every thing brings with it something of its world. In primary perception, the world is a spatial context or clearing within which things show themselves from themselves. In secondary perception, both the clearing and the things are objectified. And as Heidegger comments, in a difficult but very perceptive passage, vision in secondary perception becomes decisive: "Appearing in the first and authentic sense as bringing-itself-to-stand in togetherness involves space . . . it produces space and everything pertaining to it; it is not copied. Appearing in the second sense emerges from an already finished space; it is situated in the rigid measures of this space, and we see it by looking toward it. This vision makes the thing. Now this vision becomes decisive, instead of the thing itself. Appearing in the first sense opens up space. Appearing in the second sense merely circumscribes and measures the space that has already been opened."[25] The opening up of a space or a clearing always comes with the thing. This clearing also always has its horizon, the limits of which are always indefinite to some extent. While things come and go, there are always for our awareness some things creating a clearing as pregiven, some sensory scene that makes possible the coming and going. We are subjects over against objects, as the traditional theory claims, only because we are first and always beings-in-the-world.

The processes by which our bodies, as orientation centers, help things emerge in our awareness are extremely complex, not fully understood, and very difficult to describe even in part. However, it is clear that the body is a unity of continuously ongoing and to a large extent automatic syntheses of special centers—the body members and sense receptors. These centers function with respect to specific kinds of things and their aspects. Hands, for instance, are antennae for finding the place of things in "near-space" and are the orientation center for manipulating things which can be handled. The head is the zero-point for visual phenomena, helpful to the hands for locating things in "near-space" and indispensable for locating things in "far-space." Auditory, olfactory, and gustatory phenomena are also centered in the head: the eyes, ears, nose, and tongue are highly specialized organs that allow only certain kinds of phenomena to manifest themselves within very restricted areas of the head. On the other hand, the tactual receptors, both tactile (the surface of the skin) and haptic (muscular and visceral), lack organs and are spread through the entire

body. Likewise, awareness permeates the body and thus is with the things the body is with. We perceive things relative to our bodies and our bodies relative to things.

The sense receptors are active and interdependent. These receptors and the other members of the body are an organized hierarchy, an ongoing unity of functioning, a "perceptual system."[26] This system makes it possible for things and the sensations they stimulate to be perceived as belonging to one state of affairs. I perceive various aspects of the same thing through different sense receptors as the thing comes forth in my awareness. I perceive a red rose, for example, as unquestionably an identical thing despite the fact that I see its red shape, smell its cool fragrance, touch its smooth textures, may even taste its pulpy bitterness, and, if there is a strong breeze, hear its sway. The rose unfolds as a unity, even though that unity is dispersed through the sense receptors of my body, because the rose emerges as an identity to which my body as a perceptual system is attuned. Thus my body is a center consisting of many special centers, unifying kinaesthetic flow patterns from its special centers because the rose manifests itself as identical, and my body, like an echo, resonantly harmonizes with that identity. In primary perception I do not infer the rose behind its showing, nor do I construct the rose out of the various sensations it stimulates in my various sense receptors. As a being-in-the-world, I am already with the rose in its identity; its individuality or thingliness is given, just as my embodied awareness is given. These givens are a unity, primordially inseparable within a world. That is why the kinaesthetic flow patterns from my sense receptors are a unity: they are anchored in the togetherness of the rose with my embodied awareness. All abstractive analyses that reduce the rose to an object that fits into a species and genus, for example, and my embodied awareness into a subject that thinks at that object—by means of my body as merely an instrument— ultimately depend upon my primary perception of being-in-the-world.

In this conception of perception, it is evident that sight is no longer quite so obviously the exceptional sense. Indeed in primary perception, whether pure or oriented or aesthetic, the distinctions between the senses are unknown, for the senses function interdependently as a system. The distinctions between the senses only become manifest when conflicts of cues occur, as when I see a bent stick in the water and at the same time touch a straight one, and then I have to decide how these various perceptions can be of one identical thing. Usually we make tactual checks on our visual findings. Occasionally, however, the procedure is reversed, as when the tactile feel of a stick is an unreliable test of its

straightness. Then we look at the stick endwise. But whatever the procedures, such testing moves me away from primary perception toward secondary perception. Yet even when perception is clearly secondary, the body as a totality (the perceptual system or center of the special centers) dominates, for without that center the special centers could not function as determinants of awareness. The body is the common root—the "common sense"—from which the sense receptors stem. Even among these receptors sight is not as preeminent as has been assumed. Gibson insists that "the skin-joint [tactile-haptic] sensitivity is inevitable. It always accompanies and underlies visual sensitivity . . . and it makes an even more fundamental contribution to the control of motor skill than vision."[27] A child learns more about a ball, especially its weight, texture, and response to pressure, by holding it than by looking at it. The hand is the cutting edge of the mind. The blind are still beings-in-the-world, but not without tactuality. Although the world disappears in the dark for our eyes, it remains for our skins. If the cover of my favorite chair is changed I still have my chair, but if its contour is changed I have lost my chair. When thinking of my favorite mountain, I remember its textures and solidity and recalcitrant bulk as I climbed as much if not more than I do its visual appearance.

It is touch that hurts, soothes, nourishes, and protects us. The "where" that matters most is the tactual-kinaesthetic where. It is touch, as Locke and Berkeley noted long ago, that gives us confidence in a solid, permanent world that does not dissolve into conceptions of the mind. And even longer ago Lucretius exclaimed: "Touch, touch, ye holy divinities of the God, the body's feeling is." Touching more than seeing is believing. All such claims are oversimplifications, however, for the senses function interdependently. We see someone's face and hear him talk. We see, touch, taste, smell, and sometimes hear our food. We see the golf club that we are grasping and hear it swinging and are aware of our body movements visually, tactually, and kinaesthetically. Each sense necessarily harmonizes with the other senses, for the perceiving body, like a sounding board, vibrates as a unity. This fact is reflected in language by such phrases as velvety voice, rough green, warm silk, cold light, fragrant breeze, sweet harmonies. The sound of the water of the fountain helps uphold the summit image as it is torn by the wind. But touch-space and sight-space, especially, are tightly unified, as the work of Piaget and Inhelder verifies.[28] Wolfgang Grozinger points out: "Only when the hands have reported back, like scouts, as to how far away things are, how light they are, how solid, how heavy, only when space has been crawled through, walked through and felt through,

58

does the eye know something of the world."[29] Children will sketch an ear on the right side of a drawing with the right hand and use the left hand to draw the left ear. "In children and primitives," Grozinger continues, "the experience of touch is sometimes so closely associated with the hand which touches that in drawing each hand makes its own statement and cannot be replaced by the other."[30] Children and primitives are much closer to perception that is primary in orientation than most Western adults.

Although the showing forth of a thing is dispersed throughout our sense receptors, the thingliness of the thing is always given. No thing comes forth to just one sense receptor, no matter how much one receptor may dominate with some things. In primary perception, whether pure or oriented or aesthetic, the dispersions of the showing forth of a thing in our bodies with their kinaesthetic flow-patterns are felt as a unity because of the thingliness of the thing and the togetherness of that thing with our bodies in a world. In secondary perception the dispersions of the showing forth of a thing are separated by our analyses, and yet they almost always are synthesized in "customary perception," returning to the original unity of primary perception. For example, we see someone sitting on a bench. But do we? Only if our vision includes information gathered from other sources. "Sitting on" is not the same as "situated above." The abstraction "sitting on" derives from our perception of gravity, and we do not see gravity but sense it haptically. When we stand, we feel gravity as a force bearing down, as never being fully overcome. We feel the earth as support against that force. Memories of such feelings are touched off when we see someone "situated above" the bench, so we say "sitting on." As we approach a stone wall, we see various shapes, colors, and textures that recall certain information. We know something about how the surface of those stones would feel and that it would hurt if we walked into them. We do not know about the surface, volume, and mass of those stones by sight alone but by sight synthesized with memories of tactual and kinaesthetic perceptions. The information from the different senses synthesizes, however, not because the mind invents or infers objects or builds logical constructions, but rather because there is a pregiven community of things in our world with our embodied awareness. And that embodied awareness is a perceptual system that relates and unifies the sensations of the various sense receptors. This unity, as given in primary perception, guides the syntheses of our secondary perception.

IV

The Autonomy
of Sculpture

Things may be objectively present without having the affective power that we call "presence." The extra-ordinary object, the one with presence, is one which is . . . tyrannically there: it can no more be ignored than being stared at can. It seems to me that this charged quality of things is what a work must have to be sculpture and any technical means for achieving it is allowable. It is the ultimate realism, this presence, having nothing to do with re-semblances to "nature." The peculiar posture of the convincing being, the stance of being about to move, the enormity of the immovable, the tension between the separate parts of a whole are qualities that pull us to the special object like iron to a magnet.

<div align="right">Richard Stankiewicz</div>

The aesthetic experience is sustained perception that is primary in orientation. Instead of placing, classifying, and using the thing as one among many, I am captured by the "concrete suchness" of the thing. Because it is so captivating, the thing initiates and controls everything that comes into my awareness. The thing determines rather than causes my experience. Causal relationships, as usually understood, suggest an indifference and independence between the cause and the effect, which separation does not hold for the aesthetic experi-ence. Rather than being set over against the thing, I am in sympathetic relation with the thing. My consciousness is run through and saturated with the thingliness of the thing. "We become what we behold" (McLuhan), the refrain Blake so beautifully weaves through *Jerusalem*. The thing completely unifies with my sensations, associations, memories, knowledge, and everything else

that comes into my awareness. Thus my self-consciousness, that barrier which keeps me aloof from things, is pushed to the background. My consciousness becomes so immersed in the thing that there is no conscious energy left for explicit reflective consciousness. In the absence of that barrier the individuality of the thing pours through. Ideas of other things enrich the individuality of the thing. In steadfast intimate concentration, I allow the thing to abide as a thing. The aesthetic experience is a figurating faithfulness to the thing, allowing the figure to manifest itself fully. The anaesthetic of self-consciousness, which abstracts from my being-in-the-world and imposes the subject/object dichotomy, does not come into play.

Works of art more than any other thing are likely to engage us aesthetically, for they possess structures created to attract and hold our attention. Ideally, their structures eliminate factors that are uninteresting or distracting. Then recognitions, such as, there is a circle in that painting or a pyramid in that sculpture, help bring out the individuality of the work rather than shift our attention toward generality. The form of the work of art initiates, controls, and unifies everything that comes into awareness.

With each of the various arts certain sense receptors dominate, but resonances from all or most of the other senses are involved. Our bodies always react as a unity, as a perceptual system, in every perception, but in the aesthetic perception, especially with works of art, our awareness is governed by an exceptionally tight unity with what is being perceived. In listening to music, for example, the ear is not alone.[1] At a mass with music the fragrance of incense may blend with our listening. Or at a concert we may be seeing the orchestra or reading the score. Always present, however in the background, are the co-perceptions of our tactile sensations, such as the feel of our body on some support, the waves of incoming sound beating into our ears, the temperature and humidity of the environment, and, if we are musicians, our hands moving on an imaginary instrument. Involved also are the co-perceptions of our haptic sensations, such as the feel of our muscles and viscera in the rhythm of our breathing, as well as co-perceptions of our kinaesthetic sensations, usually strongly evoked and controlled by the rhythm of the music. If this awareness is aesthetic, we undoubtedly would report only the music as being perceived, but actually such awareness is multifaceted. There are co-perceptions of our bodies, associations, etc., so tightly interwoven by the power of the music that only by analysis can we separate them and reestablish our everyday subject/object dichotomy.

61

The autonomy of sculpture follows from the distinctive way sculpture manifests itself in our perceptions, and this distinctiveness is determined especially by the most distinctive feature of sculpture: its impact into the surrounding space. Sight-space and touch-space are always together, but whereas sight-space dominates with painting, touch-space is often as important and sometimes even more important with sculpture, as in the case of Duchamp's and Brancusi's sculptures that can be touched but cannot be seen. These are exceptional cases, of course, for without sight our perceptions of almost all sculpture would be terribly limited. As with the perception of painting, sight is also fundamental in the perception of sculpture. With sculpture, however, tactual and kinaesthetic sensations come into play in much more important ways than with painting, and so, in turn, our perceptual systems work in significantly different ways with sculpture.

Herbert Read claims that if we cannot touch the material body of a sculpture, we perceive the work basically as a kind of painting rather than as a sculpture. This claim is surely mistaken. Moreover, unlike a painting the space around a sculpture, although not part of its material body, is still an essential part of the perceptible structure of that sculpture. Furthermore, the perceptual forces in that surrounding space visually appear as impacting outward from the material body, giving to that space a thickness that is missing from the space in front of a painting. While perceiving a painting tactile sensations are not absent, of course, for there is the stimulation of the painting on our eyes. But because there are no impacting forces in the surrounding space, for the forces do not reach a threshold that would make us explicitly notice them, the tactile sensations and, in turn, haptic resonances are minimal. Then, too, our bodies usually settle into a privileged position. Thus with painting tactual and kinaesthetic sensations are largely psychological, derivative of mental association, as when the vivid velvet in a painting by Veronese evokes a memory of how this material feels when we stroke it.

With sculpture tactual and kinaesthetic sensations are felt more strongly than with painting, because the stimuli of psychological association are usually just as strong if not stronger while the physical stimuli are always stronger. Unlike our perception of a painting, we invariably perceive the forces of a sculpture as if they were pressing on our bodies. In fact, the enlivened space around a sculpture—excluding such sculptures as mobiles that stir the air—may press no more than the inert space in front of a painting. It seems that even when blind persons do not touch sculptures, they often are aware of their

presence, while they are rarely aware of paintings except by touching. But this awareness of sculpture seems to be accounted for mainly by the resounding of sounds off the material body, particularly with works in metal. Still, I have experimented with blind students deafened with ear plugs, and a few of them were still able to perceive the presence of large sculptures with significant mass or, for that matter, any large three-dimensional thing (Helen Keller attested to this also). But in experiments with visually normal but blindfolded persons, even without ear plugs, only an exceptionally few were able to sense the presence of sculptures. I conclude, therefore, that the perception of forces from the material body of a sculpture impacting into the surrounding space and pressing on our bodies is mainly a visual phenomenon.[2]

When we see the material body of a sculpture and its enlivened space, we see them as directly continuous with our space. Thus our tactile mental associations (that bronze, for example, would feel smooth) are reinforced by all the physical tactile sensations of the environment that our perceptual systems are experiencing. With a painting, conversely, our tactile mental associations are only directly engaged with an imaginary world, discontinuous with the real world. There is a dissociation in our perceptual systems between what is being perceived in imaginary space and what is being perceived in real space. Psychological tactility and physical tactility are synthesized without reinforcement, mainly because physical tactility is irrelevant to our perception of the painting and thus is kept in the background of awareness. Thus the disembodied images of paintings—other things being equal—never appear to have the tactile impact of the embodied images of sculpture. Furthermore, along with our desire to take in all aspects of a sculpture, the enlivened space helps move us around.[3] The space around a sculpture is in a state of tension. The shadows, the reflecting surfaces, the bulges and hollows, the textures, and the attraction or repulsion of the material itself pull our bodies in and out. The hidden aspects, especially with sculptures in the round, lure our bodies around. The movement of our bodies stirs up kinaesthetic sensations which reinforce our tactual sensations.[4] Whereas the forces of a painting stay within its edges or frame, the forces of a sculpture activate the surrounding space, for the latter forces are generated by a dynamic interaction between the interior and exterior of a material body continuous with real space.

Because of the compression of its imaginary space, the images of a painting may powerfully project toward us visually, as with the denizens of Picasso's *Les Demoiselles d'Avignon* (Fig. 37), 1907. Yet even in such an extraordinary

example, we do not perceive that encroachment as going so far as to enter the real space of the museum room. We are not clientele in the same room. We necessarily remain at arm's length from these painted prostitutes. There is no tactile invasion, for these girls are imaginary rather than real space-displacing presences. However charged the space within the picture, the space without remains completely uncharged. We take no notice of the outside or real space, for that would distract us from the space within, the imaginary space of the painting. The encroachment of the girls is psychological, derivative from our mental associations with real females, not physical, for the atmosphere outside the canvas remains empty of significant forces. With paintings our perceptual systems unify with imaginary presences. With sculptures our perceptual systems unify with physical presences.

The sculptor, unlike the painter, is necessarily concerned about enlivening real space. For some sculptors this activation may become even more important than the material body. For example, David Weinrib writes, "One of the things I'd like to get to is that feeling that the space in and around the sculpture [the material body] is a little more important than the object materiality of the sculpture itself, but the space cannot be activated without the sculpture."[5] Whereas a painting is edged or framed and keeps its distance, a sculpture is surrounded by space that conducts the forces of its material body—a dynamic system of outgoing visual interactions. In this sense a painting, even one that lacks a frame, has edges;[6] a sculpture, even a sharply framed low relief, has no edges.

Since the canvas of a painting is usually thin and light, it does not exert much physical force in our perception even when, for example, we are perceiving it as just a solid object to be hung on a wall and not as a painting. But, much more importantly, when we stand back from the wall and perceive the canvas and its pigments *as a painting*, then the painting creates an imaginary space that conceals the actual three-dimensionality of the canvas. Painting creates an imaginary outside that hides its real inside. Thus it is impossible to see simultaneously the imaginary outside and the real inside. Unlike a sculpture, a painting lacks interaction between an exterior and an interior because a painting has no interior. As Langer observes,

A painting is made by deploying pigments on a piece of canvas, but the picture is not a pigment-and-canvas structure. The picture that emerges from the process is a structure of space, and the space itself is an emergent whole of shapes, visible colored volumes. Neither the space nor the things in it were in the room before. Pigments and canvas are

64

not in the pictorial space; they are in the space of the room, as they were before, though we no longer find them there by sight without a great effort of attention. For touch they are still there. But for touch there is no pictorial space. The picture, in short, is an apparition. . . . the whole picture is a piece of purely visual space. It is nothing but a vision.[7]

Even when, as with John Marin and Hans Hofmann, regions of the canvas are sometimes left unpainted, those regions, just as the painted regions, are transformed into the pictorial space—the imaginary world of the painting. Mark Rothko and Jasper Johns sometimes "weave" their paint through the surfaces of their canvases in such a way that we are still aware of the canvases. Yet as long as we perceive such works as paintings, and the paintings work successfully, we are not aware of the canvases as parts of three-dimensional solids. The paintings float free from their anchorage to their material bodies. To the degree that a painting is unsuccessful, to that degree the painting fails to float free. Perhaps Duchamp's rejection of the canvas for glass around 1912, with such works as *The Large Glass (The Bride Stripped Bare by Her Bachelors, Even)* (Fig. 46), had something to do with his sense of failure in this respect. In any case, Duchamp is quoted as saying: "I used transparent glass . . . to get away from any possibility of placing this work in a material world. I wanted it to fly off completely."[8]

The images of a sculpture, unlike a painting, never float free from their material body, even Christo's *Kassel Balloon* or Robert Irwin's "scrim" pieces. When the images do float free, as when Sylvia Stone and Christopher Wilmarth use transparent, planar material that has no perceptible material body of significance, then such works are more painterly than sculptural, and it is confusing to classify them as sculptures. Similarly, the will-o'-the-wisp color-and-shape transformations of Thomas Wilfred's *Lumia*, for example *Luma Suite, Opus 158*, 1963-1964, in the Museum of Modern Art in New York, may be usefully classified as light art or film or kinetic painting, but certainly they are not sculptures. And the hologram—a three-dimensional pattern in space produced by laser lights—is just as painterly despite its three-dimensionality, for there is no perceptible material body.

A sculpture is more than just a vision. Even if the material body of a sculpture is not or cannot be touched, a sculpture is a much more touch-determined image than a painting. Since the surrounding space is energized by the material body of a sculpture, that space is not only a perceptible part of that sculpture but is felt as if it were pushing into and connecting with us. Vision is fundamental in this perception of impact, not because our eyes directly feel very

65

much impact but rather because they see the volume, mass, shapes, and textures of the material body radiating forces into real space. Sometimes we may see a sculpture in this respect somewhat the way we see the effects of a stone dropped into water, our eyes following the expanding ripples. As Carpenter correctly observes (p. 8), such sight is likely to evoke tactual memories. We recall the density and the feel of volumes, shapes, and textures and the outward advance of masses. Our skin "remembers." These evocations are an essential part of our perception of impact, however indirect or psychological. But as opposed to Carpenter, I am claiming that because the enlivened space around a sculpture is continuous with real space, there is also a sense of direct or physical impact. The space between us and any three-dimensional thing that we are perceiving comes forth into our perception by literally pushing into our bodies, as Merleau-Ponty more than anyone else—except perhaps Whitehead with his theory of "causal efficacy"[9]—has convincingly demonstrated. (The direct or physical impacting of sculpture on our bodies helps explain why the human body has been such a favorite subject matter of sculpture.) With the exception of events such as sticks and stones striking us, sculpture channels the ordinary impact of things in everyday perception into more concentrated and thus stronger currents. Sculpture transforms the real space surrounding its material body, making that space more perceptible and impacting. Sculpture, to put it awkwardly but succinctly, is a "more real world." Painting, on the other hand, withdraws from real space and in so doing makes the real space surrounding it less perceptible and impacting. Painting is "another world." Sculpture remains in real space, however enlivened the transformation of that space, whereas painting escapes from real space. In turn, sculpture makes real space more physical, whereas painting makes real space less physical.[10] Both sculpture and painting are in our world, but only sculpture is of our world, in the sense of belonging to our world as spatially present.

Compared with our vision of a painting, our vision of a sculpture is more kinetic and weighted, for we feel the moving mass of our bodies involved with our sight. A sculpture "grows" into our eyes; a painting generally—for there are such exceptions as op works—stays put in front of our eyes. These differences make our "travels" with sculpture longer and heavier than our "travels" with painting. If one sensitively perceives, for example, the magnificent collection of the ripe and robust sculptures of Henri Laurens in the Musée National d'Art Moderne in Paris ("I strive for the ripening of forms," Laurens once said. "I would like to make them so full of juice they couldn't hold any more."), a

66

heightened awareness of one's body volume and mass is inevitable as well as withness with these works—comforting for the slim, not so comfortable for the fat, and stimulating and illuminating for everybody. If, on the other hand, one sensitively perceives the radiant collection of Monets in the underground gallery of the Marmottan Museum in Paris, there will be as one emerges a heightened awareness of the colors, lights, and surfaces of the world, but for a while our bodies and our withness with three-dimensional things are likely to be ignored. Then, as Santayana puts it, "The soul is glad, as it were, to forget its connection with the body. . . . This illusion of disembodiment is very exhilarating."[11] We feel that a much longer time has elapsed after perceiving Laurens's sculptures than after perceiving Monet's paintings. The sculptures make us much more tired. Yet for those with overflowing nervous energies, catharsis of nervousness is much more likely to follow the perception of Laurens's sculptures. The aesthetic experience of sculpture illustrates better than any other phenomenon Merleau-Ponty's fundamental theme: we are beings-in-the-world (etre-au-monde), immersed with things in such a way that our bodies have no clear-cut boundaries. Our perception of things is a resonance of their withness with ourselves.

The power and the glory of painting is founded on the ability of the painter to abstract sensa—color, light, line, and texture—from the weight of things.[12] When the painter represents things on a two-dimensional plane, the sensa are freed from the actual solidity of things. Moreover, the sensa usually lie on, rather than belong to, the canvas. Even when they do belong—for instance, when the colors mesh into the canvas, as with Jasper John's Map, 1962, or soak into the canvas, as with Rothko's Earth Greens (Fig. 62)—the canvas has no significant solidity. This abstraction from solidity helps reveal the sensa as qualities with their own intrinsic values. The reds in Van Gogh's The Artist's Room in Arles bring out the redness of red; the light in Rembrandt's Portrait of Nicolaes Ruts (Fig. 25) brings out the expansive, penetrating properties of light; the lines of Botticelli's Birth of Venus brings out the sensuousness of line; the textures of Giorgione's Sleeping Venus bring out the cool smoothness of texture. In other paintings these painters sometimes reveal different properties of these sensa. And other painters continue the unending revelations. In such representational paintings, the sensa are freed from the weight but not the shape of things. The sensa are structured to represent things by means of these shapes, and in this sense the sensa are still bound to things. But even so, the freedom from the actual solidity of things allows the painter to bring forth properties of

67

sensa with a vividness that the sculptor can rarely rival. Moreover, it also allows the painter, unlike the sculptor, to represent without assaulting our credulity weighty things that completely defy gravity, as with Giotto's monumental figure of Saint John the Evangelist's *Ascent to Heaven* in the Peruzzi Chapel of Santa Croce in Florence. It also makes it easier for the painter to reveal the "surreal." Surrealistic sculpture generally has a difficult time making its point, Joseph Cornell's "box sculptures," as serene as Chardin's still lifes, being a major exception. Cornell's strange dreamlike structures are reminiscent of the Baudelaerian Voyage—"where nature is shaped by reverie, where it is corrected, beautified, remodeled," and where we are transported for a time to another place and time. Giacometti's surrealistic sculpture—such as *The Table*, 1933, and even *The Palace at 4 A.M.*, 1933—was a dead end.[13] Magritte's surrealistic paintings are usually far more convincing than his surrealistic sculptures. For example, consider his *Madame Recamier*, 1967, in the Musée National d'Art Moderne in Paris, a bronze replica of David's painting which, in turn, echoes the style and motif of Canova's *Pauline Borghese as Venus* (Fig. 29). Magritte's replacement of the Madame with a weirdly bent coffin is indeed humorous. Almost everyone smiles, and then walks away and rarely returns. And one may wonder: all that labor and cost for just a joke! The three-dimensional materiality of sculpture and its binding to its surrounding space give a "here-reality" quality to sculpture that makes it much more difficult for the sculptor, compared with the painter, to reveal subject matter that disrupts a rational sense of reality.

Compare the works of artists who create both painting and sculpture. Color, for example, comes out far more revealingly in the paintings of Picasso than in his painted sculptures; light in Giacometti's paintings, however subdued, enlightens us about light, whereas the light on his sculptures is mainly a means for showing forth the material body and its surrounding space; the line in Matisse's paintings usually sings its own melody, whereas the line in his sculptures rarely is more than a harmony with volume, mass, and textures; and in most of the paintings of Modigliani the textures shine forth, clarifying the surface of such things as female flesh, but with his sculptures the textures—even though touching them is far more relevant in our aesthetic perception than touching the textures of his paintings—are usually partially absorbed by the material body and thus not especially noticeable. The solidity of sculpture tends to make its sensa part of the materiality of the sculpture. Thus with sculpture generally the sensa cannot emerge quite as freely and vividly as with painting.

68

There are exceptions, of course, as with Neon sculpture and the garishly colored works of Red Grooms, for instance, *The Bookstore*, an Environmental sculpture recently installed in the Hudson River Museum in Yonkers. Indeed, the brilliant colors of many of Jean Dubuffet's recent sculptures are enhanced in their vividness by the "pushing out" effect of the irregular surfaces of the polyester resin, as with the *Glass of Water II* (Fig. 80). For the most part, however, the freedom of sensa from the solidity of things makes painting more like music, whereas sculpture is more like dance. Of course, painting can and often does reveal things, only abstract painting—such as Mark Rothko's *Earth Greens* (Fig. 62)—being a major exception; sculpture can and often does reveal sensa, only sculpture that tends to absorb its sensa—such as George Segal's *The Bus Driver* (Fig. 71)—being a major exception. Nevertheless, the painter is more the shepherd of sensa; the sculptor is more the shepherd of things.

The special power of painting to reveal sensa is best illustrated by abstract painting, although, unfortunately, photographs can only hint at this. Abstract painters with tender care catch sensa, the most transient aspects of reality, and make them stand still in their paintings (with exceptions such as op painters), disconnected not only from the weight but even from the specific shapes of things, as with Rothko's *Earth Green*. The underlying blue rectangle of *Earth Greens* is cool and recessive with a pronounced vertical emphasis (ninety-one inches by seventy-four inches), accented by the way the bands of blue gradually expand upward. However, the green and rusty-red rectangles, smaller but much more prominent because they stretch over most of the blue, have a horizontal "lying down" emphasis that quiets the upward thrust. The vertical and the horizontal—the simplest, most universal, and potentially the most tightly "relatable" of all axes, but which in everyday experience usually are cut by diagonals and oblique curves or are strewn about chaotically—are brought together in perfect peace. This fulfilling synthesis is enhanced by the way the lines, with one exception, of all these rectangles are soft and slightly irregular, avoiding the stiffness of straight lines that isolate. Only the outside boundary line of the blue rectangle is strictly straight, and this serves to accentuate the separation of the three rectangles from the outside world. Within the firm frontal symmetry of the world of this painting, the green rectangle is the most secure and weighty. This rectangle comes the closest to the stability of a square; the upper part occupies the actual center of the picture which, along with the lower blue border, provides an anchorage; and the location of the rectangle in the lower section of the painting suggests weight because in our world heavy

objects seek and possess low places. But even more importantly, this green, like so many earth colors, is a peculiarly quiet and immobile color. Wassily Kandinsky, one of the first and best abstract painters, finds green generally an "earthly, self-satisfied repose."[14] It is "the most restful color in existence, moves in no direction, has no corresponding appeal, such as joy, sorrow, or passion, demands nothing. This persistent lack of movement is a quality which has a quieting effect on the tired souls of men."[15] Rothko's green, furthermore, has the texture of earth thickening its appearance. Although in the green there are slight variations in hue, brightness, and saturation, their movement is congealed in a stable pattern. The green rectangle does not look as though it wanted to move to a more suitable place. On the other hand, the rusty-red rectangle is much less secure and weighty. Whereas the blue rectangle recedes and the green rectangle stays put, the rusty-red rectangle moves toward us, locking the green in depth between itself and the blue. Similarly, whereas the blue is cold and the rusty-red warm, the temperature of the green mediates between them. Unlike the blue and green rectangles, the rusty-red seems light and floating, radiating vital energy. Not only is the rusty-red rectangle the smallest but its winding, swelling shadows and the dynamism of its blurred, obliquely oriented brush strokes produce an impression of self-contained movement that sustains this lovely shape like a cloud above the green below. This effect is enhanced by the blue, which serves as a kind of firmament for this sensuous world; for blue is the closest to darkness, and this blue, especially the middle band, seems lit up as if by starlight. Nevertheless, despite its amorphous inner activity, the rusty-red rectangle keeps its place and serenely harmonizes with its neighbors. Delicately, a pervasive violet tinge touches everything. And the blue and green and red seem locked together forever, an image of sensuous eternity.

Painting and sculpture have different tendencies. Both can reveal sensa and things (the meaning of the term *reveal* will be made more definitive in Chapter 7). Paintings may and usually do reveal things as well as sensa; for example, Cézanne's *Mont Sainte Victoire* (Fig. 33) informs about that kind of mountain as well as about colors; and there are sculptures that reveal sensa as well as things; for example, Brancusi's *Bird in Space* (Fig. 49) informs about the play of light on highly polished bronze as well as about the flight of birds. But painting tends toward revealing sensa and the surface of things, whereas sculpture tends toward revealing the solidity of things and our withness with them. In turn sculptures, unlike paintings, possess physical presence.

Whether a painting or a sculpture dominates depends upon the circum-

stances. Other things being equal, the impacting between of a sculpture is likely at first to capture our attention more than the nonimpacting between of a painting, mainly because of the assertiveness of the impacting between upon our perceptual systems. But things are rarely equal. Around the outside of the choir screen of Chartres Cathedral a series of sculptures, begun by Jean de Beuce in the early sixteenth century, continued by others, and finally finished in 1714, portrays events in the lives of the Virgin and Christ. Despite the excellence of these works they usually are hardly noticed, at least initially, because the stained-glass windows of the apse are so sublime that only later are we able to turn around and attend to those very fine sculptures. This sequence seems to occur even with very tactually oriented persons.

Sometimes paintings, especially their colors, also project into the surrounding space: the scintillating colors of some Impressionist paintings, for example, or the glaring colors of some pop and op paintings. And in the case of stained glass, the light often pushes out clearly visible beams of color. (Stained glass is a species of painting, even when as at Chartres the glass is arranged in low-relief planes, for the planes appear as essentially two-dimensional and thus fail to produce an impacting between.) These various kinds of projections fill but do not energize the surrounding space. They float like mists without significant impact—unlike the push of the glazed colors of Luca della Robbia's terra-cottas, for instance—because they lack an apparent three-dimensional base that would give them projective force. Furthermore, although the projections actually come into real space, they still are perceived as belonging to the imaginary world of the painting. The surrounding space, in other words, is absorbed into an imaginary world and thus remains discontinuous with our space. In turn, our perceptions of the projections of such painting are without significant weight, so light that normally we are unaware of any tactile sensation. Only in the rare cases of exceptional stimulation are we even aware of tactile stimulation on our eyeballs, as with the green jelly-bean-like ellipses in Larry Poon's *Orange Crush*, 1963, in the Albright-Knox Art Gallery in Buffalo, which seem to jump out at us from their locations in a field of pure orange. With the space around a sculpture, on the other hand, we are aware of its transmission of impacting forces into real space, even though that space is not actually solid but only a conductor, and even though we do not touch the material body of the sculpture that is the base for the projection of these forces. The visual projections of a sculpture, unlike even a painting such as Poon's *Orange Crush*, are felt as having force behind them because they are grounded

71

in a three-dimensionality with significant mass that is not concealed and because that impacted space is perceived as part of and continuous with real space. Thus we perceive the between of sculpture much more tactually than the between of painting.

Since the sensa of a painting are perceived as free from the actual three-dimensionality and mass of its canvas (the material body of the painting), they have lost the impact that only a visible or palpable entanglement in solidity can produce. So no matter how brilliantly or intensely the sensa may be projected into the surrounding space—and few sculptures can rival the best stained glass in this respect—the projection remains ethereal. Since the sensa of sculpture, conversely, are perceived as an integral part of a three-dimensional thing (the material body of the sculpture), the sensa project something of the force of that material body. The sensa of a sculpture convey to some significant degree the dynamic interaction between the interior and exterior of the material body, and so the sensa not only fill but forcefully impact into the space. However, the line between a merely filling and an impacting filling cannot be neatly drawn. For instance, mosaics are basically flat, but if we perceive the *tesserae* or embedded pieces as significantly three-dimensional, there may also be—depending on the working of other factors such as color and light—a perception of an impacting between: the greater the impact, the greater the sculptural effect. Sculpture begins to be distinguishable from painting when the impact into the between becomes an important factor in our awareness. Whereas a painting is an image that excludes its material body, a sculpture is an image that includes its material body. A sculpture embodies a concrete sense of reality. Whereas a painting withdraws from nature, a sculpture collaborates with nature. The basic effect of a sculpture is physical presence. A sculpture is perceived as irrevocably there, present in the same continuum with us. In turn, a sculpture enhances our sense of our bodies. The feeling of the functioning of our perceptual systems mixes in strongly with our awareness of the sculpture, even though we are only explicitly aware of the sculpture. On the other hand, a painting is perceived as disembodied, and so the feeling of the functioning of our perceptual systems mixes in weakly with our awareness of the painting. Unlike a sculpture but like a mirror image,[16] a painting seems to disembody us. These very different perceptions occur because a sculpture is a physical presence determining an impacting between, whereas a painting is an imaginary presence determining a nonimpacting between.

Generally with sculpture our tactile sensations, because of the impacting

between, are much more strongly stimulated than with most paintings, even those fleshy nudes of Rubens and Renoir. Even with paintings such as these our tactile sensations are almost entirely evoked indirectly, that is, by association, "ideated" as Berenson puts it, whereas with sculpture our tactile sensations are much more directly evoked, physically as well as psychologically determined. Furthermore, with sculpture our haptic sensations reverberate more strongly and in closer harmony with our tactile sensations. Such strong and harmonic haptic resonance occurs only when strong, and thus usually direct, tactile sensations are aroused in aesthetic experiences. In nonaesthetic experiences, when we are thinking at some thing or situation rather than from, our tactile sensations are felt as "other-directed," for we are trying to control some thing or situation. For example, our hands search for the hole in the tire, but the resulting tactile sensations usually are not tightly synthesized with the sense of our knees on the ground or the temperature of the air or our haptic sensations, unless, for some reason, they help in our search. Those other tactile sensations and our haptic sensations tend to be screened out from awareness, negatively prehended, as Whitehead would put it. The tire is reduced to a problem— Where is the hole?—and, in turn, our tactile sensations are restricted in order to help solve that problem. The haptic sensations triggered off by these tactile sensations are similarly restricted, and they are unlikely to be tightly synthesized with the tactile sensations in our awareness. The "other-directedness" of nonaesthetic experiences—the thinking at—tends, except when strong bodily exertion is involved, to lessen haptic awareness. Even when haptic awareness is strong in such nonaesthetic experiences, there is still the awareness of the subject/object dichotomy which helps separate the tactile sensations of the object from the haptic sensations of the subject. In the aesthetic experience, conversely, there is an "inner-directedness"—the thinking from—which holds us to a oneness with the thing or event. Our tactile sensations are felt as more ingoing, and so when they evoke haptic sensations the unity of tactile and haptic sensations is felt as more tightly joined. Our haptic sensations echo our tactile sensations, like the sympathetic rumblings within a drum responding to the beats on its drumhead. With painting the resonance from the beats is relatively faint, compared with sculpture, because the space between us and the canvas is a nonimpacting between. With nonaesthetic experiences, however powerfully tactile, the beats, so to speak, hit all over the drum and miss concentration. The tactile and haptic sensations may be extremely powerful, as in sexual experience, but unless the oneness of the aesthetic experience comes

to the fore, the resonance of haptic with tactile sensations will not strongly harmonize. The tactile-haptic harmony in the perception of a sculpture, reinforced by the kinaesthetic sensations coming from the movements of the body toward and away from and around a sculpture, gives us a sense of spatial withness that no other art achieves. Sculptural experiences may, in turn, help us experience more aesthetically and thus more satisfactorily such nonartistic things and events as the sexual. Experiences of paintings—for example, the erotic prints and paintings of Picasso—may help also, of course, but they lack the full body withness of sculptural experiences. Picasso's obsession for showing all facets of the body simultaneously in these works is an expression of this need for full-body withness that only sculpture among the arts can fulfill, and this may account in part for Picasso's continual turning to sculpture.

As we aesthetically perceive a work of art, we are primarily aware of that work rather than our bodies, for we are thinking from the work. We have only "tacit knowledge," in Michael Polanyi's terms,[17] of our bodies in the aesthetic experience. Thus in the perception of a sculpture, any explicit awareness of our visual-tactual-kinaesthetic sensations would shift our attention away from the sculpture and weaken or destroy our aesthetic experience. Nevertheless, we are aware of those sensations tacitly or implicitly—Polanyi's *proximal* or unfocused awareness as distinguished from *distal* or focused awareness. Our body sensations are part of the unity of the aesthetic experience. Our bodies as perceptual systems are felt along with the sculpture; the sculpture is perceived the way it is determined in part by our perceptual systems. The *distal* (the sculpture) is inseparable from the *proximal* (our body awareness). Such co-perceptions of our bodies also occur in the aesthetic experience of a painting, of course, but usually these co-perceptions are relatively very weak. Consequently, even our visual perceptions of a sculpture are usually significantly different from the visual perceptions of a painting, for with a sculpture our vision is much more determined by the co-perceptions of tactual-kinaesthetic sensations. For instance, I see the light on Degas's sculptured dancer (Fig. 36) as vibrating, whereas I see the light on Degas's painted dancers (Fig. 35) as still. And the lines of a sculpture are seen differently from similar lines of a painting, because with a sculpture our eyes, heads, and bodies are moving more, and so our body awareness is more "charged up." I inevitably see the lines of Degas's sculptured dancer as much more dynamic than I see the lines of Degas's painted dancers. With the sculptured dancers, moreover, I am more likely to see bodies and then notice the lines. With the painted dancers, I am more likely to see the lines and

74

then notice the bodies. Furthermore, whereas figure and ground relationships are fundamental in my seeing the painted dancers, the motion of my body helps make these relationships relatively unimportant in seeing the sculptured dancers. Lastly, I do not see the space between the painted dancers and me, for that space is empty; whereas I see the space between the sculptured dancers and me, for that space is enlivened.

Sight-space is "distance-space"—our eyes normally must be some distance from the thing seen, and we can see things beyond things beyond things. Sight can bring a thing near in the sense of focusing it in our world, but if our eyes touch the thing we cannot bring it into clear focus. Touch-space is "near-space"—we touch the thing and the perception of it is sharpened. With sculpture, unless we are far away, there is usually a sense of direct contact, because even if we do not touch the material body of the sculpture we are continuous with its surrounding and impacting space. That contact echoes in our bodies, and these haptic reverberations along with their tactile counterparts are co-perceived with the sculpture. With painting, there is no between that we are aware of, at least during ideal conditions. And touching the canvas interferes with our perception, for we block at least part of the painting. If we place our hands on the material body of a sculpture, we also block from vision at least part of the sculpture. However, unless the work is very small, this is not troublesome, for with sculpture, except with some very low reliefs, some aspect is always hidden, and our touching or grasping, furthermore, can be informative and satisfying. On the other hand, when sight-space dominates touch-space, as with painting, we are necessarily distanced from tactile sensations of the thing being seen. Thus the tactile and, in turn, haptic sensations are weak. Furthermore, since we tend to stand or sit in a privileged position in front of a painting with little body movement, the kinaesthetic flows of tactual sensations receive no reinforcement.

Painting is the scene without direct solidity. Painting may suggest solidity very powerfully—Cézanne's mountains, for example—but they cannot present that solidity to our tactile feelings directly. The tactile stimulation on the eyes is probably no greater with Cézanne's mighty *Mont Sainte Victoire* (Fig. 33) than with Mark Rothko's delicate *Earth Greens* (Fig. 62). The solidity of the Cézanne depends upon the associations and memories it stirs up. The sense of solidity in our perception of a painting is psychological. Sculpture, on the other hand, is the scene with direct solidity. The sense of solidity in our perception of a sculpture is physical as well as psychological. All perception involves the

75

dynamic intercourse of things with our bodies, of course, and this always involves tactuality and kinaesthesia. But with a painting the physical stimulation of tactual sensations is minimal because of the nonimpacting between, and the kinaesthetic flow of tactual sensations is a low ebb because we usually rest in a privileged position in front of the painting. The between is the necessary gap that separates us from, and thus makes possible the perception of, the painting. That is the only function of the between in our perception of a painting. The painter arrests the spectacle of our world by slowing down our awareness of the flow of the showing forth of things. The projection machine of perception seems to be stopped. This arresting occurs even when the painting is of powerful motion, as with the Futurist work of Balla and Severini, for their images are still after-images, abstracted from moving things, and we perceive those after-images seemingly immobilely. On the other hand, the sculptor reinforces the flow of the showing forth of things. This reinforcing occurs even when the sculpture freezes motion, as with the solid, frontal, squat all-in-ness of Egyptian and archaic Greek sculpture. Such sculpture resists the ravages of time and reveals the timeless, sometimes commanding one eventually to stand motionless before the unyielding frontality. Yet the power of the three-dimensional material invading (from the inside out) its surrounding space impacts on the beholder and heightens his sense of the ongoing manifestation of the dynamic intercourse with things. That is why, for instance, Aristide Maillol could say, "The more immobile Egyptian statues are the more it seems as if they would move. . . . One expects to see the Sphinx get up."[18] For such a reason Balla turned to sculpture: "I understood that the single plane of the canvas did not permit the suggestion of the dynamic volume of speed in depth. . . . I felt the need to construct the first dynamic complex with iron wires, cardboard planes, cloth, and tissue papers."[19] A painting stands aloof. A sculpture bends forth, its material body meshing into the surrounding space. Anthony Caro wants his sculpture to relate to us as "presences," something like the way "one person relates to another."[20] Whereas painting closes in, sculpture stretches out, and so it is usually easier to ignore a painting than a sculpture. Unlike painting, sculpture involves the ever-changing postures of three-dimensional encounters. Thus recumbent sculpture, as on medieval tombs, is not nearly as odd as recumbent painting. With painting, a vertical placement in relation to the floor or ground, unlike many sculptures, is usually obligatory, for only then can painting be perceived optimally as a two-dimensional image creating an imaginary space. With sculpture, on the other hand, variations from the vertical are

more natural and aesthetically feasible. Thus the famous slant of the ramp of Frank Lloyd Wright's Guggenheim Museum is much more disadvantageous to paintings than to sculptures.

The three-dimensional encounter that sculpture imposes upon us tends, furthermore, to draw our attention to the gesture of a sculpture much more than to a gesture in a painting. Sometimes, even, a sculpture draws forth a reciprocating gesture. In the Musée National d'Art Moderne in Paris, I recently witnessed an amusing example of this phenomenon. A group of chattering boys were ignoring with adolescent bliss a blazing display of Vuillard and Bonnard nudes and other paintings, some of female nudity with a variety of gestures. But as they approached a standing Maillol nude, they became quiet and their pace slackened. They began to circle, more and more slowly, and then one boy gallantly placed a coin in her outstretched hand. As R. P. Blackmur points out, the gesture is much more fundamental to sculpture than to painting: "The great part of our knowledge of life and nature—perhaps all our knowledge of their play and interplay—comes to us as gesture. . . . Let us say that good sculpture has a heaviness or lightness which has nothing to do with stone or wood or the carver's trade [surely an overstatement], but which has everything to do with the gesture which illumines the medium."[21]

Sculpture is a presence embodying a concrete sense of reality, present in the same continuum as the perceiver, coming forth as a thing. Whereas sculpture is a penetrating image, painting, in a sense, is an after-image that separates itself from real space and then usually recedes. Painting by creating imaginary space generally tends toward extensiveness, as in Raphael's spacious frescoes in the nonspacious Stanze of the Vatican. Sculpture by creating impacting forces into real space generally tends toward intensiveness, as in Michelangelo's crowded Medici Chapel in Florence. Whereas painting is "elsewhere," sculpture is "here."

Because sculpture comes forth into real space without the distancing that painting and most of the other arts as well as most practical and theoretical work require, sculpture returns us to our anchorage in our world, our primordial community with things—that which holds everywhere, for everybody, at all times. No other art rivals sculpture in bringing us into direct contact with things. Sculpture silences the nervous noise of using things. Rilke:

> Things.
> When I say that word (do you hear?), there is a silence;
> the silence which surrounds things.[22]

Science and technology manipulate things most efficiently by ignoring their individuality. They give up living with the thingliness of things. Antoine Bourdelle demanded that his students sculpt "each part of the chair that cannot be seen . . . just as perfectly as the parts that can be."[23] Sculpture gives things an enhanced opportunity to manifest their internal animation, their inherent powers of enlivening the surrounding space and being with us in a world, allowing, in turn, our tactile sense of these powers to come in like a high tide.

Sight or at least the power of envisioning is indispensably involved in primary perception. Without sight secondary perception is terribly handicapped. Sight obviously is properly exploitable in painting, sculpture, architecture, film, television, and the illustrated weekly. Yet if sight achieves too great an eminence it puts us out of balance with our deepest instincts, our primordial awareness of being rooted in our homeland, our being-in-the-world. Intriguing and exciting as Duchamp's *The Large Glass (The Bride Stripped Bare by Her Bachelors, Even)* (Fig. 46) undoubtedly is, there is something profoundly disturbing about this glass work which we "see through and beyond" with nothing to hold the image in place, and which can never be seen by itself but always includes strangely "floating things" and spaces seen through it. A world of such immaterial things is a world of ghosts, and for most of us such an immaterial world is not enough. Perhaps that is why the uninitiated are often completely bewildered by abstract painting but can relate to abstract sculpture, for the physicality of the latter brings it directly into context with our living with things, thus putting less strain on our powers of abstraction. Similarly, it is usually much easier to relate to Eastern sculpture than to Eastern painting when the iconography and the iconology are unknown. The physicality of sculpture also, unfortunately, makes it much more vulnerable than painting to religious, moral, and political fanatics, many of whom, as in the French Revolution, concentrated on the destruction of sculpture.

Like most things a sculpture is self-sufficient and multilayered, whereas a painting has to be on something else. Hence it is much more difficult for a sculpture to escape association with something than a painting. Abstract sculpture can never reach the abstractness of abstract painting. It is not surprising, therefore, that the earliest abstract sculptures, for example, Vladimir Tatlin's *Relief* of 1914 followed a few years after the first abstract paintings by Kandinsky, Kupka, Picabia, and Delaunay, and that abstract painting has achieved a greater stylistic identity and influence than abstract sculpture. The physicality of sculpture also explains, perhaps, why most of us remember

78

volumes much better than colors. For example, I have fine copies of both Verrocchio's *Putto* that belongs to the fountain in the Palazzo Vecchio in Florence and Corot's *Ville d'Avray*. I never have any difficulty in imaging precisely the volumes of my copy when perceiving Verrocchio's original, but invariably I fail to image precisely the colors of my copy when perceiving the original *Ville d'Avray* in the National Gallery of Art in Washington. Except for the very visually oriented individual, the sculptural seems to have a stronger and longer hold on our memories than the pictorial. In any case, there is a primal need for sculpture, in contemporary Western society especially, for we have been surfeited with the predominantly visual modes of communication. [24] We hunger for touch, not so much because we may distrust visual experience unsupported by tactual modes of examination, but more because it is touch along with sight that reaches back into the deepest strata of the human personality and historical consciousness. Henri Focillon puts it this way:

Sight slips over the surface of the universe. The hand knows that an object has physical bulk, that it is smooth or rough, that is not soldered to heaven or earth from which it appears to be inseparable. The hand's action defines the cavity of space and the fullness of the objects which occupy it. Surface, volume, density and weight are not optical phenomena. Man first learned about them between his finger and in the hollow of his palm. He does not measure space with his eyes but with his hands and feet. The sense of touch fills nature with mysterious forces. Without it, nature is like the pleasant landscapes of the magic lantern, slight, flat, and chimerical. [25]

When caught in darkness our hands function as sentries searching for contact to warn us against collision. When we are exposed, as when giving a speech, our hands seek the podium or something solid. When our equilibrium is disturbed our hands grasp for a hold. Our hands have insight of their own. "To understand" means "to grasp" as well as "to see." We speak of "tangible evidence." Sculpture helps make our responses more sensitive to the particularity of things in their completeness. Sculpture revives the withering of our tactual and kinaesthetic senses by bringing us back into direct contact with the raw power of reality: the bumping, banging, pushing, pulling, soothing, palpitating tangibility of our withness with things. To be cut off from the thingliness of things, as when we separate ourselves as subjects from objects, injures our sense of being-in-the-world, what we most essentially are. Sculpture satisfies a fundamental craving of human sensibility that no other art satisfies in the same way. Sculpture returns us to the vital plenitude of being-in-the-world, to being in the midst of things as part of them.

79

We see things. We handle things. Both painting and sculpture clarify the way things look, but sculpture does something more—clarifying not only the way things handle, for sculpture is filled with the soil of the sensible, but our withness with that handling, healing the wounds caused by the subject/object dichotomy.[26] Painting heals too, of course, but not so directly. Since sight-space and touch-space are always a tight unity in the aesthetic experience of painting and sculpture, these arts are closely allied, but to make sculpture derivative or inferior to painting or vice versa makes nonsense of our senses. If painting is classified as a visual art, then sculpture is a visual-tactual art. If painting is classified as a static art, then sculpture is a dynamic art. Sculpture is not just an image of but an entrance to and communion with things. Because it activates real space, sculpture possesses a charged quality: sculpture presences physically in an enlivened space. Sculpture insists on its own presence and acknowledgment as a thing in a common territory. Like nature, sculpture abhors a vacuum. Painting arrests the spectacle of the world, for painting is primarily about the patina of things, the surfaces of shapes that have already emerged. Painting reflects the real world from outside, never from within that world. Sculpture is the rebirth of existents within the world, for sculpture is more about things as they are emerging. Being in real space, sculpture is in real time. Because of its impacting between, sculpture is a special force, even seeming sometimes to explode into our awareness. Sculpture is not just another thing among things but a thing that reveals the emergence of other things. Sculpture presents things in a way that breaks up customary perception, returns us to things as they unfold anew, to the primitive roots of perception, as in the creative perception of the child before he is enchained in habit and perceives principally what he has already perceived. That was Brancusi's point: "When we are no longer like children we are already dead."[27] Sculpture more than any other art reveals the primal foundations of our perceptual experience: that is why sculpture is an autonomous art.

V

The Arts
and the "Between"

My total conscious search in life has been for a new seeing, a new image, a new insight. This search not only includes the object, but inbetween places. The dawns and the dusks.

Louise Nevelson

The role of the between in the arts, with the major exception of architecture, is more like that of painting than of sculpture. In the language of the philosophers, the between is usually an external rather than an internal relation. Usually the space around the work of art is only a transparent medium—impalpable air—that is not a perceptible part of the work but only a means to it, the necessary gap between the "here" (us) and the "there" (the work) that makes it possible for us to perceive and understand the work as an imaginary world rather than a real world. More specifically, however, the between in each of the major arts differs in the way it functions.

With literature, whether we are reading or being read to, the between ideally is entirely vacuous. All we desire is to see or hear the words as clearly as possible. Bad light or interfering sounds make us aware of the real space between the printed page and us or the person reading to us, thus distracting our attention from the imaginary space created by the literature. With literature, all we want is real space as an invisible means to imaginary space. Yet as Gadamer correctly points out: "Even poetry and music, which have the freest mobility and can be read or performed anywhere, are not suited to any space whatever,

but to one that is appropriate, a theatre, a concert-hall or a church. Here also it is not a question of subsequently finding an external setting for a work that is complete in itself, but the space-creating potentiality of the work itself has to be obeyed."[1] The most appropriate space for a work of literature to be read is that space which most completely subordinates itself to the particular kind of imaginary space projected by that work. For example, John Donne's *Holy Sonnets* read better in a church than in a theater, because church space in this instance lends itself better to nonperceptibility by being more easily absorbed into the imaginary spaces created by the poems.

The space-creating demands of music are somewhat different and much more complex. With music the between must be even more carefully controlled than with literature, for the acoustical area has to possess very special characteristics for the music to sound its best. To a degree this is also true for someone listening to literature, of course, but even if the voice is heard in an inappropriate space—Browning's "Childe Harold to the Dark Tower Came," for example, in a cozy room—it is not as likely to weaken the literature quite as much as music played in an inappropriate space. A Steinway Grand piano has a special ring to its tones that usually forbids its being played in a small room, and the special qualities of a Haydn quartet may be lost in a very large concert hall or the open air. However, even a poor voice in a poor place, as long as the words are distinguishable, may still be able to convey something of the basic quality of most literature. Thus the between of music is more perceptible than the between of literature. The sounds of music are explicitly in the between. In listening to monophonic or stereophonic or quadraphonic recordings, the differences are not only in the tonal qualities as they sound in our ears but our awareness of the differences in their spatial origins and spreads. Listening to music with headphones deadens the life of music by taking away its breathing space, somewhat similar to backing *Growth* (Fig. 51) into a corner. On the other hand, the between with music is much less perceptible than with sculpture. Music fills the between, but it does not impact forces into the between with the punch of sculpture. In filling the between, however, music is usually clearly directional and in this respect is like sculpture. Thus in the beginning of the Russian Orthodox mass at the Alexander Nevsky Church in Paris, the deep bass chanting of the hidden deacon comes out from behind the iconastas or screen of the chancel—a voice of terrifying doom—answered at a higher and less frightening pitch in a continual dialectic by the visible choir stationed to the left near the main door. The spread of incense facilitates the interplay.

Some music, however, does impact, for example, music such as Giovanni Gabrielli's antiphonals for brass, in which one brass chorus in one cross section of a church answers another chorus in an opposite section. The resounding echoes from the walls, with the persistence of partials as well as primary tones, produce timbres that carry with them the outgoing forces of the church's stonework. To hear such music without perceiving the impacting between takes some of the glory out of that music. But such music, like opera, involves a wedding with other arts, in this case architecture.

The sounds of unwed music, on the other hand, are peculiarly immaterial. They inhabit an invisible between like ghosts. Thus even when music is played so loudly it bangs into our ears, the tactility of these sensations usually is not felt as reinforcing the ethereality of our hearing. To the extent that pure music is experienced aesthetically, our tactile sensations withdraw into the background, accounting for the nonimpacting filling of the between. The immateriality of pure music also accounts for its extraordinary timelessness and placelessness. Sartre observes:

I am listening to the Seventh Symphony. For me that "Seventh Symphony" does not exist in time. I do not grasp it as a dated event, as an artistic manifestation which is unrolling itself in Châtelet auditorium on the 17th of November, 1938. If I hear Furtwaengler tomorrow or eight days later conduct another orchestra performing the same symphony, I am in the presence of the same symphony once more. Only it is being played either better or worse. Let us see *how* I hear the symphony: some persons shut their eyes. In this case they detach themselves from the *visual* and dated events of this particular interpretation: they give themselves up to the pure sounds. Others watch the orchestra or the back of the conductor. But they do not see what they are looking at. . . . The auditorium, the conductor and even the orchestra have disappeared. . . . To the degree to which I hear the symphony it is *not here*, between these walls, at the tip of the violin bows.[2]

Music, especially for those more sensitive to the auditory than to the visual and the tactual, may completely screen out the world of solid things.

Still there are subtleties about music that make the idea of pure music seem like a myth that has been perpetrated upon us by Eduard Hanslick. There is a tendency in most of us to fuse tones and beats with what, at the moment of hearing, is being looked at, and we are often disturbed without such fusions. When silent films were first introduced, for example, it was noticed that audiences were uncomfortable looking at those films without some auditory accompaniment. The organ or piano was introduced to provide a needed

auditory supplement. Moreover, the favorite pieces of the organist or pianist became part and parcel of the films they accompanied. When the Villain was strapping the Heroine down to the railroad track, and the Engine was coming around the bend, the pianist picked Schubert's "Earl King" as accompaniment so often that, when Schubert's music is now heard without the words of Goethe, many American oldsters cannot get the visual aspects of those films unglued from the music. They immediately conjure, almost as in an after-image, the wax-mustachioed Villain with high silk hat and black cape, the wildly ges-ticulating, wind-blown Heroine, the tracks and train. Similarly, many children raised on television cannot play cowboys and Indians without singing along their own sound track. This singing is part of what it is to be a cowboy or Indian. Somewhat more subtly, the "Tara" theme of Max Steiner from *Gone with the Wind* is so important a part of the film that when it is now heard independently, we immediately see again some replica of scenes of the film, perhaps a white plantation mansion, a vast expanse of lawn across which a hoop-skirted south-ern belle is running, and somewhere a magnolia tree. Steiner's technique was somewhat Wagnerian and the "Tara" theme functioned like a leitmotif, sound-ing all out of harmonic whack when events were tragic, and, toward the ending, back again in its consonant original state. The continuity of the film, whose plot is episodic, rests to a large extent upon its auditory dimension. According to Arnheim, music completes the silent film so perfectly because "it vigorously transmits the feelings and moods and also the inherent rhythm of movements that the visual performance would wish to describe but which are accessible to it only through the inevitable diffraction and turbidity deriving from the use of concrete objects."[3]

Whether music is heard in a usual setting such as a concert hall, or in a more special setting such as Gabrieli's antiphonals in a church, or as fused with a motion picture, music has an undeniable spatial dimension. Furthermore, when the music is effective, it can be an essential part of the significance of what we see and touch and taste and smell. It may be, for example, that many of the exploited people in the United States survive the bleakness of their ghettos by infusing into a world otherwise squalid and inhumane the dimension of music that makes it bearable. Despite all this, the spatial aspects of music are sec-ondary, in the sense that we can shut or unfocus our eyes, we can be unoccu-pied tactually, and yet our perception of the music is not weakened. The between of music is something more than the vacuous between of painting and literature and something less than the impacting between of sculpture. Music is

ethereal, pervading the between but lacking the pushing power of sculpture.

In the stage arts (opera, drama, and the dance) and the screen arts (film and television), music or sound may fill the between. But the separation of the space of the presentation of these arts from the space of their audience (leaving aside for the moment avant-garde productions, such as Julian Beck's *Paradise Now*, that involve the audience in their happenings) tends to attenuate this filling effect. The limits of the stage or screen, however vaguely defined, divide the imaginary spaces of the production from the real spaces of the audience. "That is why the director," as P. A. Michelis observes, "while rehearsing his cast, often comes off stage into the auditorium to watch the acting in perspective and enjoy the scene as a spectator, interposing the appropriate space between himself and the work."[4] Ideally the between, the distance from our seats to the stage or screen, is empty, without head or hair or hat obstructing our vision. Even if we are ushered to a seat on the periphery and the stage or screen appears distorted, we often become oblivious of our unfortunate location and the proportions correct themselves. This correction usually happens quickly with the film because the darkened theater hides everything but the screen. With television, since the screen is usually seen in a lighted room, such adjustment is more difficult. But with television, fortunately, we normally have more control over our locations. With both film and television, furthermore, when their screens are activated by images, it is most difficult to be aware of the surfaces of the screens. E. H. Gombrich declares it to be "almost impossible to read the picture and attend to the alternative system in which the screen is an object like any other in the room. The cinema, of course, enhances the illusion by darkening the room, and television viewers may do the same, but even without this additional aid to illusion it seems to me very hard to remain aware of the projecting surface. Even if the show will not involve us emotionally, it is next to impossible to 'concentrate' on the screen to the extent that we merely see expanding and contracting shapes rather than people and objects approaching and receding."[5] The screen and its images abstract themselves from real space and are absorbed in imaginary space. Thus with the stage and screen arts, as with painting and literature, we want the between to be imperceptible. When the between is perceptible, our aesthetic experience of these arts is disturbed. Then the separation between the space of the presentation and our space as audience becomes confused, and irrelevant events within our space obscure the space of the presentation. In short, under optimal conditions the accompanying music or sounds of the stage and screen arts stay fused with the imaginary spaces

of the presentation, staying separate from us as part of another world. We may have with these arts even less sense of music and sounds impacting into the between than with pure music.

Only architecture rivals sculpture in incorporating the between as part of its perceptible structure, but since architecture articulates space quite differently from most sculpture, so, in turn, the between of architecture is usually perceived quite differently from the between of sculpture.

Space is a relation of things, not a thing itself. Space in its full reality is the power we feel in the positioned interrelationships of things. Space is not reducible to a mere collection of given things. Nor is space an envelope containing the sum of such given things, although since Newton—and despite Einstein—space is usually so conceived. Space is not a thing, and yet, because of the positioned interrelationships of things, space "spaces," manifesting itself somewhat like a thing. Space shows forth a vitality that can be felt. Usually we pass by this enlivening power because we tend to notice explicitly the position of things only when we use them. We abstract from the full reality of space and see space only as a means. We know space, for we perceive and understand things in their positioned interrelationships; but because of the anesthesia of practicality, we fail to feel space, the power of these interrelationships.

The painter does not command real three-dimensional space: he only feigns it. The sculptor molds out into space, but—aside from exceptions such as some Environmental sculptures, for instance Robert Morris's *Labyrinth* (Fig. 90)—he does not enfold an enclosed or inner space for our movement. For example, the holes in the sculpture of Henry Moore are usually to be walked around, not into, whereas our passage through its inner spaces is one of the conditions under which the solids and voids of a work of architecture have their effect. Architecture in a sense is a great hollowed-out sculpture which we perceive by moving about both outside and inside. Space is the material of the architect, the primeval cutter (as suggested by the Greek *architecton*) who carves apart an inner space from an outer space in such a way that both spaces become more fully perceptible and, in turn, intrinsically interesting. Sometimes outer space is more important, as with the Parthenon, and sometimes the inner space is more important, as with the Pantheon. But at all times, space is filled with impacting forces inside, while outside space is not only impacted into but becomes more organized and focused. The enfolded inner space is anchored to the earth. Outer space converges around the inner space. Sunlight, rain, snow, mist, and night fall gracefully upon the cover protecting the inner space as if

86

drawn by a channeled and purposeful gravity, as if these events of the outside belonged to the inside as much as the earth from which the building rises. Inner and outer space are formed over the earth by the architect to create a centered and illuminated context or clearing. "Centered space" is the positioned interrelationships of things organized *around* some paramount things as the place to which the other things seem to belong. Sometimes this center is a natural site, such as the Grand Canyon or Mount Rainier. Sometimes the center is a natural site enhanced by a work of architecture, such as the Parthenon or the Cathedral of Florence. As Aristotle says, "Art completes nature." Here is Heidegger's description of a bridge:

> The bridge swings over the stream "with ease and power." It does not just connect banks that are already there. The banks emerge as banks only as the bridge crosses the stream. The bridge designedly causes them to lie across from each other. One side is set off against the other by the bridge. Nor do the banks stretch along the stream as indifferent border strips of the dry land. With the banks, the bridge brings to the stream the one and the other expanse of the landscape lying behind them. It brings stream and bank and land into each other's neighborhood. The bridge *gathers* the earth as landscape around the stream. Thus it guides and attends the stream through the meadows. Resting upright in the stream's bed, the bridge-piers bear the swing of the arches that leave the stream's waters to run their course. The waters may wander on quiet and gay, the sky's floods from storm or thaw may shoot past the piers in torrential waves—the bridge is ready for the sky's weather and its fickle nature. Even where the bridge covers the stream, it holds its flow up to the sky by taking it for a moment under the vaulted gateway and then setting it free once more. . . . Always and ever differently the bridge escorts the lingering and hastening ways of men to and fro, so that they may get to other banks and in the end, as mortals, to the other side.[6]

If we are near such bridges we tend to be drawn into their clearing, for, unless practical urgencies have completely desensitized our senses either momentarily or habitually, centered space has an overpowering dynamism that captures our attention and orients our bodies. Centered space propels us out of our ordinary modes of experiencing in which spatial relations are felt merely as a means or an obstacle. Centered space is centripetal, insisting upon drawing us in. There is an inrush that is difficult to escape, that overwhelms and makes us acquiescent. We perceive space not as a receptacle containing things but rather as a context within which we are aesthetically active in response to the power of the positioned interrelationships of things. Centered space has a pulling power that, even in our most harassed moments, we can hardly help feeling. In such places as the Piazza before Saint Peter's, we are drawn to the center of the Piazza and

then to the church. We walk slowly and speak softly, the sounds of Maderna's two fountains tightening the embrace of Bernini's colonnades.

Space is breathing space, a clearing, and yet space exerts its power by pushing in upon us. Gravitational force is the most obvious manifestation of this power, for gravity works continuously on every aspect of our lives. Without some sensitivity to space we could not survive. But because of the exigencies of life, we learn to push things around in space. Insofar as this pushing succeeds easily and efficiently (and in a technological age such success becomes increasingly possible), space tends to become no more than a framework within which we manipulate the position of things. We become explicitly conscious of space only when things in their interrelationships frustrate us, and then only as an area within which we have to work. Space becomes part of a problem. In this aggressiveness we enslave space to the point that we pass by its power. Then it takes either the enlivening thrust of the great spaces of nature (and these spaces, such as in and around the Bay of Naples, are always centered to some significant extent) or the centered spaces of architecture to return us to an explicit awareness of the power and embrace of the positioned interrelationships of things.

Architecture, as opposed to mere engineering, is the creative conservation of space. The architect perceives the centers of space in nature and builds to preserve these centers and make them more vital. These spaces of nature are not offspring of his soul alone but appearances which step up to him, so to speak, and request realization. If the architect succeeds in carrying through these appeals, the power of the natural space streams forth through him and the work arises. The architect is the shepherd of space. In turn, the paths around his shelter lead us away from our ordinary preoccupations demanding the use of space. Instead of our using up space, space takes possession of us with a ten-fingered grasp. We have a place to dwell.

On a hot summer day some years ago, following the path of Henry Adams, I was attempting to drive from Mont Saint Michel to Chartres in time to catch the setting sun through the western rose. In my anxiety to arrive in time—I had to be in Paris the following day and I had never been to Chartres before—I became oblivious of space except as providing landmarks for my time-clocked progress. Thus I have no meaningful memories of the towns and countrysides I hurried through. Late that afternoon the two spires of Chartres, like two strangely woven strands of rope let down from the heavens, gradually came into focus. The dome of the sky also became visible for the first time, centering as I approached more and more firmly around the axis of those spires. "In lovely

blueness blooms the steeple with metal roof" (Hölderlin). The surrounding fields and then the town, coming out now in all their specificity, grew into tighter unity with the church and sky. Later I recalled a passage from Aeschylus: "The pure sky desires to penetrate the earth, and the earth is filled with love so that she longs for blissful unity with the sky. The rain falling from the sky impregnates the earth, so that she gives birth to plants and grain for beasts and man." No one rushed in or out or around the church. The space around seemed alive and dense with slow currents all ultimately being pulled to and through the central portal. Although spacious far beyond the scale of practical human needs, the inside space was full of forces thrusting and counterthrusting in dynamic interrelations. Slowly, in the cool silence inlaid with stone, I was drawn down the long nave following the stately rhythms of the columns. But my eyes also followed the vast vertical stretches far up into the shifting shadows of the vaultings. It was as if I were borne aloft. Yet I continued down the narrowing tunnel of the nave, but more and more slowly as the pull of the space above held back the pull of the space below. At the crossing of the transept, the flaming colors, especially the reds, of the northern and southern roses trans-fixed my slowing pace, and then I turned back at last to the western rose and the three lancets beneath—a delirium of color, dominately blue, was pouring through. Earthbound on the crossing, the blaze of the Without was merging with the Within. Radiant space took complete possession of my senses. In the protective space of this sheltering space, even the outer space which I had dismissed while driving seemed to converge around the center of this crossing. Instead of being alongside things—the church, the town, the sky, the sun—I was with them, at one with them. This housing of holiness made me feel at home in this strange land.

Living space is the feeling of the positioning of things in the environment, liberty of movement, and the appeal of paths as directives. Taking possession of space is our first gesture as infants, and sensitivity to the position of other things is a prerequisite of life. As Kant noted, space infiltrates through all our senses. Our perceptual systems are always being determined by space. A breeze broadens the spaciousness of a room that opens onto a garden. A sound tells us something about the surfaces and shape of that room. A cozy temperature brings the furniture and walls into more intimate relationships. The smell of books give that space a personality. Each of our senses helps record the positioning of things, expressed in such terms as up–down, left–right, and near–far. These recordings require a reference system with a center. With

abstract space, as when we estimate distances visually, the center is the zero point located between the eyes. With living space the whole body is a center. Furthermore, when we relate to a place of special value, such as the home, a "configurational center" is formed, a place that is a gathering point around which a field of interests is structured. If we oversimplify, we can say that for the peasant his farm, that place to which he most naturally belongs, constitutes his configurational center: with the Roman it was Rome; with medieval man, the church and castle; with a Babbitt, the office; with a Sartre, the cafe; and with a de Gaulle, the nation. With sculptors the configurational center is usually the studio and its environs: Brancusi's bright and spacious Paris studio, Moore's Herefordshire estate, Giacometti's dark and narrow Paris studio, David Smith's Bolton Landing "workshop" along Lake George. But for most men at almost any time, although more so in contemporary times, there are more than a couple of centers. Often these are more or less confused and changing. In living space, nevertheless, places, principal directions, and distances arrange themselves around configurational centers.

The configurational center is our personal space, to some extent private and protected. Outside the configurational center, space usually is more public and dangerous. The security of the home gradually lessens as we step out through the door into the yard, the immediate neighborhood, and then more remote places. As we move onto the typical superhighway in northeastern United States, for example, the concrete cuts abusively into the earth and through the landscape as straight as possible. The arteries of commerce pump efficiency, and there is no time for piety to space. Everyone passes hurriedly, aloof from both other people and centered spaces. There is no place for pedestrians or vistas or peace. Even the roadside rests, if any, for the fatigued driver are drowned in the whine of tires, and the necessities such as gas stations, restaurants, and motels are usually repetitious vulgarities. Everyone from the hitchhiker to the other motorist is a threat. Only a police car or a severe accident is likely to slow us down. The machine takes over, and when we have reached our destination on time, the machine mentality is likely to maintain its grip. Space is sacrificed to time.

Such desecration of space may even lead us to forget our configurational centers that give orientation and meaning to other spaces. Then orientation with reference to intrinsic values is lacking. We become displaced persons, refugees from ourselves. Secondary perception dominates our lives. We think at everything, primary perception failing to become sustained or aesthetic, provid-

ing only the material for secondary perception. Then living space, private as well as public, becomes merely used space. In turn, the efficient management of this used space requires precise placements. Used space becomes geometrical space, a static schematic vacuum. The geometricians measure out coordinate systems whereby everything is related quantitatively. The centers now are entirely impersonal, for the basic characteristic of geometrical space is its homogeneity. No center and no direction in this democracy of places is preferred to another. When we want to move through space most efficiently, geometrical space provides the map. To the degree that efficiency of movement dominates our concerns, living space becomes abstract space. Like the lumber barons of California ripping out the redwoods, we see straight through space. We still see things and the between of things, but only as means. Space iself—the power and hospitality of the positioned interrelationships of things—is ignored. Space becomes a wasteland.

A building that is not a work of architecture, even if it encloses a convenient void, encourages us to ignore it. Normally we will be blind to such a building and its space as long as it serves its practical purposes. If the roof leaks or a wall breaks down, however, then we will see the building, but only as a damaged instrument. A building that is a work of architecture brings us back to living space by centering space. Such buildings raise to clarity preceding impressions of the site that were obscure, confused, and inarticulate. The potentialities of power in the positioned interrelationships of things are captured and channeled. Our feeling for space is reawakened. We become aware of the power and embrace of space.

The surrounding space is a perceptible part of architecture just as with sculpture, but the surrounding space of architecture is much more extensive, setting up a clearing or "region" that relates things to the earth and the sky. Architecture shapes a center that more tightly organizes nature as a site. Architecture helps space become a place, for space becomes a place when something organizes or assembles other things around it. A place is a gathering power that penetrates and pervades everything within its boundaries. Sculpture like architecture helps space become a place, but architecture generally is much more cosmic in orientation. Sculpture brings out the surrounding space as the impacting power that binds us to some thing. Architecture is a place that provides (since it carves open both inner and outer space) clearings for such things as sculpture to fill. The surrounding space of architecture is between many things, including especially the earth and the sky and often other

91

buildings. Architecture structures an opening, a region that creates a place for the thingliness of things to come forth. Thus the impacting between of architecture is extensive. The impacting between of sculpture is more limited, primarily between us and the sculpture, and in this sense more intensive. As Barbara Hepworth puts it: "Sculpture should act not only as a foil to architectural properties, but the sculpture itself should provide a link between human scale and sensibility and the greater volumes of space and mass in architecture."[7] For us to participate with sculpture most fully, the surrounding space has to be carefully oriented. Hence most sculpture needs an appropriate architecture. Michelangelo's *Pietà*, in the first chapel to the right of the entrance of Saint Peter's, now that the chapel for security reasons has been boxed off by glass, has lost some of its impacting power. Even worse was its theatrical setting at the New York World's Fair of 1964-1965, where the spectators were rapidly moved past the sculpture on carrier belts, like cans on a conveyor.

Bernini's *The Ecstasy of Saint Teresa* (Figs. 26a, 26b), in the Cornaro Chapel of Santa Maria Victoria in Rome, is an interesting example of obedience to the first categorical imperative of the sculptor: Attend to the impacting between! Commissioned for the architecture, sculpture, and painting of the chapel by the Patriarch of Venice, Cardinal Frederigo Cornaro, Bernini was asked to include sculpted portraits of the donor, his father the Doge Giovanni, and six Cornaro Cardinals of the preceding century. Bernini decided to divide the eight Cornaros into two groups and place them in boxlike spaces above and to the sides of the main event—*The Ecstasy*—and such positions naturally suggested the boxes of the opera or theater. Furthermore, Bernini loved the theatrical, as his work especially at Saint Peter's shows, and yet he chose to de-emphasize in the Cornaro Chapel the obvious indications of the theater: he placed huge columns at the sides of *The Ecstasy*, completely blocking any view of Saint Teresa and the Angel from the boxes; architectural settings were stretched out left and right behind the boxes, suggesting transepts that transform the boxes into prie-dieux within a church; and no Cornaro is made to look toward Saint Teresa and the Angel. Why? My guess is that Bernini understood that if Saint Teresa and the Angel could be seen from the boxes and the Cornaros were made to look upon them, then we, in turn, would also tend to look upon Saint Teresa and the Angel as if they were on a stage. And then there would be a sense of separation of stage space from spectator space, the imaginary from the real. By having the Cornaros meditating upon or discussing Saint Teresa's vision which they cannot see, Bernini does not allow us to be held back

physically or distracted psychologically from the direct impact of *The Ecstasy*, coming forth as if it had burst open and bent the wall toward us. The directed light streaming down from a hidden source [8]—symbolic of God—seemingly penetrates and breaks up the marble of Saint Teresa and her fluffy cloud and enflames the Angel. That dramatic impact is channeled toward us by the outwardly bent pediment and the convex and tightly grouped columns, thus avoiding the suggestion of the separating function of a proscenium arch. The impact into the between is so extraordinary it seems supernatural, an objective correlative of Saint Teresa's famous description of her mystic experience:

It pleased the Lord that I should sometimes see the following vision. I would see beside me, on my left hand, an angel in bodily form—a type of vision which I am not in the habit of seeing, except very rarely. Though I often see representations of angels, my visions of them are of the type which I first mentioned [i.e., "imaginary"]. It pleased the Lord that I should see this angel in the following way. He was not tall, but short, and very beautiful, his face so aflame that he appeared to be one of the highest types of angels who seem to be all afire. . . . In his hands I saw a long golden spear and at the end of the iron tip I seemed to see a point of fire. With this he seemed to pierce my heart several times so that it penetrated to my entrails. When he drew it out, I thought he was drawing them out with it and he left me completely afire with a great love for God. The pain was so sharp that it made me utter several moans; and so excessive was the sweetness caused me by this intense pain that one can never wish to lose it, nor will one's soul be content with anything less than God. [9]

Bernini as architect, sculptor, and painter—the ceiling of the chapel was painted by Guido Ubaldo Abbatini following Bernini's designs—integrated the three arts into a tightly woven synthesis. But Bernini was first and last a sculptor, as his care for the impacting between in this chapel so powerfully witnesses.

 Sculpture may find its proper place in the centered spaces of nature; for instance, the setting of Marta Pan's *Floating Sculpture* (Fig. 84). [10] The placement of Moore's *Glenkiln Cross* above a loch in Scotland is an even better example. There are six casts of this sculpture, also known as *Upright Motive No. 1*, one of which stands in the garden of the Hirshhorn Museum in Washington. Unfortunately, the Pan-like mystery of the sculpture in its Scottish setting almost vanishes in Washington's Mall. Sometimes sculpture finds its proper place in a scene set by both nature and architecture, as with the placing of seventeen sculptures—femininity congealed into stupendous calm—by Maillol in the gardens of the Tuileries with the widespreading wings of the Louvre in the background. When the setting is so magnificent, the sculpture must be

93

powerfully impacting if it is to maintain its sculptural integrity. Most of the sculptures further to the west in the Tulieries as well as most of those in the Luxembourg Gardens have little impacting power and thus are perceptible primarily as decorative props or missed entirely.

Most sculpture finds its proper place in a site set by architecture. In turn, the life of the sensory space of architecture may be intensified by sculpture. Architecture can create a context within which sculpture can give us a strongly enhanced "felt withness" with things. Thus in the center bay of the north porch of Chartres Cathedral we can be rocked back on our heels by the coordinated power of dozens of marvelous sculptures, especially *Abraham and Isaac* and *Saint John the Baptist*, that power driving outward from the walls into and through the openings of the porch. Architecture opens up the earth as a site—earth as *earden*, the old Saxon term meaning "to dwell." Sculpture may help enliven the space of that site. That is why these arts have always been so closely related. Le Corbusier, for example, makes the interesting suggestion that the best site of sculpture would be like the focus "of a parabola or an ellipse, like the precise point of intersection of the different planes which compose the architecture. From there the word, the voice, would issue. Such places should be focal points for sculpture, as they are focal points for acoustics. Take up your stand here, sculptor, if your speech is worth hearing."[11] Architecture enlivens space extensively; sculpture enlivens space intensively. Architecture without sculpture is often like a home without furniture. Sculpture without architecture is often like furniture without a home. Sculpture needs its special place. Architecture with its sheltered opening may provide that special place, and then the screen of the commonplace is removed. Both the place and its things are allowed to unfold into their fullness.

There is a driving tendency in some contemporary arts to make the between more of an integral part of the work of art. Sculpture is one of the more adventurous arts of our time, and the sculptural effect of the impacting between is having more influence on painting, architecture, drama, and the dance than at any time, perhaps, since the Greeks.

This need to make the surrounding space more of an integral part of the work of art may be at least partially explained by our reaction against our technologically dominated times. We live in an age that uses things primarily as means, arranging them so that we can ignore their concrete suchness. Mark Twain tells how, as he learned the functions of a steamboat pilot, he became

alienated from the Mississippi River: "Now when I had mastered the language of this water, and had come to know every trifling feature that bordered the great river as familiarly as I knew the letters of the alphabet, I had made a valuable acquisition. But I had lost something, too. I had lost something which could never be restored to me while I lived. All the grace, and beauty, the poetry, had gone out of the majestic river! . . . All the value any feature of it had for me now was the amount of usefulness it could furnish toward compassing the safe piloting of a steamboat."[12] Since Mark Twain's time, technology has made tremendous strides. We are trained to see nature as an insensate empty space containing things (including persons) as units to be controlled, as raw material to be hammered into useful shape. To the degree that we succumb to, rather than dominate, this Frankenstein, our lives become scheduled by-products of the power plants of society, driven like machines into the dubious safety zones of the herd. Then technology becomes the systematic organization of our departure from things. We begin to quantify everything, even works of art, for then we can control these things and prove our theories about them. For example, in the Acton Collection in a private villa in Florence there is a late thirteenth-century *Madonna and Child*, its artist unknown, which is exceptionally lovely because, among other reasons, of the exquisite blue of the Madonna's mantle. I happened to see this painting some years ago in the company of a historian of art who was working on a monograph about early Renaissance haloes. He carefully measured the sizes of the haloes in this *Madonna and Child* and then did likewise with the haloes of some other paintings in the room. While leaving the villa and talking to my companion about the *Madonna and Child*, I realized that this expert had "missed" the painting. At least temporarily, art had been reduced to the problem of the evolving sizes of haloes. To measure and count is, in a sense, not to see.

Technology has its blessings, of course, but it also has its price: it may put us out of touch with the palpable presence of things, their splendid singularity. The tool gets between us and the thing. The tool is perceived as nothing but an instrument and the thing becomes an instrument as well, objects to be used, lacking intrinsic values. We are thereby deprived of satisfying a fundamental need, for we are with things essentially, and things possess intrinsic values. Our conception of ourselves as subjects over against objects is an abstraction from a primordial unity. We forget this prior togetherness and become beings out of joint, aching for reunion with we know not what. More than any other art, sculpture relieves that ache by bringing us back into touch with the tangible

individuality of things, inducing their existence into our senses, returning us to our withness with them that is the foundation of our world. That is why, perhaps, sculpture is such an important art today for the first time since the Renaissance, and why the sculptural effect of enlivening space is encroaching into some of the other arts. Perhaps if Rilke were writing about Rodin today, he would be a little more optimistic: "I feel more clearly than ever before that in these works sculpture has developed continuously to such power as has not been known since the ancients. But this plastic art has been born into an age which possesses no things, no houses, no external objects. For the inner life of which this age consists is still without form, intangible: it is fluid."[13] And Rodin, if he were still alive, could not possibly write: "I am one of the last witnesses of a dying art. The love that inspired it is spent."[14]

Some avant-garde sculpture intensifies the impacting between more than ever before by making possible our interaction with the sculpture. Thus Paul Talman's *K-121, Black/White*, 1965, in the Albright-Knox Art Gallery in Buffalo, is composed of a large square made up of what appear to be half-protruding billiard balls (actually they are made of plexiglass) surrounded by a plain black square double in size. The half-white, half-black balls pivot around hidden spindles. We are invited to rotate the balls into black and white combinations to our liking, and many of us accept the invitation. Robert Rauschenberg's *Publicons*, a series of six assemblages, are open to personal exploration and reconstruction. Panels slide out, doors open, pieces can be removed and shifted to new locations. Nicolas Schöffer's *CYSP I* (Fig. 63)—a name composed of the first letters of "cybernetics" and "spatiodynamics"—is also a kind of "performing sculpture." Included in its large aluminum and steel frame are photoelectric cells, microphones, and sixteen pivoting polychromed plates sensitive to a wide range of variations in color, light, sound, and temperature. These changes are fed into an electronic brain housed in the base of the structure that, in turn, activates four sets of motor-powered wheels. Depending on the stimuli, the sculpture will move more or less rapidly about the floor, turning more or less sharp angles. Blue, for example, excites rapid movement and makes the plates turn quickly. Darkness and silence are also exciting, whereas intense light and noise are calming. Complex stimuli produce, as in human beings, apparently unpredictable behavior. Moreover, the participant takes part in making the sculpture "come alive." The between is charged two ways, for the sculpture affects us and we affect it. The forces between, however unpredictable, impact powerfully, and the sense of enlivened space is exceptional.

In recent painting all kinds of devices have been developed to make the between more perceptible. Much op painting, for example, makes the participant move (as with sculpture) in order to see the changing qualities and structures of the sensa. Pop painting has always tended toward sculpture. In Tom Wesselmann's *Smoker, I (Mouth, 12)*, (Fig. 86), no frame or simple geometrical outline helps the imaginary space of the painting divide from the real space. By means of bright, aggressive colors and clever perspective, the cigarette seems to jut out into real space. We are lured to walk to the side, as with relief sculpture, to confirm the illusion. In some other works, Wesselmann incorporates three-dimensional things with his painted panels. With *Great American Nude, No. 54* a table and chair are placed in front of the panel as part of the composition. Michelangelo Pistoletto's *Man with Yellow Pants* in the Museum of Modern Art, New York, is a painted paper cutout of a man with yellow pants pasted over about half of a stainless steel panel. As you approach the painting your reflection juxtaposes with the image of the cutout man. You are pulled back and forth in order to grasp the changing composition of which you are a part. Rauschenberg's series of "white paintings," executed in 1951, are glistening monochromatic mirrors of the lights and shadows in the room. As we approach we begin to see ourselves in the painting. Rauschenberg's *Soundings*, 1968, in the Wallraf-Richartz Museum in Cologne, appears as a huge, foggy, rectangular, plexiglas mirror, forty-five feet long by eight feet high. But as you stamp your feet or clap your hands or speak or shout, lights behind the mirror are activated and you perceive myriad silk-screened images of fragmentary chairs, the mirror vanishing into transparency.[15] With such "paintings," mainly because of the movement of our bodies, the between may become as full of forces as with many sculptures. The following programmatic statement of Rauschenberg, however obscure, speaks of the painter who cannot resist becoming a sculptor: "Painting relates to both art and life. . . . I try to act in the gap between the two. . . . I'd really like to think that the artist could be just another kind of material in the picture. . . . I don't want a picture to look like something it isn't. I want it to look like something it is. And I think a picture is more like the real world when it is made of the real world."[16] Yves Klein discovered various ways of realizing Rauschenberg's program, such as covering nude models in blue oil paint and then rolling them across a canvas, or strapping a canvas with still wet priming to the roof of his car and driving from Paris to the Riviera in order to record the impact of sun, rain, and wind.

With the advent of the International Style of Architecture in the twenties

and thirties, the impacting forces in and around a building often were diminished in the clean sweep of wall and glass, where "less is more." Jacques Lipchitz recalls, "When Le Corbusier built my house after the war, I wanted to insert a relief into a large bare wall. Corbusier was aghast that I should want to spoil his beautiful wall and he would not permit it."[17] And there is sometimes an effervescent intangibility—contrasted with, for example, the Palazzo Farnese by Antonio da Sangallo the Younger and Michelangelo—about some of the buildings of Mies van der Rohe, such as the Residence of Dr. Edith Farnsworth (Fig. 60). But in the styles of Frank Lloyd Wright, Louis Kahn, Robert Venturi, Gordon Bunshaft, and many others, the solid mass of a building has come back with impacting vengeance, and even sculptural decoration—for example, Henry Moore's screen on the Time-Life Building in London—has returned. Moreover, after its first flowering even the International Style and styles strongly influenced by it almost inevitably seemed to have needed the intensification of space that only can be provided by sculpture. Thus Eero Saarinen made an enlarged bronze cast of Antoine Pevsner's *Column of Victory* and placed it as *Bird Soaring* (Fig. 59) in front of the General Motors Company Technical Center in Detroit. Saarinen's building makes a perfect dwelling place for this sculpture, and this sculpture, in turn, intensifies the space this architecture clears. In a very different way, Naum Gabo's sculpture, *Rotterdam Construction* (Fig. 65), intensifies the space around the De Bijenkorf, a store in Rotterdam designed by Marcel Breuer. Rooted like a tree, the open vertical construction of the sculpture branches out like the cranes and bridges of Rotterdam. This vertical openness brings out by contrast the horizontal compactness of the building which, in turn, accentuates the outward forces of its mass.

With literature, film, and television the between, if my previous analyses are accurate, necessarily remains basically transparent. With music, however, there is a tendency toward a more impacting between in the developments of electronic music and the sound and noise experiments of composers such as John Cage. Certainly in popular music, such as rock, the devices of electronic amplification have greatly accented the impact of music. In mixed media, where music is involved, the between sometimes becomes a very perceptible part of the work of art. In some musical comedies, for example, the audiences have become part of the action for the first time on a large scale since the seventeenth-century masques of Ben Johnson and Inigo Jones for the Stuart court. In the recent revised Broadway production of Leonard Bernstein's *Can-*

dide, the audience was seated in and around the stages, actors, and orchestras. Our heads and bodies were constantly turning to pick up the action, which seemed to be always coming from unexpected places, and we saw and smelled the sweat of the actors. Although as far as I know opera, the most tradition bound of the arts, has not yet abandoned the traditional stage, Benjamin Britten may have paved the way. In the cantata *Saint Nicholas* of 1948, the miracle of the summoning back to life of the Pickled Boys is dramatized by their procession through the church or chapel, and the audience participates by singing communal hymns. In his *Church Parables—Curlew River*, 1964, and *The Burning Fiery Furnace*, 1966—the communal singing is abolished but the audience becomes the very congregation before which the Mysteries are enacted. The vestiges of the traditional division of stage space from audience space are removed, including a conductor. The time would seem to be ripe for opera to take similar steps, and I understand that Krzysztof Penderecki, the Polish composer, is now working with the possibility of producing an opera without a dividing stage.

It is in drama and the dance that the movement toward the impacting between is most evident. There is no longer any necessary division, as in traditional theater, between stage space and audience space. In the powerful production of Euripides' *Medea*, directed by Andrei Serban at La Mama's Experimental Theater Club in New York, the principal actors rage at each other from two platforms, with the chorus and spectators seated in between. With Euripides' *The Trojan Women*, also played at La Mama's, Serban has the scenes take place in various parts of the auditorium. The audience moves to watch these scenes and the members of the chorus move through the audience. Near the end of the play, the actors guide the audience up into the side galleries, and the remaining action expands into the whole auditorium. In Lanford Wilson's *The Hot l Baltimore*, presented in the Circle in the Square in New York, not only is the stage not clearly demarcated but at the beginning, intermissions, and at the end it is never quite clear when the drama begins or stops. In Julian Beck's *Paradise Now* the whole theater is the stage, and the audience is sometimes literally forced to get into the action. The drama is a "happening." With the dance, innovators such as Meredith Monk and Twyla Tharp have at times completely eliminated the stage in the traditional sense. In *Needle Brain Lloyd and the Systems Kid*, for example, Monk uses a fifteen-acre setting including a lake. Tharp sometimes uses streets—almost any street will do—for her settings. In such works the audiences are no longer at one end of the between but, like

99

Environmental sculpture, in the between. That location, in turn, enhances the impacting power of the between. The forces emanating from the dancing bodies no longer stop, more or less, at the edge of a stage but impact directy on the audience.

In the final analysis, although it seems likely that drama, the dance, and mixed media will use the impacting between even more strongly in the future, the homeland of the impacting between will remain architecture and its most powerful expression will remain sculpture. By carving open an inside space within an outside space, architecture creates inside and outside clearings for man to dwell. Sculpture fills those clearings, and sometimes the clearings of nature as well, with the solid and penetrating materiality of things: their smooth and rough textures, voluminosity and density, repulsions and attractions, and, especially, their direct pressuring on our senses, their "push and pull withness." It is sculpture, more than any other art, that reveals our minds and bodies and other things as somehow a prior gathered unity, despite the give-and-take "otherness" of those things that causes bumps and bruises as well as soothings and satisfactions. Architecture helps nature furnish a place for sculpture to return us to the thingliness of things. The between of architecture makes room for the in-between of sculpture. Then we dwell in enlivened space, in sympathy with things, at home in the homeland.

VI

Brancusi, Moore, and Giacometti

Touched by presence, the ancient name of Being.
Heidegger

Brancusi cut away the decorative excrescences of nineteenth-century sculpture (Figs. 49, 50); Moore cleaved open the body of sculpture (Figs. 55a, 55b); Giacometti created a no-man's-land by compressing and thus sealing the space around sculpture (Figs. 57, 58). Each went his own way, although in touch with the others, carving new trails into and around the surrounding space. Brancusi's trail draws us in and up; Moore's in and down; and Giacometti's keeps us at a distance. All of them strayed at times from their characteristic approaches, but all were basically "one-track" sculptors unlike, for example, Lipchitz and Picasso. Comparisons of their central paths should illuminate not only their sculpture but others as well, for Brancusi, Moore, and Giacometti are among the great inheritors and prophets of the Western tradition of sculpture. By understanding how they impact forces into the surrounding space, we learn much about the possibilities of sculpture.

Brancusi's *Bird in Space*, c. 1928 (Fig. 49)—from 1909 to 1941 he created twenty-seven variations—was intended for sun and sky. "All my life I have only sought the essence of flight. Flight! What bliss!" All details, such as head and legs, were streamlined or eliminated for ascent, so much so that the 1926

101

version of the *Bird in Space*, bought by Edward Steichen, was unrecognizable as a bird by United States Customs officials who stamped it "block matter—subject to tax."[1] It could not have been more inappropriately described. Shaped like a space rocket, polished to a sleek goldenness made possible by the very high copper content of the bronze, this work defies matter as it seems to rise in flight, sweeping in the surrounding space in its upward thrust. The high polish "aerates the solid form," as Sidney Geist puts it,[2] diminishing density and dematerializing the bronze. The polish, moreover, not only makes the surface of the bronze seemingly transparent, opening up its inner space, but also reflective, opening up its surrounding space. This bird is sheer movement, the caressing track of its trajectory filling the between. Like a flame the bronze creates forces in the surrounding space as sensitive as smoke, the slightest wind would disturb them. To perceive this sculpture lying down in a box—probably this is the way the customs officials first saw it—is as deadening to our appreciation of it as perceiving Arp's *Growth* (Fig. 51) in a corner, or as ludicrous as perceiving Moore's *Reclining Figure* standing on end. Furthermore, to perceive the *Bird in Space* without its stone pedestal separating the undulating footing of the bronze cleanly from the earth takes away much of the airiness of the bird. Then the sculpture might well be appraised as "block matter."[3] Only when in a vertical position can the pedestal function as a springboard against which the bird seems to thrust into its movement on the wing.[4]

In 1937 Brancusi traveled to India at the request of the maharajah of Indore to build a Temple of Deliverance. The temple was to have been a small Greek-cross building without doors or windows, accessible only through an underground passage for a single person at a time, and lit by narrow shafts of natural light through the roof. Inside, a reflecting pool was to have been surrounded by Brancusi's *Spirit of Buddha* (later named *King of Kings*) and three variations of the *Bird in Space*—one in black marble, one in white marble, and one in bronze. Only the bronze version was to receive the radiance of the noonday sun through a special slit in the roof, and only on the most sacred day of the year was the full radiance of the sun to be reflected, relating this bird to cosmos and cult. Unfortunately this rare conception, in which architecture was to be subordinated to sculpture, never materialized.[5] The maharajah's illness, political upheavals, and war aborted the plan.

In its setting in the Museum of Modern Art in New York, the *Bird in Space* (Fig. 49) of c. 1928 is caged as if in a zoo in a little side room.[6] Reflecting the artificial lighting and gathering its surrounding space into a swift vertical vortex,

this bird seems about to break out of its prison. The burning bronze, hot in color and liquid in smoothness, draws us in and we see flashes of ourselves shifting and swaying. We may even have the impression of being disintegrated and gathered into the uprushing sweep, the vision of which is abruptly stopped short by the very low ceiling. In any case, we begin to walk around the bronze, following the swirl of the surrounding space. But, unfortunately, we are blocked by a wall at one point and by a protruding platform at another. We cannot follow or caress this glistening trajectory or even view the back of the piece. Yet not even this outrageous cage—nearby is a lovely garden with pools open to the sky—can prevent our imaginations from soaring skyward with this airy harbinger.[7] *Bird in Space* refuses to stay put in its allotted spot of space.

Brancusi made certain that at least one of his "flights" could not be imprisoned—the *Endless Column* (Fig. 50). This work was placed in 1937 in a park of Tirgu Jiu, the little town near his birthplace in the Carpathian mountains of Rumania, to commemorate the heroic resistance against the Germans in 1917. Arranged one above another are fifteen complete and identical cast-iron gilded modules, about four feet wide and six feet high. There is a half element at the top and a short square columnar element of about a foot and a half at the base connecting with a half element, this base unit stabilizing and locking the column to the ground. Despite Brancusi's emphasis upon flight, he never leaves the earth entirely behind—flight always has its place of departure. Although the module is about the height of a man, the column is far too large to be measured against human scale, stretching up to almost one hundred feet. The gently swelling surfaces of the modules, originally bright with gilt but now a rich dark brown from corrosion, gracefully soften the geometric precision (if the smallest width of the module is given the value of 1, then the largest width has the value of 2, and the height of each module has the value of 4).

As I came into the park the first time, a very large and open rectangular area allowed the column to be perceived from a considerable distance. The column appeared high, the half-module at the top, like the impost block above the head of a caryatid, seeming to support the load of the sky. But as with most of Brancusi's works the surrounding space is powerfully centripetal, and as I was drawn in, the column seemed to grow higher and higher, more like a celestial ladder made of crystals than a supportive column. The park, the dome of the nearby Church of the Holy Apostles, the town, and the mountains—all those objects that my eyes were using as guides for my spatial orientation—gradually gave way to only the column and the sky. As I approached the base, the column

was absorbed by the surging sky in a way that even the towers of Chartres or the RCA Building in New York cannot rival. No structure I have seen has such an absolute vertical thrust. The column penetrated and almost lost itself in the dome of heaven, a sublime effect heightened even further by the dizzying disorientation caused by the changing shapes of the modules—despite their mathematically precise uniformity[8]—as my body was pulled around the base. The proportions of each module appeared to be changing, becoming progressively more squat as the column moved skyward. At the corners the column broadened. Then slightly farther on the light glared off one side, thrusting the other side into darkness, and the column thinned. Surprisingly the near edge became a powerful and continuous vertical line, for except for the small base there are no lines that are actually vertical. Ellipses and spirals came and went. A saw-toothed profile took on an independent life. A pagoda came to mind. Even standing stock-still, the motion of the clouds saw to it that no image remained static. I recalled Plato's remark in the *Timaeus*—"The moving image of eternity." Then the column seemed to burst with energy, like an activated lightning rod. With each step everything changed again, except the soaring. My feet gripped the ground, for the earth seemed to move and the sky seemed to be drawing me upward.

Despite his peasant background and closeness to the earth (he wished, for example, to be buried naked in the earth without the prison of a coffin), Brancusi carved and molded in such a way that the enlivened space around his works draws us in and up. The sky had transcendental religious significance for Brancusi. He intuitively understood the symbol of the *axis mundi*, the world axis, an instance of which is described by Mircea Eliade:

According to the traditions of an Arunta tribe, the Achilpa, in mythical times the divine being Numbakula cosmicized their future territory, created their Ancestor, and established their institutions. From the trunk of a gum tree Numbakula fashioned the sacred pole *(kauwa-auwa)* and, after anointing it with blood, climbed it and disappeared into the sky. This pole (the *axis mundi*) represents a cosmic axis, for it is around the sacred pole that territory becomes habitable, hence is transformed into a world. The sacred pole consequently plays an important role ritually. During their wanderings the Achilpa always carry it with them and choose the direction they are to take by the direction toward which it bends. This allows them, while being continually on the move, to be always in "their world" and, at the same time, in communication with the sky into which Numbakula vanished.

For the pole to be broken denotes catastrophe; it is like "the end of the world," reversion to chaos. Spencer and Gillen report that once, when the pole was broken, "the

entire clan were in consternation; they wandered about aimlessly for a time, and finally lay down on the ground together and waited for death to overtake them."[9]

Unlike Numbakula's pole, Brancusi's column is unmovable, for Brancusi created for farmers rather than nomads. Although the shapes, colors, and textures of the metal change according to the season and time of day, the column remains as steadfast as a rock. Sometimes, indeed, as one looks up from the base, the modules at the top look like craggy boulders high on a mountain cliff swept by clouds. As in most of Brancusi's works, there is the power of undecorated primal shapes, often the egg or the sphere, but in this case a kind of stretched-out cube. "Simplicity is not an end in art," Brancusi said, "but we arrive at simplicity in spite of ourselves, as we approach the true sense of things."[10] As his style matured Brancusi simplified, for the compressed energy in primal shapes such as the egg and the cube tends to get lost in complex forms. That kind of simplicity is usually lacking in the *axis mundis* of primitive cultures, in the intricate carving and coloring, for example, of the totem poles of North American Indians. Brancusi's pure shapes bring out the sources of creation, not appearance as such but the causes of appearance, the core beneath the crust. Brancusi makes the surface the visible and tactile symptom of the density and power of the core. This power of the primal shape is not just imaginative in its upward release. The engineers were certain that the concrete foundation of the *Endless Column* would have to be sunk at least thirty feet. But Brancusi understood the structural strength of his cubes, as Buckminster Fuller understands the structural strength of his spheres, and kept the foundation to about fifteen feet.[11] "Measures are harmful," he once said, "for they are there, in the things themselves. They can rise up to heaven and come down to earth again, without change of proportions."[12] With the swirling all-encompassing sky of the *Endless Column*, unbounded by a definite horizon, Brancusi's flight finds infinity. The *Endless Column* embodies the dynamics of yearning for what is beyond human reach.

Moore's *Reclining Figure*—the theme of over half of his works, all but a few being women—belongs in the open air,[13] as a comparison of Figures 55a and 55b demonstrates. Moore wanted most of his sculptures "in a landscape, almost any landscape," rather than "in or on the most beautiful building I know."[14] Moore's sculptures desire the earth, whereas Brancusi's sculptures desire the sky. Thus the inner space of most museums fails to provide the proper

place for either Moore's or Brancusi's works. But when placed outside, Moore's sculptures, much more than Brancusi's, need unadulterated earth. If concrete or gravel completely covers the surrounding land, something of the strength of Moore's sculptures is sapped, as with the *Archer* in the Nathan Phillips Square in Toronto or even the great *UNESCO Reclining Figure* in Paris.[15] The *Nuclear Energy* of the University of Chicago is, perhaps, the one notable exception, for with this theme the separation from the earth seems appropriate.

The slow sweeping rise of the arms, shoulders, and head of the *Reclining Figure* above the horizontal stress of the low base and lying body suggest, like a wide-spreading tree, emergence from the earth, the anthropomorphic and the topographic merging. The role of the base is practical in terms of physical support, presenting the figure at an easily perceived level, and the massiveness of the base accentuates the heaviness of both the figure and the earth. The cylindrical section of the tree trunk still enfolds the figure, and the elmwood grains and the shapes of the solids and voids of the body recall the weathered moldings of English landscape—its crinkled skin of farmland, sweeping grooves eroded along riverbanks, ripples of sand and water, mountain slopes and folds as they file up to their summits, tunneled caves in hillsides and cliffs. Few of Moore's sculptures correspond better with this description: "In my reclining figures I have often made a sort of looming leg—the top leg in the sculpture projecting over the lower leg which gives a sense of thrust and power—as a large branch might move outwards from the main limb—or as a seaside cliff might overhang from below if you are on the beach."[16] Moore's father was a miner in Yorkshire, and, during the Second World War, Moore sketched miners in the pits—Britain's Underground Army—and ghostly people blanket-rolled in the underground tubes escaping the air raids. Earth and sky go hand-in-hand, of course, but Moore, unlike Brancusi, finds more satisfaction in rootedness than in flight. Most of the figures, like the *Reclining Figure*, gaze out to the land, and usually when they look up, as with the *Three Standing Figures* in Battersea Park, London, they show fear.

Earthiness makes the *Reclining Figure* weighty and stable in its place, unlike the deliverance from weight of Brancusi's *Bird in Space* and the *Endless Column*, and thus the forces in the surrounding enlivened space draw us in slowly. Whereas the flashing flight of Brancusi's sculpture speeds up our perceptions, the lumbering heaviness of Moore's sculpture makes us linger. The smooth curving wood, fit for the cushions of the fingers and the cupping of the hand, invites caressing. Just over six feet in length and easily accessible, the

whole body has been polished and sometimes stained by many handlings, especially the upper knee, like the protruding foot of Saint Peter in Saint Peter's.[17] The encircling air sweeps into the holes and concavities of the passive and receptive body, seizing the contour surfaces of the concave inlets. Once inside, like the waves reshaped and rebounding from the caves of Capri, this compressed air flows out following the channels leading to the convexities. These concave-convex polarities are strongest in the chest area, the compositional center. We sense breathing in this embracing and relinquishing of air. Indeed we may find our breathing harmonizing with the slow in-and-out rhythm of the sculpture, and then we perceive more sensitively both the volume of the figure and ourselves. This figure is a three-dimensional likeness of breathing, that activity, except for swallowing, that most reveals the volume of our bodies.

Our haptic feelings are further controlled and revealed by the dynamic and open solidity of the *Reclining Figure*. We feel our bodies, with their nine orifices that both incorporate and expel, as pulsating hollows tangibly surrounded by bone, muscle, and flesh. Moore made his *Reclining Figure* look and throb the way our bodies feel from the inside. Thus our visual and tactile sensations of this work are remarkably consonant with our haptic sensations. Through the sensual appeal of this woman in wood, the disharmonies we so often feel between the inside and outside of our bodies and things are harmonized. Our being-in-the-world is felt without dissonance.

Moore brought out the dynamic and open solidity of the *Reclining Figure* by the way he carved the wood, tunneled holes, played light, and swung shapes. This sculpture is an exceptionally fine example of what Moore calls "truth to materials." This sculpture is not a woman made in elmwood, but elmwood becoming woman. According to Moore: "Every material has its own individual qualities. It is only when the sculptor works direct, when there is an active relationship with his material, that the material can take its part in the shaping of an idea. Stone, for example, is hard and concentrated and should not be falsified to look like soft flesh—it should not be forced beyond its constructive build to a point of weakness. It should keep its hard tense stoniness."[18] Wood, on the other hand, is an organic material, lending itself more to the pliability of the human body, especially the female. The grains of the wood of the *Reclining Figure* flow around the head, twist in the viscera, steadily move down the shoulders and arms, and then, following the natural forking of the wood, thrust out with increasing horizontal rapidity and divide into the cavernous legs. The

grains lead into the concavities and climax at the convexities, as in the upper knee. The silhouette, contour lines, shapes and holes were carved to conform to those grains, bringing out the woodiness of the wood. The solidity of this wood is very active, pointing to pent-up energy underlying the surfaces, as if the sculpture had been carved by pressure from within.[19] The units of the body, although precisely articulated, flow into each other. "Even the dead ends of the hands and feet," as Arnheim points out, "are eliminated. They merge with their partners or stream back into the body of the figure, thus permitting the circulation of energy to continue unchecked."[20] Most of the body presses out into space—the breasts and limbs swell softly, the head, shoulders, arms, and knees with tense force. She thrusts from inside herself into shape.

The holes open up the solidity of the wood, accentuate its expansiveness, and allow light and shadow to penetrate. "The hole connects one side to the other," Moore observes, "making it immediately more three-dimensional."[21] By showing the core of the wood, the hole unfolds secrets of inner growth. The surfaces are perceived as an organic "coming forth." At the same time, the holes, by allowing air to penetrate, make the woman's body perceptible as permeated by and inseparable from its world. Furthermore, the holes solicit shadows and enhance varying plays of light. Thus light passes coldly and swiftly by the head, lingers softly along the body, and then is gathered and absorbed by the holes like the rays of the sun in a pool. The light and its shadows shift as we follow (for we are lured to explore every angle) the surging sinuous torsion of the moving shapes. Light vibrates here, is quiescent there, grows lighter here, becomes darker there. At certain perspectives a surface section may, like a rock in a stream, exhibit stubborn resistance to motion, but then from a further perspective that same area is swept up in the flow, rolling out like a range of hills. And always within the holes the lights and shadows undulate. As we slowly circle we feel the flowing wood, the ingoing tactile sensations touching off haptic sensations that, like a sounding board, pulsate in unison. Our kinaesthetic sensations join the rhythmic harmony. We sense the open three-dimensionality of our bodies as an ongoing withness.

This withness is much stronger with the *Reclining Figure* than with Brancusi's *Bird in Space* or the *Endless Column*. Brancusi's sculptures are not so accessible, and their unearthiness disorients our sense of place. Most important of all, the *Reclining Figure* reveals a human body, and of all things this is the thing we are with most intimately. Our body is the thing co-perceived with all other things. Moore unveils that body in a way that eliminates everything but

essentials: "The artist has no need to take a literary theme to substantiate his delight in humanity; he can make his point, reveal his love for his fellows just by suggesting, as I tried to do in my *Reclining Figure* in elmwood of 1945/46, the operations, the palpitations of a human heart."[22]

The *Reclining Figure* integrates many of the basic polarities and rhythms of human life. The flexible flow of the surfaces, soft textures, swelling breast, and spreading thighs are intensely female, but the hard aggressiveness of the head, shoulders, arms, and hands suggest the male. Below the breast the ambiguities multiply with the perspectives. Facing the figure—the eye-slit view (Fig. 55a)—the spherical shape suggests the heart or viscera or cradled child or child in the womb. The atmosphere within and around that sphere, unlike around the head, appears warmed by body heat. The stretch of the body is calm and contented, like the river goddesses of Rome. Moving to the right (Fig. 55b), for the heaving shapes inexorably draw in that direction, the stretch of the body becomes disturbed, remarkably reminiscent of the *Dawn* by Michelangelo in the Medici Chapel. Continuing around, the shadows lengthen and soften, as with evening. Farther on, from the perspective of the feet, the holes become cavelike and draw in shadows, like air into a vacuum. The shadows become night, and below the breast the spherical shape, which seems to revolve as we move, suggests an immense penetrating phallus. Now the fleshy fullness of the stretch of the body is both orgiastic and pregnant. Yet pleasure gives way to pain as the head for the first time takes on a tortured twist and the eye-slit becomes an agonized scream. The body seems about to collapse. There is even a hint of death, for despite its beauty this is dead wood, and elmwood carries a slight but distinct coffinlike scent. But the cascading shapes continue to pull us around, and life fights back. The rotating wood bares the history of its life—fertility and drought, the thrusts and counterthrusts of its physical struggles, for the carving seems to have been done as much by time and erosion as by Moore. Around the back the grains move up to the head, despite the pull of gravity, as once the tree moved upward from its roots toward the light. As one returns to the eye-slit view—the mouth has vanished—the head is a generalized vigilance, indicating ability to survive and even dominate.

The concentrated gaze sweeps out like a lighthouse beacon, both warning and beckoning. The absence of facial detail makes the head mysterious and eternal, beyond disguise. The head, except for its coldness, is one with the body, the eye-slit, for example, echoing the gashes in the breast. The *Reclining Figure*, through the rhythmic unification of its polarities, is ultimately still and

109

collected and content in its mass and in its enlivened space. This weighty Earth Woman brings us slowly and securely into her world, and in our withness with such ultimate fundamentals we find a patience great enough, perhaps, to soothe some of our sufferings. At the very least, we feel we are not alone.

> We are this man unspeakably alone
> Yet stripped of the singular utterly, shaved and scraped
> Of all but being there
>
> He is pruned of every gesture, saving only
> The habit of coming and going. Every pace
> Shuffles a million feet.
> The faces in this face
> Are all forgotten faces of the street
> Gathered to one anonymous and lonely.
>
> Embodied here, we are
> This starless walker, one who cannot guess
> His will, his keel his nose's bony blade.
>
> Richard Wilbur, "Giacometti"

Giacometti's people, as in *City Square* (Fig. 57) and *Man Pointing* (Fig. 58), belong to the city.[23] Though the mammoth feet seem melted down in asphalt as if seeking the earth (Giacometti's pedestals usually look like slabs of sidewalk), and the narrow heads above the elongated Belsen-like bodies seem to seek the sun, neither earth or sun is reached. This almost seems fortunate, for the strength of either earth or sun would seem to be too powerful for them to absorb without disintegration. The protection of surrounding city buildings or the cloistered containment of the museum room is as right for Giacometti's sculptures as it is wrong for Brancusi's and Moore's. In the terms of Henri Focillon's *The Life of Forms in Art*, space for Giacometti is a "limit," whereas for Brancusi and Moore space is an "environment": "In the first case [l'espace-limite], space more or less weighs upon form and rigorously confines its expansion, at the same time that form presses against space as the palm of the hand does upon a table or against a sheet of glass. In the second case [l'espace-milieu], space yields freely to the expansion of volumes, which it does not already contain: these move out into space, and there spread forth even as do the forms of life."[24] Until Giacometti's later sculpture—with a few exceptions such as Picasso's *Head* (Fig. 38)—the material body of a sculpture characteristically only impacted out into the atmosphere. But with works such as *City Square* and *Man Pointing*, we begin to find the atmosphere also impacting on the material

110

body, its imprint mottling and thinning that body to wirelike lines that seem on the verge of snapping from the pressure. Indeed, the space around Giacometti's people appears to impact so heavily it almost squeezes them out of existence. They are impaled in a spatial texture full of the motor pattern of city routine, the corroding smell of gasoline, the staccato pulse of rush-hour jams, the relentless hammering of noises, the maze of inflexible intersections, the endless gauntlet of cold shoulders, the gray (Giacometti's favorite color) that is neither quite night nor day.:

> Let us go then, you and I,
> When the evening is spread out against the sky
> Like a patient etherised upon a table. . . .
> T. S. Eliot, "The Love Song of J. Alfred Prufrock"

The cancer of the city has left only the armatures of bodies stained with nicotine and scarred with sickness. There is neither a center nor an exit in *City Square*, nor does communication among these citizens seem possible. No previous sculpture of grouped human figures reveals such separation, not even the disjointedness that accents the isolation of each man's agony in Rodin's *The Burghers of Calais* (Fig. 32), note, for example, the disconnected plinths. Even the naked female in *City Square*, the only figure at a standstill, is ignored by the males. Yet everyone seems terribly aware of the other, illustrating Sartre's "look":

I am in a public park. Not far away there is a lawn and along the edge of the lawn there are benches. A man passes by those benches. I see this man; I apprehend him as an object at the same time as a man. What does this signify? What do I mean when I assert that this object is a man?

If I were to think of him as being only a puppet, I should apply to him the categories which I ordinarily use to group temporal-spatial "things." That is, I should apprehend him as being "beside" the benches, two yards and twenty inches from the lawn, as exercising a certain pressure on the ground, etc. His relation with other objects would be of the purely additive type; this means that I could have him disappear without the relations of the other objects around him being perceptively changed. . . . Perceiving him as a man, on the other hand, is not to apprehend an additive relation between the chair and him; it is to register an organization without distance of the things in my universe around that privileged object. To be sure, the lawn remains two yards and twenty inches away from him, but it is also as a lawn bound to him in a relation which at once transcends distance and contains it. Instead of the two terms of the distance being indifferent, interchangeable, and in a reciprocal relation, the distance is unfolded starting from the man whom I see and extending up to the synthetic upsurge of a

111

univocal relation. We are dealing with a relation which is without parts, given at one stroke, inside of which there unfolds a spatiality which is not my spatiality; for instead of a grouping towards me of the objects, there is now an orientation which flees from me. [25]

Each Giacometti figure in the intensity of his solitude separates his spot of space from the common place—everyman's exile.

Intense nervous energy is diffused through Giacometti's bodies, and sometimes light flickers off them like sparks. If we were to touch them, we would expect them to jump like charged springs. But, of course, they are untouchables. The terrible gaze of the stark-staring eyes keeps us back. The grimace of their bodies and the scarred skin, like the blistered lava of the incinerated Pompeians, send shock waves of pain into the between—"Do not touch me!" And we do not. That naked flesh gone seeking the bone repulses our touch, and the push of the shock waves keeps us back as if the space surrounding these bodies had sealed outskirts. [26] Giacometti's figures are creatures of distance. Not only do they have to perceived at a distance but they seem to be haunted by distant vistas of their own. The disease and utter distress of these vulnerable creatures, furthermore, demand our respectful distance, as if they were lepers to whom help must come, if at all, only from some public, impersonal agency.

Yet these creations, and this is the marvel of Giacometti's art, are not marionettes drawn by unseen threads. They are human and they fight back. Giacometti observes: "I am always conscious of the weakness and frailty of living things [especially human beings] and it seems to me that they need tremendous powers just to hold themselves upright from one moment to the next."[27] Articulated from the ground upward, the upright postures of Giacometti's figures, unlike the pacifism of the looming grandeur of Lehmbruck's, vibrate with resistance: "I stand, therefore I am." It is difficult to imagine them resting. Unlike sculptures that could be rolled down hills without damage, an ideal Michelangelo espoused, Giacometti's sculptures would break if they were to fall. If they were to lie down, like Moore's reclining figures, they would surely die. They have no earth to sustain them or, as with Brancusi, sky to escape to. In their "withstanding" is revealed the dignity that comes, as Albert Camus explains, from defiance of this absurd situation in which there is no support from below or above. This defiance is further expressed by the dynamic power of the plumb lines of their bodies, x-rayed to their essentials: the sweep of the leg as it strides forward into the abyss, the twist of the torso as it follows the leg, the diagonal of the back as it presses against the wind, the curve of the neck as it points the head toward its objective, the lean stretch of the body as it comes

112

to full height. As Picasso once remarked: "Sculpture with Giacometti is the residual part, what remains when the mind has forgotten all the details."[28]

Giacometti's people tremble with a nervous energy so sensitively exposed that the internal aspirations of the human body—so often concealed by clothes, fat, and accident—are unconcealed for our perception as never before. The spirituality of the body is liberated from the corporeality of the body. The walkers imperatively stride across the square with their thin compressed heads cutting like knives into space; we would feel compelled, if we were there, to step aside despite their slenderness. The spiritual intensity in the statuesque stand of the woman in the square is reminiscent, despite her lack of mass, of Egyptian goddesses. The outstretched arm of the *Man Pointing* (Fig. 58), despite its thinness, takes complete command of its surrounding space, even more decisively than the famous statue of *Caesar Augustus* in the Vatican, and the line of the arm of the *Man Pointing* is inexorably counterpoised by the graceful arc of its companion. And notice, also, the flexibility of the hand of the outstretched arm, ready to mold itself to any shape, like Michelangelo's hand of God in the *Creation of Adam* of the Sistine Chapel. As Giacometti points out, "I never regarded my figures as a compact mass [the ductility and lightness of plaster made it his favorite material], but as transparent constructions. It was not the outward form of human beings which interested me, but the effect they have had on my inner life." Like an anatomist stripping a cadaver, Giacometti was after the internal rather than the external image of the body. Even more than Moore, Giacometti rendered the human body, not as it looks from the outside, with its proportions objectively fixed, but as it feels from the inside, with its relationships subjectively determined. Yet always with his figures there is an intense interplay between deep inner experience and the sweep of the outside urban world. Whereas Moore reveals the slow dynamism of the open solidity of the human body, Giacometti reveals the rapid currents of its nervous system, the lines of force that traverse the felt interiors of the body. Moore's wood becomes anthropomorphic; Giacometti's bronze becomes "anthropokinetic." William Barrett points out another interesting difference:

Moore's figure yearns to belong to the earth, to be reintegrated with nature and instinct, to become almost a simple natural object "rolled around . . . with rocks, and stones, and trees." But this yearning comes out of a lack, a need with which this needy time desperately threatens it. The threat is expressed in the Giacometti figures, where the body has become so meager that it seems on the point of vanishing altogether. . . . The faces of these tiny statues are modeled with infinite care, delicacy, and expressiveness.

The whole being of the figure has been sucked up into the head and face. In the Moore figure the head is smaller and the features of the face eroded, as if these were drained back into the body in its thrust to rejoin the earth. While Giacometti's have lost nature in the anguish of the void, Moore's forms must lose their human features in order to find themselves once again in the nonhuman world. [29]

In Giacometti's revelation, just as with Moore's, we discover something of ourselves. To our astonishment, we may even find a grace and beauty in those lifelines, especially their balance. We continually seek equilibrium in our physical and psychological existence; hence we enjoy perceiving models of such hard-won achievement.

There is, nevertheless, no lure to Giacometti's bodies. Their features do not grow larger or become more clearly defined as we approach them. We are uncertain where the solid forms of the bodies end and the atmosphere begins. The interpenetration between mass and atmosphere goes further than in any earlier monolithic sculpture. We have to stand back a considerable distance in order to perceive properly these bodies. The whole completely dominates the details. Furthermore, forces in the enlivened space push out centrifugally, guaranteeing our distance. Whereas we walk around and into the encircling space of Moore's *Reclining Figure*, we just walk around the closed-circuit energy systems that are Giacometti's sculptures. As Sartre perceived, by compressing space Giacometti cut out its fat and made it impenetrable:

He was the first to sculpture man as he is seen—from a distance. He confers *absolute distance* on his images just as the painter confers absolute distance on the inhabitants of his canvas. He creates a figure "ten steps away" or "twenty steps away," and do what you will, it remains there. . . . You can't approach one of Giacometti's sculptures. Don't expect a belly to expand as you draw near it; it will not change and you on moving away will have the strange impression of marking time. We have a vague feeling, we conjecture, we are on the point of seeing nipples on the breasts; one or two steps closer and we are still expectant; one more step and everything vanishes. . . . His statues can be viewed only from a respectful distance. . . . Now we know what press Giacometti used to condense space. There could be but one—distance. He placed distance within our reach by showing us a distant woman who keeps her distance even when we touch her with our fingertips. [30]

Since the attrition of Giacometti's figures appears to be caused by the invading centripetal forces of the encompassing space, and yet there are also powerful centrifugal forces, we are made acutely aware of that space. In turn, these figures, like Samuel Beckett's characters, seem to be shut up in their own private

114

space, carrying their space with them like their shadows. Giacometti's space creates a seemingly impenetrable enclosure.[31] His figures are isolated because of the extraordinary impacting forces—both in and out—around them, not because the between is a void.[32] This segregation gives his figures a terrible pathos. There can be no comforting contact. Yet they also express a heroism, for like Faulkner's Dilsey "they endure."

The figures in the *City Square* seem both remote and monumental, for such tiny human bodies—the height of the tallest is only eight inches—are perceived as in the far distance. This sense of distance, moreover, makes the enlivened space even more impenetrable because the greatly reduced dimensions compress the spatial forces. This intensification helps squeeze the figures almost to nothingness. At the same time, however, these spatial forces help sustain the uprightness of the figures, as if they were in water. Paradoxically, although the enlivened space around the *Square* is full of forces that connect with us, both the enlivened space and the *Square* seem strangely apart from us. We relate everything to our own size, and very small human figures, especially when they are so divided from one another as in the *Square*, appear to be divided from us. On the other hand, although the *Man Pointing* is about our height, he looms much larger despite his emaciation. Giacometti once said, "If I begin to wish to draw that head, or paint it, or above all sculpt it, it all transforms into a form under tension, and, it always seems to me, to a violence powerfully held in, as if the form always extends beyond what the person actually is"[33] When the size of a human figure by Giacometti is very much smaller than average human size, the encroachment of the surrounding space seems to compress the material body, despite its outgoing tensions, into an even smaller size. When, however, the height is about the same as or larger than average human size, the encroachment of the surrounding space reinforces the outgoing tensions and the material body is magnified in height. In either case, Giacometti disorients our sense of scale and sees to it that communication with his figures is beyond reach. We can look, we can touch the boundaries of their enlivened spaces, but their strange distances and the ashes in their mouths prevent conversation. Silence surrounds them.

Brancusi, Moore, and Giacometti swept away the external details and literary themes of nineteenth-century sculpture in order to sculpt out the internality of things. Brancusi brings out the core of all things as sustained by a transcendent reality, symbolized by the sky. Moore brings out the core of the

human body as sustained by nature, symbolized by the earth. Giacometti brings out the core of the human will sustained by nothing. All three evoke the past: Brancusi recalls the transcendental thrust of Medieval sculpture; Moore recalls the healthy humanism of Fifth-century Greek and High Renaissance sculpture; Giacometti recalls the anxiety of Hellenistic and Late Renaissance sculpture. All three opened up possibilities for the future: Brancusi's way of tracking through enlivened space has influenced Space sculpture; Moore's way has influenced Earth sculpture; Giacometti's way has influenced Environmental sculpture. Each one enlivens space differently: Brancusi returns us to the sky; .Moore returns us to the earth; and Giacometti gives us a world without sky or earth. Brancusi and especially Moore enhance our sense of spatial withness with things. By showing forth the absence of that spatial withness, Giacometti reveals our alienation. All three remind us, through the powerful visual, tactual, and kinaesthetic impact of their sculptures: we are beings-in-the-world.

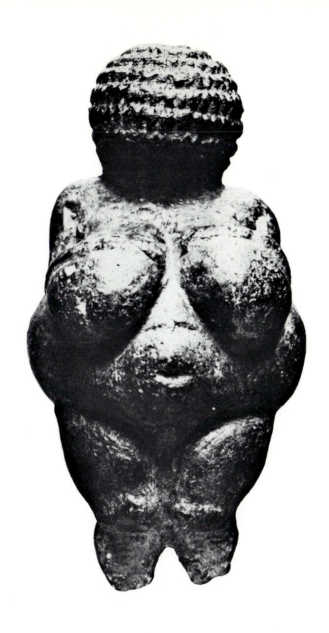

1. *Venus of Willendorf,* Paleolithic period (© Arch. Phot.
Paris / S.P.A.D.E.M.)

2. *Venus of Laussel,* Paleolithic period (© Arch. Phot. Paris / S.P.A.D.E.M.)

3. *Running Animals,* Before 3000 B.C. (Walters Art Gallery)

4. Pheidias, Detail from Parthenon Frieze, c. 440 B.C. (Reproduced by courtesy of the Trustees of the British Museum)

5. Pheidias, *Moon Goddess's Horse* from East Pediment of Parthenon, c. 438 B.C. (Reproduced by courtesy of the Trustees of the British Museum)

6. *Aphrodite of Cyrene*, c. first century B.C. (Alinari / Editorial Photocolor Archives)

Opposite

Left: 7. *Female Personage* from Chartres, 1145-1155 (Lefevre-Pontalis / © Arch. Phot. Paris / S.P.A.D.E.M.)

Right: 8. *Eve* from Reims, c. 1250 (© Arch. Phot. Paris / S.P.A.D.E.M.)

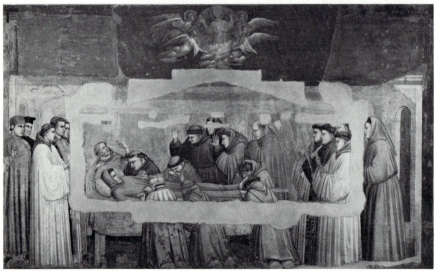

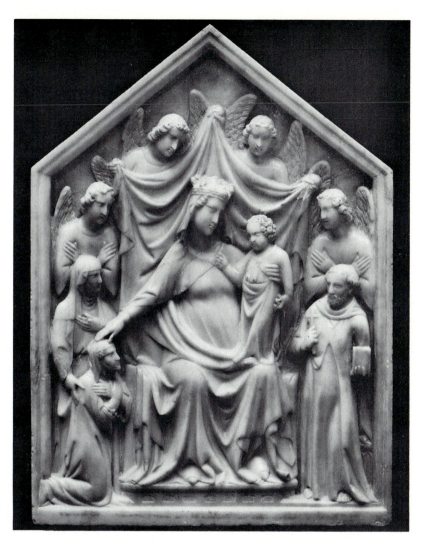

11. Tino di Camaino, *Madonna and Child with Queen Sancia, Saints and Angels*, 1330-1337 (National Gallery of Art. Washington, D.C., Samuel H. Kress Collection)

Opposite
Top: 9. Magdalen Master, *Madonna Enthroned*, c. 1270 (Alinari / Editorial Photocolor Archives)

Bottom: 10. Giotto, *The Death of Saint Francis*, c. 1318 (Alinari / Editorial Photocolor Archives)

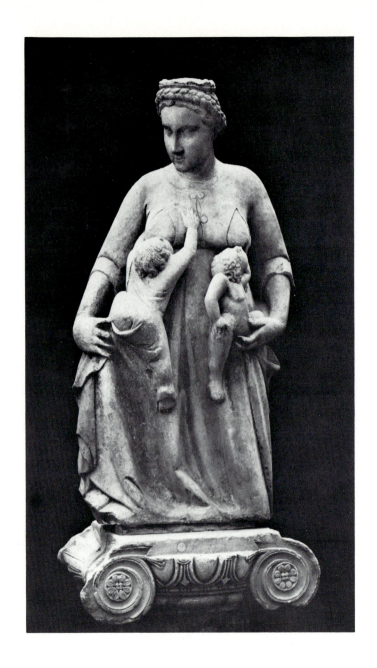

12. Tino di Camaino, *Charity*, 1321-1324
(Alinari / Editorial Photocolor Archives)

13. Orcagna, *Tabernacle*, 1349-1359, and Bernardo Daddi, *Madonna and Child*, 1332 (Alinari / Editorial Photocolor Archives)

16. Ghiberti, *East Doors of Baptistery* in Florence, 1425-1452
(Alinari / Editorial Photocolor Archives)

Opposite
Top: 14. Donatello, *The Feast of Herod*, c. 1423-1427 (Alinari / Editorial
Photocolor Archives)

Bottom: 15. Luca della Robbia, *Cantoria*, 1431-1438 (Alinari / Editorial
Photocolor Archives)

19. Michelangelo, *David*, 1501-1504 (Alinari / Editorial Photocolor Archives)

Opposite
Top: 18. Verrocchio, *Lorenzo de' Medici*, c. 1482 (National Gallery of Art, Washington, D.C., Samuel H. Kress Collection)

Bottom: 17. Donatello, *Mary Magdalene*, 1456 (Alinari / Editorial Photocolor Archives)

20. Parmigianino, *Portrait of a Young Prelate*, 1529 (Editorial Photocolor Archives)

Opposite
21. Michelangelo, *Pietà*, 1550-1555 (Alinari / Editorial Photocolor Archives)

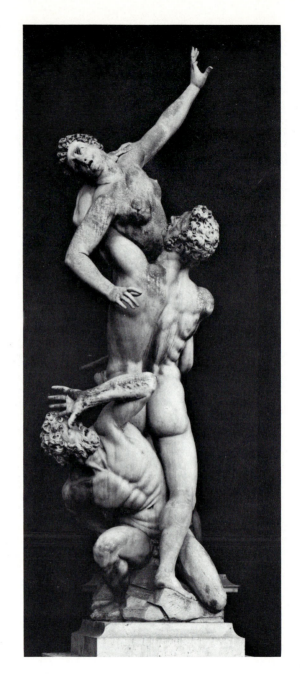

22. Giovanni da Bologna, *Rape of the Sabines*,
1579-1583 (Alinari / Editorial Photocolor Archives)

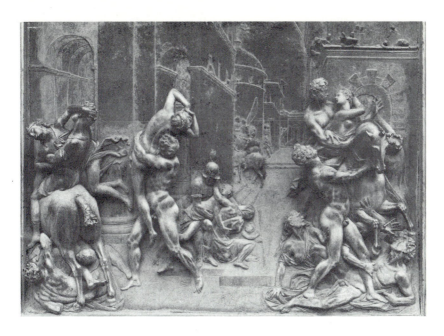

23. Giovanni da Bologna, *Rape of the Sabines*, 1579-1583 (pedestal
relief) (Alinari / Editorial Photocolor Archives)

Below left: 24. *Mother and Child*, 18th or 19th C., from the Ivory Coast,
Senufo

Below right: 25. Rembrandt, *Portrait of Nicolaes Ruts*, 1631 (© The
Frick Collection, 1944)

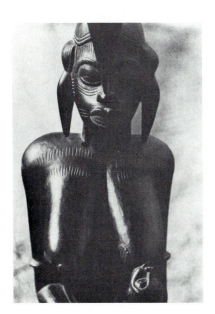

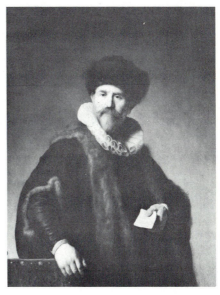

26a. Giovanni Bernini, *The Ecstasy of Saint Teresa*, 1646-1652 (Staatliches Museum, Schwerin)

Below: 27. Gonzales Coques, *The Sense of Sight*, c. 1650 (Koninklijk Museum voor Schone Kunsten)

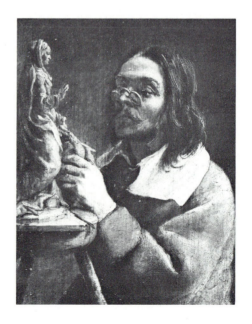

26b. Eighteenth-Century Painting of Bernini's Cornaro Chapel

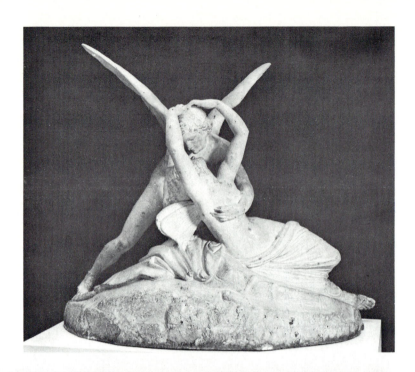

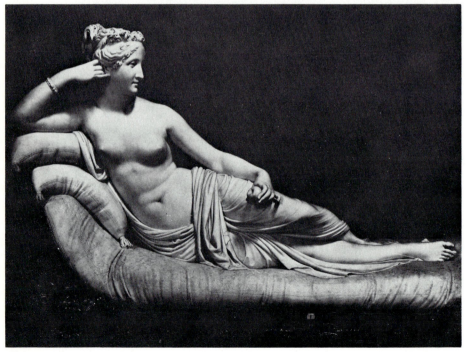

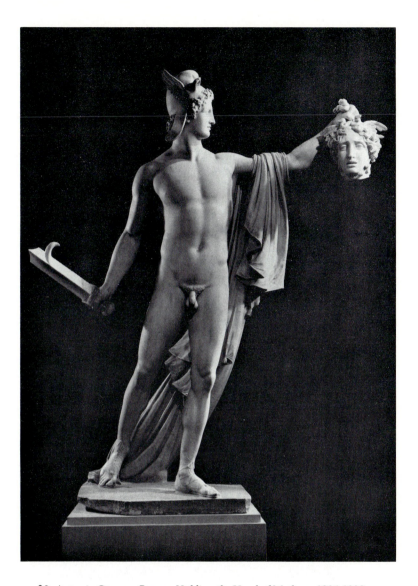

30. Antonio Canova, *Perseus Holding the Head of Medusa*, 1804-1808
(The Metropolitan Museum of Art, Fletcher Fund, 1967)

Opposite

Top: 28. Antonio Canova, *Cupid and Psyche*, c. 1794 (The Metropolitan
Museum of Art, Gift of Isador Straus, 1905)

Bottom: 29. Antonio Canova, *Pauline Borghese as Venus*, 1807
(Alinari / Editorial Photocolor Archives)

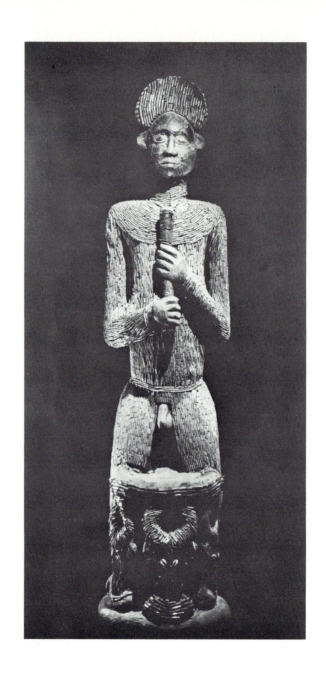

31. *Afo-A-Kom*, c. 1870
(© National Geographic Society)

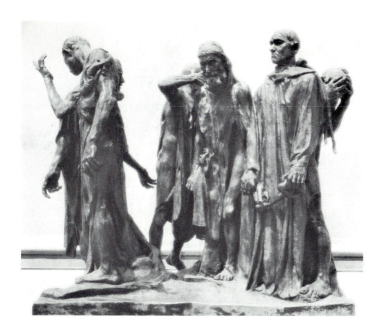

32. Auguste Rodin, *The Burghers of Calais*, 1886 (Hirshhorn Museum and Sculpture Garden, Smithsonian Institution)

33. Paul Cézanne, *Mont Sainte Victoire*, 1886 (The Phillips Collection, Washington, D.C.)

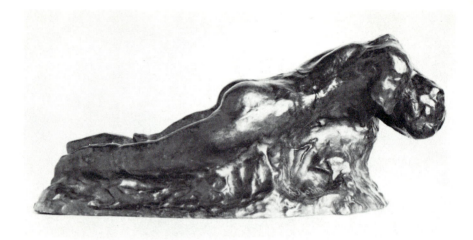

34. Auguste Rodin, *La Terre*, 1884 (Musée Rodin)

35. Edgar Degas, *Répétition d'un ballet sur la scène*, 1874
(Documentation photographique de la Réunion des musées nationaux)

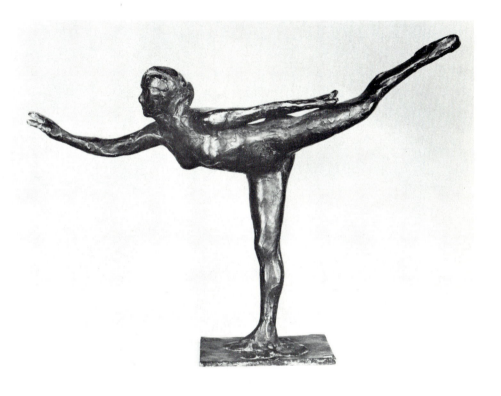

36. Edgar Degas, *Dancer,* c. 1882-1895 (Documentation photographique de la Réunion des musées nationaux)

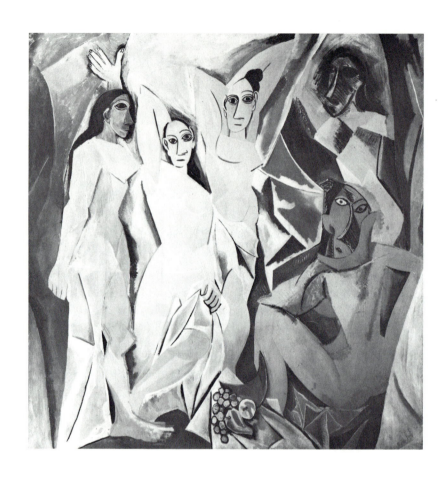

37. Pablo Picasso, *Les Demoiselles d'Avignon*, 1907 (Collection, The Museum of Modern Art, New York. Acquired through the Lillie P. Bliss Bequest)

Opposite

Top: 38. Pablo Picasso, *Head of a Woman*, 1909 (Hirshhorn Museum and Sculpture Garden, Smithsonian Institution)

Bottom: 39. Pablo Picasso, *Glass of Absinthe*, 1914 (Philadelphia Museum of Art: A. E. Gallatin Collection)

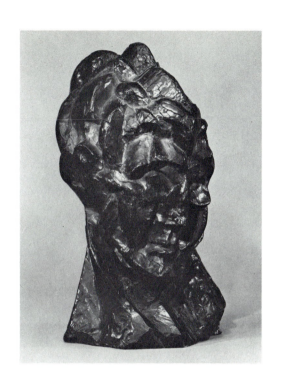

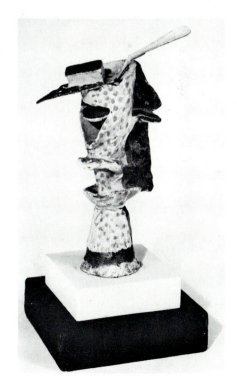

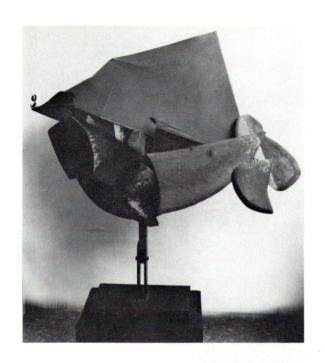

42. Henri Laurens, *Head*, 1918 (Collection, The Museum of Modern
Art, New York. Van Gogh Purchase Fund)

Opposite
Top: 40. Umberto Boccioni, *Dynamic Construction of a
Gallop-Horse-House*, 1913-1914 (Peggy Guggenheim Collection)

Bottom: 41. Marcel Duchamp, *Bottle Rack*, 1914 (Galleria Schwarz)

43. Kurt Schwitters, *Merz Konstruktion*, 1921 (Philadelphia Museum of Art: A. E. Gallatin Collection)

Opposite

Top: 44. Henri Laurens, *Crouching Woman*, 1922

Bottom: 45. Constantin Brancusi, *The Fish*, 1924 (Courtesy Museum of Fine Arts, Boston. William Francis Warden Fund)

46. Marcel Duchamp, *The Large Glass (The Bride Stripped Bare by Her Bachelors, Even)*, 1915-1923 (Philadelphia Museum of Art: Bequest of Katherine S. Dreier)

47. Gaston Lachaise, *Floating Figure*, 1927 (Collection, The Museum of Modern Art, New York. Given anonymously)

48. Pablo Picasso, *Monument*, 1928–1929 (Collection, The Museum of Modern Art, New York. Gift of the artist)

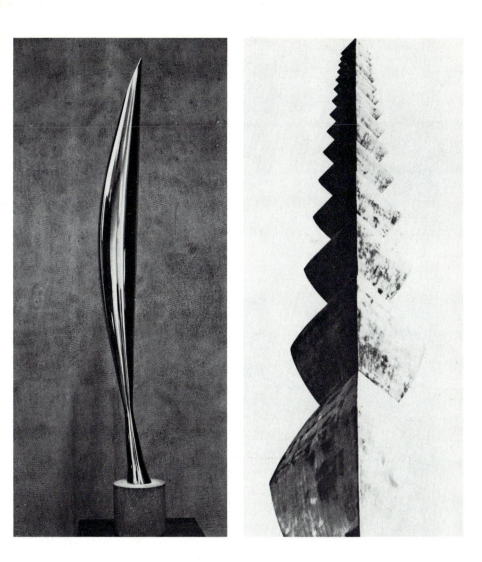

Left: 49. Constantin Brancusi, *Bird in Space*, 1928 (Collection, The Museum of Modern Art, New York. Given anonymously)

Right: 50. Constantin Brancusi, *Endless Column*, 1937

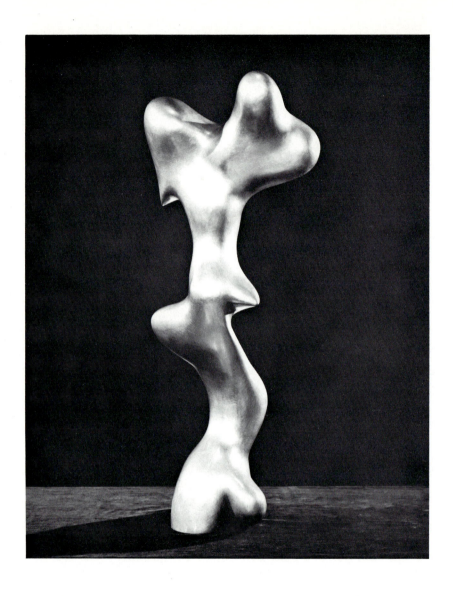

51. Jean Arp, *Growth*, 1938 (Philadelphia Museum of Art Collection: Curt Valentin)

Opposite
Top: 52. Ben Nicholson, *Painted Relief*, 1939 (Collection, The Museum of Modern Art, New York. Gift of H. S. Ede and the artist)

Bottom: 53. Julio Gonzalez, *Cactus Man*, 1939–1940 (Documentation photographique de la Réunion des musées nationaux)

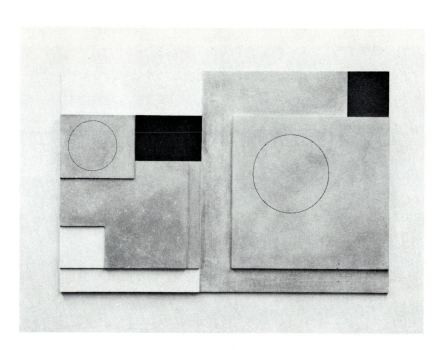

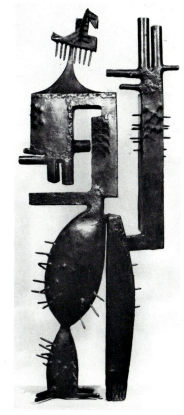

54. Naum Gabo, *Spiral Theme*, 1941 (Collection, The Museum of
Modern Art, New York. Advisory Committee Fund)

55a. Henry Moore, *Reclining Figure*, 1945–1946 (Henry Moore)

55b. Henry Moore, *Reclining Figure*, 1945–1946 (Henry Moore)

56. Alexander Calder, *Bougainvillea*, 1947 (Collection of Mr. and Mrs. Burton Tremaine, Meriden, Conn. Photograph by Herbert Matter)

57. Albert Giacometti, *City Square*, 1948 (Collection, The Museum of Modern Art, New York)

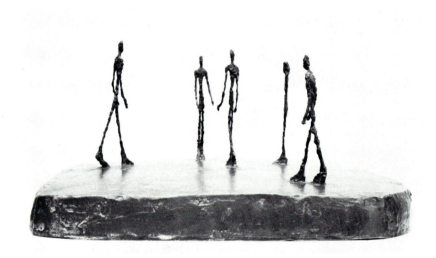

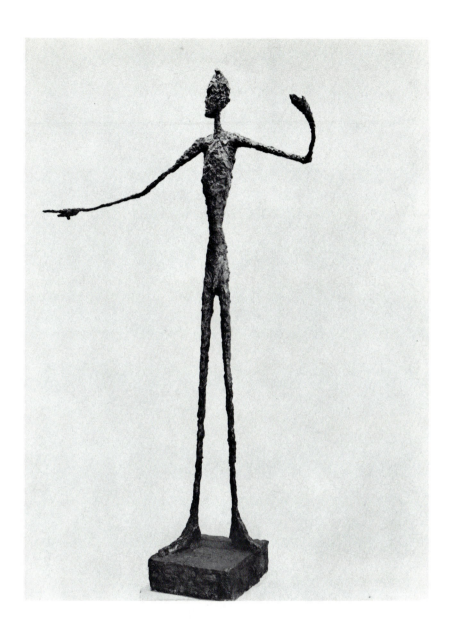

58. Albert Giacometti, *Man Pointing*, 1947 (Collection, The Museum of Modern Art, New York. Gift of Mrs. John D. Rockefeller III)

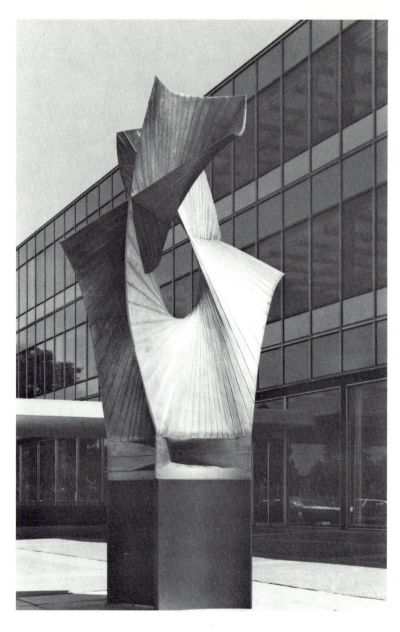

59. Antoine Pevsner and Eero Saarinen, *Bird Soaring*, 1956 (enlarged
version of *Column of Victory* of 1946) (General Motors Corporation)

60. Ludwig Mies van der Rohe, The Residence of Dr. Edith Farnsworth, 1950 (Bill Hedrich, Hedrich-Blessing)

61. David Smith, *Hudson River Landscape*, 1951 (Collection of Whitney Museum of American Art, New York)

63. Nicolas Schöffer, *CYSP I*, 1956 (Nicolas Schöffer)

Opposite
Top: 62. Mark Rothko, *Earth Greens*, 1955 (Rheinisches Bildarchiv)

Bottom: 64. Drago Tršar, *The Demonstrators II*, 1957 (Photograph by Edvard Trier)

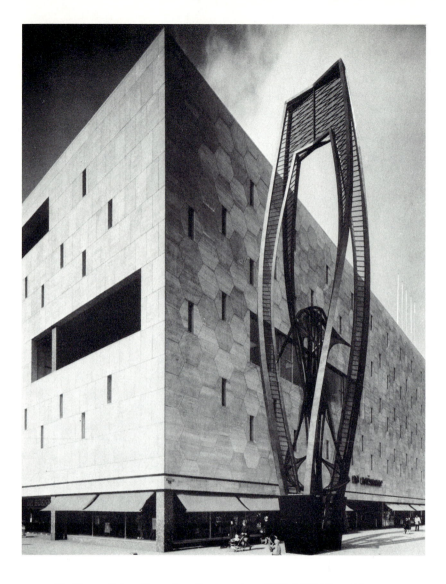

65. Naum Gabo, *Rotterdam Construction*, 1954–1957 (Copyright, Tom Kroeze, Rotterdam)

Opposite

Top: 66. Ossip Zadkine, *Monument to the Destroyed City of Rotterdam*, 1953 (aart fotograaf klein)

Bottom: 67. José de Rivera, *Brussels Construction*, 1958 (Courtesy of The Art Institute of Chicago)

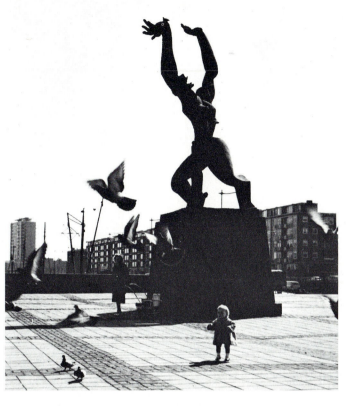

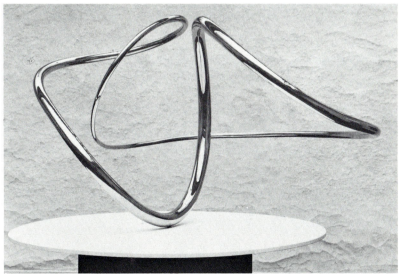

Left: 68. Jacques Lipchitz, *Song of the Vowels,* 1931–1932
(Documentation photographique de la Réunion des musées nationaux)

Right: 69. Marcel Duchamp, *Etant Donnés: 1. La Chute d'eau 2. Le Gaz d'eclairage Given: 1. The Waterfall 2. The Illuminating Gas,* 1946–1966 (Philadelphia Museum of Art: Gift of the Cassandra Foundation)

Opposite: 70. Jean Tinguely, *Homage to New York,* 1960 (David Gahr, photographer)

71. George Segal, *The Bus Driver*, 1962 (Collection, The Museum of Modern Art, New York. Philip Johnson Fund, Eric Pollitzer, photographer)

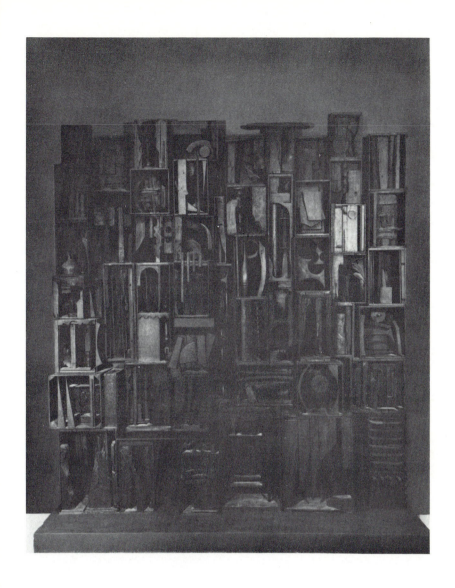

72. Louise Nevelson, *Sky Cathedral*, 1958 (Collection, The Museum of Modern Art, New York. Gift of Mr. and Mrs. Ben Mildwoff)

75. David Smith, *Cubi* X, 1963 (Collection, The Museum of Modern Art, New York. Robert O. Lord Fund)

Opposite
Top: 73. Chryssa, *Times Square Sky,* 1963 (Walker Art Center. Gift of T. B. Walker Foundation)

Bottom: 74. Len Lye, *The Loop,* 1963 (Courtesy of The Art Institute of Chicago)

76. Anthony Caro, *Titan* (stone floor), 1964 (Collection of William S. Rubin)

77. Anthony Caro, *Titan* (wood floor), 1964 (© Floyd Picture Library. Photographer John Goldblatt)

78. George Rickey, *Two Lines—Temporal I*, 1964 (Collection,
The Museum of Modern Art, New York. Mrs. Simon
Guggenheim Fund)

79. Ernest Trova, *Study: Falling Man (Wheelman)*, 1965 (Walker Art Center. Gift of T. B. Walker Foundation)

80. Jean Dubuffet, *Glass of Water II*, 1967 (Hirshhorn Museum
and Sculpture Garden, Smithsonian Institution)

83. Mark di Suvero, *Praise for Elohim Adonai*, 1966 (Pedro E. Guerrero)

Opposite
Top: 81. Mark di Suvero, *Pre-Columbian*, 1965 (Stephen Frisch)

Bottom: 82. Anthony Caro, *Homage to David Smith*, 1966 (© Floyd Picture Gallery)

85. Claes Oldenburg, *Giant Soft Fan*, 1966–1967 (Collection, The Museum of Modern Art, New York. The Sidney and Harriet Janis Collection)

Opposite

Top: 84. Marta Pan, *Floating Sculpture*, 1967 (National Museum Kröller-Müller, Otterlo, Netherlands)

Bottom: 86. Tom Wesselmann, *Smoker, 1 (Mouth, 12)*, 1967 (Collection, The Museum of Modern Art, New York. Susan Morse Hilles Fund)

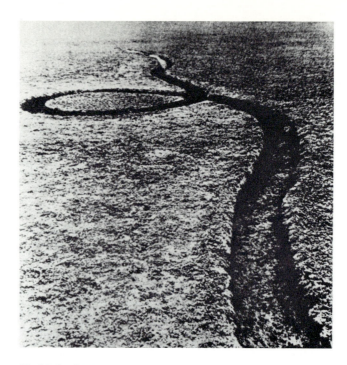

87. Michael Heizer, *Circumflex*, 1968

88. Robert Smithson, *Spiral Jetty*, 1970

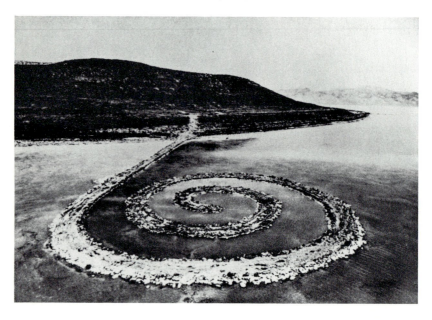

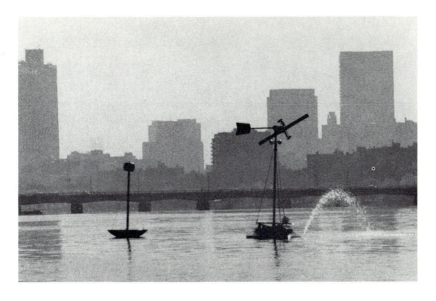

89. Harold Lehr, *Ecological Sculptures*, 1971 (Harold Lehr)

90. Robert Morris, *Labyrinth*, 1974 (Courtesy, Institute of Contemporary Art, University of Pennsylvania. Photo: Will Brown)

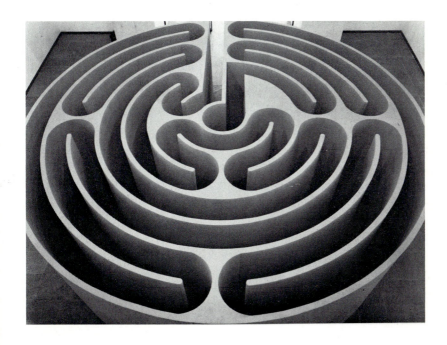

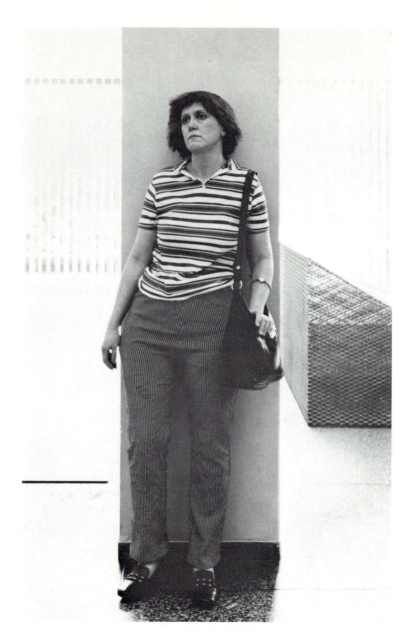

91. Duane Hanson, *Woman with a Purse*, 1974 (Rheinisches Bildarchiv)

HOW DOES SCULPTURE COME TO BE?

VII

The Subject Matter
of Sculpture

The hidden harmony is stronger than the visible.

Heraclitus

"The 'origin of art,'" as E. H. Gombrich notes, "has ceased to be a popular topic."[1] In the case of the origin of sculpture, especially as more than a chronological question, it has never been a popular and rarely a serious topic. Aside from Hegel, Schopenhauer, Henri Focillon, Herbert Read, and a very few others, the question of what has moved man to create and treasure sculpture has rarely been examined systematically. Yet without an answer to this question the autonomy of sculpture is left ungrounded. I will try to show that in identifying and understanding the subject matter of sculpture, we have the key to the answer about the origin of sculpture. Although the determination and explanation of the chronological beginnings of sculpture do not provide an answer, they point—as do the previous conclusions about how sculpture is perceived—to an all-pervasive, underlying subject matter of sculpture.

The origin of sculpture in the chronological sense is only dimly discernible in prehistory. Human beings as tool-using mammals are believed to have emerged at least 600,000 years ago, but very little archaeological evidence of the existence of humans before the latest phase of the Old Stone Age or Upper Paleolithic period—40,000 to 8,000 B.C.—has been discovered. In that period, however, some outlines can be roughly sketched, especially with respect

to the appearance of sculpture before both architecture and painting. The earliest surviving sculptures antedate anything resembling architecture by many thousands of years, contrary to Hegel's speculations in *The Philosophy of Fine Art*. Prehistoric humans, for the most part, found their architecture in caves and trees. And in the so-called primitive societies[2] of the historical period, sculpture of the highest quality is often found—the *Mother and Child* (Fig. 24) from the Ivory Coast, for example—while the architecture remains rudimentary. It also seems likely that the first sculptors preceded the first painters, for radiocarbon tests place the earliest extant sculptures before the earliest extant paintings, and many more sculptures have been found than paintings. Nevertheless, our knowledge about prehistoric sculpture and painting is so fragmentary that no certain conclusions about which came first can yet be made. It may be that the scarcity of paintings compared with sculptures is accounted for by the much greater vulnerability of painting to the destructiveness of time. It seems more likely, however, that the simpler techniques of incising lines with sharp tools, often by found or ready-made rocks, encouraged drawing[3] and relief sculpture. The difficulty of extracting colors from minerals and charcoal to be bound by gummy substances and applied by formed tools (in the case of most cave paintings probably either scraped on by shredded bone or blown on through a hollowed-out bone) presumably discouraged the widespread development of painting. Raoul-Jean Moulin points out that the incised lines of prehistoric relief are usually more precise and powerful than the lines of painting.[4] Moreover, the simplicity of the technique of small sculpture in the round, with hands modeling readily available materials such as clay, would seem to account partially for the apparent earlier beginnings and quantitative dominance of sculpture. Then, too, the practical need for artifacts such as pottery and tools would seem to have provided more occasion for the emergence and proliferation of sculpture. As Germain Bazin comments: "If I had to say which was the first basic artistic gesture—sculpting or painting, I would choose the former. For primitive man, painting was a luxury, whilst sculpting was a matter of life and death. The making of objects in the round was closely linked with the rudimentary industry which allowed man to perfect his way of life, through the use of tools, thus multiplying his possibilities of action."[5]

Examples of the techniques of sculpting, drawing, and painting have been found going back long before the Old Stone Age, and it would be surprising if artifacts with artistic qualities are not found in those earlier periods.[6] However,

up to the present time, the earliest examples possessing unmistakable artistic qualities are roughly datable between 25,000 and 18,000 B.C. The earliest examples of sculptures in the round, for instance, the *Venus of Willendorf* (Fig. 1), and relief sculptures, for instance, the *Venus of Laussel* (Fig. 2), probably belong to this period. On the other hand, the earliest paintings are considerably later. The cave paintings of Lascaux, for instance, are now dated 15,000-13,5000 B.C. These rough datings will doubtless be greatly refined by further evidence from archaeologists and historians of art as they develop their iconographical and iconological investigations, but it seems unlikely that the precedence of sculpture will be changed. Even as the determination and explanation of the chronological beginnings of sculpture become more precise, however, they will not fully answer the question about why sculpture comes to be. That question centers on the special human need the creation of sculpture satisfies.

The origin of any basic human activity lies in the essential necessity it fulfills. The most general and essential necessity art fulfills is the revelation or clarification of values—of what is important to us—thus making life more understandable, enjoyable, and, especially with the clarification of tragic values, manageable. Most sorrows seem to be bearable if we can understand them. It is its revealing power that makes art "life enhancing," to use Berenson's famous phrase. Art transforms life and in doing so informs about life. The conscious intentions of the artist may include magical, religious, political, economic, and other purposes; the conscious intentions do not necessarily include the purpose of clarifying values. Yet underlying the artist's activity *qua* artist is always the creation of a form—the relationship of part to part and part to whole—that illuminates or reveals some subject mater. Every work of art has a subject matter, form, and content. The subject matter is what the work is about, something of basic value, an objective of some vital human interest. Such a value may be any aspect of experience that is fundamentally related to human beings as purposive and valuing agents, "the esteemers" as Nietzsche describes them. Theodore Meyer Greene writes:

If the true artist seeks to express in his art an interpretation of some aspect of the real world of human experience, every genuine work of art, however slight and in whatever medium must have *some* subject matter. It is not *merely* an aesthetically satisfying organization of sensuous particulars. The entire history of fine arts and literature, from the earliest times on record down to the present, offers overwhelming evidence that art in the various media has arisen from the artist's desire to express and communicate to his

fellows some pervasive human emotion, some insight felt by him to have a wider relevancy, some interpretation of a reality other than the work of art itself in all of its specificity.[7]

A subject matter is not necessarily—although this is the traditional conception—an object or event. It may be an abstraction from objects and events, for instance, the quality of blackness, as in Ad Reinhardt's "black paintings." And, obviously, many works of art, notably pure music and architecture, are not about objects and events, at least strictly speaking. But every work is about some basic value, as is attested to by the history of art and an overwhelming consensus in the critical literature and statements by artists, as well as some consensus in aesthetics.[8]

The subject matter is never directly given in the work of art, for the subject matter has been transformed by the form. Whereas the subject matter is a value prior to artistic interpretation, the content is the significantly interpreted subject matter as revealed by the form. Content is the subject matter detached by means of the form from its accidental aspects. Content is the revealed subject matter, the meaning of the work. Form makes the meaning of a subject matter more manifest, more comprehensible. Form and content are directly and indivisibly perceptible in the work. Only by reflective analysis can we divide form from content. Form is the means whereby values are threshed from the husks of irrelevancies. Whereas decorative form merely pleases, artistic form also discloses or informs, and it informs about neither the arbitrary nor the unimportant. Rather, on the one hand, artistic form draws from the chaotic state of life, which, as Van Gogh graphically puts it, is like "a sketch that didn't come off"—a distillation, an economy that produces a lucidity which enables us better to understand and, in turn, to cope with what matters most. Or, on the other hand, because life when it is not chaotic is such a habit-forming drug, artistic form reveals something so vividly the drug fails to work. The work of art creates an illusion that illuminates reality. Thus is explained such paradoxical declarations as Delacroix's: "Those things which are most real are the illusions I create in my painting." Or Edward Weston's: the artistic photographer reveals "the essence of what lies before the lens with such clear insight that the beholder may find the recreated image more real and comprehensible than the actual object."[9] Aristotle asserts, "Art completes what nature cannot bring to a finish. The artist gives us knowledge of nature's unrealized ends." Hegel asserts, "Art is in truth the primary *instructress* of peoples." Camus asserts, "If the world were clear, art would not exist." Or note Whitehead:

Art is the arrangement of the environment so as to provide for the soul vivid . . . values. Human beings require something which absorbs them for a time, something out of the routine which they can stare at. But you cannot subdivide life, except in the abstract analysis of thought. Accordingly . . . art is more than a transient refreshment. It is something which adds to the permanent richness of the soul's self-attainment. It justifies itself both by its immediate enjoyment, and also by its discipline of the most inmost being. Its discipline is not distinct from enjoyment, but by reason of it. It transforms the soul into the permanent realization of values extending beyond its former self.[10]

The informing of a work of art reveals a subject matter with value dimensions that go beyond the artist's idiosyncracies and perversities. The art of a period is the revelation of what is important in that period.

Does sculpture in all its many exemplifications possess a distinctive subject matter, some fundamental value that the forms of sculpture reveal in a unique way, making that value more intelligible, making, in turn, our lives more meaningful because of that revelation? Various sculptures obviously have various subject matters. But do all sculptures also have an underlying, all-pervasive subject matter? I hazard the hypothesis: sculpture has a distinctive underlying, all-pervasive subject matter—the importance of being aware of our unity with things, our direct relations with things. More than any other art, sculpture is the means whereby we try to extricate ourselves to some extent from our inevitable isolation—the subject/object dichotomy—and try to regain more direct contact with things. (By things as part of the distinctive subject matter of sculpture, I mean things as physically present, not such things as concepts, memories, dreams, or mirages.) By consummating our withness with things, sculpture helps us overcome the "gray cold eyes that do not know the value of things" (Nietzsche). Sculpture is a unique way to the real, to what really is. Sculpture helps us understand ourselves as emerging together with things, not as over and against things. What sculpture reveals can make our lives far more meaningful, especially now, when our togetherness with things has been so forgotten. The Zen Buddhists put it this way:

The unreal life is a life forever unconsummated. The man who stands apart from things, unable to give himself to them, receives payment in kind; because his relation to things is an external one, these things, in turn, withhold their full reality from him. When life is contemplated objectively, nowhere is there to be found anything that is free of limitations, nothing that fully satisfies the yearning of the human heart. It is only when man's experience of life is integral that it "means everything" to him; only when the subject is not outside the object, where each lives in the other as well as in itself—only then is life complete from moment to moment.[11]

123

This need to be directly with things is the instinctive and fecundating force that explains, I believe, those fantastic, ever-expanding "total environments" of Kurt Schwitters—the *Merzbau* of Hanover, 1920-1936, and the later versions he assembled in Norway and England. That same force on a less sophisticated level of creation explains the monumental works built by Simon Rodia in the backyard of his home in Los Angeles, the so-called Watts Towers. As J. Bronowski tells it:

He came from Italy to the United States at the age of twelve. And then at the age of forty-two, having worked as a tile-setter and general repairman, he suddenly decided to build, in his back garden, these tremendous structures out of chicken wire, bits, of railway tie, steel rods, cement, sea shells, bits of broken glass, and tile of course—anything that he could find or that the neighborhood children could bring him. It took him thirty-three years to build them. He never had anyone to help him because, he said, "most of the time I didn't know what to do myself." He finished them in 1954; he was seventy-five by then. He gave the house, the garden and the towers to a neighbor, and simply walked out.[12]

Whether as creators of or participants with sculpture, we instinctively try to regain more direct contact with things—a sense of spatial withness with things as three-dimensional solids—because to be broken away from such things leads to madness. When we awake from a nightmare, for example, we desperately seek the solidity of the bed, the floor, the walls, anything, for only then do we regain our sense of being-in-the-world and sanity. We cannot help thinking at things, of course, thereby distinguishing ourselves as subjects as opposed to objects. If we did not, we could not survive as human beings, for practical and theoretical thinking presuppose thinking at. But that way of thinking can be kept from completely dominating our lives. If we can manage a better balance, if we can sometimes subordinate thinking at to thinking from, we can enrich our perceptions and gain an understanding of ourselves and our world that avoids madness and may even bring peace and joy. More than any other art, sculpture by enlivening space clarifies our spatial withness with things, making our belonging in a world more sensitive, informed, and explicitly valuable. That is why sculpture is a necessity, not just an adornment.

Every thing that is in our awareness is in our world, but not every such thing is necessarily of our world, in the sense of belonging to our world as directly present spatially. By in our world, I mean presence in general, including, for example, a thought or a memory. By of our world, I mean direct sensory or physical presence. A thing that is of our world possesses spatial contiguity

124

with us. I am remembering, for example, my favorite bridge, the Ponte di Santa Trinità in Florence,[13] and it may be that this bridge is more in my world because of its value to me than it is in the world of the oblivious tourist who happens to be looking past it at this moment. Since, however, I am not now in spatial contiguity with that bridge, it is not of my world. The "of my world" is composed only of those things that I am spatially with now, whose showing forth necessarily involves perception. My recollection brings back many aspects of the bridge. I even have kinaesthetic and tactual sensations triggered off by memory images of walking over the bridge and the feel of its stones. Nevertheless, there is no spatial withness, no contiguity with the bridge in my awareness. The bridge is "thoughtfully" but not perceptually present.

In the aesthetic experience of any work of art, when we are thinking from rather than at, that work is very much in our world. The more the work compels and controls our attention, the more the sense of "inness." A thing gets into our world proportionately to its value to us. In the aesthetic experience of all works of art, furthermore, we obviously perceive them, and we can do so only if we are in spatial contiguity with them. Thus all works of art experienced aesthetically are also of our world. But since the various arts differ in the way they are perceived, the degree to which they are of our world also differs. The greater the awareness of spatial withness, the greater the awareness of "ofness." Furthermore, the awareness of spatial withness is ultimately founded on tactility, however much tactility may be influenced by the other senses.

Sylvia Plath's "Paralytic" has little physical tactile impact, despite the powerful images of touch her poem evokes. The tactile imprint of the words and pages on my eyes and hands is insignificant. Carl Nielsen's Fifth Symphony arouses in me powerful haptic sensations, and the rhythms, especially of the "snare drum" theme in the first movement, channel those haptic sensations into strong kinaesthetic flows. Few things have been more in my world than that music. Yet even in my ears there is very little noticeable tactile sensation. That music has never been of my world in any significant sense. Painting, drama, opera, dance, film, and television generally separate their spaces from our spaces (Chapter 5), draining the between of impacting forces. Although the between of architecture contains forces that impact, that enlivened space opens up a site that relates things to earth and sky. Space is made by the positioned interrelationships of things, but architectural space—the opening—is at least as perceptible as the things that create and fill it. That opening, furthermore, is usually very extensive. Thus the impact of the enlivened space of architecture

125

tends, compared with the impact of sculpture, to be more extensive than intensive. Because sculpture emphasizes our withness with things, whereas architecture emphasizes the site for things, sculpture, other things being equal, usually impacts with a greater tactile intensity, often at least equal to that of haptic and kinaesthetic sensations. Because of the openness of architecture, and because architecture usually moves us around much more than sculpture, tactile sensations rarely reach the intensity of haptic and kinaesthetic sensations. Both sculpture and architecture, unlike the other arts, are without qualification in and of our worlds. Both sculpture and architecture are without qualification spatially with us. But whereas sculpture narrows the contiguous space, architecture broadens it. That is basically why sculpture and architecture are so closely allied and yet autonomous.

Consider the following examples with respect to perceiving spatial withness: a man in my garden; Duane Hanson's *Woman with a Purse,* (Fig. 91); Parmigianino's *Portrait of a Young Prelate* (Fig. 20); and Verrocchio's *Lorenzo de' Medici* (Fig. 18).

The man in my garden is walking toward me. He generates physical forces in the space between us more strongly than the grass, flowers, and even the massive trees, mainly because he is moving and advancing in my direction. We share a community of real space. He is in and of my world. His presencing in this situation, however, is not experienced aesthetically. His "look" (see the quotation from Sartre, pp. 111-12) makes me defensive, conscious of my appearance and social role. I identify this man. I wonder why he is coming. I conceive hypotheses. I recall a problem he had broached before. His remarks return to that problem. We agree on a way of solving the problem. He walks away and I continue to observe him, yet still not aesthetically, for there is little about his appearance that attracts my attention in this respect. His figure, motion, and black suit are nondescript, and, besides, I am thinking mainly about the actions I must take to solve our problem. My perceptions are secondarily oriented, distracted from thinking from. So it is, unfortunately, most of the time. Either things do not fall into an interesting pattern that attracts and holds our attention or some kind of problem or anxiety prevents the aesthetic experience. In nonaesthetic experiences something is always in our world and something is almost always of our world, but any satisfaction from our sense of spatial withness with things is usually only faintly felt. Spatial withness is so omnipresent its familiarity breeds contempt.

In a large room in the basement gallery of the Wallraf-Richartz Museum,

126

standing by a large pillar staring at Frank Stella's *Ctesiphon III*, is a life-size statue entitled *Woman with a Purse* (Fig. 91). On entering the room, however, I thought I was perceiving a woman having an extraordinary aesthetic experience of the Stella. After some aesthetic experiences of my own with the Stella and some other paintings and sculptures in that room and an adjacent courtyard, I was amazed on return to find the young lady still entranced. My curiosity was aroused. Summoning courage, I moved very close; the *trompe l'oeil* was almost unbelievable, becoming recognizable only within a foot or so. Very few visitors in that gallery made my amusing discovery. And when they did, they were also amazed and amused, but no one's attention was held on this work for very long. Any concentrated attention was given to technical details. Was the hair real? Were those real fingernails? The form, being less than artistic, had nothing to reveal about women or anything else, showing itself in Gombrich's terms as no more than a "substitute," a duplicate of the real thing.[15] Such copies, as with the wax figures of Madame Tussaud, fail to sustain attention because once recognized there is little else to be interested in except technical details. Thinking from rapidly moves to thinking at.

The *Portrait of a Young Prelate* (Fig. 20), on the other hand, not only attracts but sustains my attention. For me, no portrait of the Renaissance equals its compelling intimacy of communication. The prelate's mild, magnificent eyes seem to gleam replies to my questions, while the unavoidable gaze both meets me and withdraws. He seems accessible and yet diffident, as if shy or fearful of disclosing his thoughts, cautiously probing me while defending himself against my probing, and his lips seem about to part either in greeting or in a mumbled excuse for departure. Although the volume of his face is not exceptionally large, it appears so because it almost fills the frame. This makes it seem that I am very close to him, so close that I seem to perceive the beating of the pulse, while the outlines of the nose are blurred, as when I am overly close to an object, and these outlines are thrown further out of focus by the way his eyes draw my attention. The liveliness of every feature reveals an intelligent, skeptical, gentle, and introverted spirit.

This portrait is in my world more securely than most other things, engraved and treasured in my memory. Yet even when standing in front of the *Young Prelate* in the Borghese Gallery, it is not in any significant sense of my world. We do not share the same space. His space is imaginary; my space is real. He makes no noticeable tactile impact on me because the space between us is a vacuum through which no evident physical forces appear. My communication

with him leaps across the between as if there were no between—a completely imaginary communication. My perception of the *Young Prelate* is peculiarly timeless and placeless. I have no clear memory of when or where I was perceiving this portrait, for such recall is irrelevant. If I make a special effort, I do vaguely remember its placement on a swinging hinge near an open doorway on the second floor of the Borghese Gallery, but this recall is of no importance to my memory image of the portrait. When in front of the *Young Prelate*, I spontaneously block out everything except the image, for everything else is irrelevant. When I vividly remember the *Young Prelate*, the image completely separates itself from its doorway placement. The image stays aloof, like a Platonic idea, from the physical world.

Verrocchio's *Lorenzo de' Medici* (Fig. 18) is both in and of my world, without qualification when I perceive it in the National Gallery of Art. Much more strongly than with my previous examples, *Lorenzo* impacts forces into the surrounding space, and these forces are felt as impinging tactilely on me. The sculpture also attracts and sustains my attention much more than my visitor and the *Woman with a Purse*. The space around the sculpture, especially in front of the face, is filled with energy pushing out from the sculpture. The enlivened space is a perceptible part of the sculpture, an essential element making my perception of the sculpture what it is. This is not the space of natural things or nonartistic three-dimensional artifacts but space transformed by the form of the material body of the sculpture. Nevertheless, that space shows forth as a transformation of real space, not an imaginary space. The sculptural space does not cut itself off from real space, as with the space of the painted portrait; rather the sculptural space is a metamorphosis of real space, making it more dynamic and perceptible.

The space around the *Woman with a Purse* impacted somewhat on me; the space around my garden visitor slightly more. Three-dimensional things always have some mass, whether man-made or natural, and mass always generates some impacting forces into its surrounding space. However, the space around the *Lorenzo* is far more impacting, because Verrocchio formed his terra-cotta in such a way that it makes the surrounding space a field of strong vectors pushing and pulling one's attention and body in various directions. The gaze of Lorenzo pierces outward, the jutting jaw rams toward us, reinforced by the lines of the broken nose, the colors bounce light, the shapes throw shadows, and the fierce sphere-shaped head is felt as capable of thrusting out from its pedestal. I perceive *Lorenzo* as both in and of my world: very much in my world because the work

captivates my attention; very much of my world because the work seems to press strongly on me tactilely, a part, however transformed, of my physical space. I vividly recall the times I was with this work in the National Gallery. I vividly recall its placement in a small octagonal room. The *Lorenzo* is not timeless and placeless, as in the *Young Prelate*, because the *Lorenzo* comes forth in real rather than imaginary space. My sense of spatial withness with the *Lorenzo* is strongly felt, far more than with the other examples. This sculpture and sculpture generally by enlivening space vivifies our spatial withness with things, making us more sensitive to what we are most basically: beings-in-the-world, or, more precisely, beings with things that are always in and sometimes of our worlds.

Sculpture, being in and of our world in an especially powerful way, comes forth as more physically present and in this sense more real than most things. Sculpture immerses itself in *our* world. Painting immerses us in *its* world. In this respect all the other arts, with the exception of architecture and "happenings," are more like painting than sculpture. Painting, being strongly in our world but only weakly of our world, comes forth as less physically present and in this sense less real than most things. Painting is "another" or imaginary world. [16] These phenomena are exemplified by the way damaged sculptures are usually not as disadvantaged for aesthetic perception as damaged paintings. Photographers often can select details from paintings that stand out as if they were independent works of art, as Malraux's *The Voices of Silence* so vividly illustrates. Moreover, paintings can reveal fragments of things just as successfully as sculpture, as the *Young Prelate* or Dürer's *Praying Hands* exemplify. Generally, however, we are much more accustomed to the fragment in sculpture, especially the anatomical. Most Greek sculptures have come down to us in parts, and there are far more Roman busts than full figures. Perhaps even the medieval custom of exhibiting sacred bones in reliquaries has helped to strengthen the convention of the sculptural fragment. In any case, as Gombrich points out: "We come to their [artists'] works with our receivers already attuned. We expect to be presented with a certain notation, a certain sign situation, and make ready to cope with it. Here sculpture is an even better example than painting. When we step in front of a bust we understand what we are expected to look for. We do not, as a rule, take it to be a representation of a cut-off head; we take in the situation and know that this belongs to the institution or convention called 'busts' with which we have been familiar even before we grew up." [17] Reference to this convention, unfortunately, explains little about why the fragment is

usually more acceptable in sculpture than in painting. Moreover, as so often happens when one appeals to habit, further inquiry is discouraged and the question becomes uninteresting.

When parts of a painting are torn, burned, discolored, scraped off, or covered up, the aesthetic effectiveness of the painting is often very noticeably diminished. For example, imagine placing a small patch over any area of the face of the *Young Prelate*. Even if the patch were placed on the background, the form-content would be disturbed. On the other hand, such patching over any part of the *Lorenzo* would not be as disturbing. If the nose of the *Young Prelate* were destroyed, the painting would be terribly blemished. But if the nose of *Lorenzo* were destroyed, the sculpture would not be so terribly blemished. Indeed, many sculptures seem to have lost little by such damage—witness the *Winged Victory* and the *Venus de Milo* in the Louvre, and the *Aphrodite of Cyrene* (Fig. 6). If one of Degas's sculptured dancing girls were beheaded (Fig. 36), her body would not appear monstrous and the aesthetic loss would be minimal. But if one of Degas's painted dancing girls lost her head (Fig. 35), her body would appear monstrous and the aesthetic loss would be considerable. Of course, bodies without heads can be represented in paintings with aesthetic gain, if the form and content require such representation, as in the case of the decapitated woman with the milk pails in Marc Chagall's *Moi et la Village*. But with the Degas sculpture something different is happening: there is a "filling in" of the missing head.

Generally this filling in does not occur when a sculptor harnesses and preserves the forces of an accident in his sculpture—refusing to "cover his tracks"—as in the case of the cut in the lower legs of Rodin's *La Terre* (Fig. 34). As Leo Steinberg notes: "It is not enough to observe that no feet are present, for, as the base indicates, no feet were intended; nor arms for the deltoid down. And this portrays the novelty of the approach. Unlike the arms of the 'Venus de Milo,' the limbs here are not conceivable as missing or as replaced in imagination. The bulk of 'La Terre' allows no fringe forms; it is finished without them because what Rodin represents is not really a human body, but a body's specific gesture, and he retains just so much of the anatomical core as that gesture needs to evolve."[18] In other words, with *La Terre* the part is the whole, whereas with the *Venus de Milo* the part stands for the whole. But how can this be? If the fragment broken away from a sculpture does not destroy the basic shape of the material body, that body continues to throw out the same basic vectors into the surrounding space and also pushes out new vectors that aid our imaginations to

130

position, mold, and fill in the empty space of the departed fragment. The space that was once occupied by the head of the *Aphrodite of Cyrene*, for instance, is not left entirely undefined and empty. Our perceptions easily follow the vectors set forth by the body, and so we perceive the space above the neck as a volume limited to the size of a head conformable to that body and imagine within that boundary a calm solidity. Our perceptions are aided by the way a damaged sculpture remains in real space, however transformed. In real space we are constantly confronted with incomplete things—a demolished building, a broken vase, a man with an amputated limb. Because of all kinds of obstructions on a crowded bus, we see heads without bodies and bodies without heads. So when we perceive a sculpture with missing parts such fragmentation does not strike us as particularly exceptional, especially since what remains throws out forces that help us fill in the missing gaps, guiding our perceptions toward completeness. The formal relationships may be upset by the fragmentation, but these relationships are usually set right to some extent by the filling-in process.

Painting, unlike sculpture, is "another world." When that imaginary world comes into our awareness, we are accustomed to and expect completeness, both with respect to that world's internal as well as its external relations. The world of a painting is edged or framed, set off from real space by sharp and distinct boundaries. Hence the world of painting, like the world of pure mathematics in this respect, seems absolved from the accidents of real time and space. When such accidents unfortunately do occur, they therefore seem to involve a much more violent invasion of the integrity of a painting than of a sculpture. In turn, the formal relationships of an impaired painting, compared with an impaired sculpture, are likely to be more distorted by the damage. Usually the damage mixes real space into imaginary space. This mixing almost always drastically weakens the content of a painting. The frescoes by Giotto in the Peruzzi and Bardi chapels in Santa Croce in Florence have recently been cleansed of whitewash and several earlier restorations, leaving large blanks of unpainted wall plaster (Fig. 10). The glories of Giotto's imaginary scenes are constantly being interrupted by these meaningless gaps of real space. We can imagine to some extent what Giotto had frescoed there, of course, for the lines, colors, shapes, and textures of what remains help us fill in the gaps. But it is a bumpy, distracting perceptual process, for we are constantly and abruptly swinging back and forth from Giotto's imaginary world into the real world of physical wall textures that stubbornly resist incorporation into the imaginary. Sculpture, conversely, is already in the real world in the sense that it is a

131

transformation of real space. Consequently, the filling in of the spaces of departed fragments is not as perceptually distracting. A damaged sculpture, when the forces of its material body continue to energize the surrounding space, heals itself to some extent. A damaged painting, because the invasion of the real world into its imaginary world defies assimilation, remains essentially incurable. The healing of sculpture is possible because sculpture is both in and very much of our worlds, a spatial withness.

The strong "of character" or physical presence of sculpture also accounts for some of the expansion and compression of forces into the surrounding space when a sculpture is either significantly smaller or larger than the thing it represents. For example, consider the *Venus of Willendorf* (Fig. 1). We perceive a very large and fat lady. Yet the material body is only 4 1/8 inches high. How can this be? Most obviously, clues such as the large breasts and pregnant belly tell us that an adult female is represented. Second, conventions governing sculpture help organize our perceptions so that small or large sculptures are perceived as standing for roughly the average size of what is represented. Similar clues and conventions also work, of course, in our perceptions of sizes in paintings. The stage setting of Degas's dancers (Fig. 35) completely determines the proportions of the imaginary world of that painting as representative of the real world of the dance theater, and so we judge the dancing girls as more or less five feet tall even though they are only about five inches tall on the canvas. The separation of the space of a painting from real space and the isolated context provided by the edges and framing usually make the clues in the depicted world of the painting easily read with references to proportions. The conventions of painting concerning size, though these may be of various sorts, are also readily understandable. In the Medieval period, for instance, great size differentials of figures with human features in appropriate contexts were understood as signifying the separation of the earthly from the saintly. Thus in the Magdalen Master's *Madonna Enthroned* (Fig. 9), the tiny figure of the donor at the bottom left of the throne is perceived as being in the secular world adulating the sacred world above. If the conventions of Christian painting are understood, the size of the donor, which is so out of scale with the rest of the painting, presents no perceptual problems.

The clues and conventions about the size of what is represented by the material body of a sculpture affect, unlike a painting, the surrounding space. Thus, as Henry Moore observes, "Sculpture is more affected by actual size

considerations than painting. A painting is isolated by a frame from its surroundings (unless it serves a decorative purpose) and so retains more easily its own imaginary scale. "[19] Because a sculpture is physically present in our space, we usually perceive (in contrast to our perception of a painting) a noticeable tension between the size of a small or large material body relative to the size of the thing it represents, and this tension reinforces the impacting between. We perceive the material body; we imagine what the material body represents. In the aesthetic experience of a sculpture, the "image" is determined by and tied to the percept.[20] Thus we perceive the tiny material body of the *Venus of Willendorf* and simultaneously imagine, more or less distinctly, a very large and fat lady. Lights, shadows, lines, textures, and especially convex shapes appear to push out from the material body into the surrounding space with great force. The perceived volume of the *Venus* is both the material body and the space into which that body impacts—the perceived space over which that body exerts control. On the one hand, the impacting forces are extended by our image of this little figure as a heavy adult female. At the same time, the limits of that expansion are perceived as held to roughly the average size of a heavy adult female. This limitation compresses and intensifies the forces in the surrounding space. When, conversely, the material body of a sculpture is significantly larger than what it represents, we perceive the larger material body and simultaneously imagine, more or less distinctly, the smaller size of what is represented. Thus we image a youth in Michelangelo's *David* (Fig. 19) much smaller than our perception of the almost seventeen-foot material body. If for some reason this kind of percept-image relation is not experienced (by someone, for example, ignorant or forgetful of the biblical story), then the forces impacting into the space from the material body flow outward without restriction like ripples in water from a dropped stone. But if, on the other hand, this percept-image relation is experienced, then we are aware of a manifest disparity in sizes. And then the small image of David will exert a powerful centripetal pull, slowing down and limiting the spread of forces emanating from the huge material body. It is as if a dike surrounded the *David*, holding back its outward flow. Thus, unlike the *Venus*, the impacting forces of the *David* are not extended but, like the *Venus*, the impacting forces are compressed and intensified. In short, a sculpture whose material body is considerably different in size from the size of what it represents, other things being equal, tends to be more physically present, more of our world, than a sculpture whose material body is similar in size to

what it represents. An awareness of disparity in size adds psychological forces to the physical forces operating in the surrounding space. This enhanced impact strengthens the sense of our physical withness with sculpture.

Physical or spatial withness is the distinctive subject matter of sculpture. Without the transformation of the surrounding space into a vivification of spatial withness, a three-dimensional artifact is perceived more pictorially than sculpturally. Sculpture is not just a three-dimensional creation but a three-dimensional creation that impacts. More than any other art, even architecture and "happenings," sculpture reveals the value of being aware of our physical unity with things. That does not imply, of course, that this is the only value sculpture reveals. For example, Michelangelo's *Pietà* (Fig. 21) clarifies compassion, among other things, and that compassion is surely more evident as the subject matter than the spatial withness. Still, the interpretation of compassion is incarnated in an impacting three-dimensional material that is essential to the content of Michelangelo's work. The revelation of the spatial withness is part and parcel of the revelation of the compassion. Take away all other subject matter from sculpture, and there always remains the underlying subject matter of spatial withness. Some abstract sculptures may even have only that subject matter; for instance, some of the minimal sculptures of Robert Morris and Donald Judd.

Bring out spatial withness! That is the second categorical imperative of the sculptor. As with the first categorical imperative—Attend to the impacting between!—obedience to this command is necessary because it makes possible the satisfaction of the ultimate goal of sculpture: the revelation of our unity with things. That goal accounts for the common problems of sculptors. As Rudolf Wittkower concluded, after carefully investigating the technical processes of sculpture, "The problems about which sculptors meditate and around which their dreams revolve are comparatively few and have hardly changed in the long course of the history of western man."[21] Sculptors may and usually do reveal other things as well, but the revelation of our unity with things is the foundation of everything sculptors do *qua* sculptors. *Perseus Holding the Head of Medusa* (Fig. 30) by Canova or any work by Thorwaldsen or any monument in Gettysburg does not impact into space much more, if any, than objects of similar size. Because their surrounding spaces are not significantly perceptible, we perceive such works basically the same way we perceive ordinary objects. When sculptors succeed, their work impacts into space, makes that space significantly perceptible, and we perceive ourselves physically with both that

space and the material body of that work. Their sculpture, provided we are capable of perceiving it sensitively, brings us back to our physical unity with things from which everything else is an abstraction. That physical unity was felt by prehistorical people and is still felt by primitive people with a power and understanding that escape most of us. Because it is so basic to our humanity, that understanding helps account for the appearance of sculpture before painting and architecture.

The origin of sculpture—the essential motivation that has moved human beings most basically to create and treasure sculpture—lies in the instinctual and essential need it satisfies: vivifying and clarifying our physical withness with things. That is the ultimate cause of the existence of sculpture. In turn, sculpture is an autonomous art because sculpture, by means of its special ways of enlivening space, reveals with special and informing vividness the spatial withness basic to being-in-the-world, to being the kind of beings we are.

Strict or experimental verification of such a sweeping hypothesis is not possible, of course. But I can attempt to make this claim plausible in the sense of what Paul Tillich calls experiential verification:

The verifying test belongs to the nature of truth; in this positivism is right. . . . The safest test is the repeatable experiment. A cognitive realm in which it can be used has the advantage of methodological strictness and the possibility of testing an assertion in every moment. But it is not permissible to make the experimental method of verification the exclusive pattern of all verification. Verification can occur within the life-process itself. Verification of this type (experiential in contradistinction to experimental) has the advantage that it need not halt and disrupt the totality of a life-process in order to distil calculable elements out of it (which experimental verification must do). The verifying experiences of a nonexperimental character are truer to life, though less exact and definite. [22]

Supporting evidence, mainly of the experiential kind, for locating the origin of sculpture in the drive to reveal our primordial unity with things will now be examined.

VIII

The Paradigmatic
Role of All-Roundedness

The first comprehension of depth is *an act of birth*—the spiritual complement of the bodily.

Oswald Spengler

Sculpture in the round rather than relief sculpture is likely to be chosen by most of us as more indicative of sculpture as a distinctive art. Using photographs I tested this generalization with 200 randomly selected college students. Photographs generally, and the ones I used specifically, significantly weaken our perception of the three-dimensionality of sculpture, especially sculpture in the round and high relief. Nevertheless, in every case most students (by at least two to one) selected the example with the greater three-dimensionality. Despite the fact that relief sculpture and sculpture in the round in most parts of the world coexist quantitatively on more or less equal terms, as L. R. Rogers points out,[1] sculpture in the round was taken by a very large majority to be the paradigm of sculpture. Such results are not a proof, of course, but they lend weight to D. H. Lawrence's point (see Appendix, p. 226) that the "intuitive perception" (or what I have been calling the aesthetic experience) of things requires all-roundedness—shape and volume in their full spatial completeness—for its ultimate satisfaction. Sculpture in the round, other things being equal, satisfies our need for perceiving things as three-dimensional and from all sides better than relief sculpture, and all sculpture, other things being equal, satisfies that need better than painting. (Of course, painting satisfies other needs better than sculpture.) Further weight is given to these claims by 1) the apparent dominance of sculpture in the round in prehistoric, primitive, and child sculpture, 2) the

136

seemingly inevitable growth from low to high relief to sculpture in the round in the development of most sculptural styles, [2] and 3) the movement in contemporary sculpture toward new ways of revealing all-roundedness, especially Environmental sculpture.

Most prehistoric sculptures are in the round, one of the roundest being the unforgettable *Venus of Willendorf* (Fig. 1), and most primitive sculptures of historical times, for example, the *Mother and Child* (Fig. 24), are also in the round. One reason for the quantitative dominance of this kind of sculpture has already been mentioned (p.120), but a more basic reason may be that both prehistorical man and primitive man may have found in sculpture in the round (and still find in the case of the latter) a manifestation that made more vivid and intelligible their constant, direct, and dynamic encounter with things. Their technology was limited, of course, and so they were immersed in experiences of pulling and pushing foreign bodies: making them move by means of their own bodies; failing to move them because the resistance offered was too great; being forced to move, in spite of resisting to the utmost, by the thrust of other bodies. Only in the wilderness, provided we are without sophisticated tools, can we feel something analogous to what prehistoric man felt and what primitive man still feels about the withness with things.

The Venus of Willendorf is very small, like most Paleolithic sculptures in the round, not only because there were great technical difficulties in making monumental sculpture in the round but also because small sculpture could be more easily transported by nomadic people. Lacking facial features, this Venus seems to withdraw into the fecundity which she embodies, completely collected and content in her own mass. Yet because she was made to be grasped from all sides and top and bottom, there is strong feeling of withness with her. Furthermore, the radial organization—the extension in more than one direction from an inner core—of the body helps exude energy into the surrounding space, the shapes "rolling out" like lava from a deep volcano, the imposed-upon space seemingly charged with heat. The vertical axis of the body is the spinal center from which this energy expands, each wave of rounded shape leading to another. The *Venus of Laussel* (Fig. 2), on the other hand, is much less impacting into the surrounding space because the flat surface of her body forms a plane that tends to divide us from her. She is also far less tangible because we cannot grasp her body, only touch its front surface. Despite the fact that carving sculptures in the round tends to be technically more complex than carving reliefs—other things being equal—it seems likely that sculpture in the round

137

dominates relief sculpture in both prehistoric and primitive societies because sculpture in the round gives a more vivid revelation of the worlds of these societies. Prehistoric and primitive sculptures of all types are usually over-whelmingly sculptural because they impact into space so powerfully. No one is likely to mistake them for painting. And this is especially true of the sculptures in the round.

Child sculpture is almost always in the round. The "primordial ball" presenting radial or three-dimensional expansion of a thing, whether human, animal, or inanimate, into its surrounding space is the counterpart of the "primordial circle" of painting representing the nonradial or two-dimensional expansion of a thing on a plane. Then with the ball comes the sausagelike sticks that, as Arnheim points out, produce directionality—the device of countless young children as they work in playdough, putty, and similar materials.[3] Unfortunately systematic studies of children's work with three-dimensional materials have been very limited.[4] My observations indicate that most very young children, up to at least the age of seven, enjoy playing with three-dimensional materials such as putty more than with two-dimensional materials.[5] They seem to find modeling more natural than either drawing or coloring. If they are just playing with materials or forming interesting patterns, then three-dimensional materials seem to be less inhibiting. If they are trying to portray some event or thing, then the tactile sensations of the developing structure from all sides seem to aid their representation (although to adults the three-dimensional representation often seems more clumsy than a two-dimensional representation). These observations are confirmed by Charles Biederman who experimented with children between the ages of four and eight by having them draw and model a chair. He concludes that a "general pattern of events prevailed: namely, difficulty and reluctance to cope with the problem of drawing the chair—the visual image; confidence in making a chair with form-material—the tactile 'image.'"[6]

When very young children draw or color, furthermore, they tend to go at it as if they were modeling, often using both hands simultaneously if the pencils or crayons or brushes are available. Grozinger comments, "The child still feels itself to be entirely two-handed, a *bilateral* being. After all, it is not so long ago that the scribbling hand, together with its companion, was helping in the process of crawling about—two hands and two feet were used, and both hands still distinctly remember what it felt like when they closed round things for the first time."[7] The very young child works on two-dimensional materials with the

rhythm of his whole body—reminiscent in a crude way of the action painting of artists such as Jackson Pollock—producing effects that recall the macaroni patterns streaked on the walls of caves by prehistoric man. The motion of the child's arm and torso shows in the scribbles, ovals, circles, and their interlacings; and sometimes breathing also shows its effects, especially in the lovely "in and out" or "breath" patterns. Consequently, the very young child is more at home in three-dimensional materials than in two when he creates, for his body is completely attuned to the concreteness of three dimensions. His grasping hands are his anchors in reality. With three-dimensional materials what his eyes see his hands can touch and grasp, whereas with two-dimensional materials what his eyes see his hands can only touch. When working with two-dimensional materials, he inevitably tries to portray three-dimensionality. Thus Arnheim reports, "Kerschensteiner, who examined a large number of children's drawings, claims never to have found a 'stick man' whose trunk consisted of a straight line. This, he says, seems to be an artifact of adults. Apparently a drawing must contain at least one two-dimensional unit in order to convey the solidity of "thingness" in a way satisfactory to the child. Oval oblongs are used early to combine solidity with 'directedness'—for example, in the representation of the human or animal body."[8]

Prehistoric, primitive, and child sculpture remind us that sculpture in the round was not a latecomer, as might be suggested by the evolution from low to high relief to sculpture in the round in most historical styles. The dominance of sculpture in the round in prehistoric and primitive societies as well as in the work of children strongly suggests that sculpture in the round, more than relief sculpture, satisfies the distinctive sculptural function: clarification of our withness with things.

It should not be supposed that the presentation of things, especially when complexly structured, in three-dimensional materials is necessarily easier than the representation of things in two dimensions. The conception and techniques of three-dimensional organization have to be mastered step by step, just as with two-dimensional organization. The added dimension often accentuates the problems, analogous to the added complexities of solid compared with plane geometry, as Plato noted in the seventh book of *The Republic*. Consider, for example, the difficulties involved in rendering the iris and pupil of the eye in three dimensions. It was not until the Hellenistic period that sculptors found a way of indicating the iris by cutting a circle into the eyeball and the iris by drilling a small hole within that circle. The shadow of that hole gave the effect of

139

a dark pupil, while the ridge around the hole caught light in a way reminiscent of the flash of the human eye. Moreover, since in reality this light shifts with a person's turn of the eye, the ridge enabled the sculptor to fix the direction of the look. Such discoveries, even ones as apparently simple as these, usually take a long time to be worked out. So as sculptural styles develop, there often seems to be, in retrospect, an inevitable evolution from low relief toward roundedness. In Greek, Medieval, and Renaissance styles, respectively, these evolutions took centuries. Herbert Read asserts, "The human race was not divinely gifted with the ability to perceive the three-dimensional character of objects: only gradually did it acquire that ability."[9] On the one hand, Read's claim that we gradually have to learn to perceive the three-dimensionality of things is incorrect.[10] Even as infants we perceive things as solids. The visual perception that sees only two dimensions is an abstraction from the primary perception of things, for things as they manifest themselves show forth as voluminous. Whitehead remarks that he is "very skeptical as to the high-grade character of the mentality required to get from the coloured shape to the chair. One reason for this skepticism is that my friend the artist, who kept himself to the contemplation of colour, shape and position, was a very highly trained man, and had acquired this facility of ignoring the chair at the cost of great labour."[11] On the other hand, if we take Read's claim to mean that there is a gradual increase in the ability to perceive the complexities and subtleties of three-dimensionality, then that claim is correct. That is why so many sculptural traditions begin with low relief.

Sculptors are especially sensitive to the three-dimensionality of things, and yet they continually have to learn—unless they fall back on repetitions—how to bring out unperceived aspects of three-dimensionality. Every sculptural style uncovers new aspects, the newly opened up aspect leading on to another. Thus the "coming out" of the body of the *Female Personage* (Fig. 7) from the wall of Chartres was one of the precedents for the further coming out of the *Eve* from Reims (Fig. 8). It is very difficult to conceive of a reverse development. The cumulative chains of mining out three-dimensionality, sometimes leading into blind alleys before the veins are exhausted, often are the evolutions of low relief to sculpture in the round in many sculptural styles. In following the tracks of those discoveries, we gradually refine our perceptions of three-dimensionality, enriching our awareness and understanding of our withness with things, for three-dimensionality makes possible not only the showing forth of a thing as a thing but also the unity of that thing with other things and ourselves. The interweaving of volumes is the process that makes it possible for us to be

140

beings-in-the-world. Only from that primordial unity is it possible to abstract two-dimensional images from things or imaginatively project such images.

In the following discussion I shall not attempt to describe even the outlines of the evolutions of sculptural styles from low to medium to high relief to sculpture in the round. These progressions are well known and rather obvious in their basic developments, and the details and subtleties have been explored and reported in many treatises. Rather, drawing examples from various styles, I shall compare differences among kinds of relief sculpture and sculpture in the round concerning how these modes of sculpture bring out various features of three-dimensionality, how these features impact differently into space, and how sculpture in the round is paradigmatic of traditional sculpture because it exemplifies, more than relief sculpture, the coming forth of things in enlivened space. Probing these issues digs to the roots of the origin of sculpture.

At the stage at which a sharp tool has done no more than scratch lines on a flat surface, it is difficult to distinguish sculpture from drawing. The moment the scratches become incised lines or indentations cut through the surface to a perceivable depth, the sculptural may begin to separate itself from the pictorial, enlivened space may begin to come forth with the deepening three-dimensionality. Thus the *Venus of Laussel* (Fig. 2)—like the *Venus of Willendorf* (Fig. 1) probably an icon to promote fertility—was outlined by "pecking" holes or hollows that were joined by carved lines. The foremost features of her body meet the most forward or frontal plane, which is part of or very close to the uncarved and roughly flat surface of the stone. A pane of glass placed over this frontal plane and the surrounding surfaces of the stone would confirm our perception, despite the unevenness of the stone, that the outermost points of her body meet approximately along the plane joined by the surrounding surfaces, the three-dimensional shapes of the body being brought out by the cutting in from this frontal plane. Since this cutting was shallow, generally less than two inches, the prominent features—especially the drooping breasts, the bulging hips, the hand over the womb, and the horn, perhaps a symbol of plenitude—are easily perceived as part of the frontal plane, the gathering of these features on this plane helping produce a compositional unity. Furthermore, since there was no polishing, the stoniness of the limestone was preserved, this texture strengthening the impact into space. On the other hand, the shallowness of the cutting limits our perception of the depth of her figure, and the lack of a clearly defined rear plane makes our perception of the volume ambiguous, both factors weakening the impact into space.

141

The riders and their horses from the Parthenon frieze (Fig. 4), probably designed by Pheidias and executed by his craftsman around 440 B.C., were cut to approximately the same depth as the *Venus of Laussel*, and their outermost features also meet to form a frontal plane. With these figures, however, a clearly defined rear plane, smooth and flat, was carved behind the frontal plane. The parallel frontal and rear planes box in the figures, forming close three-dimensional limits within which the overall shapes and details of the figures are organized in a careful scheme of stylized naturalism. Since the rear plane is much more distinct than the frontal plane, the figures seem to come toward us despite their strong leftward movement. This effect is reinforced by the tilt of the frieze, cut so that the lower parts project only 1 1/4 inches from the background plane, whereas the upper parts project 2 1/4 inches. Most observers are surprised that the cutting is so shallow. The powerful movement toward us produces an illusion of greater depth. Since the frieze was placed on the cella wall directly below roof level and within the surrounding colonnade, the frieze was viewed at a steep angle from points about thirty-three feet below the frieze and only eight feet from the wall. The frieze was relatively dimly lighted, much of the light being reflected from the marble floor, and this reflected light tended to cast the shadows upward, hiding somewhat the rear plane. Thus the tilt not only helped bring the frieze into clearer focus but, by making the rear plane more visible, it also helped give the elements of the frieze an outward movement. Even more so today, as we see the frieze at almost eye level in the artificial light of the British Museum, the rear plane acts as a "ground" from which the "figures" come out. With the *Venus of Laussel*, conversely, the frontal plane is much more distinct than the rear plane, and so the frontal plane acts as a "ground" from which the Venus tends to keep her distance. In this respect, the impact into space by the riders and their horses is considerably greater than that of the Venus. With respect to textures, however, the impact into space by these figures is less than the Venus. Because the marble has been so delicately worked over and polished, the frieze figures seem very thin-skinned compared with the thick-skinned Venus. In turn, the skins of the riders and their horses seem to exude less outward energy. In general, the thicker a surface appears the more it emanates forces into its surroundings. The thin surfaces of the frieze figures are compensated to some extent, however, by our perception of the life beneath the skin, the suggestions of blood, bone, and sinews. The contour lines have not been imposed upon the figures as borders but seem to have grown organically and inevitably from the inside. Furthermore, the rear and frontal planes by

142

clearly showing the depth and the surface reinforce our feeling of the interior mass of the marble. These distinct limits make the figures appear thicker and denser than the Venus, helping account for their solid impact into space.

The greater the sense of definite volume and density, as a general rule, the greater the impact into space. For example, the magnificent life-size head of the *Moon Goddess's Horse* (Fig. 5) from the east pediment of the Parthenon, either by Pheidias or under his supervision and completed a couple of years later than the frieze, has considerably more impact into space, not only because it projects toward us more strongly but also because of its "almost all-roundedness." This sense of a more complete volume gives us a more complete sense of its density, as well as vibrancy and warmth of living flesh. Furthermore, the marble impacts toward us because the suggestion of the rear plane, actualized originally by the back wall of the pediment, and the absence of a frontal plane as a barrier allows for a strong forward momentum. The structure is more radial than planar, however, for the marble seems to expand outward from a central spine running diagonally from back to front. The impact into space is reinforced by the lights and shadows which play out much more forcefully than on the figures of the frieze, so much so that in the openness of the pediment to the strong Grecian sunlight color probably was used to tone down the reflections that could have confused the textures, shapes, and outlines of the marble.

Tino di Camaino's *Madonna and Child with Queen Sancia, Saints and Angels* (Fig. 11), originally part of an altar in the Badia of Cava dei Tirreni near Amalfi, has a planar organization, like the Parthenon frieze, within an extremely compacted depth of slightly more than one inch between the frontal and rear planes. The moldings of the square forthright frame with its pedimental top help establish the frontal plane; the blank marble behind the two upper angels establishes a strong rear plane; and four subtly differentiated planes intervene between these two limiting planes. The fore points of each figure's head, the foremost side of the Child's body, and the lower legs of the Virgin join with the bodies of Queen Sancia, at the lower left, and Saint Francis, at the lower right, to help form the frontal plane bounded by the moldings. The fervent glance of the Queen directed toward Saint Francis seems to startle him. This psychic tie helps solidify the lower half of the frontal plane, helping, in turn, to balance the solidity of the upper half of the rear plane. The wings of the angels as attached to the back of their shoulders establish the plane closest to the rear plane; the next plane is shaped by the bodies of the two upper angels; then comes a plane shaped by the robe held by these angels; finally, the upper body of

the Virgin, the bodies of the two lower angels and Saint Clara (above Queen Sancia) organize the last plane about one-half inch back of the frontal plane. All the planes behind the frontal plane, except the static rear plane, flow forward, guided by the projecting diagonals, the outwardly curved contours, and the focus on the Virgin and Child. This forward movement is channeled rapidly into the space immediately in back of the frontal plane. Here the movement slows down somewhat, not only because of the greater spaciousness of this last space, tiny as it is, but also because diagonal shapes, especially the turn of the Child's body on the right and the Virgin's arm on the left, draw the forward expansion to a meeting place at the Child's hand. With the heads of the outlying figures and the feet of the Virgin like bumps on the perimeter of a turning wheel, the Child's hand is its hub. The rapid push from the rear becomes a slow circular motion in front. Even so, the compression of energy is claustrophobic. In this respect, Tino's *Charity* (Fig. 12) seems much more comfortable. The tension of the *Madonna and Child* is almost unbearable, despite the calm of its protagonists, but it helps reveal the otherworldly significance of the sacred scene.

Donatello's *The Feast of Herod* (Fig. 14), one of the six panels around the hexagonal font of the Baptistery of Saint John in Siena, is an even more remarkable example of the power of low relief to enliven space primarily by means of very compact, flattened-out planar organization ("stiacciato"). In the dark Baptistery, built into the steep cliff below the apse of the cathedral, the font panels are barely visible. When the old Italian guardian, like a character from Dante, swings his lamp in front of the Donatello, the reflections sparkle and flash like fire from the smoke-blackened bronze. The space in front of the bronze is immediately activated, powered further by the many sharply articulated and compressed planes that energize the slices of space, shoving them toward us with the accelerated speed of a tidal wave. Compared with Tino's *Madonna and Child*, this forward flow is even more irresistible, not only because the bronze has a greater tension and spring but also because the greater number of more distinct planes are arranged in a rhythmically repetitive expanding order that more tightly funnels the swelling spaces. Nor is there, as in the *Madonna and Child*, a "pinwheel" effect that cushions this forward expansion. The nearer figures are perceived as increasingly larger and more animated—not so much because they are actually much larger or because they are closer to us, for these size and distance differentials are very small, but because the geometrically expanding planes pass on energy which fills out and charges

144

the figures, especially those closest to the frontal plane, with a vitality that is almost too much for them to contain. Thus the heads of Salome and the servant with the head of the Baptist expand into the round, Salome's body is bursting with motion, and the little boys on the far left are being pushed off the scene. Rodin once remarked that "procession is the soul of bas relief,"[12] meaning sideward movement as in the Parthenon frieze. However, sideward movement is basically pictorial in the sense that it minimizes impact into space, whereas frontal movement is basically sculptural in the sense that it maximizes impact into space. Few low reliefs embody the soul of sculpture—its impact into space—more strikingly than *The Feast of Herod*. That impact makes the drama of the events presented all the more dramatic. *The Feast of Herod* can make one tremble.

Donatello, according to H. W. Janson, was the first to use in this relief the newly discovered linear perspective as developed by Brunelleschi.[13] Linear perspective creates a grid within which the inwardly leading lines are orthogonals, i.e., they project perpendicularly from the frontal plane and lead in depth to a single vanishing point. In *The Feast of Herod* the dominating orthogonals lead to a vanishing point slightly above the center of the panel, on the eye level of the three figures seated at the table. However, the inwardly leading lines in the upper righthand corner do not fit into the grid of the rest of the panel, a strangely effective incoherence adding to the mysterious force of the tragedy. Donatello also used the "window-box perspective," first theoretically formulated by Alberti and described by Leonardo as "nothing else than seeing a place behind a pane of glass, quite transparent, on the surface of which the objects behind the glass are drawn." Thus the frontal plane of *The Feast of Herod* functions like a window, with the borders of the relief functioning as its frame, through which we perceive the planes beyond arranged parallel to the window. Linear perspective and window-box perspective were developed concurrently, first to systematize real depth relationships in architecture and then to systematize illusory depth relationships in painting. But no one is likely to mistake *The Feast of Herod* for a painting, because the impacting forces of the planar organization bring out actual as well as illusory three-dimensionality. The orthogonals constantly come up against planes that are not transparent like panes of glass but solid bronze. And when the orthogonals reached the background plane, Donatello used sharply engraved lines to emphasize their striking impact, their forces rebounding into the between. Indeed, the impact of the enlivened space is so strong that I, at least, have never wanted to touch this bronze, as if it were

145

electrically charged. Any further tactile impact would have been too over-whelming, as if my haptic response to any greater tactile stimulation would, like a bell rung too loudly, shatter the harmony of my perceptions. And, further-more, even if this effect did not occur, touching the surfaces of this relief would destroy the illusion of very deep space.

The power of Donatello's planar organization becomes even more evident when compared with Ghiberti's more famous East Doors of the Baptistery of Florence (Fig. 16), commissioned in 1425 and completed in 1452. Almost every device available to the Florentine painter of the early Renaissance was used by Ghiberti for creating the illusion of spatial depth. He remarks in his *Commen-taries:* "I strove to realize in what manner an object strikes the vision, and how best to understand the theory of graphic and pictorial art." He was very successful, the pictorial illusion of depth coming close to nullifying the impact of the actual three-dimensionality. The representation of some of the scenes from an elevated height ("bird's-eye perspective"), the linear perspective, the window-box perspective, the retreating undulations of the earth, the higher placement of more distant objects, the overlapping and diminishing sizes of objects, including foreshortening in many instances, the increase in delicacy of modeling as the size of objects decreases, and even a progression from a clear to hazy atmosphere, the forms in the far distance fading off into the background, suggest an unlimited space in which the various biblical events take place. The orthogonals of each panel lead to a vanishing point, pivoting every thing as if on hinges within their paths, and squeezing them toward a vague horizon. Whereas Donatello's orthogonals lead through a series of distinct crossing planes to a clear-cut rear plane, Ghiberti's orthogonals do not cross such sharply delineated planes—except in the panels of *Jacob and Esau* (third panel from the top on the left) and *King Solomon and the Queen of Sheba* (bottom panel on the right)—and in place of clear-cut rear planes there are fluid matrices. Whereas Donatello's rear plane is a solid object in its own right, Ghiberti's rear planes permit the illusion that one sees through them to spaces beyond. In these East Doors, unlike his more sculptural and earlier North Doors (1403-1424), Ghiberti avoided solid background areas that could function as the bases for planar organization. Instead, the surface planes of Ghiberti's panels, set up by the surrounding frames, are the planar basis for organizing the structures behind and in front of the surface—so-called surface or flat relief. Since these surface planes are barely perceptible, the very noticeable projecting high-relief figures, sometimes on "shelves," merge into the surface planes and then into the

backgrounds in such a way that we perceive straight through the spaces because the hardly noticeable planes, unlike Donatello's, are also made porous by an open atmospheric chiaroscuro that facilitates smooth passage. The solid crusts of Donatello's planes are pierced and vaporized, for Ghiberti's bronze, unlike Donatello's, has a viscous flow. Foreground, surface plane, and background are a continuum, and space wanders off into the infinite. Whereas with Donatello's panel our perception begins with the rear plane and moves forward, with Ghiberti's panels our perception begins with the nearest figures and moves backward. Given their respective subject matters, Donatello appropriately keeps us at the edge of the impacting between, whereas Ghiberti appropriately invites us through his *Gates of Paradise* into the Baptistery. Unlike Donatello's bumpy outward journey through the scaffolding of planes, Ghiberti's smooth penetration into space is similar to most Florentine Renaissance paintings, but even so the panels are sculptural for two basic reasons. In the first place, the bronze—especially when its gold plating has just been cleaned, as after the flood of 1966, and the gasoline fumes have not yet had time to work their blackening havoc—reflects the light and shadows in a glinty way that only three-dimensional metallic material can do, and this produces a vibrant and airy countermovement to the inward penetration. Second, the human figures are so precisely and exquisitely modeled, especially the ones in high relief on the "shelves," that their solidity fills up and counteracts to some extent the porous quality of the spaces.

These high-relief figures of Ghiberti compared with his low-relief figures in the same settings exemplify the principle that the more full-bodied a volume and the more its mass is perceptible, the more it presences physically and, in turn, the more sculptural it appears. This need to bring out the thing in its full individuality or thingliness in enlivened space is the ultimate drive that pushes sculptors on toward sculpture in the round. Low-relief sculptures may have great impact into space and, in turn, on our visual and tactual sensations, as Tino's *Madonna and Child* (Fig. 11) and Donatello's *The Feast of Herod* attest. These works are strongly sculptural. Other things being equal, however, the higher the relief and the greater the volume and mass that show forth, the greater the impact into space and the physical presencing, as a comparison of the heads of the horses from the Parthenon (Figs. 4, 5) demonstrates.

The *Female Personage* (Fig. 7) by the Master of the Portail Royal, in the splayings to the right of the central door of Chartres Cathedral, is carved from the same block as the "working column." Although as part of the column she

147

comes out from the wall, she remains part of the architecture, emphasizing its lines and sharing its substantiality and majesty. According to J. K. Huysmans, "Never in any period has a more expressive figure been thus wrought by the genius of man." Even when isolated as in this photograph, she appears much more substantial than the figures in Tino's and Donatello's reliefs. The wall to which she and the column are attached functions as a rear plane, and the frontal plane is gracefully articulated by long vertical lines and folds, although that frontality is somewhat compromised by the subtle curves of her body. There are no other distinct planes, but the perceptible thickness of that long rectangular body, with its lovely crowned and haloed head in higher relief, gives this stone pillar of tenderness a slow, steady impact into space, quite unlike the fast staccatolike rhythms of the marble of Tino's *Madonna and Child* and the bronze of *The Feast of Herod*.

About a hundred years later, the *Eve* from Reims (Fig. 8), perhaps by the Master of the Queen of Sheba, steps out from her wall. Although the wall still functions as a rear plane, her more rounded, supple shape weakens the frontal plane so much that, unlike the *Female Personage*, there is no clear planar organization that channels energy into the surrounding space. Eve's body, furthermore, is not nearly as compact as that of the *Female Personage*. In these respects there is a considerable loss of impact. Yet Eve's more three-dimensional body, radially organized, amply compensates. Although she does not quite escape the wall, we sense her weight on the pedestal and her feet as gravitational anchorages, and as we move from side to side we perceive all of her body except the back. *Eve* comes forth as almost a full body, pulsing with blood, and this increase in what appears as "living mass," as contrasted with the relatively "inert mass" of the *Female Personage*, increases her thrust into space.

Radial organization involves extensions in more than one direction, not from a plane but from an inner core, reaching its culmination when the radiation extends in all directions. Of course, every three-dimensional thing exhibits some radiality, for in being aware of "outside" and "inside" we inevitably sense expansions from the "inside." At the same time, every three-dimensional thing also exhibits some planar aspects. Even the round ball, no matter what the angle of perception, suggests planes cutting through its middle. But in most sculptural traditions, planar organization tends to be superceded by radial organization. Rodin, who organized almost all of his sculptures radially, declared: "Each profile is actually the outer evidence of the interior mass; each is the perceptible surface of a deep section, like the slices of a melon, so that if

one is faithful to the accuracy of these profiles, the reality of the model, instead of being a superficial reproduction, seems to emanate from within. . . . In a reproduction of nature . . . sculpture in the round approaches reality more closely than bas-relief."[14] When the inner core is of an organic body, usually a spine is indicated, as with *Eve*. When the inner core is of an inorganic body, usually there is the indication of either an axis (or axes), as with Brancusi's *Endless Column* (Fig. 50), or points of concentration or nodes, as with De Rivera's *Brussels Construction* (Fig. 67). Radial organization generally is more sculptural than planar organization. Radial organization tends toward roundedness and the sculptural, whereas planar organization, since it is structurally composed of combinations of two dimensions, tends toward flatness and the pictorial. With planar organization, even when it is as powerful as *The Feast of Herod* (Fig. 14), the aura of the pictorial remains. That is why low-relief sculpture and painting sometimes are so difficult to distinguish. This difficulty is especially evident when one plane completely dominates the others and tends to absorb them, as with the dominating rear plane of the Summerian *Running Animals* (Fig. 3), or when there are a number of very compact, barely differentiated planes, as with Ben Nicholson's *Painted Relief* (Fig. 52).

With Tino's *Charity* (Fig. 12) there is further development of radial organization and progression toward the full body. It might appear from the photograph that we should be drawn completely around the figure, but we are held back because the front completely dominates the sides and the back is of little interest. This work was evidently designed for the right field of an elevated niche, for she is turned and looks down to the left. The niche protects a sculpture physically from full exposure to the elements, governs the point of view from which the sculpture is perceived, and controls the angle and amount of light admitted. Generally the enveloping environment of the niche with its shadows is psychologically protective as well, suggesting in the case of religious buildings a shrine that shelters something precious. Furthermore, the wall of the niche can function as a rear plane for planar organization, as Tino probably intended. Thus in her present open placement in the Museo Bardini in Florence, *Charity* is very much out of place. Even so, something of a planar organization is still evident, for Tino kept his rounded shapes restricted in a framework of simple, relatively flat patterns: the outline of the back of Charity's body functions as a rear plane; more forward planes are suggested, especially the lower folds of the robe as they work out to the bent forward knee; and the slightly profiled frontality hints at a frontal plane. Compared with the *Madonna and*

149

Child (Fig. 11) and *The Feast of Herod* (Fig. 14), however, there is not much energy emanating into space from these planar relationships. The enlivening of space comes mainly from the radial organization of the marble, extending outward in all directions from the spine of this mother's massive body. The swelling oval shapes—the dreamy head, the drooping shoulders and arms, the soft breasts, the greedy babe on the left and the satisfied one on the right—"spill out" their plentifulness down upon the static solidity of the planes of the lower body and dress and then down into the space below, following her sad gaze into the distance. Our sense of gravitational force is much stronger than with the *Female Personage* (Fig. 7) or even *Eve* (Fig. 8), adding weight and resonance to our haptic sensations and harmonizing with the content of the statue, for *Charity* is a woman of the people, heavy and voluptuous, instinctive in her devotion to duty.

In the fifteenth and early sixteenth centuries, the Italian Renaissance style moved steadily toward radial organization and sculpture in the round. Even with relief sculpture, planar organization was often subordinated to radial organization. For example, in Luca della Robbia's *Cantoria* (Fig. 15), originally placed as a choir-gallery parapet inside the Cathedral of Florence, the rear plane is the only distinct plane, and it functions as no more than a point of departure for the vigorously expanding bodies. Gradually the oblique viewpoints of sculpture become more interesting but, as with *Charity*, the back remained unimportant. Finally, however, in the latter part of the fifteenth century in Florence at least two sculptures almost completely in the round were created—Verrocchio's *Putto*, c. 1470, for the Fountain in the Palazzo Vecchio and Antonio Pollaiuolo's *Hercules and Anteus*, c. 1480, in the Bargello. [15] With these sculptures every viewpoint is almost equally important. Yet even then they are small and very exceptional works, and it is not until Giovanni da Bologna and Mannerism of the late sixteenth century that monumental sculpture in the round without qualification not only appears but is also unexceptional. There were three basic reasons for this slowness of development. First, the technical difficulties in creating a representational work completely in the round, especially of a large size, are extraordinary. Second, most monumental sculpture was commissioned for architectural niches that made the rear more or less inaccessible. Third, human beings were usually portrayed, and the front side of most human beings is usually more interesting than the back side.

Michelangelo's sculpture, for example, was always of the human shape for

placement within architectural settings, and only gradually did radial organization become more interlaced with planar organization. Although Michelangelo's contract with the Opera del Duomo of Florence for the *David* (Fig. 19) did not settle on a specific site, his emphasis upon the 180° frontal arc indicates that he expected it to be placed against some kind of background. The Signori dell 'Opera, after much advice from a commission composed mainly of artists, agreed with Michelangelo's intent by having it placed in 1504 to the left of the main entrance into the Palazzo Vecchio in such a way that the massive rusticated front wall of the building served as a kind of a niche. In 1873, for the purpose of preservation, the *David* was moved to its present location in the rotunda of the Accademia. Now the back of the *David* can be better perceived, and it is carefully sculpted. Yet for most people the front is far more interesting, and the long tunnel that leads us to the rotunda correctly emphasizes this view. Nevertheless, the *David* would be more effective if it still possessed a niche with a close and flat background, an observation confirmed by the behavior of most spectators who swing back and forth slowly within the frontal arc of the *David*, but who upon going around the back rarely linger very long, as if wondering what they were supposed to be doing back there. The pull around to the back, furthermore, is weak because the figure is basically planar in its organization. It is radial to some extent, of course, for the body is rounded and all sides come forth from a vertical spine; but there is a blocklike flatness about the *David* because of the twist of the head, the sweeping plane of the torso, the pictorial quality of the smooth polishing done with abrasives, the delicate shadowing, and the thinness of the body which makes the rear plane set up by the back of the body seem unnaturally close to the front plane, given the gigantic proportions of the marble. Thus up to about thirty paces in front, the sharp outline of the *David* appears to be almost flat. This two-dimensional illusion may be partially accounted for by the rectangular block Michelangelo inherited, the block having been thinned down in the 1460s by Agostino di Duccio (the most pictorial sculptor of the Renaissance) for a David or more likely a prophet to be placed on one of the buttresses of the Cathedral of Florence. When Agostino did not finish the work, it was turned over to Antonio Rossellino in 1476 who apparently did nothing with it, and eventually it came to Michelangelo. But it also seems likely that Michelangelo accepted both this thinness and the still remaining suggestion of the original outer envelope of the rectangular quarried block as advantageous.[16] Such blocks lend themselves to planar organization, and the young male body, especially of the athletic type, is relatively planar.

Moreover, because of his thinness, *David*, despite his great height, is more easily perceived as a young boy facing a giant. In any case, Michelangelo never completely abandoned planar organization, even in the radial torsions of the four allegorical statues of Time on the caskets of the Medici Chapel or the serpentine figures of *Victory* in the Palazzo Vecchio and the *Christ* in Santa Maria sopra Minerva in Rome.

Michelangelo always carved in from one side of his block, rather than working in concurrently from all four faces, as did most Egyptian and ancient Greek sculptors. Thus a typical Greek marble statue of the sixth or fifth century shows four planes meeting one another at right angles with only the corners chamfered. Michelangelo's relieflike method lent itself to planar organization that shows even in sculptures in the round such as the *David*. As Rudolf Wittkower following Vasari describes it: "Imagine a figure in a basin filled with water lying evenly in a horizontal position. If you lifted the figure out of the water, it would slowly emerge, first the protruding parts, then you would see the figures as if it were a relief and finally it would appear in its three-dimensional roundness. . . . His procedure implies that the work will have one principal view—it is the view. . . that one will see emerging from the water."[17] Nevertheless, no sculptor has been more successful than Michelangelo in enlivening the space around the frontal arc of a sculpture by means of integrating radial with planar organization. The *Pietà* (Fig. 21) in the Cathedral of Florence, one of his last works, is an extraordinary example of this integration and power, despite the fact that it was unfinished and apparently even damaged by Michelangelo in a moment of frustration. Originally Michelangelo wanted to be buried in Santa Maria Maggiore in Rome at the foot of this sculpture. Hence he portrayed his own features in the head of Joseph of Arimathea and apparently was making good progress when a series of accidents occurred. In carving the left leg of Christ a vein in the marble broke, and there are also breaks above the left elbow of Christ, his chest on the left, and on the fingers of the hand of the Virgin. The story goes that in despair Michelangelo did some of this damage himself. Subsequently, he discarded the sculpture as a monument for his tomb and sold it unfinished in 1561 to Francesco Bandini, deciding he preferred burial in Florence. Tiberio Calcagni, a pupil of Michelangelo, restored some of the damaged parts and completed the figure of Mary Magdalene to the left. Although the general position and shape of the Magdalene may have been blocked out by Michelangelo, the final carving is not from his hand. The Magdalene's pose, relative to the others, is artificial and stiff; her robe, com-

pared with those of Mary and Joseph, fails to integrate with the body underneath; the marbleness of the marble does not come out; and the rhythms of her figure fail to harmonize closely with the others.

Despite the clear pyramidal outline of the statue, all the figures, except Christ, extend from a vertically oriented rear plane stabilized by Joseph, and even the right elbow of Christ extends back to that rear plane. Like a protecting shell, the head of Joseph hovers forward to join with Christ's head and left arm, shaping a strong vertical line that helps establish a frontal plane behind which the S curve of the highly polished body of Christ is tied. About mid-distance within the pyramid a rightward moving plane composed of the upper body of the Magdalene, Christ's torso, and the upper body of Mary crosses the space between the vertical rear and frontal planes, stilled in its motion by the tender parenthesis of Joseph's hand on Mary's back. These intersecting planes, centered on Mary's hand, suggest a cross, as well as stabilizing the slippage of Christ's huge body, for the support of that immense weight by the others, especially Mary, is wondrous. Within this planar grid, parallel planes, diagonals, curves, and twisting shapes push out radially from the axis of the pyramid. A pattern of linked ovals helps us perceive that, despite the complexity of configurations around the grid, the axis of the pyramid is the backbone that binds everyone together except the unfortunate Magdalene. Appropriately, this binding is so powerful that the face of Mary remains fused with the face of Christ. The delicate carving of these faces softly cross-hatched by a fine claw chisel hardly breaks the skin of the stone, producing an extraordinary combination of heaviness and tenderness.

The most obvious oval is formed by Joseph's hood, repeated at the opening of his neck. These connect with the oval shaped by the crook of Mary's arm to form a larger oval. This same crook is the apex of another large oval, whose upper and lower lines are bounded by the bands across Christ's body that lead around the arc of the right arm of Christ and the arm of the Magdalene. Slightly farther down, this same arc leads to the intersection of the Magdalene's hand and Christ's knee to form another overlapping oval that runs up the inside of Christ's left arm to his right shoulder. Finally, a fourth major but less obvious oval has its upper apex at the right armpit of Christ, swinging across the band over his chest and down the inside of the left arm and lower leg of Christ until it meets the lower leg of the Magdalene. Then we perceive, even if we do not see, a curved line moving up to Christ's right hand, thus making a closure. The completion of this "unrealized oval" is forced upon our perceptions by the

dynamism of the "realized ovals" and the "almost completeness" of the pyramid which "needs" an outline on the left. The ovals are planar in their overlapping but radial in their diagonal turning, suggesting a common center around which, like satellites, the ovals rotate. The overlapping planes move forward, the oval shapes twist around, and the dense mass of the marble, except for the Magdalene, seems to burst out into space. Although the lights and shadows are reflected outward from Christ, on the rough surfaces of Joseph and especially Mary the light is diffused, giving them an inner glow, and throughout the shadows help bring out the three-dimensionality of the shapes. The enlivened space is electric with intensity and forces us to move, and then everything changes, but the shapes continue to come forth dynamically, the ovals, for example, being perceived not as static ideal forms but as the limits of emerging things. We are drawn in but at the same time held back from the material bodies, for like a tomb the pyramid closes in on itself. Few people touch this numinous marble. We are drawn from side to side, each step opening up a new aspect. Elliptical masses become round, and round masses become elliptical; diagonal lines become straight, and straight lines become diagonal; light becomes shadow, and shadow becomes light; the spaces between the masses change proportion; the pyramid becomes more or less obvious. The impact into space becomes overpowering. Yet finally mass, volume, line, light, shadow, silhouette, and space achieve an almost perfect equilibrium, a sublime context suggesting that the Resurrection will follow this Deposition. There is no pull around to the rough-hewn back, except our need to escape for a moment from the intensity of the spatial forces and the awesome compassion. Even in our time of the Death of God, this *Pietà* may bend our knees.

With Giovanni da Bologna's *Rape of the Sabines*[18] (Fig. 22) in the Loggia dei Lanzi of Florence, sculpture achieves a kind of Copernican revolution, a complete centeredness that forces our orbiting around it as the earth around the sun. No beginning position is given or any direction regarding orientation from which to perceive these intertwining figures who represent, according to Bologna's description, "a proud youth seizing a most beautiful girl from a weak old man." The all-roundedness without any dominant viewpoint brings us back full cycle to the *Venus of Willendorf* (Fig. 1), except that the *Venus* is so small that we orbit her imaginatively around us. There are a few monumental sculptures in the round before the *Rape* that also compel us to orbit around, but with a few exceptions such as Trajan's Column in Rome there are almost always "way stations" that arrest our motion, as with the *Farnese Bull*, of the Hellenistic

period, from Rhodes and now in Naples, and the *Laocoon* by Agesander, Athenodorus, and Polydorus of Rhodes, late second century B.C., now in the Vatican. With the *Rape* we circle without any stopping places.

The "serpentinata" or spiraling line of the *Rape*, like Trajan's Column, strives for freedom from the niche and any kind of surrounding obstruction. Thus the Loggia, chosen by the Grand Duke Francesco dei Medici, is an unfortunate location, for it prevents our unobstructed circling. Each turn of the screw of these intermeshing marble figures turns the forces in the surrounding space and turns us as well. As we travel around, our eyes swing upward in order to get a better view of the upper masses, tending to widen our circuit; but, unfortunately, other sculptures in the Loggia and the balustrade break the rhythm of this expansion. In this respect, the completely accessible placement of the plaster model in the Accademia of Florence is much more satisfactory.

Although horizontal planes cut brutally across the upward spiral, for example, the back and shoulders of the young man, there is not much planar impact because there is no base, such as a rear or frontal plane, from which a continuity of planes can be perceived. The impact into space is generated primarily from a vertical core from which energy radiates outward and upward in widening circles. No ideal boundaries of the block, as with Michelangelo, restrict the contours and the protruding extremities. As Hercules took the load of the sky off the shoulders of Atlas before turning him to stone, Bologna made the twisting young man appear almost impervious to gravity.

On the pedestal below is a bronze relief (Fig. 23) of the same subject matter. Planar organization dominates the background and radial organization the foreground. Except that this bronze below is so relatively small it may get overlooked, it is a fitting prologue to the marble above, for as we swing from side to side in front of the bronze our perceptual appetite is whetted for the complete solidity the violence of the subject matter demands, and which the marble above satisfies.

The *Rape of the Sabines*, with its democratic all-roundedness, culminates for the Italian Renaissance style the victory of radial over planar organization, of sculpture in the round over relief sculpture. Yet until Rodin in the late nineteenth century, as in *The Prodigal Son*, c. 1885, the many possibilities opened up by Bologna's discovery remained unexplored. In the interim periods, there are many variations on the theme of all-roundedness but nothing new. This is surprising, for in the Baroque style and on through the eighteenth and nineteenth centuries, monumental sculpture in the round reaches a domi-

155

nance it never had before. [19] For example, with Bernini radial organization is far more important than planar, and he rarely neglects the back side. Nevertheless, Bernini seldom abandons the frontal arc as the dominant view and in this respect seldom goes beyond Michelangelo. This frontal dominance is probably explained by the fact that the human figure was almost always involved in his sculpture—the exceptions are the *Elephant and Obelisk* in the Piazza Santa Maria sopra Minerva in Rome and a few fountains—and with human figures we generally want and have a face-to-face point of view. [20] Thus our memory images of other people are usually of the front, occasionally of the profile, and rarely of the rear. That is why, perhaps, there may be something of a tour de force quality about the *Rape*, and Bologna, in a letter to Ottavio Farnese, Duke of Parma, of 13 June 1579, wrote: "The subject was chosen to give scope to the knowledge and study of art." Of course, it is possible to make the human figure equally interesting from all sides without succumbing to the mere cleverness of craft. For example, in addition to the spiraling configurations of Bologna, the body can be distorted, as in Cubism, or the frontality of the face can be disguised, both devices being used by Laurens in his *Crouching Woman* (Fig. 44), producing in Proust's words "a perfect continuity unbroken by any intrusion of the eyes." In any case, the *Rape* is a very successful sculpture as well as being something of a technical experiment.

In the eighteenth century, the all-sidedness of sculpture advances beyond Bernini's principal view emphasis to a return to Bologna's democratic all-sidedness. Etienne-Maurice Falconet declared a generally accepted principle of eighteenth-century sculptors: "A work has to have as many viewpoints as there are points in space surrounding it." [21] Yet even in the best work, as in many of the sculptures of Falconet, Edmé Bouchardon, Jean-Baptiste Pigalle, and Canova, there is little sense of the mass radiating in all directions. Usually the mass is little more than an anchorage for the surfaces which almost float free. That is why such works appear so pictorial. However much the form is visualized from all round itself, the lack of power emanating from the inside out makes their work retain something of a relieflike character. Canova's *Perseus Holding the Head of Medusa* (Fig. 30) is a prime example; his *Cupid and Psyche* (Fig. 28) is a prime exception. If a group of relief panels were placed side by side in something of a circle, as with Baccio Bandinelli's panels around the center of the crossing of the Cathedral of Florence, then, even assuming that the transitional areas between the panels were rounded out, the effect with reference

to radial expansion would not be very different from most eighteenth-century sculptures in the round.

In the nineteenth century the master of all-roundedness and radial expansion was Rodin. His friend Camille Mauclair published in 1905 his impressions of Rodin's working procedures. "The study of movement has led him to give unlooked-for values to the general outline and to produce works which may be viewed on all sides and which continually show a fresh and balanced aspect that explains the other aspects."[22] "Rodin made successive sketches of all the faces of his works, going constantly around them so as to obtain a series of views connected in a ring. . . . He desired that a statue should stand free and should bear looking at from any point; moreover, it should remain in relation with the light and with the surrounding atmosphere."[23] Now taken in isolation there is nothing especially original about such procedures—Bologna, for example, surely must have used something like them—but Rodin combined them with procedures that produced what he called "cubic truth." He advised himself and others: "Imagine forms as directed toward you; all life surges from a center, expands within outwards."[24] As with *The Burghers of Calais* (Fig. 32), the radial effect is not so much a result of its all-sidedness, but rather that all-sidedness appearing as a result of internal energy spreading outward in all directions. This effect, furthermore, is augmented by the daring informal placement—nothing like this had been done previously in monumental sculpture—of the figures scattered about like stragglers on a rough street. The spaces between the burghers both absorb and enhance the radial pushes. When the placement is kept low to the ground following Rodin's intention, as in the Rodin Museum in Paris, we may feel an urge to mingle within those intervening spaces. Rodin paves the way to Environmental sculpture, i.e., sculpture that includes us within rather than at the perimeter of its space.

So powerful is Rodin's presentation of the core vitalizing the crust, that usually no one side appears more important than another, even in the case of the human body, for example, as with *La Terre* (Fig. 34). Moreover, this vitalization usually does not appear to come from the skeletal axis or from bone, muscle, and sinew as seen from the outside. Rodin reveals the human body not as it looks from the outside but as it is felt from the inside. Note, for example, the forehead of Jean d'Aire, the burgher on the far right, and his grip on the keys. Objectively both features are clumsy and overstated, but subjectively they look as we feel when under exceptional stress. Rodin was a sculptor of our haptic and

kinaesthetic feelings. That is why it is so difficult to perceive Rodin sculptures from photographs, for their stances and gestures are to be reexperienced internally. As Leo Steinberg says of *The Burghers of Calais:* "One must do it oneself and perform every one of these poses to realize how desperately these statues act out the drama of powerful bodies giving their whole strength to the labor of holding on. As though standing still were the utmost that could be asked of a man."[25] In his most powerful works, the human body is truncated, or broken into incongruous parts, or charged with desperate energy, or plugged with the accidents and inorganic intrusions of the making process. In turn, the energy of these sculptures takes on an aura of the cosmic. To quote Steinberg again, the strength "resides in the most irresistible energy of liquefaction, in the molten pour of matter as every shape relinquishes its claim to permanence. Rodin's form thus becomes symbolic of an energy more intensely material, more indestructible and more universal than human muscle power. And it is here, I believe, that Rodin links up with contemporary vision."[26] Rodin opened the path for the new ways the sculptors of the twentieth century have found to present roundedness.

Sometimes we talk about the "face of things," but with nonhuman beings, except insofar as we "humanize" them, a principal view is in general not so important, because, among other reasons, only human beings speak. In the twentieth century nonhuman beings have begun to rival human beings as part of the subject matter of sculpture. In turn, roundedness without a principal view, i.e., all-roundedness without qualification—as in Brancusi's *Bird in Space* (Fig. 49) and *Endless Column* (Fig. 50)—finally has begun to be explored in ways that go far beyond even Rodin's discoveries, expanding and deepening our perceptions of thingliness. For example, rotating machinery, as in the base of José de Rivera's *Brussels Construction* (Fig. 67), can show forth all sides of a sculpture without our moving. Lacking a principal view, such sculpture, even if not mechanically turned, lends itself to a democracy of directions and sides. As Marta Pan remarks, "I like sculpture which has neither front nor direction, properly speaking, but which can be turned in all directions, set on any side."[27] Gabo, as in *Spiral Theme* (Fig. 54), by means of internal transparency opens up all the parts and their relationships to inspection from every angle. All-roundedness is immediately perceptible. Anthony Caro, conversely, often delays our awareness of all-roundedness, and yet that very delay dramatically enhances that awareness. For example, in *Homage to David Smith* (Fig. 82), Caro uses a strategy of discontinuity: there is no orderly

158

sequence of gradually changing projections, and thus no readable relation from one side to the next.[28] Noguchi's *Portal*, black painted steel erected in 1976 in front of Cleveland's new Justice Center, because of its continuously curving steel pipe four feet in diameter, has gradually changing projections, unlike *Homage to David Smith*. Yet despite these projections there are, as with Caro's work, schismatic breaks between one facet and the next. From the front, the *Portal* appears monumental, much higher than its actual thirty-six feet, like a great post-and-lintel Japanese *torii*. From the left, the *Portal* is less monumental, gracefully curvaceous and simple. From the back, sweeping upward from a slant, the vertical dimension completely dominates, partially because our view is necessarily closer than from the other sides. From the right, the *Portal* becomes much more complex, swirling with intricate S curves. With both the Caro and the Noguchi, our awareness of all-roundedness is emphasized because the disparate facets are ultimately unified perceptually due to our conceptual knowledge—derived from walking around the sculpture—that these discontinuities surprisingly belong to one thing, that the disparate facets share a common mass.

Even with human beings as the subject matter, all-roundedness is being explored in this century as never before since the sixteenth century. For example, the use of holes through the body, as in Moore's *Reclining Figure* (Figs. 55a, 55b), helps us grasp the sculpture as a volume and also gives us access to the core. Open structures, as in Picasso's *Monument* (Fig. 48) and Julio Gonzalez's *Cactus Man* (Fig. 53), make all the sides more visible from any particular view. Sculptures such as Giacometti's (Figs. 57, 58) expose the skeletal and nervous core of the human body, revealing the axis of radial expansion that is the basis for our sense of all-roundedness.

The most revolutionary exploration into all-roundedness, however, has occurred with Environmental sculpture.[29] As I am using the term, works such as Edward Kienholz's *Portable War Memorial*, 1968, in the Wallraf-Richartz Museum of Cologne, or George Segal's *The Bus Driver* (Fig. 71), or Raymond Mason's *Une tragédie dans le nord*, 1977, installed in the Galerie Claude Bernard in Paris are not Environmental sculptures, for we cannot touch or enter. They are "tableaux," aspiring to the condition of the theater, being presented as if on a proscenium stage. With traditional sculpture in the round, the sculpture is the center and we walk around it. With Environmental sculpture, space is an ambiance and we are in the center of that space, turning or circling within the material structures of the sculpture that surround us.

159

Examples are some of the works of Robert Morris, Lucas Samaras, Bruce Nauman, Peter Berg, Mary Miss, Alice Aycock, Nancy Holt, Harriet Feigenbaum, Red Grooms, Charles Ross, and Richard Long. Such works often aspire to the condition of architecture, yet generally their inner space is not used for practical purposes (Grooms's *The Bookstore*, 1979, in the Hudson River Museum in Yonkers being a notable exception), and usually these works do not relate outer and inner space to the earth (some of Mary Miss's works, such as *Perimeters/Pavilions/Decoys*, 1978, installed at the Nassau County Museum of Fine Arts, Roslyn, New York, being notable exceptions). Environmental sculpture makes us more intensely aware of our bodies as radial centers that orient our immediate environment and even sometimes our worlds, more consistent with the cosmic view of Ptolemy than that of Copernicus. Space is sensed as a continuum organized around us.

Bruce Nauman's *Corridor* was installed in the Wilder Gallery, Los Angeles, in 1970. The corridor, measuring about 17 feet high, 36 feet long, and 3 feet wide, includes a video camera high on a wall near the entrance and a video screen on the floor of the closed-off far end. Walking down the corridor, we can see the image of our backs on the screen. Coming closer to the screen, we can see our image receding and becoming smaller, for we are moving away from the camera. Although spatial orientation is very confused as we approach the screen, we feel the spaces around us as enlivened and organized by the centering power of our moving bodies.

Robert Morris's *Labyrinth* (Fig. 90), a temporary project now dismantled, was constructed of masonite and plywood painted gray about 8 feet high and 30 feet in diameter. Seven spiraling rings of walkways about 1 1/2 feet wide tightly guided us, like balls rolling in a groove, along a 500-foot one-way passage to the goal—the center. As we gropingly proceeded we had no clear idea of where we were, except that we were circling inward. There was a claustrophobic effect, despite the opening above, and our tactual and kinaesthetic sensations were strongly stimulated as we touched and rubbed against the wooden walls. We sought the sensations of these walls for security, compensating partly for the anxiety created by the inability of our vision to discover where our path was leading. As we circled, we underwent a disoriented dialectic between the inside and the outside. We perceived the inside and, at the same time, thought the outside as being somehow organized around the inside. But once we arrived at the center—an opening about four feet in diameter that allowed for the first time a sense of a little spaciousness—we had an intense feeling of being located,

placed. The center enclosed us like a womb. We rested. Then we wound ourselves outward, and this reversal of direction helped unify our sense of space with time. "Grasping time," says Piaget, "is tantamount to freeing oneself from the present, to transcending space by a mobile effort, i.e., by reversible operations. To follow time along the simple and irreversible course of events is simply to live it without taking cognizance of it. To know it, on the other hand, is to retrace it in either direction."[30] The spatial meaning of the *Labyrinth* lies not in the sum-total record of individual perceptions of it but in the concretion of a temporal gestalt, a meld of interrelated perceptions, as with listening to music. The "feel" of the sculpture was the result of a personal reconstruction of the event of passage that took about five minutes. We finally perceived the sculpture, despite our previous confusion about its structure, as a domain that in its all-roundedness made us more aware of both the mobile and immobile all-roundedness of our bodies. As Gaston Bacholard observes: "For when it is experienced from the inside, devoid of all exterior feature, being cannot be otherwise than round."[31]

Samaras's *Mirrored Room* (frontispiece) is also an exceptional example of the power of an Environmental sculpture to make one aware of being in the middle of encompassing space. A large room shaped as a cube is constructed of more than one hundred square mirror panels, inside and out, floor and ceiling. Inside the room there are outlines of a table and chair also made of mirrors. We are presented with a seemingly boundless penetration of perpendicular extensions in every direction, a hallucination of infinity. Kim Levin writes: "The effect was less narcissistic than the idea—endless receding space stole the show from the human figure, which diminished on all sides to infinity. The body became the object—the pin, the jewel, the star—caught and endlessly shrinking into infinity in the floor, ceiling, walls, in each mirror panel of the room. The spectator is the multiplied object of fascination, fascinated with himself and horrified as he sees himself a mile down through endless boxlike spaces, vanishing into invisibility."[32] However, despite their infinite recessions along the perpendicular axes, one's images rebound against one another with the slightest turn of the eyes, filling the space of the glass cube with inrushing forces of "yourself." One is both outside and inside, not confined but contained. Motionless we perceive an incredible extension; moving we perceive an unbelievable compression. When we remain motionless the mirrors are transparent windows through which our images sweep like ghosts; when we move, the mirrors become glinty metals that throw back our images like meteorites.

161

Standing still the reflective glass is invisible; turning transforms invisibility into physical presence. Eventually we feel ourselves as the solid, all-rounded center from which all those images stream forth and reflect back. And then as we leave this magic room the images disappear, an instant erasure of enlivened space. But for a while, at least, the all-roundedness of our bodies and our worlds is perceived with heightened sensitivity.

In the final analysis, all-roundedness is the ultimate satisfaction of our instinctual need for withness with things, for we are beings primordially attuned to a world of volumes. More than anything else, the vivification of things in enlivened space is what sculpture is about, and, other things being equal, sculpture that brings forth roundedness can do this with greater power than relief sculpture. Painters can approach sculpture by creating the illusion of three-dimensionality and thus indirectly evoke by suggestion tactual stimulation, "ideate it" as Berenson claims; but painters—even Cézanne or the Cubists—can never show forth the actual solidity of things and thus reinforce ideated tactuality with physical tactuality. Nor can painters reinforce ideated kinaesthesia with physical kinaesthesia as strongly as sculptors. Tactual and kinaesthetic reinforcement can best be evoked by sculptors and architects, and with sculptors only to the fullest extent by those who plumb the depths of the "given" by working with roundedness. So no matter how impacting a relief—as in the case of the pedestal of the *Rape of the Sabines* (Fig. 23)—it still beckons on toward a further bringing forth of three-dimensionality. Great as Michelangelo's *Pietà* (Fig. 21) is, it is still a milestone that points beyond. And so it always will be with every masterpiece of sculpture, for thingliness and our withness with it are inexhaustible. Sculpture that reveals all-roundedness is paradigmatic because it is the most thingly of all modes of sculpture, and therefore such sculpture is the ultimate lure and aim of sculptors.

IX

Sculpture and the Human Body

One need only shut oneself in a closet and begin to think of the fact of one's being there, of one's queer bodily shape in the darkness (a thing to make children scream at, as Stevenson says), of one's fantastic character and all, to have the wonder steal over the detail as much as over the general fact of being, and to see that it is only familiarity that blunts it. Not only that anything should be, but that *this* very thing should be, is mysterious.

William James

Our awareness is incarnated. Thus no other thing is as important to us as the human body, for it is the thing that makes possible the showing forth of all other things. Moreover, the organization of our bodies, as Theodor Lipps and Heinrich Wölfflin pointed out in systematic detail, is the form that determines our apprehension of all physical bodies. Sometimes even our measuring units of things are derived from the dimensions of the body; a foot, for example, is based on the average length of an adult foot, [1] a yard on the average single stride. Moreover, the human body is supremely interesting aesthetically, not only possessing fascinating textures but manifesting the most complex three-dimensional shapes, the subtle transitions of muscular movement producing inexhaustible configurations. In turn, those configurations take on added interest because they often are expressions of a personality. Furthermore, although there may be other things in the world as sensuously attractive—the full glory of autumnal leaves, for example—the human body also possesses a sexuality that greatly enhances its sensuousness. No wonder, then, that we prize the human body, especially when it is beautiful. No wonder, then, that Kenneth Clark claims, "Before the 'Crucifixion' of Michelangelo we remember

that the nude is, after all, the most serious of all subjects of art; and that it was not an advocate of paganism who wrote, 'The word was made flesh, and dwelt among us . . . full of grace and truth.'"[2] Goethe even claims, "No evil can touch him who looks on human beauty; he feels himself at one with himself and with the world."

It is not surprising, therefore, that the human body, clothed or unclothed, beautiful or even ugly, has been and still is a favorite subject matter of painters. Often it has been the favorite, as with Titian, Rubens, Ingres, Renoir, Matisse, and Picasso. Yet it is somewhat surprising, perhaps, that the human body has been an even more favored subject matter of sculptors. In the West, except for the period between the fifth and fourteenth centuries,[3] and until works such as Boccioni's *Development of a Bottle in Space*, 1912, and Picasso's *Musical Instrument*, 1914, the human body, especially nude, has been considered to be the noblest and almost the exclusive subject matter of sculpture.[4] Dewitt Parker claims, for example: "The sculptor has this advantage over all other artists, that his chief subject matter is the most beautiful thing in the world—the human body."[5] Moreover, as Albert Camus maintains, sculpture captures the fleeting expressions of the body: "The greatest and most ambitious of all the arts, sculpture, is bent on capturing, in three-dimensions, the fugitive figure of man, and on restoring the unity of great style to the general disorder of gestures. . . . Its purpose is not to imitate, but to stylize and to imprison in one significant expression the fleeting ecstasy of the infinite variety of human attitudes."[6] And Henry Moore declares: "For me sculpture is based on and remains close to the human figure. That works both ways. We make the kind of sculpture we make because we are the shape we are, because we have the proportions we have. All those things make us respond to form and shape in certain ways. If we had the shape of cows, and went about on four legs, the whole basis of sculpture would be different."[7]

Even abstract sculpture, according to Reg Butler, is aesthetically appealing "because it contains within it certain references which are acceptable, and these are based not only in my culture but in my biology. So that if dogs made sculpture they would make sculpture with different plastic values from ours."[8] Barbara Hepworth, usually an abstractionist, remarks, "I love working on a large scale so that the whole body of the spectator becomes involved."[9] Claes Oldenburg counters the mechanization of man with the humanization of the machine, creating what he describes as "an object in the shape of an artist."[10] Every piece of sculpture is significantly similar to our bodies, unlike a painting,

164

because it occupies a significant area of three-dimensional space. Yet, as Herbert Read notes, it is still surprising that "at least nine-tenths of all sculpture ever carved [as well as molded or assembled] is devoted to one subject—the human body."[11] Why do sculptors devote themselves more to the human body than painters?

Read's explanation is based on the Narcissus myth: "A youth falls in love with his own image with corporeality, pines away and dies."[12] There is an element of profound truth in this myth: the insatiable desire we have to arrive at a satisfactory image of our bodily selves, a material counterpoint for the mental images of our bodies. Mirror images help, of course, but they are always seen as far behind the mirror as we are in front. We cannot rub against or even touch our image, for what is in the mirror is not there at all. The image has no being of its own, entirely dependent upon what it is reflecting. Like the image of a painting, a mirror image has no physical tangibility. And as with a painting, the mirror image can only present the surface of our bodies, the mass being represented by reflected perspective. Such images with their unreality are not very satisfactory material counterpoints of our mental images of ourselves. "Hold it up sternly! See this it sends back! (Who is it? Is it you?)"—Walt Whitman, "A Hand-Mirror." The nonreflected sight of ourselves helps but we can see only part of ourselves. Touching ourselves and other people also helps, but usually such perceptions are blurred with distractions.

Through its forms sculpture brings out three-dimensionality directly, making possible clarifying embodiments of both the exterior and the interior of the human body. Two-dimensional images are usually not very revealing of our bodies as occupying a place that resists invasion by other things, our ability to advance to and occupy other places, our kinaesthetic sensations and our sense of haptic volume bounded, however vaguely, by tactile sensations. Two-dimensional images are outlines of ourselves in those respects because they cannot bring forth mass and volume directly. This is not to suggest that paintings are necessarily inferior to sculptures in revealing the human body, for paintings often can reveal many aspects of the human body far more richly and subtly than sculpture, for example, as in Rembrandt's portraits, the color, warmth, and softness of flesh, the luminosity of the eyes, and the character complexities of the face and hands. However, paintings generally cannot reveal the mass and volume of the human body as richly and subtly as sculpture because paintings can only directly present surfaces. The presentation of the mass and volume of the body is indirect, and such representation inevitably

loses the materiality that is so helpful in clarifying that "strange thickness" so basic to our awareness of our bodies, that "inner space one never sees, the brain and the heart and other caverns where thought and feeling dance," as Samuel Beckett describes it in *Molloy*. Nor can paintings, because they lack an impacting between, reveal as forcefully as sculptures our awareness of our bodies as three-dimensional centers thrusting out into our surrounding environment. This awareness of thrust occurs even when we are motionless. Gaston Bachelard remarks, "Immensity is within ourselves. It is attached to a sort of expansion of being which life curbs and caution arrests, but which starts again when we are alone. As soon as we become motionless, we are elsewhere; we are dreaming in a world that is immense. Indeed, immensity is the movement of a motionless man."[13] Gaston Lachaise's *Floating Figure* (Fig. 47), with its ballooning buoyancy emerging with lonely but powerful internal animation from a graceful ellipse, is exceptionally revealing of this need for expansion, this instinctual longing of our bodies to be united with our world. More than any other art, sculpture, because of its immensity—its radiating impact into its surrounding space—enables man to reunite the two-dimensional image of himself when he looks at reflecting surfaces with his tactual and kinaesthetic sensations of himself. The mirror image is only a ghost of our bodies. If only Narcissus had had a sculpture of himself, presumably he would have been saved.[14] We are all doubting Thomases who need to confirm by touch what is given by sight. Then plasticity defeats caricature. By vivifying and clarifying our bodies in their fullness, sculpture in a special way helps us understand our bodies. The sculptor shapes sculpture, and sculpture shapes us.

The sexual instincts are also involved, according to Read. "Not only do we tend to idealize the object we love and desire, but also we transfer to an ideal representation of the human body those desires that we cannot satisfy in reality."[15] Pygmalion falls in love with the marble mimic of the ideal girl he sculpted and asks Aphrodite to give the marble life. His desire is granted, the marble being metamorphosized into flesh, and Pygmalion marries his beautiful creation and names her Galatea.[16] For the rest of us, who neither sculpt nor have influence with Aphrodite, the beautiful statue may also provoke sexual desires. Unlike Pygmalion, however, we can only receive imaginative satisfaction, but, on the other hand, sculptural beauties, such as the *Aphrodite of Cyrene* (Fig. 6), are available to all. Even without head and arms, this *Aphrodite* in a sense is more substantial than a real woman because the female shape, texture, grace, sensuality, sexuality, and beauty are interpreted by a form and

166

thus clarified. With all those enhanced feminine qualities, the seductive forces of *Aphrodite* enliven space more vividly than a real female, and we are bound to be drawn close and circle her. If the guards are not looking—she is watched over in the Museo Nazionale delle Terme of Rome by some of the most zealot Puritans of Italy—we touch and caress her. Even the most perfect real woman—at least from a male chauvinist viewpoint—is always moving away, or talking too much, or covering up, or in bad light, or sick, or getting old. The sculptor can make her stand still, shut her up, strip her, give her good light, and keep her young and healthy. Then "the frustrated lover of love," as Camus put it, "can finally gaze at the Greek caryatides and grasp what it is that triumphs, in the body and face of the woman, over every degradation."[17] And the sculptor can do the same for males, of course, as Michelangelo did with the *David* (Fig. 19). Indeed it may be the case generally that the sculptor finds the male body an even better subject matter than the female—certainly this was the case with Donatello and Michelangelo—because the male body lends itself more to the aggressiveness that helps enliven space. Maybe Donatello and Michelangelo were not homosexuals after all—just sculptors. On the other hand, Brancusi had a much higher regard for the female body. His *Leda* might be perceived as Jupiter transforming himself into the swan of the Leda myth. But Brancusi said, "It is Leda, not Jupiter, changing into a swan. A man is ugly as a frog; a swan has exquisite curves, like those of a woman's body."[18]

The painter can also reveal the human body, of course, and with respect to the sensuousness of the flesh especially, he can far surpass the sculptor, as Giorgione, Titian, Rubens, Renoir, Modigliani, among many others, have proved. Yet since the painter, unlike the sculptor, has to sacrifice the direct presentation of substantiality, he loses much of the seductive force. Beauty is more than skin deep. Painters cannot be Pygmalions. Thus statues even more than paintings teach us how to idealize our actual lovers, training us to perceive what we want to perceive. But conversely, as Read points out, the human body can also be used by the sculptor to reveal sadism or masochism or nihilism, seeking "to destroy the body image as an object of desire,"[19] as, for example, in Ernest Trova's *Study: Falling Man (Wheelman)* (Fig. 79) or almost any sculpture by Giacometti (Figs. 57, 58). And, of course, the painter can also do this, as, for example, in many of the "women paintings" by Willem de Kooning. Generally, however, both in painting and sculpture, the human body resists more than most subject matters ugly deformations. Even Picasso, as Kenneth Clark observes, "has often exempted it from that savage metamorphosis which

167

he has inflicted on the visible world and has produced a series of nudes that might have walked unaltered off the back of a Greek mirror."[20]

The extensive use of the human body as part of the subject matter of sculpture helps confirm the withness with things that I have been claiming to be the underlying subject matter of all sculpture, for it is our bodies as three-dimensional that are with things as three-dimensional. Even when a human body is only very vaguely portrayed, if at all, the sculpture is usually and easily anthropomorphized. For example, Lipchitz's *Song of the Vowels* (Fig. 68 and also in the background of the site of Marta Pan's sculpture [Fig. 84]), which seems to float through space despite its great weight, at first appears as completely lacking any reference to the human body, the harp to be played by the wind. But then we notice fingers and they suggest a hand that leads to an arm, and then we inevitably perceive a player. Lipchitz recalls: "I hired a mason to help me with the base, an Italian who spoke very little French. While we were working, the mason suddenly said, 'I am very proud to work on this.' And I said, perhaps a little rudely, 'Why are you proud? Do you like it?' He said, apologetically, 'Of course, some people like those unknown soldiers more.' (Because in every town in France there are those awful monuments to unknown soldiers.) 'But I prefer this.' So I said, 'Why do you prefer it?' and the mason said 'Perche parla!' ('Because it speaks!')."[21] This kind of remark often occurs. When discussing with students Arp's *Growth* (Fig. 51), they usually describe the animation of the statue as a human vitality, not a vegetable or animal power, or some power immanent in all things. Such anthropomorphic description is in part a consequence of the enlivened space around the sculpture, which involves a co-perception of our bodies in spatial witness with things more directly than any other art, and so there is a tendency to perceive sculpture in bodily terms. Except perhaps for the dance, no other art is as conducive to empathy—"to feeling into"—as sculpture, for most sculpture is a compelling invitation to bodily identification.

Piaget observes, "Space is . . . the product of an interaction between the organism and the environment in which it is impossible to dissociate the organization of the universe perceived from that of the activity itself."[22] However, the awareness of this inseparable unity rarely occurs except in pure primary perception. Even in the aesthetic experience, where perception is primary in orientation and sustained, there usually is some awareness of "here" and "there." In viewing a film, for example, we are at least implicitly aware that the film space is imaginary and discontinuous with our space in the theater. We

168

know that we cannot get up from our seats and traverse an intermediate space into the film space. In the case of the dance—the most "bodily" art of all in the sense that the body is always involved in its performance[23]—we can, unless an usher or someone stops us, get into the dance space, but except in some rare avant-garde dance this destroys the dance. A sculpture and our bodies, however, are in the *same* space, and a sculpture energizes that space. No other art, except sometimes architecture and "happenings," has the concentrated impact of the enlivened space of sculpture. Sculpture "bangs" into our bodies with convergent forces, and this heightens our body awareness. We feel physically with sculpture, more than with any other art. That is why even basically abstract masses, such as Lipchitz's *Song of the Vowels* (Fig. 68), sometimes seem to speak.

When confronting other people, the space between is impacted by their presence. "To be," in Sartre's words, "is to be *for* someone." The liveliness of others would seem, therefore, to insure more impact, despite all the distractions, than even the most powerful sculptures can exert. Yet except when we experience another human being aesthetically (i.e., at moments when our consciousness is so penetrated and permeated by the "other" that our consciousness has no energy left for explicit self-consciousness), distractions usually siphon away much of the impact. The most powerful of these distractions is undoubtedly "the look," as Sartre describes it (pp. 111-12). When the "other" looks—except when it is a sympathetic or loving look in an appropriate context—the space between us is divided into the other's space and our space. There is neither the centripetal "drawing in," as with Moore's *Reclining Figure* (Figs. 55a, 55b), nor the centrifugal "pushing out," as with Giacometti's figures (Figs. 57, 58). Instead the impact into the between is more or less neutralized, the power into the between being short-circuited to the degree that "the look" intensifies our self-consciousness. When "the look" of others upon us is in a socially respectable context, as when as teachers we are conscious of our being observed by students, the impact into the between may only be weakened. When, however, "the look" of others upon us is not in a socially respectable context, as when we are caught as voyeurs, the impact into the between may be annihilated. Perhaps more than any other emotion, shame evokes vivid self-consciousness, which, in turn, sharply separates our world into the subject/object dichotomy. And when we distance ourselves as subjects from objects, we also distance ourselves from any impacting forces in the between.

Marcel Duchamp's mysterious last creation (Fig. 69) which he worked on

secretly from 1946 until his death in 1968—*Etant Donnés: 1. La Chute d'eau 2. Le Gaz d'éclairage (Given: 1. The Waterfall 2. The Illuminating Gas)*—is a fascinating example of how self-consciousness can destroy our sense of enlivened space. As I approached the permanent installation of this work in the Philadelphia Museum of Art, I passed through the large gallery containing the Arensberg Collection of many of Duchamp's earlier works, dominated by his *The Large Glass (The Bride Stripped Bare by Her Bachelors, Even)* (Fig. 46). I came to an open doorway that led into a small room whose roughly stuccoed left wall contained an arched brick doorway that framed an old Spanish door. There were no knobs or handles, and I realized that the door could not be opened. I noticed, mainly because of the stains around them, two small oblique holes at eye level. [24] The door barred me from what was behind it, and yet allowed me to see through it. I brought my eyes to these holes. There was a strong tactile feel of the weathered wood. My view was locked into a forced position, more so than with any painting I have perceived, for not even the slightest shifting of the head was possible. A shocking scene bathed in strange brilliant light thrust itself toward me. I saw in the foreground a battered brick wall apparently a few feet in from the door—distances seemed strangely unreal and difficult to judge, for I could see with only fixed head—with a jagged hole beyond which, on a bed of what appeared to be real leaves and twigs, lay a nude young woman, realistically molded and erotically spread-eagled on her back. Her legs extended toward the door but her feet were hidden by the brick wall. Her vagina was curiously deformed. Her face was farthest from my view and almost completely hidden by seemingly real blonde hair. Her left arm stretched to the left, and her left hand held a faintly glowing gas lamp. In the distance behind the lamp was a romantic lake bordered by a hilly, wooded landscape and above a blue sky filled with soft white clouds, in the style of French academic painting of the nineteenth century. A waterfall sparkled in the depth of this landscape, the only moving element. The impact into the between, despite the obstructing door, was powerful. Again I surveyed the nude. I heard someone behind me; my "look" was being "looked on"; I was aware of my voyeurism; my self-consciousness overwhelmed me; the impact of the enlivened space, which had been peculiarly concentrated on the skin around my eyes, drained away. I stepped back from the peep holes and "looked" at my "looker."

This short-circuiting of the impacting space is the primary reason why this work is better described as mixed media than as sculpture. Even the tactile sensations of the peep holes on one's face are dissipated to some extent by the

"Peeping Tom" phenomenon, and one's vision cannot be complemented by touch. The freezing of the eyes to the peep holes, moreover, immobilizes our bodies. There is no kinaesthetic reinforcement of our tactual sensations. Furthermore, even if one is alone and no one enters the room, we may be aware of the possibility that our ludicrous position may be observed. Then we cannot escape the self-consciousness that insulates us from the impacting space. In his strangely ironic and humorous way, Duchamp by neutralizing enlivened space shows what sculpture is by showing what sculpture is not.

Sculpture is the vivification of our withness with things by means of enlivened space. The bodies of "others" are the things we are most noticeably with, except that "the look" tends to separate us from that withness. As Giacometti observed, "One doesn't walk around a man like a tree." The frontal confrontation, as in the handshake, is basic to our relationships with others. But we can and do walk around a sculpture of a man in somewhat the same way we do a tree. Sculpture, even with those intense gazes of Giacometti's figures, takes away the actual look, and in doing so sculpture can animate our withness with the sculptural likenesses of the human body rarely achieved in interpersonal relationships. By returning us to a closer unity with likenesses of the human body, sculpture may even teach us how to overcome "the look" and the self-consciousness that alienates us from others. The look becomes beautiful. The handshake becomes a "giving-receiving" unity, a "carnal intersubjectivity" (Merleau-Ponty). "Two hands fold into one," Heidegger poeticizes, "a gesture meant to carry man into the great oneness."[25] Especially on the deathbed there is the need to hold hands. Sculpture teaches us how to come together.

The basic subject matter of sculpture is being-in-the-world, and the fact that the human body is so often a part of the subject matter of sculpture helps confirm that claim. Far more than any other figure, the human body has led sculptors again and again, over many thousands of years, toward structures revealing our withness with things.

X

Sculpture and "Truth to Things"

Every discoloration of the stone,
Every accidental crack or dent,
Seems a water-course or an avalanche.
William Butler Yeats, "Lapis Lazuli"

Our bodies are animated things, and things, both animated and otherwise, are what our bodies are with. The basic subject matter of sculpture is this withness with things, our primordial unity with them. Therefore we should expect that sculpture reveals a "truth to things" in the sense that it helps things stand forth as they are—undisguised—in the starkness and strangeness of their being what they are. Sculpture on its most fundamental level is the revelation of our withness with thingliness.

Things are usually perceived in our customary consciousness, their concrete fullness being passed over. "What do you perceive?" usually means "Can you identify the thing before you?" There is a tendency toward invariance operative in all perception, so that we are prone to perceive things, as far as possible, in the same way. We perceive "constancies," the stabilizing mechanisms of perception that counteract the confusing fluctuations of stimuli impinging on our senses. "Things are (in a sense) recognized," as Stuart Hampshire notes, "before they are really seen or heard. 'What does it mean?' is the . . . reaction that prevents perception."[1] Because of practical or theoretical demands, we are rarely free to perceive things as things. Usually things are used as instruments, becoming unnoticed in our using. As Heidegger puts it: "What can be immediately seen when we look at things, the image they offer to immediate sensible intuition, falls away. The calculating production of

technology is an 'act without an image.'"[2] Things are analyzed into quantities, their qualities dissected away. Moreover, things that we are perceiving are often obscured by other things. Furthermore, most things are ordinary, thus ignorable, simply because they are always around. Jean Dubuffet observes: "I cannot get over the feeling that the things closest to us, most constantly in sight, have also always been the least noticed, that they remain the least known, and, that if one is searching for the keys to things, one has the best chance of finding them in those things which are most copiously repeated."[3] But there are not many Dubuffets among us. Respect for things is diminishing in our times. Yet, as Hannah Arendt reminds us:

Although the durability of ordinary things is but a feeble reflection of the permanence of which the most worldly of all things, works of art, are capable, something of this quality—which to Plato was divine because it approaches immortality—is inherent in every thing as a thing, and it is precisely this quality or lack of it that shines forth in its shape and makes it beautiful or ugly. To be sure, an ordinary use object is not and should not be intended to be beautiful; yet whatever has a shape at all and is seen cannot help being either beautiful, ugly, or something in-between. Everything that is, must appear, and nothing can appear without a shape of its own; hence there is in fact no thing that does not in some way transcend its functional use, and its transcendence, its beauty or ugliness, is identical with appearing publicly and being seen.[4]

Henry Moore's conception of "truth to materials" (p. 107) demands that the sculptural material be determinant of sculptural form. As distinct from mere craftsmanship, sculpting involves a dependence on the thingliness of its material, for the form is continually adjusted to the material the sculptor feels in his hands or beneath his tools. The woman comes out of the wood (Figs. 55a, 55b). If the image had been imposed on the wood, the thingliness of both the woman and the wood would not have been revealed. Truth to materials is respect for the material as a thing.[5] This respect is usually interpreted to mean that sculpture should not be painted, for paint hides and thus is dishonest to the material. Clement Greenberg, one of the executors of David Smith's estate, has had paint removed from some of Smith's metal sculptures, and other works have been sandblasted, allowed to rust, and then varnished,[6] apparently for the basic reason that Smith's sculptures are so structurally strong that color is a needless cosmetic. In an essay on the sculpture of Anthony Caro, Greenberg argues, "Here, as almost everywhere else in post-gothic Western sculpture, color remains truly the 'secondary' property that philosophers used to think color in general was."[7] For other critics that claim is not only false but also a violation of

173

both Smith's sculptures and his intention, allowing the medium to become the message. The opposition to Moore and Greenberg has been succinctly expressed by Sidney Geist: "Materials have sensuous qualities and structural properties, but no intrinsic artistic content, and a mystique of materials is limiting, delusive, and finally a concern of craftsman. 'Love of material' is a psychological, not a sculptural, affair; 'truth to material' is a truth which changes from style to style and sculptor to sculptor."[8] "It is," Geist remarks in another context, "never color which tips sculpture toward painting, but an atmospheric quality [a nonimpacting space] arrived at by *malerisch* means, as in [Medardo] Rosso or the reliefs of Manzu."[9]

The history of the practice and theory of sculpture shows that the doctrine of truth to materials, although usually stated in different terms than Moore's, has had a long, noble, and still-living tradition. Sculpture is understood as the reality of materials with the obfuscating wrappings peeled away. When truth to materials is absent, the sculptural impact is usually weakened, for example, copies of originals, with such notable exceptions as the *Aphrodite of Cyrene* (Fig. 6).[10] A general absence of truth to materials is almost always a sign of sculptural decadence, as in the Roman period. The exceptional works stand out mainly because their materials have been respected, for example, in Rome the *Ara Pacis Augustae*, Trajan's Column, and the battered *Boxer* in the Museo Nationale delle Terme. When truth to materials is present, the physical "presencing" or sculptural impact of the work is usually strengthened, as in the work of Moore (Figs. 55a, 55b). Moreover, truth to materials makes sculpture better adapted to the erosions of time. Unpainted wood and stone, for instance, usually take on a charming patina, whereas painted wood and stone usually become blemished. Uncolored bronze sometimes takes on gorgeous colors when buried in the earth for a long time. As Sherman E. Lee observes: "The beautiful greens and blues found on the Chinese bronzes are completely accidental, the product of many centuries of burial in the earth. The action of salts in the earth produces various oxides that give the beautiful colors to the surface of the bronze."[11] Conversely, colored bronze, no matter how beautifully done, usually is stained ugly by the earth. Nostalgia, which can be a very positive aesthetic value, is much more likely to be preserved in works with truth to materials, often more than compensating for the damages of history, as with the *Aphrodite of Cyrene*, *Winged Victory*, and *Venus De Milo*. "More beautiful than a beautiful thing," Rodin wrote in *Les Cathedrales*, "is the ruin of a beautiful thing." Furthermore, as Leonard Baskin points out, with some

174

sculpture corrosion causes the right loss of detail: "Because loss of detail inevitably causes simplification, as in many archaic works that we now rightly admire and correctly assume to be *improved* by weathering. The superficial polish and veneer—what the sculptor who was less than a genius added *last*—are the first things to go."[12] Such compensations and improvements brought on by time, however, rarely occur when the materials have not been respected.[13] Thus there would seem to be little hope for most sculpture of the Roman period.[14] Nevertheless, there are circumstances when truth to materials has been fittingly transcended by truth to things. When the thing to be revealed requires ignoring or even disguising the sculptural material, the sculptor simply goes ahead and does it. The sculptor is the midwife of thingliness, not materials, and sometimes truth to materials may bring out the wrong thing. In the next section, I will examine further the justifications for truth to materials. In the last section, I will examine the justifications for transcending truth to materials.

The materials of sculpture inevitably exert their thingliness in a negative way, that is, the structural properties of a material cannot be violated too far or the sculpture will cease to exist. Thus the carvers, i.e., the "take-off sculptors" who usually struggle with the hardness of things, are limited by the size of their stone or the wood or other material and must take into account the faults and fissures and tensile strengths. The "put-on" sculptors—both the modelers, who usually struggle with the softness of things, and the assemblers—often need to buttress their materials with internal supports and braces. All sculptors must consider the factors of size and weight, and they may need lifting apparatus and assistants. Positively, the qualities of materials as "thingly" usually enter far more deeply into the forms of sculpture than into the forms of painting. As the work and words of Michelangelo and Moore so clearly show, most sculptors are obsessed with their materials, love them "deep down," and feel them as extensions of their bodies. Gabo writes: "Our attachment to materials is grounded in our organic similarity to them. On this akinness is based our whole connection with nature. . . . We love materials because we love ourselves."[15]

The material of the sculptor can help a three-dimensional form that is vaguely alive in his imagination find its way to realization. The material may completely dominate his imagination. In a letter of 1935 to Carola Giedion-Welcher, Max Ernst relates: "Alberto Giacometti and I are afflicted with sculpture-fever. We work on granite blocks, large and small, from the moraine

of the Forno Glacier. Wonderfully polished by time, frost and weather, they are in themselves fantastically beautiful. No human hand can achieve such results. Why not, therefore, leave the spadework to the elements and confine ourselves to scratching on them the runes of our own mystery."[16] Marble is cold and aloof. Bronze is hot and intense. Terra-cotta is tender and intimate. Iron or steel is powerful and brutal.[17] Most sculptors, especially the carvers, feel such qualities as inseparably *in* their materials. The Cartesian-Lockean distinction between primary and secondary qualities that Greenberg recalls makes little sense in this context. On the other hand, the painters mix and combine powders and liquids that for the most part already have been abstracted from other materials. As Duchamp remarks, "Since the tubes of paint used by an artist are manufactured and readymade products, we must conclude that all the paintings in the world are 'readymades aided.'"[18] Not only do their colors usually retain few traces of the qualities of the things from which they have been abstracted, they also usually lack significant solidity. Consequently most painters lack a strong "feel" for their materials as three-dimensional things. Sculptors, on the other hand, almost invariably have this feel. Muses Brancusi: "It is while carving stone that you discover the spirit of your material and the properties peculiar to it. Your hand thinks and follows the thoughts of the material."[19] Seonaid Robertson, a potter, rhapsodizes about her clay:

One takes a lump of clay, the very stuff of this earth—clay which was once hard granite, thrusting in sharp blocks out of wind-swept moors; granite which softened through countless ages of time, and which eventually decomposed into clay which was washed down by the rains into the beds of rivers spreading at flood-times over the flat valleys, where, among the coal-seams or the gravel-beds, we now find it.

To be a potter means to take a lump of clay, plastic from its damp, thousand-year journey to the potter's bench, and to work it to increase that essential plasticity. . . . A good clay, like a good wine, has a bouquet.

The potter "walks" the clay, stamping up and down, treading the soft, squelchy mass underfoot till it grips the heels and almost seems threatening to engulf one. By this time one's body is becoming deeply aware of the clay, and other awarenesses are falling away. One seems to have gone down into something unformed, primeval, and almost given up oneself to it.

Describing throwing and centering, she writes:

Here, laved in more water, the lump is centered not only between the hands but with the whole body. The weight is taken on the ball of the foot and one is conscious of the force of the solid earth, which is felt through the muscles of the calves, of the thighs, of the loins, of the shoulders, a force drawn up and directed downward through the arms so that

176

beneath enveloping hands the thrust of the earth is poised against the thrust of the centrifugal force of the wheel. To learn to use one's body thus as a mediator without strain, to centre the lump of clay until it spins like silk beneath the fingers, that is the perfection of co-ordination, an exquisite sensation of wholeness. [20]

Many if not most twentieth-century sculptors like to work directly with their materials. Modeling a statue in clay or plaster and then giving the model to expert craftsmen to translate into marble or some other stone—a practice going back to antiquity but becoming a standard practice only after the Renaissance—is now generally frowned upon, especially the employment of the "pointing machine."[21] That mechanical tracing undoubtedly accounts for some of the poor quality of some eighteenth- and nineteenth-century sculpture, Baudelaire's "tiresome art." One of the more hilarious examples is the *Monument to the Completion of the Fréjus Tunnel*, 1879, in the Piazzo dello Statuto in Turin. The design was generally conceived by M. Panissera and vaguely modeled in clay by Luigi Belli. Students of the Royal Academy at Turin made a more precise model in gesso. This model was turned over to a local stonecutting firm which used a pointing machine and added its own embellishments in the final construction. In those times, academic sculptors apparently did not handle carving instruments.

If the origin of sculpture is in the instinctual need to bring forth our withness with things as thingly, and depth is always essentially involved with things, then presumably the sculptor must bring to the surface the substance within, as the skin shows forth the muscle. Rodin relates how his teacher, a sculptor named Constant, advised him: "Henceforth, when you carve, never see the form in length but always in thickness. Never consider a surface except as the extremity of a volume, as the point, more or less large, which it directs toward you." Rodin applied this principle with astonishing success: "I applied it to the execution of figures. Instead of imagining the different parts of the body as surfaces more or less flat, I represented them as projections of interior volumes. I forced myself to express in each swelling of the torso or of the limbs the efflorescence of a muscle or of a bone which lay deep beneath the skin. And so the truth of my figures, instead of being merely superficial, seems to blossom from within to the outside, like life itself."[22] Brancusi said that the surface of his *Sculpture for the Blind* felt in his hands as if it were, "seething with tiny cubes."[23] John Ruskin noted, "From the Elgin marbles down to the lightest tendril that curls around a capital in the thirteenth century, every piece of stone that has been touched by the hand of a master becomes soft with under-life, not

177

resembling nature merely in skin-texture, nor in fibres of leaf, or veins of flesh; but in the broad, tender, unspeakably subtle undulations of its organic form."[24] Direct working with the sculptural material would seem to be, at the very least, a great aid in wresting out thingliness. Furthermore, as lovers of sculpture we enter to some extent into the feeling of the struggle—Michelangelo's chiseling of the marble (Figs. 19, 21), Brancusi's polishing of the bronze (Fig. 49), Moore's carving of the wood (Figs. 55a, 55b), Giacometti's manipulations of the plaster that became bronze (Figs. 57, 58).

Antonio Canova is an especially interesting sculptor to study with reference to truth to materials, for sometimes he respected his materials and sometimes he vanquished them. "Clay is life," he said, whereas "plaster is death and marble is the resurrection," and with *Pauline Borghese as Venus* (Fig. 29) he proved his point about marble. The physical charm and even something of the character of this intriguingly nonchalant woman, a Venus Victorious with some justification according to legend, are brought out in the finely polished grains of the translucent marble. The cold, aloof smoothness of the marble speaks for the snob, but the warm shadowing of the fastidious flesh speaks for the female. There is present both Canova's love of carving marble—note, for example, the delicacy of the folds in the pillows and the exquisite chaise—and his love of sensuous reality. Now compare his *Perseus Holding the Head of Medusa* (Fig. 30), much acclaimed in the nineteenth century, at the summit of the grand staircase of the Metropolitan Museum of Art in New York. As we finally conquer the mighty spread of steps, like the terror-inspiring stairways to the Mayan sacrificial platforms, and gradually bring our breathing under control, the image begins to focus, and because there is a pedestal instead of a frame, we assume we are perceiving a sculpture. Yet the white marble, smoothed by chemical solutions, is like shaded white paper, a monotonous chalky white without the slightest hint of grain or translucency. We walk around the statue, not because there are any vortices within the surrounding space that draw us around or because the frontal aspects entice us to further aspects, but in order to reassure ourselves that this ghostly outline is a thing rather than a mirage. Depth is minimized because the marble appears to thin out and withdraw, as if its "white silence" were embarrassed by its three-dimensional exposure in the noisy hall. The sharply outlined silhouette does not lead our eyes beyond its edges. Light lies passively on the chilled skin, being neither absorbed nor reflected. Shadows slip over surfaces too smooth to retain them. Gravity seems irrelevant to the statue. There is no attraction, as there is with

Pauline, to come in and caress. Indeed if we were to touch these muscleless flaccid shapes, we would expect them to collapse, like the cardboard structures of a Hollywood set. The Neoclassic formulas of Winckelmann—"noble simplicity and quiet grandeur"—that was so dear to Canova's mind but not his heart produced a work so quiet there is no enlivened space. Despite the work being in the round, we tend to move toward a privileged position in front and scan the *Perseus*, a paradigm of nonsculptural sculpture, as if it were a painting.

A few rooms farther inside is a plaster model of Canova's *Cupid and Psyche* (Fig. 28). Plaster is rarely an appealing material,[25] and in this case it is dull and dirty, yet this plaster moves the light, swings the shapes, brings out mass, submits gracefully to gravity, integrates the rough base with the smooth figures (whereas the *Perseus* is on its base), and propels forces into the surrounding space like a whirlpool. The plaster model and its embracing space nicely set up the concentric composition that surrounds the moment of suspense before the kiss. Conversely, the marble *Cupid and Psyche* in the Louvre is almost as lifeless as the *Perseus*, the volumes completely lacking expanding pressure, like windless sails. Canova's craft was so great that, except for a few works such as *Pauline*, it completely dominated and thus diminished the density of the marble. When working with "lowlier materials" such as plaster or clay (for example, *Meekness*, 1783), he invariably was more sculptural. It was as if marble inspired him to an ideal imagery that must, like the Platonic heaven, leave all matter behind.

The Neoclassic tradition of sculpture, unfortunately, was founded on works such as the *Perseus* and was institutionalized by technicians such as Bertel Thorwaldsen. They built intellectual constructions so geometrically smooth and ideally sweet that there was very little or no sculptural impact. The École des Beaux-Arts in France and state-sponsored art schools all over Europe became the arbiters of nineteenth-century sculpture.[26] The Academy and its Salons extolled the personification of abstract ideals made permanent in stone: to educate, elevate, and delight (in that order!), especially about the heroes, institutions, and middle-class values of the nation. Above all, academic sculptors concentrated on tombs and celebrated the dead, as with all those unknown soldiers of all those concluded wars. The materials of these tombs, after being worked over by their sculptors, were as dead as the soldiers. And yet, paradoxically, the Academy proclaimed (in very high-sounding terms) truth to materials, proscribing, for instance, the use of paint. To color sculpture was to gild the lily. As Albert E. Elsen points out: "The academic attitude was against the use of applied color on the grounds that it hid the sculptor's genius and

brought his work into dangerous proximity to nature. Color only heightened the falsity of sculpture's attempts to imitate life. . . . Polychromed sculpture was viewed as too close to actual movement and life and, as a result, revealed sculpture as immobile and dead. The use of naturally colored materials was tolerated, but art students were taught that the 'eternal function' of sculpture was to avoid all but the intrinsic color of the stone."[27] Thus the truth to materials doctrine of the twentieth century was a revolt against academic practice not academic theory. It has only been in this century that the movement toward justifications for transcending truth to materials, both in practice and theory, has gained ground.

Until the late Renaissance, sculptures often were painted. From the late Renaissance to the end of the nineteenth century, except for ceramics and the Spanish tradition, sculptures were rarely painted. Gauguin had begun painting his sculpture by 1882, and by the early 1900s Kirchner, Schmidt-Rotluff, Nadelman, Archipenko, Picasso, Tatlin, Vantongerloo, Lipchitz, Laurens, and many others were coloring their sculpture. Yet color presumably masks the thingliness of sculptural material. If the underlying subject matter of sculpture involves thingliness, how then is the use of color to be justified? Thingliness is not necessarily abandoned in the use of color. In the first place, sometimes color does not mask but is neutral, and sometimes it may even enhance the thingliness of the sculptural material. Second, sometimes things other than the sculptural material take precedence.

Color has been used decoratively in all periods to make sculpture more attractive. Until the twentieth century, however, color rarely was used to mask the sculptural material. Greek marble sculpture, for example, was often made for outdoor placements such as temple pediments. But marble in Greece can rarely face the sun and hold its own, for the pressure of the Mediterranean light breaks up the shape and diminishes the depth of the stone. Therefore, rather than emphasizing the pictorial, color firmed up the shape and the mass in such cases by absorbing and dimming the light.[28] Furthermore, it seems that in almost all cases some of the marble was left unpainted, the colored marble helping the marbleness of the uncolored marble come forth. With Medieval sculpture, on the other hand, color was used primarily for symbolic purposes, as with Nino Pisano's *Madonna del Latte*, c. 1350-1368, in the Museo of San Matteo in Pisa. The gold "stood for" the sacred. The materials of the medieval statue, as with the Greek statue, usually were not completely covered by color,

180

the colored parts helping place the uncolored parts in proper context. Nino's Madonna and Child were still marble, for much of the marble still showed, but the gold of the hair and the trim of the Madonna's mantle helped remind her worshipers that this, indeed, was sacred marble.[29] With Renaissance sculpture, color was used in three basic ways: symbolically; to help bring out the sculptural material; and for expressive purposes. The gold on Donatello's *Annunciation*, 1438-1440, in Santa Croce in Florence not only is appropriate symbolically as a sacred color but it also helps reveal by contrast the gray depths of the "pietra serena." On the other hand, Verrocchio sometimes used color to help express the vitality of his subject matter, as with the buoyant energetic colors on the terra-cotta portrait of *Lorenzo de'* Medici (Fig. 18).[30]

In the twentieth century, the use of color achieves an unprecedented flexibility, although this usage often has a tentative, experimental quality. As Lucy R. Lippard observes:

Color in sculpture is more difficult to work with than color in painting because so many factors must be taken into consideration. It is also more difficult to assess from a critical point of view. Whereas color in painting can be judged within a relatively understood system of theory or experience, such a system . . . is not yet established for sculpture. No matter how large a painting is, the surface can be taken at a glance, and while the form and color action may be extremely subtle and engender different effects after different viewing times, it can be perceived initially as a unity. A sculpture must hold its own in space and from different angles; color must be so thoroughly controlled that it is both absorbed by and heightens the purpose (formal or psychological) of the sculpture itself. Because of this, and because color had largely disappeared from sculpture for so long, its development is in a much earlier stage.[31]

The following examples are a very small but representative sampling in which the use of color is basically sculptural rather than pictorial. Brancusi polished the skin of his *Bird in Space* (Fig. 49) to such a golden transparency that the solidity of the bronze is dematerialized, making the surrounding space seem to penetrate the skin. This is "untruth" to bronze, running counter to the natural impenetrability of the material. But Brancusi was sculpting *Flight*, and the perceptual particularity of that activity was helped by that dematerialization. Elie Nadelman often painted wood, as with the face and dress of *Woman at the Piano*, c. 1917, the Museum of Modern Art in New York. The woodiness of the cherry wood is obscured, but the smooth shapes of that wood are enhanced. Boccioni variously colored the wood planes of his *Dynamic Construction of a Gallop-Horse-House* (Fig. 40) to help delineate their shapes as sharply as

possible. Although the colors hide the textures and grains of the wood, they stabilize the light on the surfaces, bring out the depths of the various planes, and keep the planes separate but related. These practices were soon followed and developed by Arp. In 1893 Hildebrand saw what was coming: "Color contrasts are primarily significant to bring out the form. . . . Light and shade become more effective than the actual form. These changes may be counteracted by the use of colors. . . . Form proportions may be made apparent by the aid of colors, quite independent of the illumination and, indeed, in spite of it. . . . Proportions of form are expressed by these colors without regard for the special meaning which the colors may have in Nature."[32] George Sugarman in more recent times writes: "In my sculpture, the color is as important as form and space. . . . It is used to articulate the sculpture. . . . One of the uses . . . is for the color to help each form hold its own space and not merge into the form adjacent to it."[33] It seems that more people are "form-blind" than color-blind, and so the use of color on sculpture helps the "form-blind." And it may be, incidentally, that this greater incidence of "form blindness" is one of the fundamental reasons, along with the eminence of the eye tradition, why painting generally is more popular than sculpture.

Picasso, Archipenko, and Laurens, influenced by the Analytic Cubistic techniques of the painters, used color to help fragment the depth of a thing. Color multiplied recessive and projective effects, strengthened or weakened lines, concavities, and convexities, and while hiding the material helped bring out the three-dimensional facets especially of the interior, as in Laurens's *Head* (Fig. 42). Such a work is a "sculpture of scaffolding." Dislodged from its traditional function as an invisible support, the armature, accented by color, is brought forth. The skeleton becomes as important as the flesh. Laurens recalled: "I wanted to do away with variations of light by means of color, to fix once and for all the relationship of components, so that a red volume remains red regardless of the light. For me, polychrome is the interior light of sculpture."[34] Calder often colors his metal, as with *Bougainvillea* (Fig. 56), in this example making the disks appear like blossoms. Louise Nevelson's encompassing black helps draw all parts into a quiet whole, as with *Sky Cathedral* (Fig. 72). The factory-made identity of her "ready-mades" is obscured which, in turn, helps bring out the nostalgia of things once used by absent people. The painted white inside of Hepworth's *Pelagos*, 1946, Tate Gallery in London, helps bring out by contrast the grainy warmth, glow, and roundedness of the unpainted wood outside. Segal until recently usually used color negatively,

sucking it from his plastered bodies, as with *The Bus Driver* (Fig. 71), helping leave them as pathetically alone as Giacometti's shriveled figures (Figs. 57, 58). Segal explains, "The whiteness intrigues me for all its special connotations of disembodied spirit, inseparable from the fleshy corporeal details of the figure."[35] Red Grooms uses color realistically, as in *Hollywood*, 1965, in the Hirshhorn Museum in Washington, to mask completely the sculptural materials and unmask the tinsel shallowness of some of the things that make up that kind of life-style. John Chamberlain uses smashed metal from junkyards. The metal material creates a crushed and relatively static space; the bright applied colors, usually factory-applied but sometimes supplemented by Chamberlain, create a dynamic space. The two kinds of space fight each other, reinforcing the theme of savage physicality and destruction, as in *Velvet White*, 1962, in the Whitney Museum in New York. Since some kinds of industrial materials such as iron and steel require paint for preservation, truth to that kind of material may call for color, and such usage usually appears more sculptural than pictorial. Thus the monochrome color of many of Anthony Caro's floor-bound, or earthbound beams seems to belong naturally to those beams, sharpens their lines, and helps reinforce the aggressive probing of the beams out into space (Figs. 76, 77). Color can also make more coherent our perception of often very complex configurations, as in the case of the red paint on the steel of Caro's *Homage to David Smith* (Fig. 82). Tony Smith, on the other hand, sometimes allows his metals to rust, bringing out their vulnerability and giving them a quality of nostalgia, as in *Cigarette*, 1967, Albright-Knox Art Gallery in Buffalo. Dubuffet sometimes brightly colors irregular surfaces made out of polyester resin, the colors accenting the bumps which jump out into space, as with *Glass of Water II* (Fig. 80).

There are instances as well, of course, in which color is more pictorial than sculptural, weakening the impact into space. The insouciant colors painted on the bronze of Picasso's *Glass of Absinthe* (Fig. 39) work contrapuntally not as an adjunct to the three-dimensional shapes but as reflectors of light that thin the three-dimensional into the two-dimensional, whatever the angle of perception. Thus the pictorial is as important as the sculptural, and this work is an excellent example of mixed media, of "Sculpto-painting." However, that kind of balance—like the real sugar spoon tilted on the lip of the glass—is rarely achieved. For all their cross-fertilization, sculpture and painting are so rooted in their respective origins that one or the other almost always dominates in a given work.

183

Most sculptures illustrate the doctrine that truth to materials helps bring forth truth to things. With some sculptures, however, this doctrine is not illustrated, as when color by concealing the material helps reveal the thing. In Aristotelian terms, with sculpture as with everything else made by man, the material cause ought to be determined by the final cause. For the sculptor insofar as he achieves the "be-all and end-all" of sculpture, truth to materials is always subordinated to truth to things—the sullen, intractable, porous, impenetrable, opalescent, granular, smooth, fleshy, brittle, ugly, beautiful, threatening, appealing solids that surge forth and make up the "isness' of our world. Sculpture extends to us the thing as thing. Sculpture allows us to take full possession of a thing.

XI

Sculpture and Place

The piece of sculpture was a thing standing apart as the picture was apart, the easel-picture, but, unlike the latter, it did not need even a wall. Nor even a roof. It was something which could exist for its own sake alone, and it was well to give it absolutely the character of an object round which one could pass and which could be observed from all sides. And yet, it must in some way be distinguished from other things, ordinary things, which anyone may lay hold of. It must be made . . . sacrosanct, separated from the influence of accident or time, in the midst of which it appears solitary and strange, like the face of some visionary. It must have its own assured place, uninfluenced by arbitrary considerations, and it must be made part of the calm permanence of space and its great laws. It must be fitted into the surrounding air as into a niche and thus be given a security, a stability, a sublimity due to its simple existence.

Rainer Marie Rilke, *The Rodin-Book*

After the flood in Florence in 1966, I was wandering through the restoration center, which was then little more than a drying-out place. Like patients in a hospital, Donatello's life-size sculpture of *Mary Magdalene* (Fig. 17) and a large painting of the *Crucifixion* by Niccolo di Pietro Gerini (active 1368-1415) were lying on tables side by side. The sculpture seemed terribly out of place. The painting was also out of place, of course, but since it could have fit in many places—almost any church or museum—it seemed only temporarily displaced. The space around a painting is only a means to perceiving it, and there are all kinds of places that can provide suitable spaces. The *Magdalene* did not appear to be nearly as physically damaged as the *Crucifixion*. Her leathery-looking flesh and skeletal figure had never appeared healthy, but in her original niche within the Baptistery she had always seemed, however penitent, very much alive. Now she looked like a corpse, not only because the flood had damaged her and she was lying in a horizontal position but also because she had been torn from her proper place.

185

A work of architecture creatively preserves its space, an immovable centered place. Of course there are exceptions to this immovability, such as the lifting of buildings, even across continents. And more commonly, the centeredness of a work of architecture may be weakened by changes in the environment, especially the crowding in of other buildings, as has happened with Sainte-Chapelle in Paris and Bramante's *Tempieto* in Rome. Occasionally, however, the centeredness of a work of architecture may be strengthened by environmental changes, as by the removal in the nineteenth century of buildings that had been constructed between and against the buttresses of Chartres Cathedral.

Unlike a work of architecture, a painting, since it creates an imaginary space separate from real space, only has to find a place in which it may be advantageously perceived. This discovery may require great care, but usually a place is not exceptionally difficult to find, for a painting can be at home almost anywhere, not even necessarily requiring a centered place. All that is necessary is a protected place with easy access, proper lighting, and good sight lines. With a painting the surrounding space is not part of the painting but only a means to it.

Although more movable than architecture, sculpture also creates its own centered place, though more limited in extent, for space is organized around or within the material body of the sculpture and belongs to it. Space becomes part of the sculpture. Consequently, the *Magdalene* on the table still carried about her, like an aura, something of both the space inside the Baptistery and her role there as a reminder to the participants in the baptismal ceremony of the original sin that is washed away. It was impossible for me to separate her completely from my memory of her original place. Such a sculpture is like a planet torn from its sun but still indicating the place and rhythm of its origin. On the other hand, the *Crucifixion* carried no spatial aura of the place it had been moved from, except that, because of its content, the painting suggested a church as its original place. If my memory is correct, the *Crucifixion* came from the Museum of Santa Croce, but any knowledge of its most recent place did not seem nearly as relevant as with the *Magdalene*.

After restoration the *Magdalene* was returned to its niche in the Baptistry. However, the humidity was damaging the wood, so since 1974 it has been placed in the middle of a square room in the Museo dell' Opera del Duomo, standing as if it were a sculpture in the round. This placing is most unfortunate, for the history and mystery of the environment of the Baptistery is now only a

186

memory. Furthermore, the *Magdalene*, like Michelangelo's *David* (Fig. 19), needs a wall as a niche, for the backside is of little interest and a wall, as in the Baptistery, accentuates the planar push of the figure. Without this accentuation, much of the immediacy of the suffering penitence of the *Magdalene* fades away.

It is true, of course, that many paintings were made for special places, e.g., the Pompeian wall and floor decorations, Medieval murals, the ceilings of Renaissance and Baroque palaces, the walls of the General Assembly Hall of the United Nations. Generally, however, even such paintings do not lose very much, if anything, when they are detached from their original locations. The obvious exception occurs when paintings are closely tied to the architecture, especially multiple scenes of dramatic narrative. For example, Michelangelo's Sistine frescoes are perceptually inseparable from the vast monumentality of their ceiling. Giotto's frescoes in the Peruzzi and Bardi chapels in Santa Croce in Florence and Raphael's frescoes in the Vatican Stanze, which were so carefully designed for their spaces, would be terribly disadvantaged if they were to be wrenched from their walls. If Giovanni Battista Gaulli's famous fresco on the ceiling of the Church of the Gesu in Rome, representing the *Triumph of the Name of Jesus*, were removed, then the extraordinary illusionistic continuation of the space of the architecture would be entirely lost. It is certainly true, furthermore, that the grand style of history painting derived from Raphael often required a special place. Sir Joshua Reynolds and his follower Sir James Barry, who decorated the Great Room of the Society of Arts (1777-1783), properly proclaimed the need of a great place for a great subject. Moreover, programs by private donors can also give paintings a place that resists displacement, as sometimes with the domestic iconography in Renaissance and Baroque palaces as well as villas and mansions of the eighteenth century.[1] Yet with most paintings, even those commissioned for a special place, the place is not as essential as with sculpture. For example, in Florence for a while many of the Renaissance frescoes that were decaying on their original, too-humid walls were removed to the airy bright rooms of the Forte di Belvedere. Not only were all of them being better preserved, but most of them were being better perceived. Similarly, the famous Pompeian floor mosaic of *The Battle of Alexander* from the House of the Faun, 3d-2d centuries, is surely better seen on a wall in the National Museum of Naples then if it had been kept in its original place.

Federico Fellini opened his film *La Dolce Vita* with an astonishing shot of a white marble statue of Christ with outstretched arms being rapidly flown over

187

Rome by a roaring helicopter and viewed by bikini-clad, sun-bathing sexpots. This travesty of a sculpted Christ being so handled and ogled is heightened by its uprootedness. This Christ is headed for a museum, perhaps? We do not know, for Fellini never brings it back to earth. This kind of levitation is appropriate for the resurrected Christ and possibly a painting of Christ, but never for a sculpture of Christ. Whatever its subject matter, a sculpture has a material body that demands grounding, however tenuously, on the earth. Moreover, that body cannot breathe without incorporating a surrounding space. A sculpture needs a centered place and fixed abode.

Oriental monumental sculpture, perhaps more than any other tradition is usually strongly earthbound. For example, near Kyŭngju, Korea, about thirty miles from Pusan, on a high mountain overlooking a glorious view of the sea of Japan, an immense, finely carved Buddha—the famous Sŏkkuram—looks out majestically and serenely from a cave facing the east. When I was there in 1946 it was extremely difficult to get up the mountain, but the effort was rewarded: the sculpture shone forth magnificently from the dark cave to the rising sun, surely one of the most sublime placements of sculpture in the world.

Things, including our bodies, are place-dependent. We walk vertically and rest horizontally. Our ability to distinguish between earth and sky and their constant conjunction establishes the basic setting for place and directions to them. We are usually aware of up and down, near and far, left and right, north, south, east, and west. We are always aware when we are "out of place," always accompanied with anxiety. And when we do not know where we are, we do not know where other things are. We are directionless. Our world becomes an abyss, and our anxiety may become dread. When we are "in place," things around us also have their place. For example, equipment belongs to a place as part of a totality of "fors." The hammer is *for* the nails and the nails are *for* the boards and the boards are *for* the table being built. Their here or there, up above or down below, inside or outside have not just the character of nearness or farness but are directional as determined by the context of the making of the table. And when the table is finished it also finds a place, and that place-character stays with it. The table is designed for a particular kind of place, and that place fits in with it. We are usually aware when the table is out of place, as when the table is in a place where it cannot be used as a table.

Greek philosophers had conceived of abstract space—a void independent of things—as in the theories of the Atomists such as Democritus and Leucippus. But the idea of abstract space never became part of the "mental habits," to

use Erwin Panofsky's term, [2] of Greek culture. In the ordinary language of the Greeks, who were close to things, there were no words for abstract space. Indefinite space meant little to them. Their space words were place words, indicating location or distance. Every thing was at a place, and every thing had its proper place. It is not surprising, therefore, that sculpture was a far more important art (in practice though not in theory) than painting. If Greek painting had achieved the greatness of Greek sculpture, it seems likely that the Greeks would have found words for describing space without restriction to particular place relations. The perception of a space independent of real places tends to lead to the conception of space as an independent void. Although the spaces of Greek painting show places, they are in an imaginary space, and this is a detachment that suggests the possibility of abstract space. It may even be that if their painting had been more important, the Greeks would have conceived of works of art as detachable. But, as Herbert Read points out, "One cannot emphaize too strongly that the *objet d'art*, as a detached and independent *thing*, transportable or movable in space, is foreign to the Greek. [3] Probably it is no mere coincidence that words for space without place came into popular consciousness in the Renaissance, when painting finally became the dominant art not only in theory but also in practice. There is no doubt that developments in mathematics, astronomy, and physics were leading to concepts of abstract space, foreseen by Nicholas Cusanus in the fifteenth century and culminating in the "container" theory of Galileo and Newton in the seventeenth century. These discoveries inevitably required terms that referred to space as a void. But, at the same time, the development of geometrical perspectival systems in painting by such innovators as Alberti, Uccello, Piero della Francesca, Leonardo, and Dürer were also creating a need for words describing space abstractly. These scientific and artistic developments were closely associated, for most of the artistic innovators were also either scientists or familiar with science. The intellectual atmosphere of the Renaissance was governed by "mental habits" that made possible the development of concepts of abstract space which were more than merely exotic philosophical notions, as with the Greeks and Romans, and which were beginning to enter the popular consciousness.

Whereas place is fundamental to sculpture, it is usually incidental to painting. Generally paintings are not place-dependent, exceptions confirming the rule, such as the mighty mosaic of the half-length figure of Christ on the ceiling of the apse of the Cathedral of Monreale in Sicily. Although sculpture

transforms real space, it stays in that space. Sculpture dwells in the real world. Thus sculpture can sometimes dispense with the pedestal, as with many of the sculptures of Anthony Caro (Figs. 76,77,82) or at least the pedestal can be kept very close to the earth. Rudolph Arnheim disparages Rodin for conceiving "the idea—fortunately blocked by the good sense of the burghers of Calais—of having his bronze figures of Eustache de St. Pierre and the six other citizens placed in single file directly on the pavement of the square in front of the Town Hall, as though they were actually on their way to meet the English conqueror. 'By almost elbowing them,' says Rodin, 'the people of Calais of today would have felt more deeply the tradition of solidarity which unites them to these heroes.' Such intermingling of art and the traffic of life is a vulgar aberration."[4] Arnheim's judgment, it seems to me, is slanted by his visual and pictorial interests.[5] Indeed, the sculptural power of the *Burghers* (Fig. 32) tends to diminish as they rise from the earth. Compare the very low placement of the sculpture in the garden of the Rodin Museum in Paris with the higher placement in the garden of the Hirshhorn Museum in Washington. On the other hand, paintings almost invariably are more effectively perceived when they are set up in a way that accents their separation from real space. Paintings abstract themselves from real space and the real world, using places in the real world but not dwelling. Sculptures settle into a place by enlivening the surrounding space, reaching out and centering other things around themselves, and resisting detachment. That is why, along with their comparative lightness, paintings usually are commercially much more convenient than sculptures. David Smith once remarked that he was going to make his sculptures "so big that they can't be moved."[6] But even movable sculptures become place-bound. Donatello's *Saint George*, c.1417, which stood for centuries as an exemplar of courage in the Niche of the Armourer's Guild on the outside north wall of Or San Michele in Florence, has lost much of its proud fierceness in an anonymous niche inside the Consiglio Generale, the largest room in the Museo Bargello. Formerly *Saint George* looked out on a bustling street, full of noisy movements; now he looks out on a room jammed with some of the finest sculptures of the Italian Renaissance, each fighting without success for a place. The lack of breathing space deadens much of their liveliness. In the winter, sometimes, when few people are around, the frigid salon with its frozen figures is strangely like a morgue. In the summer, sometimes, when many people are around, one feels helplessly caught in a whirlpool of crowded spaces. Sad, indeed, for we know

190

from examination of the sculptures as well as from surviving documents how carefully their creators prepared them for their places.

In 1966, the *Afo-A-Kom* (Fig. 31), whose name literally means "the Kom thing," was stolen from the Kom people of the Cameroon.[7] Carved from a single log of teaklike iroko about one hundred years ago, the extremely hard and heavy dark wood showed forth a standing man a little more than five feet tall, with a long torso and strongly stylized features, crowned and holding a scepter. At knee-high level was a throne, supported by three carved buffalo heads. Sometime later the body was covered, except for the hands, genitals, and toes, with opaque beads of reddish brown and dark blue, and the face was sheathed in copper. In 1972 the statue surfaced in a New York art gallery, and in November 1973, after complicated negotiations, the *Afo-A-Kom* returned home to its proper place. The king of Kom felt and smelled the statue to be sure it was not a copy. The people of Kom "sang, and feasted, and drank enough palm wine to call down the curse of tomorrow's regret. The festivities continued for four or five days—brief enough, considering that they were celebrating the end of seven years of grief."[8] Although not a religious icon, the statue is invested with communal symbolisms of the traditions of the Kom people. The three-dimensionality of the statue helps make this investiture possible, not only allowing symbols to be literally pinned to the statue but also facilitating, because the statue dwells, metaphorical pinnings.

Paintings are less receptive than sculptures to the symbolic investitures of a people. Vasari reports the way the Florentines greeted the *Rucellai Madonna*:

He [Cimabue] . . . painted a picture of Our Lady for the church of S. Maria Novella, where it hangs high up between the chapel of the Rucellai and that of the Bardi of Vernio. . . . The people of that day, who had never seen anything better, considered this work so marvellous, that they carried it to the church from Cimabue's house in a stately procession with great rejoicing and blowing of trumpets, while Cimabue himself was highly rewarded and honored. It is reported, and some records of the old painters relate, that while Cimabue was painting this picture in some garden near the gate of S. Piero, the old King Charles of Anjou passed through Florence. Among the many entertainments prepared for him by the men of the city, they brought him to see the picture of Cimabue. As it had not been seen by anyone, all the men and women of Florence flocked thither in a crowd, with the greatest rejoicings, so that those who lived in the neighbourhood called the place Borgo Allegri (Joyful Quarter), because of the rejoicing there. This name it has ever afterwards retained, being in the course of time enclosed within the walls of the city.[9]

Actually the *Rucellai Madonna* was painted by Duccio di Bounisegna. Also the King Charles story is false, for when the king, a brother of Saint Louis, was in Florence, the foundations of Santa Maria Novella had not yet been laid. However Vasari's tales indicate that paintings, because of their easy detachability, are more susceptible to confusions about their history than sculptures. These tales also indicate that paintings can be given great community adulation. Yet if symbolic investiture is given to a painting, it seems to be more religious than communal. The *Rucellai Madonna*, which is now in the Uffizi, has never found a permanent place, nor perhaps does it need one. As with most religious paintings, its very detachability tends to make it more receptive than religious sculptures to investitures of sacred symbolism. The sacred, at least in Western religions, is usually conceived as being beyond any earthly or specific dwelling place. Conversely, the dwelling of a sculpture in an earthly and specific place tends to make it more receptive than a painting to investitures of communal symbolism. The traditions of the Kom people come from a special place, and their *Afo-A-Kom* not only symbolizes that special place but takes command, by centering, of that place.

Imagine the *Marcus Aurelius* in the Campodoglio of Rome or Donatello's *Gattamelata* in the Piazza del Santo in Padua or Verrocchio's *Colleoni* in the Piazzo Santi Giovanni and Paolo in Venice or Rude's *Chant du Depart* on the Arc de Triomphe in Paris or Ossip Zadkine's *Monument to the Destroyed City of Rotterdam* (Fig. 66) removed to museums! Imagine the increased power of the Elgin marbles if they were taken back from that dull hall in the British Museum and restored to the Parthenon or even the Acropolis Museum. Consider what happened to Brancusi. He willed his studio and its belongings from Rue Ronsin 11 in Paris to France. Barbara Hepworth wrote a moving tribute:

In 1932, Ben Nicholson and I visited the Romanian sculptor Constantin Brancusi in his Paris studio. . . .I encountered the miraculous feeling of eternity mixed with beloved stone and stone dust. It is not easy to describe a vivid experience of this order in a few words—the simplicity and dignity of the artist; the inspiration of the dedicated workshop with great millstone used as bases for classical forms; inches of accumulated dust and chips on the floor; the whole great studio filled with soaring forms and still, quiet forms, all in a state of perfection in purpose and loving execution, whether they were in marble, brass or wood—all this filled me with a sense of humility hitherto unknown to me.[10]

Brancusi assumed that his "place" would be preserved in situ. Instead, everything including the skylight was transported piece by piece into a dimly lit gray

room in the Musée National d'Art Moderne. Miserable replicas of many of his major works were then crowded in to complete the travesty. The recent history of Carpeaux's *The Dance* further illustrates the point. Because of deterioration *The Dance* was removed from the facade of the Paris Opera to the Louvre, a fairly good copy by Paul Belmondo taking over the original place. Now this copy sings and dances. The original is silent and still. However, there are occasions when removal to museums is not only necessary for preservation but advantageous for perception. Henry Moore recalls going to Pisa as a student to see the Giovanni Pisano figures on the top of the Baptistery:

About all I could get from them was that they represented a change away from the Byzantine towards the Renaissance. They were too high, they were just silhouettes against the sky and it was impossible, at that distance, to see the form inside the silhouette. These figures (because they were weathering too rapidly and some were becoming unsafe) have since been taken down from the Baptistery and put into a museum at Pisa where, four years ago, I saw them again. They are set up on eye-level and on turntable stands and I now think they are some of the world's greatest sculptures. Now that one can go near them one can respond to them as sculpture, as bumps and hollows, as volumes and taut compressions, and as humanist expression, and not merely a decorative architectural feature. [11]

Museum space or gallery space and sometimes even things in such spaces can become an integral part of a sculpture. For example, at a Moscow exhibition called "Year 1915" Mikhail Larinov was placing a relief construction on a wall close to a motorized fan. One of his colleagues jokingly asked if the fan were part of his sculpture. Larinov stepped back, paused for a while, and then reorganized his relief to include the mechanical object. If Larinov had been placing a painting, any reorganization—unless he had turned the work into a sculpto-painting or a sculpture—would have been impossible. Sculptors generally are much more conscious than painters of the spaces their works go into.

Perhaps one of the basic motivations leading to Environmental sculpture was the need to protect the space around a sculpture from tampering. The outer perimeters of the surrounding space for the most part usually get out of the sculptor's control once his work leaves his studio, but with Environmental sculpture the sculptor has some control at least over the "inside" of that space. That is why museums are often fairly appropriate places for such works. The sculptor can specifically use a preestablished gallery space as part of his design, as with Morris's *Labyrinth* (Fig. 90) or the Neon sculptures of Dan Flavin, the

gallery space becoming a "container." Generally, however, the transformed mansions of millionaires and the marble-pillared mausoleums (which most museums, such as the National Gallery of Art in Washington, needlessly are) deaden sculpture far more than they deaden paintings. Ipousteguy remarks that "sculpture is put in museums to let sculptors go on living, but it's not the right place."[12] Ipousteguy also paints, but it is not surprising that he did not say the same about paintings, for museums provide the kind of places in which paintings can be readily perceived. Because a painting stays within itself, a painting uses places but does not dwell in them. That is not to deny that there are good and bad places for paintings to use. Paintings must have fitting surroundings if they are to be optimally perceived. Corot's *Ville d'Avry* would be overwhelmed on a wall full of Cézannes. Even Cézanne's *Mont Sainte Victoire* (Fig. 33) would get lost on a wall in a supermarket. Nevertheless, most paintings are detachable and movable from place to place without the inevitable loss of "rightness" suffered by most sculptures. Whereas a sculpture belongs "here" or "there," usually a painting can be almost "anywhere." Indeed many paintings seem to receive renewed interest when placed in new settings. For example, I have noticed that most lovers of both painting and sculpture move their paintings around in their homes, whereas their sculptures get rooted. Once located properly, a sculpture dwells and resists removal. And when a sculpture is moved, it may badly upset other spatial relationships. A sculpture with a strong physical presence placed in the corner of a living room may distort the whole setting of one's living arrangements by becoming a powerful center to which everything must submit. Such distortion is not quite as likely with a painting, even if it is larger than the sculpture, on a wall in the same room. A sculpture invades an environment, whereas a painting evades. A sculpture heightens our sense of real space, whereas a painting "derealizes," to use Ortega y Gasset's term, our sense of real space. A weak sculpture usually fits more harmoniously into functional living arrangements than a strong sculpture, for the former is less dominating. A strong painting, because of its "derealization," tends to make itself irrelevant to its environment. Thus if one wants a picture to enhance the decor of a living room, for instance, it may be wise to choose a weak painting or better a work of decoration. Then the color, textures, lines, and shapes may be able to reinforce similar qualities in the room, whereas a strong painting withdraws into its own world.

When a sculpture and a painting of more or less equal quality and size are exhibited together, the painting must be very carefully placed or it may be

overwhelmed. For example, in Or San Michele in Florence, Orcagna's *Tabernacle* (Fig. 13)—a massive Gothic masterpiece in marble ornamented with colored glass, small statues in the round, and reliefs of the life of the Virgin— contains a colorful *Madonna and Child* by Bernardo Daddi. The painting holds its own because of its excellent quality, large size, and the inset centrality of its placement, but it is ironical that the sensitive placing of the painting is matched by an insensitive placement of the sculpture. The *Tabernacle* is not only terribly crowded against two walls and the ceiling but barely visible without the help of artificial lighting, and the main entrance leads to the back of the *Tabernacle* through a door that on opening almost hits the base.

Because of the concave openness of the *Tabernacle*, its impacting forces are mainly centripetal, transforming the surrounding and interior real space into preparatory "steps" that lead us visually into the *Tabernacle*. In the center of its open space, the spatial forces quiet down, creating a gentle setting for the imaginary space of the painting. If the *Madonna and Child* were moved to the front of the *Tabernacle*, there would be an unfortunate clash between the real space of the sculpture and the imaginary space of the painting. Daddi's *Madonna and Child* dwell within Orcagna's Tabernacle, but the *Madonna and Child* could be detached to other places such as the Uffizi without disastrous results.

In their detachability from place, paintings are more like dance than sculpture. Except for certain magical or religious dances where the dance must be performed on specified grounds, as with the Rain Dance of the Zunis, the dance does not dwell in a place. As a performing art its place of performance, like those of music, film, and the drama, is transient. Even the space surrounding the dancers—the space of the dance which, except with some avant-garde works, is clearly separated from the space of the audience—vibrates only with the performance, returning at the finish, like the space of music, to stillness.

Eugene Dodeigne, the Flemish sculptor, insists that "the character of the land—the sculpture is like that. . . And then what the earth is, or the pear tree, or the light, or the wind: all that exists in the sculpture.. . . Especially in sculpture, a *place* is necessary."[13] The origin of sculpture is the need to bring forth our "withness" with things. That is why sculpture moves to all-roundedness, continually tries to reveal the human body, strives to be truthful to things, and seeks to dwell in a place. We are beings who can lose our place, especially now, and then "Five minutes on even the nicest mountain is awfully long" (W. H. Auden, "Mountains"). Despite its obvious and great benefit,

technology puts tools between us and things and twists places into common-places. We are led toward nihilism, to not knowing where we are, for technology tends to arrange things and places so that we do not have to participate with them. Technology can so externalize our lives that we become alienated from ourselves and others, our artifacts, and nature. Technology not only stiffens bureaucracy's yoke of custom and convention, but the arid, asphyxiating atmosphere of a technological society can fragment us into "bits of paper, whirled by the cold wind" (T. S. Eliot, "Burnt Norton").

Under the pressure of technology we are pushed away from things and places, but our departures can never be complete. The calculative thought that governs our practical affairs, our sciences, and our technologies is still necessarily grounded in our primordial unity with things. As Heidegger reminds us: "Calculative thought places itself under compulsion to master everything in the logical terms of its procedure. It has no notion that in calculation everything calculable is already a whole before it starts working out its sums and products, a whole whose unity naturally belongs to the incalculable which, with its mystery, ever eludes the clutches of calculation."[14] By bringing forth thingliness, sculpture also brings forth the earth as a place where our bodies can resonate to the rhythm of things. In the origin of sculpture is its purpose: to return us to the home, to the mystery, we so often run away from and yet never quite leave.

XII

Avant-Garde
Sculpture

The past is always new: it changes continuously as life goes on. Parts of it, seemingly forgotten emerge again, while others, being less important, plunge into oblivion. The present directs the past as the member of an orchestra.

<div align="right">Italo Suevo</div>

If Sculpture merely repeats the revelations of the past, sculpture becomes decadent, the sort of thing we find in so many products of the eighteenth and nineteenth centuries, the work of little men who only liked what they knew. On the other hand, if sculpture cuts itself off from its roots, it becomes gimcrackery, as with many products of this century, the work of clever men catering to a public taste for the unthinking acceptance of novelty for its own sake. In one sense, every sculpture that is a work of art is avant-garde, for "working" through the work is an original showing forth of some aspect of being-with-things. In another and more usual sense, avant-garde sculpture impatiently challenges the traditional ways of sculpture, and in this sense the twentieth has been the most avant-garde century in the history of Western sculpture. From the *Venus of Willendorf* (Fig. 1) to Rodin (Fig. 32, 34), the human body and monolithic structures completely dominated sculpture. The hydra-headed phenomena of twentieth-century sculpture still include many fine examples of this tradition—the works of Despiau, Laurens, and Maillol, for instance—but after Brancusi, Gabo, and Pevsner had paved the way, sculpture also included many kinds of subject matter other than the human body and a seeming infinity of open rather than monolithic structures. Brancusi: "Nude men in sculpture are not as beautiful as toads."[1] Gabo and Pevsner: "We deny volume as an expres-

sion of space. Space can be as little measured by volume as a liquid by a linear measure. . . . We reject physical mass as an element of plasticity."[2]

The sculpture of the twentieth century continues to be so abundant and diversified that it is extremely difficult to assimilate. Moreover, we lack perspective in the sense of Goethe's wise observation: "It is impossible to contemplate an epoch from a standpoint within that epoch." Sculptors today, furthermore, project their individuality as never before. There are no schools in the traditional sense, as with the schools of Canova and the Beaux-Arts. There are no definite progressions from one "ism" to the next, and rarely any sharply drawn lines of influence. Few styles can be clearly delineated. Nevertheless, twentieth-century sculptors generally, besides their movement away from the human body and the monolith, also have moved away from making their works dependent upon architecture, deemphasized pictorial aspects, and avoided representing things in an idealized manner. They have concentrated upon completely free-standing sculpture in the round and developed all-roundedness. Additionally, twentieth-century sculptors have a common problem and opportunity: How to use the power inherent in technological advances and a rapidly expanding range of sculptural materials in way that will reveal how contemporary man values things and being-with-things. Gombrich observes:

The modern artist wants to create things. The stress is on create *and* on things. He wants to feel that he has made something which had no existence before. Not just a copy of a real object, however skillful, not just a piece of decoration, however clever, but something more relevant and lasting than either, something that he feels to be more real than the shoddy objects of our humdrum existence. If we want to understand this frame of mind, we must go back to our own childhood, to a time when we still felt able to make things out of bricks or sand, when we turned a broomstick into a magic wand, and a few stones into an enchanted castle. Sometimes these self-made things acquired an immense significance for us—perhaps as much as the image may have for the primitive. I believe it is this intense feeling for the uniqueness of a thing made by the magic of the human hand that the sculptor . . . wants us to have in front of his creations.[3]

The most important influence on the way the modern sculptor creates things is the invasion of technology into almost every aspect of our lives. As never before, the machine has come between us and things, turning things into objects. The qualitative individuality of things tends to be unperceived because, among other reasons, we so often are not in direct contact with things as things. We are out of touch. So usually we notice things, if at all, as apart from us, alien. Never has the subject/object dichotomy been sharper. Sculptors have

reacted either by protesting this alienating effect of technology or by accepting technology as a means which can help return us to things. Sculptors cannot ignore technology, for the machines have laid their "hands" on almost every thing.

In attempting to organize this very brief discussion of a few examples of the avant-garde sculpture of this century, I will examine the protest against technology and the accommodation with technology. Then, finally, I will examine Space sculpture and Earth sculpture, two of the most interesting innovative ways among the many that twentieth-century sculptors have found to reveal things and our being-with-things in a technological age. Environmental sculpture, one of the most revolutionary developments of the avant-garde, has already been briefly discussed. I will not attempt to outline the historical developments of twentieth-century sculpture. I will attempt to show that, despite the obvious differences, the new sculpture is rooted in the same origin as the old.

PROTEST AGAINST TECHNOLOGY

Giacometti's *City Square* (Fig. 57) and *Man Pointing* (Fig. 58) show no machine. Yet we are aware that probably only an environment dominated by the machine could reduce humans to such distress. Trova's *Study: Falling Man (Wheelman)* (Fig. 79) makes Giacometti's implicit protest explicit. Flaccid, faceless, and sexless, this anonymous robot has "grown" spoked wheels instead of arms. Attached below the hips, these mechanisms produce a sense of eerie instability, a feeling that this antiseptically cleansed automaton with the slack, protruding abdomen may tip over from the slightest push. In this inhuman mechanical purity, no free will is left to resist. As expressed in Aldous Huxley's *Brave New World*, the value of persons has been reduced to manpower, functions they perform in the world of goods and services. Since another individual can also perform the same functions, no individual has special worth. One's value is x, a unit that can easily be exactly replaced by another.

Whereas the habitat of the *Wheelman* is the clean, air-conditioned factory, the habitat of Segal's *The Bus Driver* (Fig. 71), as with Giacometti's ravaged people, is the grubby street. Grimly set behind a wheel and coin box taken from an old bus, the driver is a plaster cast made in sections over a living well-greased model.[4] According to Segal, "People have attitudes locked up in their bodies and you have to catch them."[5] In the air around the stark white figure, we sense

199

the hubbub of the streets, the smell of fumes, the ceaseless comings and goings of unknown customers. However, despite all these suggestions of a crowded, nervous atmosphere, there is a heartrending loneliness about this driver. Worn down day after day by the same grind, Segal's man, like Trova's, has been flattened into an x, a quantity.

Drago Tršar's *The Demonstrators II* (Fig. 64) is a powerful presentation of the potential for violence embedded in mass demonstrations. More specifically, it is a prophecy of the 1960s in the United States. To take just one example, *The Demonstrators II* evokes images of the Kent State massacre—the anonymous mass of gas-masked guardsmen with their rifles, and the upraised arms of those in defiance packed together in a design expressing blind, fanatical rigidity. No smiles lighten this rough dark mass. Light flashes on it like lightning. Irrationality reigns, as in a machine which has gone beyond human control.

A walk through a junkyard full of the debris of automobiles can be a terrifying experience, the macabre metal shapes carrying with them the gashes of violence and death. In *Velvet White*, 1962, in the Whitney Museum in New York, John Chamberlain—a "Bulldozer Bernini," as Irving Sandler describes him[6]—roughly assembled large sheets of such twisted, torn metal. He preserved and made even more vivid "the sound and the fury" in the discipline and compression of his composition. It is as if the torn metal were screaming.

Jean Tinguely is dedicated to humanizing machinery. The machine for him is "the ensemble of little mechanisms which are our slaves but which, at the same time, imply a bizarre change in man's lot with respect to the object—I mean the mass production of no matter what object, which is done today by machines, and the automation of the mass production, which will modify us, without any doubt."[7] Elsewhere he writes, "It is simple enough, this idea of reviewing the inutility of all our efforts, the madness of all our mechanisms, the terrifying quantity of machines that begin by serving us. . . . One can say that the machine is mad."[8] Sometimes he humorously disconnects the machine from its utilitarian purposes and helps us perceive it as a thing rather than an object. For example, with *Metacanique*, 1965, in the Musée National d'Art Moderne in Paris, we are invited to press a pedal which energizes wheels that pivot a plank of wood in various straight-line projections, sharply contrasting with the circular turns of the wheels. There is a childlike innocence about this "useless" functioning which brings us into rapport with the individuality of this machine, and children, especially, love to press the pedal. Tinguely remarks, "For me, the machine is above all an instrument that permits me to be poetic. If

you respect the machine, if you enter into a game with the machine, then perhaps you can make a truly joyous machine—by joyous I mean free."[9] At other times, however, Tinguely sadistically dominates the machine, even to the point of making it commit suicide. For example, *Homage to New York* (Fig. 70), exhibited at the Museum of Modern Art in New York in 1960, was made to destroy itself electronically. The mechanical parts, collected from junk heaps and dismembered from their original machines, stood out sharply, and yet they were linked together by their spatial locations, shapes, and textures, and sometimes by nervelike wires. Only the old player piano was intact. As the piano played, it was accompanied by howls and other weird sounds in irregular patterns that seemed to be issuing from the wheels, gears, and rods, as if they were painfully communicating with each other in some form of mechanical speech. Some of the machinery that runs New York was exposed as comic and tragic, for Tinguely humanized this machinery as he exposed it. Even self-destruction was suggested as the piano burned and the structure collapsed. With the humor and the pathos of this work, there is also a violent protest against technology. Tinguely, like Giacometti, Trova, Segal, Tršar, Chamberlain, Joseph Bueys, and many other contemporary sculptors, keeps informing us that if we continue to allow the machine to separate us from things, we will be annihilated. Tinguely also informs us—for he loves as well as hates the machine—that the machine is also a thing. This realization leads to an accommodation with technology. The "protesting sculptors" bring out the horror of technology when it is misused. But Tinguely is also revealing man, not technology, as responsible.

ACCOMMODATION WITH TECHNOLOGY

Many contemporary sculptors perceive in technology blessings for mankind. Lipchitz, for example, states: "It is natural that we should have been interested in machines, not only because we were seeking in our painting and sculpture something of the clarity and precision of machine forms but because this was a moment in history when the machine loomed very large in our consciousness. It was the beginning of modern technology and much of modern industrial expansion. . . . I was never interested, like the futurists, in machine forms as symbols of speed and power, but rather as models of clarity and order."[10] And Charles Biederman states: "As art advanced in its expressive qualities, so necessarily it advanced in its mechanical means of expression. So

we are having remarkable advances in the power of man to express himself creatively through art. Indeed the machine liberates the artist's creation. Therefore, one falls into a very serious error when he thinks the new arts are becoming 'mechanical.' "[11] Sculpture can be accomplished with the most primitive of tools, but such tools tremendously restrict the sculptural possibilities. Far more than painting, sculpture in our day can take advantage of some of the most sophisticated advances of technology. As Jack Burnham points out, there is a natural and special relation between sculpture and technology: "Quite broadly sculpture and technics are related in that they are both extensions of an urge to control and shape a limited part of man's environment."[12] Thus many sculptors today interpret the positive rather than the negative aspects of technology, using technology to help us turn away from objects and return to things. This respect for technology is expressed by care for its materials or its products or its machines and their powers.

Many of the seemingly unending materials produced by technology—steel, aluminum, glass, neon tubing, fiberglass, plexiglass, liquid resins, polyurethane, acrylics, vinyls, rubber, lead, felt, graphite, cloth, and string, to name just a few—open up fascinating sculptural possibilities when released from their commercial functions. Moreover, these materials are things that can be worthy of attention for their own sake. David Smith's *Cubi* X (Fig. 75), like Chryssa's *Times Square Sky* (Fig. 73), exemplifies truth to technological materials. Unlike Chryssa, Smith usually accomplishes this by wedding these materials to nature. The stainless steel cylinders of the *Cubi* support a juggling act of hollow rectangular and square cubes that barely touch one another as they cantilever out into space. Delicate buffing modulates the bright planes of steel giving the illusion of several atmospheric depths and reflecting light like rippling water. Occasionally, when the light is just right, the effect is like the cascading streams of fountains, recalling the Arabic inscription of the *Fountain of the Lions* in the Alhambra, Granada: "Liquid and solid things are so closely related that none who sees them is able to distinguish which is motionless and which is flowing." Usually, however, the steel reflects with more constancy the colorings of its environment. Smith comments: "I like outdoor sculpture and the most practical thing for outdoor sculpture is stainless steel, and I make them and I polish them in such a way that they take on . . . the colors of nature. And in a particular sense, I have used atmosphere in a reflective way on the surfaces. They are colored by the sky and the surroundings, the green or blue of water. Some are done by the water and some are by the mountains. They reflect the

202

colors. They are designed for outdoors."[13] But Smith's steel is not just a mirror of nature, for in the reflections the fluid surfaces and tensile strength of the steel come forth in "a structure that," as Smith puts it, "can face the sun and hold its own." There is truth to this man-made material.

Chryssa also has this "truth to," but in *Times Square Sky* she has her materials reflect the city rather than nature. The materiality of the steel, of the neon tubing, and, especially, of the aluminum is brought out very powerfully by their juxtaposition. Unfortunately, this materiality is difficult to perceive from a photograph, for the effectiveness of the neon light in helping bring out the special sheen of the aluminum that sparkles forth in smooth and rough textures through subtle shadows depends upon our moving from side to side in front of the sculpture. But almost equally unfortunate is the present placement of *Times Square Sky* on a wall in the cafeteria of the Walker Art Center in Minneapolis because tables interrupt one's perception of the sculpture. The subject matter as indicated by the title is about a quite specific place, and the content, by means of its form, is an interpretation of that subject matter. Times Square is closed in almost entirely by manufactured products, such as aluminum and steel, animated especially at night by a chaos of flashing neon signs. Letters and words—often as free of syntax as in the sculpture—clutter that noisy and noxious space with an overwhelming senselessness. The feel of that fascinating square is Chryssa's subject matter, just as with Mondrian's *Broadway Boogie-Woogie* in the Museum of Modern Art in New York. Both works reveal something of the rhythm, bounce, color, and chaos of Times Square, but the mass of the molded matter of *Times Square Sky* helps interpret more of the physical character of Times Square. Whereas Mondrian abstracts from the physicality of Broadway and Forty-second Street, Chryssa gives us a heightened sense of the way that place feels as our body is bombarded by the street and its crowds. Those attacks—tactual, visual, aural, olfactory, and thermal—can have a metallic, mechanical, impersonal, and threatening character, and some of those menacing qualities are revealed in *Times Square Sky*. The physicality of that effect is made possible by the way Chryssa manifests the thingliness of her technological materials.

Twentieth-century sculpture sometimes also brings out the thingliness of technological products. For example Kurt Schwitters, "the archaeologist of the present" as José Pierre once called him, assembled worn-out, discarded, and despised manufactured materials such as cardboard, wire mesh, paper, and nails in his *Merz Konstruktion* (Fig. 43). The waste of our world is brought to

our attention. With sensitive ordering with respect to shape, texture, color, and density, these rejects are rehabilitated. We perceive them as things-in-themselves, perhaps for the first time, a little like returning to an old abandoned house we once lived in but ignored except for practical purposes. We used these things, Schwitters is informing us, and we should recognize that, despite their lowly status, they have a dignity over and above their utility that demands our respect. [14]

Pop sculpture often reveals the products of technology. Duchamp's *Bottle Rack* (Fig. 41), 1914, was probably not so intended, for Duchamp at that time was poking fun at overblown artistic pretentions. For example, one of his more hilarious inventions was buying a urinal, turning it on its side, placing it on a pedestal, signing it R. Mutt, and entitling it *Fountain*. Nevertheless, *Bottle Rack* and works like it became prototypes for the pop sculptor of the fifties and sixties. By removing the distractions of the utilitarian context, the industrial product could now be perceived for its intrinsic values. *Bottle Rack* is a "ready-made," for Duchamp had nothing to do with its making but only its display. Duchamp was apparently the first to recognize the artistic potentialities of what was then a very familiar object. The contrast of the diminishing rings with their spikey "branches" makes an interesting spatial and impacting pattern, especially if, as in Man Ray's photograph, light is slanted across the rough surfaces of the galvanized iron. Duchamp had the imagination to conceive this possibility, for rarely are bottle racks—or any other industrial product, for that matter—so effectively displayed. The object was transformed into a thing with enlivened space.

Most pop sculpture in recent years does not incorporate ready-mades. Brancusi's wooden *Cup*, 1917, in the Musée National d'Art Moderne in Paris, was a forerunner of this development, an everyday thing becoming worthy of being part of the sculptural subject matter. As Geist observes, "'Cup' is a modest creation modeled upon a commonplace artifact; by the simplest means it releases a poetry of the object."[15] By using material different from the original, attention often can be drawn more strongly to the product itself. Thus Oldenburg's *Giant Soft Fan* (Fig. 85) is made in the functionally impossible materials of vinyl, wood, and foam rubber. Someone might be tempted to carve a containing hole into *Cup* or to use *Bottle Rack* for practical purposes, but *Giant Soft Fan* completely frustrates such temptation. "I am," Oldenburg confesses, "a technological liar." The scale and character of the fans of the marketplace, the ones we usually only dimly perceive, are completely changed. This ten-foot

shining giant opens our eyes to the existence of all those everyday fans. As Oldenburg comments, "I want people to get accustomed to recognizing the power of objects. . . . I alter to unfold the object and to add to it other object qualities."[16] This kind of sculpture is concerned not so much with the materials of our consumer world as with its products.

Some avant-garde sculptors are not interested in the materials and products of technology but rather in revealing the machine and its powers. Such "Machine sculpture" is not only kinetic, as with Calder's *Bougainvillea* (Fig. 56), but the motion is caused by mechanical forces rather than by natural forces, for example, Calder's massive *White Cascade*, 1976, in the Federal Reserve Bank in Philadelphia. Sculptors in this tradition, going back especially to the ideas and work of László Moholy-Nagy after World War I, welcome the power of the machine and its sculptural possibilities. By 1920 Moholy-Nagy, Gabo, Tatlin, and Rodchenko had produced machine-driven sculptures. The first literary prophet of machine sculpture, however, was Filippo Marinetti. In his "First Futurist Manifesto," printed in the Paris newspaper *Figaro* on February 20, 1909, he stated: "We declare that the world's splendour has been enriched by a new beauty; the beauty of speed. A racing motor-car, its frame adorned with great pipes like snakes that have explosive breath—a roaring motor-car, which looks as though it was running on shrapnel, is more beautiful than the 'Victory of Samothrace.'"

Under the turntable of *Brussels Construction* (Fig. 67), José de Rivera hides a rotating machine that turns the sculpture and saves us the trouble of circling around, but many machine sculptors expose their machines. They are interested in manifesting not only the power of the machine but also the mechanisms that make that power possible. George Rickey writes, "A machine is not a projection of anything. The crank-shaft exists in its own right; it *is* the image. . . . The concreteness of machines is heartening."[17] His *Two Lines—Temporal I* (Fig. 78), although depending upon air currents for its motion, is basically a machine: two thirty-five-foot stainless steel "needles" balanced on a knife-edge fulcrum. Placed in the Sculptural Garden of the Museum of Modern Art, the sculpture shows forth something of the skeletal structure and vertical stretch of the skyscrapers of New York, as well as something of their sway. An even better placing might be in a grove of tall trees, for in New York the lyrical poetry of the gentle swaying of the "needles" tends to be reduced to the rhythm of the metronome.[18]

Sculptors such as Len Lye usually use much more complicated machinery

than Rickey. Because of their expense, works of this type are rarely exhibited. Unfortunately, also, it is very difficult to appreciate their effectiveness except by direct participation. Lye's *The Loop* (Fig. 74) was first exhibited in Buffalo in 1965, and he provided the following description in the exhibition catalog:

"The Loop," a twenty-two foot strip of polished steel, is formed into a band, which rests on its back on a magnetized bed. The action starts when the charged magnets pull the loop of steel downwards, and then release it suddenly. As it struggles to resume its natural shape, the steel band bounds upwards and lurches from end to end with simultaneous leaping and rocking motions, orbiting powerful reflections at the viewer and emitting fanciful musical tones which pulsate in rhythm with "The Loop." Occasionally, as the boundless Loop reaches its greatest height, it strikes a suspended ball, causing it to emit a different yet harmonious musical note, and so it dances to a weird quavering composition of its own making. [19]

The sounds help shape the surrounding space. [20]

Harold Lehr has created machine sculptures with an ecological function. Looking like buoys or markers (Fig. 89), they are placed in waters such as the Charles River, Boston, where they were first exhibited in 1972. Inside the sculptures are pumps and filters, powered by wind and water and sun, which constantly clean the surrounding water. Lehr sees his sculptures as a perpetual connection between two primordial forms of nature—water and wind.

The sculpture's interaction takes many forms. It is seen on two levels. One when tides, winds, waves and currents affect movement and they skim across the water as a group or divide and scatter randomly. Weather, light and the water's surface also affect this visual appearance. Secondly, interaction is visible over a period of time. It involves the sculpture's response to the animating variety of nature. As it responds to the wind and ocean, it moves and changes. Some of this energy is converted into electricity, which is stored and used to purify water. As a result, positive change is created. Cleaner water is a better environment. Sea life is attracted to the man-made structures, and the area is improved. [21]

Machine sculptures are being developed in many forms. For example, there are water-driven sculptures, works suspended in midair by magnets or by jets of air or water, synthetic membranes stretched like sails by mechanical forces, color and motion produced by lasers and polarized light, and mechanically powered Environmental sculpture. Many of these developments are more experimental than artistic, the engineer often dominating the artist. But the story is just beginning, and it will be fascinating to watch its unfolding. At

206

the very least, Machine sculpture has had a stimulating effect upon the more conventional species of sculpture. For instance, the movement of Marta Pan's *Floating Sculpture* (Fig. 84) depends, like Lehr's work, on wind and water.

In all these works (an extremely small sampling, of course), the accommodation with technology is used to clarify some of the values of our machine-dominated age. The "protesting sculptors," rebelling against the machine, make vivid our alienation from things. The "accommodating sculptors," conversely, make vivid as things the many facets of the machine and its products. The "protesters" call us back to things by making manifest our separation from things. The "accommodaters," conversely, celebrate the machine and its products as things with which we can be in unity, as with natural things.

SPACE SCULPTURE

All sculpture involves a material body of some kind and a perceptible surrounding space. Even Gabo, who perhaps more than any other sculptor has deemphasized mass in his sculpture, states, "Volume still remains one of the fundamental attributes of sculpture, and we [the Constructionists] still use it in our sculptures. . . . We are not at all intending to dematerialize a sculptural work. . . . On the contrary, adding Space perception to the perception of Masses, emphasizing it and forming it, we enrich the expression of Mass, making it more essential through the contact between them whereby Mass retains its solidity and Space its extension."[22] But whereas mass dominates the surrounding space in traditional sculpture, space dominates or is at least as important as mass in that work of the twentieth century that I am calling "Space sculpture." The enlivened space becomes at least as energetic as the material body. Light and shadow, for instance, become at least as important as the material from which they are reflected. Branscusi's *Bird in Space* (Fig. 49) is a harbinger of Space sculpture, for the surrounding space is almost as important as the bronze. The space presses in and dematerializes the bronze to some extent, driving it skyward. On the other hand, Moore's *Reclining Figure* (Figs. 55a, 55b) obviously is not Space sculpture despite its holes, for the woody masses completely dominate the surrounding spaces and the spaces of the holes. Giacometti's *City Square* (Fig. 57) and *Man Pointing* (Fig. 58) are difficult to classify, for the seeming impenetrability of their surrounding spaces brings these spaces into a near balance of importance with the thinned-out material bodies. Since such "importances" cannot be weighed, these and many

other works escape neat classification. Paradigms, however, are easily identifiable. The material body clearly dominates space in most monolithic sculptures, for example, Arp's *Growth* (Fig. 51), whereas in most very open sculptures, for example, Calder's *Bougainvillea* (Fig. 56), space clearly dominates the material body. With *Growth* there is the impact of the material body on space, whereas with *Bougainvillea* there is also the impact of space on the material body.

Made of wire and sheet metal, *Bougainvillea* is an exceptionally lovely example of the push of the atmosphere. Like quivering tendrils, the sinuous wires expand in all directions with the fibrous strength of wood branches, and the graceful disks ride the breezes. These disks draw lines and shape the space, creating and effacing lines and shapes simultaneously. Our perception of the impact of space that makes these metal blossoms dance is more important than our perception of the impact of wire and metal. We have no desire to touch these blossoms and their stems; yet, in their flowing movement to and fro, these blossoms and stems reveal the tactile quality of the open air and our bodies flow with them. To cage *Bougainvillea* in a museum or any inside place would be paralyzing. As with most space sculptures, *Bougainvillea* belongs to wind and sky.

Archipenko claimed that with traditional sculpture space was "a kind of frame around the mass . . . sculpture begins where material touches space."[23] If my previous analyses are accurate, Archipenko's claim is inaccurate, for all sculpture impacts into the between and makes that surrounding space not a frame but a perceptible part of the sculpture. Archipenko had a point, however, for until the twentieth century the surrounding space was always kept in perceptual subordination to the material body. Along with Archipenko, Umberto Boccioni was one of the first in both deed (Fig. 40) and word (in his "Technical Manifesto") to proclaim at least the equal rights of space with the material body. He writes, "Traditionally a statue is carved out or delineated against the atmospheric environment in which it is exhibited. . . . We proclaim that the environment must be a part of the plastic block."[24] The outlines of the figure "go up in smoke," as Boccioni puts it, weakening the presence of mass and strengthening the presence of enlivened space.

Space sculpture may be made out of either translucent or opaque materials. As with glass-curtained architecture with its open framework, translucent materials, such as glass and a vast range of plastics, allow us to perceive both the materials and other things beyond as well as the intervening space. Thus in Gabo's *Spiral Theme* (Fig. 54), the planes of plastic divide space with mul-

tidirectional movement, a pure mobility abstracted from things that move as numbers are abstracted from things we count. The plastic lets the light not on but in and through, enabling us to grasp something of the whole simultaneously, the surface and the depth. We are not as involved, as with monolithic sculptures in the round, in summing up views from successive angles. We see through more than we see around. Each plane varies in translucency as our angle of vision varies, and in seeing through each, we see them all. This translucency makes possible the freely flowing transitions between the space without and the space within, as so often with fountains. In turn, the tactile attraction of the plastic, especially its smooth surface and liquid fluidity, is enhanced. The plastic catches and molds light beams, enclosing and shaping rather than filling space. The light fills and seems to float through space, [25] and although sometimes caught in pockets, the light helps bring out the unity of the "within" with the "without." The trapped air within the plastic pockets seems to be exerting outward and upward pressures. Thus the volumes seem to float, as if on water. The volumes, rather than being masses, are contained spaces, soaring above rather than emerging from their bases. Instead of outlining silhouettes, the edges of the plastic as well as the incised lines are trajectories of energy which pierce and impact through space, splintering brightness into mists and bending light around corners, and yet investing space in such a way that the various volumes are tied together. [26] The voids of Gabo's volumes are not just voids, for as Bergson noted, "The object, once annihilated, leaves its place unoccupied; for by hypothesis it is a PLACE, that is, a void limited by a precise outline, or, in other words, a kind of thing." [27] In more concrete terms, Henry Moore makes essentially the same point: "One gets to know eventually that the understanding of space is only the understanding of form. . . . If you hold your hand as I am doing now, the shape that those fingers would enclose if I were holding an apple would be different from the shape if I were holding a pear. If you can tell what that is, then you know what space is. That is space and form. You can't understand space without being able to understand form and to understand form you must be able to understand space." [28] In annihilating the object, Gabo makes us aware of where the object had been or where it or something like it might be again, a voided container, a leftover emptiness. In carving up space he makes us aware of the value of space as a "situation," and, as Bergson points out, that transforms space into a "kind of thing." *Spiral Theme* is space-defining rather than space-displacing, *of* space rather than *in* space.

When space sculpture is made out of opaque materials, the silhouette

usually is maintained. In some Space sculpture, such as David Smith's *Hudson River Landscape* (Fig. 61), the silhouette is sharpened as never before.[29] Seemingly woven of wind and water, the stretched steel traces lines through space along an implied flat plane[30] at right angles to the line of our vision, the rectangular contour around the outside suggesting a frame of a painting. But the "picture plane" is perforated. Not only do we perceive things through and beyond the silhouette but the pattern of the steel lines etches itself on these things. Space is shaped by both these things and the steel lines while, conversely, space shapes both these things and the steel lines. Things in the distance are perceived as through a framed prism which telescopes the distance, while at the same time the space seems to sweep through the steel lines like a river. If the material body of the sculpture were laid upon sand, it would suggest wavy patterns left by receding waters. We are caught in an ambiance in which the material body of the sculpture, the things beyond, the spaces between, and our body are perceived in an exceptionally tight unity. Even if we circle—for the implied picture plane facing us tends to discourage circling—every aspect of the ambiance impinges differently on the other aspects. In the free flow of this enlivened space, no thing escapes the interrelationships. As with Gabo's *Spiral Theme*, a sharp distinction between "within" and "without" is completely irrelevant. But unlike the plastic of *Spiral Theme*, the steel of *Hudson River Landscape* absorbs and gathers strength from the things which are around it. That is why *Spiral Theme* is not necessarily weakened in the white vacuums of the contemporary museums, whereas *Hudson River Landscape* is incapacitated.

By making space more perceivable than in traditional sculpture, Space sculpture reveals the primordial unity of being-in-the-world in an original way. Although the enlivened space of traditional sculpture links us with the material body of the sculpture, the material body is more perceptible than the enlivened space. In Space sculpture, the enlivened space is at least as perceptible as the material body of the sculpture. The relation is at least as apparent as the relata—the material body of the sculpture and ourselves. But that way of putting it is misleading; for if we are perceiving sculpture intensely ("thinking from"), we are explicitly aware only of the sculpture, no matter what the kind. The distinctions of material body, enlivened space, and ourselves are reflective awarenesses that follow after our participation with the sculpture. But Space sculpture, other things being equal, tends to keep such reflective awarenesses further in the background than traditional sculpture during our participations,

because Space sculpture tends to incorporate us more into its enlivened space, sometimes even becoming Environmental sculpture, as with Samaras's *Mirrored Room* (frontispiece). Whereas Space sculpture usually brings us into its enlivened space to some degree, Environmental sculpture incorporates us completely. On the other hand, traditional sculpture usually leaves us at one end of the enlivened space, and from there it is easier to step back into the everyday subject/object stance.

In making space as perceptible as mass, or even more so, Space sculpture (for example, many of the later works of David Smith and most of the works of Gonzalez) generally replaces, on the other hand, planar and radial with "nodal organization" and, on the other hand, carving and modeling with the technique of "assemblage" (or "construction"). Nodal organization, as put together by the assemblage technique, is exceptionally adaptable to opening up the material body and making space more perceptible. With planar organization, reinforcing planes move out into space, accentuating and channeling the impact of the mass, as with Donatello's *The Feast of Herod* (Fig. 14). With radial organization, planes are deemphasized and the shape of the material body extends and impacts in more than one direction from an inner core, reaching its culmination when the radiation extends equally in all directions, as with Bologna's *Rape of the Sabines* (Fig. 22). With nodal organization, points of structural concentration or nodes appear to be generating centers from which the various parts of the material body connect with each other and impact out into space. In *Hudson River Landscape* (Fig. 61), for example, the primary node is formed at the juncture of the welded steel just above the base, and various secondary nodes, normally at the welding points, provide structural coherence and "taking-off" points for further extensions.

Assemblage—the joining of independent parts or materials—permits the monumentality of carving, the freedom of modeling, easy and flexible ways of opening up the material body, the building of Environmental sculpture, and the synthesis of different kinds of materials. When metals are the materials, welding is usually used to join the parts. This technique was developed in the late 1920s by Picasso, assisted by the know-how of his friend Gonzalez. Apparently this development was inspired by Picasso's earlier work with the collage and his openwork sculptures going back to 1912.[31] Works such as his humorous *Monument* (Fig. 48), 1928-1929, in turn, inspired Gonzalez to some of the most interesting assemblages of our time.

Gonzalez's *Cactus Man* (Fig. 53) possesses some planar organization,

211

especially in the upper half of the structure, as well as some radial organization, especially in the lower half. But the basic form is organized around nodes, [32] the welding points that hold the wrought-iron parts together, four of which group near the center of the body, easily identifiable because Gonzalez used his oxyacetylene torch like a paintbrush. Beyond the nodes he allowed the iron not only to come forth as iron but ingeniously varied the iron textures, as if they were modeled, surprisingly suggesting male flesh and bones. Twenty-six inches tall, this complex cantilevering not only produces a monumental four-squareness but, despite the heaviness of the upper parts, a stable equilibrium. The stretched-iron lines do not move, and yet they are perceived as full of forces, like ropes that do not move because people of equal strength are pulling in opposite directions. At the same time, the interstices—which as we move around sometimes produce fascinating abstract patterns—open up the body and suggest organic vitality.

The sharp outlines are for the most part incomplete, enticing us to imagine their completion and make explicit the implicit tensions between the parts. Furthermore, we are aware of the *Cactus Man* as adult, so we perceive strong tensions between the small size of the material body and the large size of what it represents (see pp. 132-34). The impacting forces of the material body are thus limited roughly to the size of an adult man. This limitation compresses and, in turn, reinforces the forces expanding from the material body. We perceive a stretching and pulling between the material body of the *Cactus Man* and the outer limits of an adult body. These perceptions give the *Cactus Man* vigorous motion, a gesturing man. The atmosphere around his body is powerfully impacted into—the nails, for example, and the strong leftward-moving horizontals—and, at the same time, this atmosphere sweeps through the prefabricated iron, as if it were boring the openings. Despite his stability, the *Cactus Man* seems vulnerable, especially on the right side (the side pictured in the photograph). Here he appears talkative and defensive. As one moves to the left and front, commanded by the horizontals, the figure becomes aggressive and threatening. Further to the left, phallic imagery comes into play. Finally, on the fourth or back side, the Man becomes more geometrical and mechanical, a robot man. The showing and integration of these different dispositions of gesture and character, with something of a narrative quality, is aided by the openness of the assemblage, for the interstices smooth the transition from one disposition to the next. We are given not the moment of suspense before some action, so dear to Rodin (Fig. 32) and even Canova sometimes (Fig. 28),

but rather the continuity of action. We perceive one man with various dispositions of gesture and character rather than four men back to back.

It happens that as presently placed the *Cactus Man* projects shadows against one wall. As opposed to paintings in which two-dimensional patterns create the three-dimensional, here the three-dimensional creates the two-dimensional. By limiting the surrounding space on this side to the very precise boundary of a wall, coinciding with the imprecise boundary of the imagined adult size of the material body, these shadows help contain and compress the spatial forces even more tightly. Furthermore, the encapsulation of the space on this side, as we walk into this area, makes us much more aware than do most traditional sculptures of existing in the same space as the sculpture. But as we perceive the *Cactus Man* within this bounded environment, we may sense an almost terrifying spatial compression. It is as if we were in the sealed, claustrophobic space of Giacometti's *City Square* (fig. 57). This "abnormal" compression of space fails to harmonize with the "normal" compressions of the other three sides. It would be better, I believe, if the *Cactus Man* were placed farther from any walls. That is not to suggest that shadows cast on surfaces beyond the material body of a sculpture should always be avoided. For example, Mark di Suvero's *Shadowframe*, 1973, Des Moines Art Center, creates shadows only on the ceiling. By increasing our sense of spatial compression and thus intensifying the enlivened space, these shadows increase the sculptural presence, and there is no meaningless disharmony among the various sides.

In place of walls and ceilings that catch the shadows, mirrors can be used to reflect a sculpture. However, such usage requires special care. When mirrors are used behind monolithic sculptures, as in the case of a number of Rodin's works in the corners of some of the rooms of the Rodin Museum in Paris, the sense of the solidity of the mirrored side of the sculpture is almost completely dissipated, the sculptural being reflected into the pictorial. We directly perceive three-dimensionality on three sides, while on the fourth side we are compelled to read a projection on the flat surface of the mirror as a report of a three-dimensional configuration. On three sides we directly perceive mass, while on the fourth side mass is conjectured—a confusing mishmash. As Leo Steinberg comments about similar phenomena, "Objects and image repel one another. Even if carefully hyphenated by means of proximity and obvious likeness, they do not cohere. They want to diverge from each other like one's own two hands back to back."[33] In the Walker Art Center in Minneapolis, a lovely eighteenth-century Chinese sculpture named *Jade Mountain* is completely imprisoned within a set

of trick mirrors worthy of Disneyland. Our visual sensations are kaleidoscopic mirages, and our tactual sensations are weakened. On the other hand, Brancusi's use of a mirror as base in *The Fish* (Fig. 45) gives an impression of floating depthlessness marvelously appropriate to the subject matter.

With Space sculpture, generally, the openness and, in turn, relative nonsolidity of the material body lends itself to an effective use of mirrors. For example, Larry Bell's *Untitled*, 1960, in the Albright-Knox Art Gallery in Buffalo, is a polished steel cube containing opaque planes, transparent glass through which you can see through the sculpture to other things in the room, and inset mirrors. There is a dialectic between the transparency of the glass and the reflective surfaces of the mirrors; the mirrors reflect one's face, enhancing our sense of withness with the sculpture and the things perceived through it.

The assemblage, like the collage, permits the incorporation of materials, natural or manufactured, loaded with their own meanings. Mark di Suvero, for example, is often a sculptural beachcomber, living on what comes to hand. Whereas Schwitters was usually attracted to small debris which he attached to opaque backgrounds (Fig. 43), Di Suvero is usually attracted to large debris which he assembles in open compositions, as with *Pre-Columbian* (Fig. 81). Timber, a rubber tire, and iron pipes, broken away from their utilitarian functions and weathered by sea and sun, are joined by bolts, and, from time to time, the winds slowly swing these strange companions. Unlike Calder's disks (Fig. 56), each piece maintains its individuality. The timber on the left, from one angle reminiscent of the Tower of Pisa, would surely fall without the counterbalance of the massive beam on the right. Yet both these castoffs come forth as unique—once belonging to ships, then each smoothed in its own way by the sea, then swept up the beach. Now they are thrust against the sky and the rubber tire angles upward like a space ship. Space seems more expansive than usual and yet more intimate, infused by gentle motion like a ship at anchor. The sand, the sea, the sun, and the stars are gathered. Di Suvero remarked in a recent interview, "I want to wake people up. It's not to cause a stir, it's to enlarge, to create a bigger space. I would like to give children back the sense of space which exists within them."[34]

EARTH SCULPTURE

By Earth sculpture, I mean works that reveal the thingliness of the earth. Whereas space usually dominates mass in Space sculpture, mass usually

214

dominates space in Earth sculpture (as with traditional sculpture). Whereas Space sculpture is vertically oriented and skyborne, Earth sculpture is horizontally oriented and earthbound. Whereas most sculptors walk over the earth, the earth sculptors carve the earth.

The earth is the solid foundation that makes it possible for us to stand and walk and find our way from place to place. The rigidity of the earth gives permanence to places and constancy of shape and size to things. The earth produces our bread and wine and receives our dead. We dwell on the earth. Yet traditional sculptors, for the most part, have ignored the earth as part of their subject matter. Both sculptural protestors of technology and accommodaters with technology have emphasized things at the expense of neglecting the earth. Space sculptors have turned away from the earth to the sky. Human beings "flounder about foolishly," as Arp remarks, "on the dark and clotted wave into which they sink and vanish in so short a time. When have they bent down over the ground and its disguise to contemplate it?"[35] Anteus, the son of Mother Earth, was unconquerable as long as his feet were planted on the earth. Hercules conquered Anteus, as Antonio Pollaiuolo so powerfully shows us in both sculpture and painting, simply by lifting him off the ground. Herculean forces have been at work in our world dividing us from the earth, technology especially separating us from direct contact. Rarely do we directly work the earth. Rarely do we go shoeless. Rarely do we lie down on the earth. Unless we are mountain climbers, we seldom grip the earth, except, perhaps, in moments of dread or vertigo. Even to walk the earth—if one can find it beyond the asphalt—is exceptional, and in doing so to feel its drawing power and stability and security and mystery is even more exceptional. Yet a stick or stone can be as splendid as a star or sun, a cave as fascinating as the Milky Way, the depths of the ocean as overwhelming as outer space. The feeling of the earth—that reassuring constant—can be as soothing to our senses as the openness of space, for the earth gathers and holds all things. The mystery of the reaches of the earth can be as sublime as the heights of the heavens. But the mystery of the earth is usually perceived, if at all, only when we witness a burial.

All sculpture has elements of the earth in its materials, both literally and metaphorically. For example, Marino Marini, who has a Promethean feeling for the heat of the earth, declares that it is important "that sculpture be alive in its material presence. The material is treated in a hot, volcanic way, like the earth here [Italy], like the mountains—which, on the surface, are far more hot than the mountains of the north. And so, one finds that difference again in the

surface of the sculptures. Again and again I look at nature, at the mountains, to find the spirit of the material, to put it in the sculpture."[36] Even when colors are used to hide the material of a sculpture, the sheer physicality of a sculpture always has some earthy quality, and the colors themselves can never be completely abstracted from their earthly origin. Moreover, all sculpture is subject to gravitation, that ever-present "call" that proclaims the presence of the earth. Although the pedestal of traditional sculpture separates sculpture from direct contact with the earth, the pedestal cannot completely negate the draw and support of the earth. All sculptures settle into a place, and that place is on the earth. Even Space sculpture, with its emphasis upon the sky, is tied to the earth. Brancusi's *Bird in Space* (Fig. 49) must have its point of departure. There is no sky without an earth. There is no place without the earth. There is no sculpture without a place. Yet it has not been until this century, with a few exceptions such as the Indian Mounds of Ohio, that Earth sculpture has become a special kind of sculpture.

Henry Moore and Anthony Caro, who worked with Moore, although not Earth sculptors strictly speaking, have led the way back to the earth. By the 1960s, Earth sculpture in the strict sense had evolved, the earth itself became part of the subject matter, the medium, and sometimes the site, as in the work of Robert Smithson, Michael Heizer, Richard Serra, Michelle Stuart, Walter de Maria, Hans Haacke, Dennis Oppenheim, Carl Andre, Ed Herring, Mark Boyle, Joan Hills, Beverly Pepper, Michael Singer, and Christo. The earthiness of Moore's *Reclining Figure* (Figs. 55a, 55b) has already been discussed. In works such as the *Titan* (Figs. 76, 77), 1964, Caro goes further: no pedestal, the material body and the center of gravity below eye level, the lateral extensions completely dominating the vertical extensions, and the surface of the earth not just a support but articulated as part of the form. Whereas Moore thinks from the ground up, Caro thinks along the ground.[37]

As with most paintings, the top part of most sculptures corresponds roughly to where we hold our heads aloft, whereas the lower part gravitates to where we place our feet. By eliminating the pedestal and hugging the material body along the ground, Caro discards this head-to-toe correspondence and draws our perception "down-to-earth," to the horizontals on which we walk, work, sit, and sleep. Instead of facing a vertically oriented sculpture, with its inevitable suggestions of the pictorial and person-to-person address, we perceive not only "downness" but "outness." The lateral extensions of *Titan* spread out our sense

of the downward pull of gravity and, because there are no points of concentration supporting higher elements, lessen our sense of piled-on weight. Unlike a vertical pile, all the elements of *Titan* have the ground for their support. Thus they are merely bolted rather than welded together. We perceive the earth, as when we stretch our bodies over its surface, as a gentle, completely secure support.

The vertical panels of the *Titan*—the relatively low "swastika" and the slightly higher I-beam—accent the powerful lateral movements that drive out into a low L-shape which takes possession of the earth. There is no special place to begin nor any climactic focus. We are not drawn in, for to come in weakens the vectors. Nor, despite the low center of gravity, is there any lure to bend down, for to do so makes the form unintelligible. There is, however, a powerful pull to circle. Only then does the sculpture begin to unfold. As we walk around, the ground plane, unlike pedestaled sculpture, ceases to be a foil against which everything else moves. We perceive that plane as much through our feet as through our eyes, and it moves with us in relation to the sculpture. That moving plane is part of the form, nor just a support as we at first might have supposed. Thus when the *Titan* is placed on different ground, the spatial choreographies and the rhythms of the work are changed. The sense of gravity is stronger with the stone plane (Fig. 76) than with the wood plane (Fig. 77). In turn, the movement of the stone plane is slower than the movement of the wood plane, the regular slender shapes and flow-lines of the wood from some angles seeming to converge like a river sweeping to a narrow outlet. On the wood plane, we walk around more quickly and our kinaesthetic sensations are stronger. On the stone plane, we walk around more slowly and our haptic sensations are stronger. With both placements, however, the earth is strongly felt beneath these planes as the solid permanent base—the core that unlike the crust requires no support—that makes the movements of these planes possible. Indeed it is helpful to go barefoot around the *Titan*, reminiscent of Dani Karavan's *Environment for Peace* for the Venice Biennale of 1976. Karavan asked his visitors to share the tactual feeling of the sand by walking barefoot on his sculpture. His manifesto declared: "I was born on the dunes of the Mediterranean shores. With my bare feet I first felt the forms pressed in the sand: soft/hard, round/sharp, warm/cold, wet/dry. My footsteps in the sand were the first reliefs, the first pieces of sculpture that I made; the sunlight discovered them. The ever-changing dunes were my first environmental sculpture; on them my shadow told the time."[38]

In retrospect, it seems inevitable that after Caro the core of the earth along with the crust would become part of the subject matter of sculpture,[39] that sculpture would embrace rather than dominate its location, capturing the grittiness of both crust and core. In Earth sculpture proper (sometimes called "Earth works"), the earth is also always the medium and often the site, as with Smithson's *Spiral Jetty* (Fig. 88), 1970, about 1,500 feet long and 15 feet wide, constructed of soil, black rocks, and salt crystals. Only photographs and film record its existence, for the jetty has been consumed by erosion, as Smithson, now dead, anticipated. The spiral swirled out from the shore into Utah's Great Salt Lake like a great curling snake, its mass part of the mass of the shore, bringing out by sharp contrast the fluid properties of the salt water colored by red algae. The translucent smoothness of the lake was made more evident both by the opaque ruggedness of the spiral (the salt crystals glittering against the dark soil and black rock) and the linkage of the spiral with the rough textures and contours of the mountains. Furthermore, the geometry of the spiral not only compensated for the perceptual complexity of the landscape but linked with the arch of the sky, thus drawing earth and sky into tighter unity. There were even mythic suggestions, for Smithson heard of an old legend that the lake originally had been connected to the Pacific Ocean—thus explaining the salt water— through a great underground waterway, the mouth of which caused a hazardous whirlpool. And so Smithson selected the supposed whirlpool site and shape for the spiral of his *Jetty*, the positive stone mirroring in solidity the negative eddy of the displaced water.

Heizer's *Circumflex* (Fig. 87), 120 feet long, "carved" out of a dry lake in Massacre Creek, Nevada, is concave and cavelike, although the wind is gradually sweeping away the darkness that came into light. Yet as the trench fills in, there remain the photographs, although they never can capture the sublimity of such works as the *Circumflex* and the *Spiral Jerry*. In one sense the *Circumflex* is of the void, a taking away rather than a making of things, as if Heizer feels that the world is so full of things he refuses to make more. One of his works in the Mohave Desert in Nevada is called *Double Negative*. But in another sense the *Circumflex*, like the *Spiral Jerry*, reveals the earth as the most tangible of all things. One hardly can resist walking out on the *Jetty* or following the curve of the *Circumflex*. Our combined feelings of gravity and of the resistance of our legs against the substratum is overpowering.[40] Moreover for me, the sense of the earth in relation to the sky, especially with the *Spiral Jetty*, has rarely been stronger. I also wanted to be in the sky, floating above and looking down from

218

various angles in order to perceive that relationship from the other limit.

Edmund Burke Feldman claims, "Earth sculpture constitutes mainly a change in materials, scale, and ambition of art; it appears to be, moreover, a type of anti-art—a gesture by artists that expresses disgust with civilization, resentment toward art institutions, and contempt for the artistic traditions of usefulness, object-ness, and signification."[41] Heizer, on the other hand, claims that he is not a radical. "In fact, I'm going backward. I like to attach myself to the past."[42] This attachment is to the past not of the clichés of Gutzon Borglum's *Mount Rushmore* but of the Stonehenge—the bones of Mother Earth—the kind of sculpture that succeeds in freeing its material to impact into space and, in doing so, brings us back to our place on the earth and our being-with things. It is also the past of the Greeks, whose language talked about sky and earth and things rather than space and mass and objects. In our technological era, even our language alienates us from our origins. In showing forth the earth as the ever-present cradle of things, sculptors such as Smithson and Heizer return us to the healthy, natural manner of things before we manufacture them. More romantic Earth sculptors do not even impose their structures upon the natural order. Thus Michael Singer in his *Bog Ritual Series*, 1978, placed in Marlboro, Vermont, yields his structures to the forces of the environment. Water and wind are allowed continually to change the form of the sculpture. Whether romantic or not, the intervention into nature by Earth sculptors turns away from the representation of nature to concrete contact with nature itself.

Conclusion

Sculpture is a gift of presencing thingliness. For a thing to come forth, it must have space (sky) and a place (earth). The sculptor's wings are made of clay, and so he can only reveal the sky from the earth. Space sculpture makes us more sensitive to the sky; Earth sculpture makes us more sensitive to the earth. Both kinds of sculpture are rooted in the origin of all sculpture: the basic instinctual need to vivify and make clear our primordial unity with things.

Mark di Suvero, who may be the greatest sculptor of our time, presences his sculptures in such a way that it is virtually impossible to ignore them (Figs. 81, 83). Although the sheer size and mass of most of his works sprawl outward, their poetry draws us in. The twenty-two-foot-high *Praise for Elohim Adonai*, 1966, a mobile tetrahedron made of logs, steel pipe, and steel cable, formerly outside the Saint Louis Museum of Art, was installed in the Plaza of the

Seagrams Building (Fig. 83) in New York, October 1975. As the work was finally coming into place, a bystander remarked: "You know what people say about modern art. They keep saying that one of their kids in kindergarten can do it with his left hand. I'd like to see one of the little geniuses try that." Di Suvero uses the materials, the tools, and the techniques of technology. But he humanizes technology—poetically the great timbers lightly feather around their static constant axis, sensitive to the slightest breeze. The verticals and jutting diagonals, thrusting and counterthrusting through the cantilevered balances, open up the sky. The awesome weight of the beams brings us back to the earth. The lower elements crawl over the earth like Caro's sculpture. But Di Suvero cannot be accurately described as either a Space sculptor or an Earth sculptor. He is becoming, like Dani Karavan, more and more an extraordinary and creative synthesizer of the major trends of the avant-garde.

Gravity saturates the enlivened space within and around the *Praise for Elohim Adonai* as we swing around the flow. Human gestures, especially erotic play elements, are suggested in opposition to the rigid industrial materials and the geometric structures. In the retrospective exhibition at the Whitney Museum (Winter 1975–1976), many of his sculptures invited us to touch, handle, write on, rearrange, sit on, and climb. Such sculpture takes on the added significance of actual physical contact, somewhat like the contact involved in the making of the sculpture. Always we are invited to participate. In a room of sculptures made for children, the shouts of joy those giant toys evoked even brought in an auditory dimension. Here is a sculpture of zest, power, hope, and exceptional physical immediacy. Moreover it is a sculpture that seems to be bridging, at last, the gap between the contemporary sculptors and the laymen. There has been, at best, only narrow bridges of communication since the demise of the Beaux Arts tradition early in this century. The gap was embarrassingly exposed in the 1950s by the abortive competition for a Franklin Delano Roosevelt Memorial in Washington. Out of hundreds, not a single design could be found that was acceptable to both the jury and the Fine Arts Commission. But in the fall of 1975, despite the financial plight of that city, fifteen of Di Suvero's largest sculptures were installed in New York.

By helping the genesis of things come forth in our awareness, sculpture vivifies things, our being-with them, our place on the earth beneath the rhythms of the sky. Created in the openness between earth and sky, sculpture brings us to the security and peace that comes from sensing the pulse of nature. There is truth in those haunting lines of Wallace Stevens:

220

The earth for us is flat and bare
There are no shadows. Poetry

Exceeding music takes the place. . . .

But not the whole truth, for sculpture is a more secure way toward finding our place, toward overcoming our alienation from nature. "Where all we see is change," Noguchi writes, "I like to think that sculpture may have in this a special role—as an antidote to impermanence—with newness yes, but with a quality of enduring freshness relative to that resonant void, within us and without."[43] "I was never really there," exclaims one of Samuel Beckett's characters. Sculpture helps us to be "there." Sculpture is solid, a "thereness" that casts beckoning shadows, that can bring us back in touch.[44] Sculpture is an art of gathering that relieves existence of its alien otherness.

In our destitute time, as Rilke names it, when we are so thingless, for that very reason we can be nearer to things than ever before. There is an old Zen saying: "Before you have studied the philosophical doctrines, mountains are mountains and rivers are rivers; while you are studying it, mountains are no longer mountains and rivers are no longer rivers; but when you have obtained enlightenment, mountains are once again mountains and rivers once again rivers." Sculpture enlightens by returning us to the things themselves. Sculpture renews our presence in nature, liberating us from the enclosing shells of our egos. "A man alone," Paul Valéry wrote, "is in bad company." Perhaps we are entering upon, or already are in, an Age of Sculpture, despite or even because of our machine-conditioned sensibilities that reduce things to objects and ourselves to subjects. In any case, we could not feel so homeless if there were not a home. Heraclitus warned long aso, "Man is estranged from that with which he is most familiar, and he must continuously seek to discover it." Rilke advised his young poet friend, "If there is no communion between men and you, try to be near things; they will not abandon you." Communion with things—the touch that participates—may lead to communion with men, to escaping our isolation as spectators in separate worlds of private sensation. That seeking is love, which Plato called "the desire and pursuit of the whole." Sculpture can help our seeking, our love, for by enlivening space sculpture creates a sacred space, a dwelling nearness.

Appendix: Statements of Sculptors

I feel the cubic means of all things—the plane, the volume—come home to me as the law of all life and beauty.

Auguste Rodin

The use of statements by artists as evidence, particularly for broad claims, is rightfully suspect. A generation before W. K. Wimsatt and Monroe C. Beardsley wrote their famous essay on "The Intentional Fallacy," D. H. Lawrence formulated the doctrine in a sentence: "Never trust the artist; trust the tale." The artist, Lawrence believed, "is a damned liar." Nonliterary artists, especially, are notorious for their misleading statements. Contradictory statements by other artists, literary or nonliterary, are usually not difficult to discover. Moreover, sculptors generally are impatient and confused when talking about what sculpture is. For example, Jacques Lipchitz recalls how in 1913 Diego Rivera, the Mexican painter, introduced him to Picasso:

He took me to Picasso's studio but Picasso was not there. Rivera showed me a little painted sculpture by Picasso and said, "And that is sculpture by Picasso," as though that were the real thing, not what I was doing. When Picasso came back and I met him, and we came to this piece, I asked him rather naively whether he considered it painting or sculpture. Picasso somewhat sarcastically asked if I could tell him what is painting and what is sculpture. I answered I could not, but that I was sure this piece was not sculpture. Picasso said, "Why, because it is painted? Look at that Negro mask; it is painted too." And I said, "But look how it is painted; just look at the white, round shapes under the eyes; they are shadows and they are white because the sculpture is black."[1]

Apparently the argument was never resolved. On the other hand, when sculptors focus on why they are sculptors—how they feel and think about their work—their reports, granting ambiguities, are remarkably consistent. Unfortunately, sculptors are much more reticent about their work than painters. There are many manuals on the craft of painting, for instance, whereas manuals on the craft of sculpture are scarce. William Zorach tells us: "You have no idea how difficult it is to find out some bit of essential knowledge. . . . There were endless books on painting but almost none you could recommend to a serious young student eager to learn sculpture. I decided to write one myself. I

223

wanted not only to give young sculptors complete information on actually doing sculpture; I included information as to where materials could be found and purchased as well as information on what books would be useful and related subjects."[2] Fortunately, more reports by sculptors have been coming in recently, enough to make it possible to generalize—cautiously, as always should be done in ordinary language analyses—about how they understand their art.

These reports indicate that sculptors are obsessed not only with things as three-dimensional but with showing through their sculpture "withness" with such things. The painter is apt to ask, "What is the appearance of things?" The sculptor is more likely to ask, "What are things and how I am related to them?" Even when alienation from things is indicated in sculpture, as with Giacometti, that alienation presupposes an original withness. These obsessions point to a distinctive underlying subject matter and, in turn, an origin distinct from the origin of painting. Only very rarely have I been able to find this independence of origin denied—David Smith, for example, makes "no separate provision for the cause of sculpture apart from painting,"[3] and Marino Marini claims that sculpture and painting are for him inseparable procedures.[4] Even in such cases, however, practice belies the words. After an extensive search, I advance the following statements by Ernst Barlach, Moore, Edouardo Chillida, Boccioni, Calder, Segal, Rickey, Noguchi, Tony Smith, Lipchitz, Seymour Lipton, César Balducci, Lyman Kipp, Victor Pasmore, and Tinguely (see also those of Gabo, p. 175, Morris, p. 238,n4, and David Weinrib, p. 64) as representative of the sculptors' care for things, their feeling for the interdependence of things and human beings in enlivened space, and their sense of the autonomy of sculpture.

Barlach was fascinated with things, even to the extent of attempting to represent, as Kant would say, the thing-in-itself: "I do not represent what I, on my part, see or how I see it from here or there but what it *is*, the real and truthful, which I have to extract from what I see in front of me. I prefer this kind of representation to drawing because it eliminates all artificiality. I would say, sculpture is a healthy art, a free art, not afflicted by such necessary evils as perspective, expansion, foreshortening, and other artificialities."[5] Moore is always concerned with the "fullness" of things. Whereas the painter re-presents reality, the sculptor presents or makes reality. "This interest in three-dimensional form—is expressing oneself through solid form—this is for me the sculptor's aim. I think I am a sculptor and not a painter because I want

something absolutely realized from all points of view, as I want to make it, something which exists like myself, or like a table, or like a horse."[6] Chillida has this same concern, and that is why he finds it "necessary to work directly. That is, it is the direct confrontation of man with matter—with canvas, with wood, stone, iron, what you will; wax, it's all the same—which gives you the éclat and the contact."[7]

Boccioni in his "Technical Manifesto of Futurist Sculpture, 1912," announced his desire to sculpt the interdependence of things: "Sculpture must give life to objects by making their extension in space palpable, systematic, and plastic, since no one can any longer believe that an object ends where another begins."[8] Calder declares: "When I have used spheres and disks, I have intended that they should represent more than just what they are. More or less as the earth is a sphere, but also has some miles of gas about it, volcanoes upon it, and the moon making circles around it, and as the sun is a sphere—but also is a source of intense heat, the effect of which is felt at great distances. A ball of wood or a disk of metal is rather a dull object without this sense of something emanating from it."[9] And Segal: "The peculiar shape and qualities of the empty air surrounding the volumes become an important part of the expressiveness of the whole piece. The distance between figure and object becomes crucial. My pieces don't end at their physical boundaries."[10] Rickey insists that sculpture is a thing in space: "Painting is a projection onto a flat surface. Sculpture, by its nature, is a *thing*. The sculptor is dealing with space itself."[11] For Noguchi the essence of sculpture is "the perception of space, the continuum of our existence. . . . It is the sculptor who animates and orders space, gives it meaning."[12] Tony Smith wants to create "an awareness of oneself as existing in the same space as the work. . . . The object itself has not become less important, it has become less self-important."[13] Lipchitz is fascinated with how to make forms that bring out things as related—"the encounter": "In my sculpture I think continually of the idea of encounter. This means to me not only the meeting of two individuals as in such sculptural themes as the embrace. . . . Whatever the specific subject, I continually think of the sculpture itself as an encounter between the artist, the material, and the forms he is using."[14] Lipton: "Sculpture is used by me to express the life of man as a struggling interaction between himself and his environment."[15]

César unequivocally asserts that sculpture has a different origin from drawing (and painting):

I ought to draw with a view toward sculpture, but I don't. When I draw, as soon as I am on a flat surface, I follow another pattern of behavior, I have another attitude. I am no longer in touch with the sculpture. Because my imagination stops. I can't make the effort to imagine my draughtmanship in space. Because physically it's false. I can very easily work with objects—clay, iron, plastic, any material that I can utilize in space. But as soon as I take a sheet of paper and draw a line or spot on it, my behavior is entirely different. I am no longer a sculptor who happens to be drawing.[16]

Kipp makes essentially the same assertion: "I do a lot of drawings, but they are not related to sculpture. For me they function as another work, another art."[17] Pasmore, who turned to sculpture after many years as a successful painter, insists upon the separation of sculpture from painting: "Between a painted square and a sculptural cube there is nothing. A square cannot be rendered in relief. In the square and the cube, therefore, we have two distinctly different forms involving different sensory experiences. Thus, although painting and sculpture may be related and concerned with the same problem, they are in themselves uniquely different manifestations of this problem."[18] Similarly, Tinguely draws a sharp distinction between his sculpture and his drawings: "My drawings are purely functional. They have no goal in themselves. I don't draw for the sake of the drawing. Which is why I can't make etchings and things like that. For me, the drawing is only a possible approach to my real work."[19]

Literary artists have said essentially the same thing about what drives sculptors. Rilke, for example: Does "it not seem that at every hopeful or disquieting turning-point of history the human soul has ever and again demanded this art [sculpture] which gives more than word and picture, more than similitude and appearance, this simple becoming-concrete of its longings or its apprehensions?"[20] And D. H. Lawrence: "For the intuitive perception of the apple is so *tangibly* aware of the apple that it is aware of it *all around*, not only just of the front. The eye sees only fronts, and the mind, on the whole, is satisfied with fronts. But intuition needs all-roundedness, and instinct needs insideness. The true imagination is forever curving round to the other side, to the back of presented appearance."[21] Lawrence was writing about Cézanne's apples, but the full satisfaction of that instinctive need for all-roundedness and insideness—for "eyefulness"—is accomplished, if my previous analyses are accurate, much more by sculpture than by painting. The visible, as Merleau-Ponty continually points out, has a layer of invisibility which is made present as a certain absence, a curvature turning out of sight. "The phenomenal object [three-dimensional thing] is not spread out on a plane, as it were; it involves two

226

layers: the layer of perspectival aspects and that of the thing they present."[22] Although the front of the desk hides the back, the front by the way it manifests itself discloses the back as also there. Oscar Wilde's aphorism—"The true wonder of the world is the visible, not the invisible"—is inaccurate. The visible both conceals and unconceals the invisible, for the invisible is the outline and depth of the visible. Painting only suggests the invisible; sculpture not only suggests but, since sculpture is three-dimensional, makes it possible for some of the invisible, if we move around, to become visible. Moreover, both the visible and the invisible are made tactilely "there" through the enlivened space of sculpture. A sculpture expands behind its surface not just because of our knowledge of what lies behind it but also because we visually and tactually perceive what lies behind. The need to bring out the invisible as well as the visible is more peculiar to the sculptor than the painter. As Archipenko remarks, "It is not exactly the presence of a thing but rather the absence of it that becomes the cause and impulse for creative motivation."[23] Sculptors domesticate the invisible.

That sculpture has a different underlying subject matter than painting, and thus a different origin, is indicated also by the many artists who began with painting but then turned to sculpture. This turn seemingly might be explained by their lack of success in painting, as with Gonzalez, David Smith, Theodore Roszak, and Oldenburg. But this is clearly an inadequate explanation, for many very successful painters have turned to sculpture because their images, so to speak, kept forcing themselves out of the canvas: Renoir, Degas, Gauguin, Modigliani, Bonnard, Matisse, Arp, Picasso, Braque, De Kooning, and Miro, to name only a few from recent times. This tradition goes back at least to Pheidias, but what was previously a tendency has become in the twentieth century almost a necessity. [24] This "almost a necessity" is especially exemplified by painters who in their paintings move in the direction of representing a greater solidity of things. Renoir was supposed to have said that he painted female flesh until he could pinch it. But only with his sculpture could he actually pinch, at least when he was modeling. It is not surprising that after their cubist paintings Picasso and Braque turned to sculpture. It is surprising that Cézanne never tried sculpture. On the other hand, painters who move away from representing solidity—for example, Pisarro, Monet, Seurat, Signac, Reinhardt, and Rothko—rarely move on to sculpture. Dubuffet is an interesting example of a painter with abstract tendencies who, nevertheless, used increasingly grainy textures, leading finally to sculpture in his more recent work. There is an

inclination for painters as they turn to sculpture, Degas for instance, to model in soft materials such as plaster or clay rather than carve. With modeling the fingers are the principal tool and a modeled sculpture can be readily changed, as with a painting. Oldenburg, for example, remarks, "I used to paint but found it too limited so I gave up the limitations that painting has. . . . [I want] to give a concrete statement to my fantasy. In other words, instead of painting it, to make it touchable, to translate the eye into the fingers. That has been the main motive in all my work. That's why I make things soft that are hard."[25] Very few sculptors, conversely, successful or unsuccessful, have turned to painting. Verrocchio did, but he soon returned to sculpture, and Michelangelo usually painted, as in the Sistine Chapel, only when compelled by others. In recent years Jean Ipousteguy has turned more to painting, and Giacometti came to painting after sculpture. Max Weber is an unqualified exception, however, completely abandoning sculpture for painting. Sculpture, however, generally maintains a stronger grasp on its practitioners than painting, even in the curious case of Roel D'Haese, who regrets not being a painter "because I like painting much more than sculpture."[26]

If painting reveals the same underlying subject matter as sculpture, this turn to sculpture by so many successful painters, and, on the other hand, the hold sculpture maintains on the vast majority of sculptors is hard to explain. It could be that the turn to sculpture by successful painters is caused by playfulness or technical challenge or money. But the words and actions of painters who also sculpt as well as sculptors who are not painters indicate that what drives them to or keeps them in sculpture is a fundamental need—an obsession—to reveal that which eludes painting: the actual three-dimensionality of things and our withness with them in enlivened space. Flat surfaces are relatively restricted in what they can reveal about these aspects of our worlds. Two-dimensional media, moreover, usually require means different from those appropriate for three-dimensional media. As Arnheim points out: "A shape that expresses roundness best in one medium may not do so in another. A circle or disk may be the perfect solution in the flat picture plane. In three-dimensional sculpture, however, circle and disk are combinations of roundness and flatness and thus imperfect representations of roundness."[27] Figure and ground relationships on a plane become very different relationships on a three-dimensional thing. Furthermore, the tyranny of the frame may inhibit the sculptural drive. According to Donald Judd: "The main thing wrong with a painting is that it is a

rectangular plane placed flat against a wall. A rectangle is a shape itself; it is obviously the whole shape; it determines and limits the arrangement of whatever is on or inside of it."[28] This influence of the boundary and its shape, usually accented by a frame, can work in relief sculpture as well, as in so much Romanesque relief. The boundary can be an ordaining and restricting power that not only structures the axes, proportions, and symmetry of the design, but reaches into the very interior of the shapes. Thus most sculptors tend to move beyond low-relief sculpture toward greater three-dimensionality. For example, Reg Butler observes that "when I made thin linear sculpture, it made me unhappy in the ultimate sense because it was thin and linear and nothing else. . . . The things that excite me are the conditions under which a volume can have tensions—so that you feel the sensuous plasticity."[29] It is not strange to find a painter such as Barnett Newman declaring: "An artist paints so that he will have something to look at."[30] But it would be strange to find a sculptor only declaring: "A sculptor sculpts so that he will have something to look at."

Sculptors move generally in the direction of larger sculpture, as notably in recent years in the work of Bourdelle, Lipchitz, Zorach, Moore, Calder, Picasso, David Smith, Chillida, Alexander Liberman, and Sol LeWitt. Zorach states: "Sculpture is a monumental art. It depends primarily on a magnificent design. If these essentials are visualized and incorporated in a small work, they become stupendous and awe-inspiring when the scale is enlarged to monumental proportions, and the larger the scale the finer the sculpture becomes."[31] If one knew nothing about a sculptor's stylistic development, one still might be able to put his works into something of a rough chronological order by ranging them from smaller to larger. [32] Tracing the ways the sculptor reveals previously unperceived three-dimensional aspects of things also can be helpful in discovering the chronological order of his work. To quote Zorach again: "When I carved 'Affection' directly in stone back in 1933, it occurred to me that I tended to be limited in my work to a four-sided relief [an excellent example, incidently, of Hildebrand's theory of sculpture]. I did not like the idea, so I penetrated the stone all the way through this time to get another dimension, releasing space around the legs and bodies. It was the first time I had done this and it took away the flatness and gave the stone a more three-dimensional feeling."[33] Most important of all, however, is the tracing of the ways a sculptor brings us to a witness with his sculpture through enlivening space. These three ordering principles—size, three-dimensional aspects, and witness—are interdepen-

dent, of course, and require caution as sign posts to the chronological order of a sculptor's work, for sculptors, like other artists, sometimes detour off their main road or return to stretches they have already traveled.

Whereas the painter touches reality with his fingertips, the sculptor grasps reality with his hands. The sculptor is driven by a primordial need that demands embodiment: to bring forth the solid, to make the invisible tangible, to enliven space, to bring us back to our withness with things. That is the destiny that lures sculptors.

Notes

INTRODUCTION

1. *Isamu Noguchi: A Sculptor's World* (New York: Harper and Row, 1968), p. 159.

2. Plato thought of sculpture as a craft whose function was either to honor the gods or to commemorate great men and their deeds. Plato's references to sculpture are almost always employed as analogies helpful for suggesting either the nature of art generally or the nature of cognition.

3. The only statement that can be traced back with certainty to Polyclitus reads: "The beautiful comes about, little by little, through many numbers." See Erwin Panofsky, *Meaning in the Visual Arts* (Garden City, N.Y.: Doubleday, Anchor Books, 1955), p. 68. Galen in *Placita Hippocratis et Platonis* reports, "Chrysippus . . . holds that beauty does not consist in the elements but in the harmonious proportion of the parts, the proportion of one finger to the other, or all the fingers to the rest of the hand, of the rest of the hand to the wrist, of these to the forearm, of the forearm to the whole arm, in fine, of all parts to all others, as it is written in the canon of Polyclitus." Panofsky, *Meaning in the Visual Arts*, p. 64.

4. *History of Aesthetics*, ed. J. Harrell, trans. Adam and Ann Czerniawski (The Hague: Mouton, 1970), 1:55. This monumental three-volume work documents the references to sculpture as well as the absence of an aesthetics of sculpture.

5. *Renaissance Thought II: Papers on Humanism and the Arts* (New York: Harper and Row, Torchbooks, 1965), p. 171.

6. See, for example, Edgar de Bruyne, *The Esthetics of the Middle Ages*, trans. Eileen B. Hennesy (New York: Frederick Ungar, 1969), pp. 185 ff.

7. *Due Lezzioni* (Florence: [n.p.], 1549).

8. Haig Khachadourian attacks the attempt to set up a definition of the necessary and sufficient conditions of sculpture with the weapon of the theory of family resemblances. The negative results are impressive, but not the positive. "On the Nature of Painting and Sculpture," *British Journal of Aesthetics* 14 (Autumn 1974). See also Maurice Mandelbaum's incisive critique of the theory of family resemblances, "Family Resemblances and Generalization Concerning the Arts," in *A Modern Book of Aesthetics*, ed. Melvin Rader (New York: Rinehart and Winston, 1973), pp. 519–34.

9. *The Image in Form*, ed. Richard Wollheim (New York: Harper and Row, 1972), p. 86.

10. Albert E. Elsen, *Origins of Modern Sculpture* (New York: George Braziller, 1974), pp. 174–75.

11. As Charles W. Millard points out: "Probably no other artistic production has been so thoroughly under the control of a body of theoretical writing, or so thoroughly bent to the ends seen as desirable by that writing, as was academic sculpture in the nineteenth century. As great a sculptor as Canova, constantly importuned by Quatremère de Quincy toward a purer classicism, seems to have altered his style and conceptions in the face of these theoretical demands." "Sculpture and Theory in Nineteenth Century France," *Journal of Aesthetics and Art Criticism* 34 (Fall 1975): 15.

12. "La stylistique ornementale dans la sculpture romane," in *Criticism* (New York: Vintage Books, 1963), p. 128.

13. The conception of sculpture as subordinate to architecture has been continued into the twentieth century by no less a sculptor than Antoine Bourdelle: "Architecture is the core of sculpture, and sculpture to be effective, must simply extend it." Pierre Descargues, *Bourdelle* (Paris: Hatchette, 1954), p. 3. Wylie Sypher also maintains that architecture is the basic art, *Rococo to Cubism in Art and Literature* (New York: Vintage Books, 1963), pp. 26 ff. And Piet Mondrian

thought that both painting and sculpture would be absorbed by architecture: "Although there is a great deal to do and develop, one can already observe, as well in our palpable environment as in our social life, that the end of painting and especially of sculpture is slowly appearing, and that these arts will lose themselves in a new architecture which will contain the whole." *Cahiers d'Art*, Nos. 1–4 (1935), p. 31.

14. *Art as Experience* (New York: Minton, Balch, 1934), p. 232.

15. "Beyond Function and Form," *Saturday Review World* (November 1974), p. 41. Architects have a tendency to "defend the myth that architecture is the mother of all fine art," as the sculptor David Smith points out. But "sculpture has its own form. It is based upon a different aesthetic structure." *David Smith*, ed. Garnett McCoy (New York: Praeger, 1962), p. 145.

16. We are so accustomed to the dependency of sculpture that a title placing sculpture before painting is likely to seem odd. Texts on the arts and aesthetics invariably place the chapter on painting before the chapter on sculpture. Anthologies of the arts almost always include essays on painting and architecture, whereas essays on sculpture are rare.

17. *Greek Sculpture* (Chicago: University of Chicago Press, 1960), pp. 34–35. Cf. Bernard Berenson: "Sculpture, while using materials that have their own mass, shape, and weight, transcends them when it does not ignore them. Who, when he looked at the chryselephantine Athena of Phidias, thought of the original mass, weight, and shape of the gold and ivory that went to produce it? If mass and heft retain meaning in sculpture, it is as in painting through the represented figures and not through their original bulk." *Aesthetics and History* (Garden City, N.Y.: Doubleday, 1954), p. 86.

18. *Young Children's Sculpture and Drawing* (Cambridge, Mass.: Harvard University Press, 1974), p. 175.

19. Ibid., p. 185.

20. See A. M. Hammacher, *The Evolution of Modern Sculpture* (New York: Harry N. Abrams, n.d.), p. 136, and William Fleming, *Arts and Ideas* (New York: Holt, Rinehart and Winston, 1963), pp. 740–41. Charles Biederman, the contemporary sculptor, states that sculptors such as Jean Arp, Henri Laurens, Jacques Lipchitz, Brancusi, and Julio Gonzalez "are men who thought a three-dimensional medium was more suitable for solving contemporary problems, but failing to comprehend this adequately enough, they failed to profit from Cubism." *Art as the Evolution of Visual Knowledge* (Red Wing, Minn.: Charles Biederman, 1948), p. 559. Clement Greenberg, the contemporary critic, states, "Sculpture was freed from the monolith by cubism." Quoted by David Smith in *David Smith*, p. 66. Greenberg even claims that "after several centuries of desuetude sculpture . . . is now undergoing a transformation, at the hands of painting itself." *Art and Culture* (Boston: Beacon Press, 1961), p. 140.

21. "Tests for Visual and Haptical Aptitudes," in *Readings in Art Education*, ed. Elliot W. Eisner and David W. Ecker (Waltham, Mass.: Blaisdell, 1966), p. 97.

22. See, for example, *Experiments in Visual Perception*, ed. M. D. Vernon (Middlesex, Eng.: Penguin Books, 1970).

23. Skepticism about the usefulness of definitions in art is nicely expressed by Rabindranath Tagore: "Should we begin with a definition? But definition of a thing which has a life growth is really limiting one's own vision in order to see clearly. And clearness is not necessarily the only, or the most important aspect of truth. . . . Living things [and art for Tagore is metaphorically such a thing] have far-reaching relationships with their surroundings, some of which are invisible and go deep down in the soil. In our zeal for definition we may lop off branches and roots of a tree to turn it into a log, which is easier to roll about from classroom to classroom, and therefore suitable for a textbook. But because it allows a nakedly clear view of itself, it cannot be said that a log gives a truer view of a tree as a whole." *Personality* (Madras: Macmillan, 1970), pp. 6–7. Furthermore, Tagore would also have been very skeptical of the usefulness of the Weitzian family-resemblance approach to art. In these respects, Tagore is close to Heidegger.

I THE EMINENCE OF THE EYE

1. *The World as Will and Idea*, trans. R. B. Haldene and J. Kemp (London: Routledge and Kegan Paul, 1957), 1:258.

2. The main literary sources of our knowledge of Greek sculpture are Pliny the Elder and Pausanias, and their reports are often suspect. For selected passages and a bibliography of the ancient references to sculpture, see *Selected Passages from Ancient Writers Illustrative of the History of Greek Sculpture*, ed. H. Stuart Jones (Chicago: Argonaut, 1966).

3. *Art as the Evolution of Visual Knowledge*, pp. 150–51.

4. See, for example, Erwin Panofsky, *Meaning in the Visual Arts*, *pp*. 128 *ff*.

5. For the differences between the theories of light of the Middle Ages and the Renaissance, see Wolfgang Schoene, *Ueber des Licht in der Malerei* (Berlin: Verlag Gebr. Mann, 1954).

6. *De re aedificatoria*, Ed. 1485, Bk. VII, Chapt. 10.

7. See, for example, Anthony Blunt, *Artistic Theory in Italy*, 1450—1600 (Oxford, Eng.: Clarendon Press, 1940).

8. *The Notebooks of Leonardo da Vinci*, ed. Edward MacCurdy (New York: Reynal and Hitchcock, 1938), 2:29.

9. Giorgia Vasari, *The Lives of the Painters, Sculptors and Architects*, ed. William Gaunt, trans. A. B. Hinds (London: Everyman's Library, 1970), 2:171.

10. Elizabeth Gilmore Holt, *A Documentary History of Art* (New York: Doubleday, Anchor Books. 1957), 2:15–16.

11. Marsilii Ficini *Florentini* . . . Opera (Basel: Henric Petrina [1576]), 1:966.

12. Holt, *A Documentary History of Art*, pp. 35-37. The many sides had to be coordinated, of course, but in a serial rather than in a gestaltist manner.

13. *De' Veri Precetti della pittura* (Ravenna: n.p., 1586), Book i, Chapt. 8.

14. Such probing theory or explicit description, as far as I have been able to discover, does not appear before the nineteenth century. But Professor Piero Colacicchi of the Accademia de Belle Arti in Florence has pointed out to me that Alberti seemingly was aware of sculptural space as a feature that essentially distinguishes sculpture from painting. In *De Statua* Alberti invented a "machine to define limits," called a "definitor," indicative of Alberti's intuition that the material body of a sculpture, unlike a painting, controls its surrounding space. Since ancient times, sculptors had used versions of a "pointing machine," basically a hollow rectangular box. Within that box an artificial or live model or a sculpture to be copied was centered, and the limits of the material body were measured by putting calibrated rods through holes in the sides of the box. This machine was quite adequate for measuring the limits of models or sculptures that were essentially monolithic blocks with four sides (for a sketch of the pointing machine, see Rudolph Wittkower, *Sculpture: Processes and Principles* [New York: Harper and Row, 1977]. pp. 31, 223). But this machine, as Alberti recognized, was not well adapted to measuring models or sculptures completely in the round, i.e., those in which all sides and angles are equally important for perception. Although Alberti never made or even sketched his machine, it was to have included a calibrated round piece of wood to be attached to a pole centered on the top of the model or sculpture. From this round piece a straight calibrated piece of wood was to be extended parallel to the ground, and at the end of this piece another calibrated extension was to be attached at right angles and downward. On turning the round piece, the limits of the model or sculpture were to be determined from every angle by measuring in from the vertical extension rod. Although far too complicated for practical use, this machine suggested—because of the moving cylindrical structure of space created by the round turning piece and its extensions—the control and enlivening of the surrounding space by the model or sculpture. On the other hand, the pointing machine, because of its immobility as well as its tendency to reduce the model or sculpture to a four-sided painting, suggested the lack of control and enlivening of the surrounding space by the model or sculpture. Thus Alberti's machine, perhaps, is

the first recorded awareness in the West, however unarticulated, of a feature that essentially distinguishes sculpture from painting. What makes Alberti's intuition so remarkable is the fact that, except for a very few Hellenistic examples such as Trajan's Column in Rome, there were no sculptures completely in the round for him to have perceived. After the Hellenistic period, the first Western sculpture almost completely in the round was probably Verrocchio's *Putto*, c. 1470, of the Fountain in the Palazzo Vecchio, completed at least a few decades after *De Statua* was written. Antonio Pollaiuolo's *Hercules and Anteus* in the Bargello in Florence also comes close to being an unqualified example, especially if one disregards the mantle that was added to Hercules, probably in the sixteenth century, in order to help stabilize the sculpture after it had been broken. The mantle closes off to some extent our perceiving through and around the figures, and thus deemphasizes the democracy of viewpoints. In any case, Pollaiuolo's work was almost certainly done after Verrocchio's, and it is not until Giovanni da Bologna's *Rape of the Sabines* (Fig. 22), 1579-1583, that a monumental sculpture in the round without qualification was created.

15. See Rensselaer W. Lee, "Ut pictura poesis: The Humanistic Theory of Painting," *Art Bulletin* 22 (1940): 197-269.

16. See C. A. Du Fresnoy, *L'art de peinture*, ed. R. de Piles, 4th ed. (Paris: n.p., 1751), p. 100, and Félibien, *Entretiens sur la vie des peintres* (Paris: n.p., 1685), 4:155.

17. *Discourses on Art* (Chicago: Packard, 1945), p. 241. Cf. Kant: "Among the formative arts [painting, sculpture, and architecture] I would give the palm to painting: partly because it is the art of design and, as such, the groundwork of all the formative arts; partly because it can penetrate much further into the region of ideas, and in conformity with them give a greater extension to the field of intuition than is open to the others to do." *Critique of Aesthetic Judgment*, trans. James Creed Meredith (Oxford: Clarendon Press, 1911), p. 196.

18. *Spectator* No. 411.

19. *Poems and Fragments*, trans. Michael Hamburger (London: Rutledge and Kegan Paul, 1966), p. 603.

20. *The Problem of Form in Painting and Sculpture*, trans. Max Meyer and Robert Morris Ogden (New York: G. E. Stechert, 1945), p. 82. Hildebrand was the first sculptor of the nineteenth century to denounce naturalism and diffusion of detail. His discussions of form even point the way to abstract sculpture. Yet his sculptures—for example, the *Archery Lesson*, 1888, a relief in stone now in the Wallraf-Richartz Museum in Cologne—are almost always rhetorical, lifeless, and full of meaningless detail. They are the epitome of Bureaucratic Art—the *Unknown Soldier* monuments, for example—whether democratic, communist, or fascist.

21. Ibid. p. 94.

22. *The Philosophy of Fine Art*, trans. F. P. B. Osmaston (London: G. Bell and Sons, 1920), 3:121.

23. Touch, along with smell and taste, is even excluded from the aesthetic experience of works of art. "The sensuous aspect of art is only related to the two *theoretical* senses of *sight* and *hearing*; smell, on the other hand, taste, and the feeling of touch are excluded from the springs of art's enjoyment." Ibid., 1:52. Cf. Kant: "The formative arts, or those for the expression of ideas in *sensuous intuition* . . . are arts either of *sensuous truth* or of *sensuous semblance*. The first is called *plastic* art [sculpture and architecture], the second *painting*. Both use figures in space for the expression of ideas: the former makes figures discernible by two senses, sight and touch (though, so far as the latter sense is concerned, without regard to beauty)." *Critique of Aesthetic Judgment*, pp.185-86. Even with the materialistic theories of sense perception in the later part of the century, this downgrading of touch continues. Eugène Véron, for example: "The principal governing the differences [among the senses] is the fact that, in most cases, the enjoyments of the palate, of smell or of touch, are closely confined within themselves. Whenever they are accompanied by sentiments and ideas, it is because they are connected by the power of memory to anterior impressions of some other kind. On the other hand, the sensations of hearing and sight are intimately connected with, and spring spontaneously from, the centres where sentiments and ideas are elaborated. It is this

particular character of the organs of the eye and ear that has constituted them . . . the indispensable aids to human development, and the depositaries of its successive acquisitions." *Aesthetics*, trans. W. H. Armstrong (London: Chapman and Hall, 1879), pp. 51-52.

24. *Oeuvres* (Paris: N.R.F., 1938), 2:127-28).

25. "Physical Distance as a Factor in Art and an Aesthetic Principle," in *A Modern Book of Aesthetics*, p. 375.

26. Ibid., p. 408.

27. *Realms of Being* (New York: Scribner's, 1942), p. 679.

28. See, for example, *The Life of Reason* (New York: Charles Scribner's Sons, 1946), Chapt. 7, and his poem "Before a Statue of Achilles."

29. See, for example, *The Life of Reason*, pp. 157 ff.

30. Sartre's "The Paintings of Giacometti" is a notable exception. Typically, however, the title reflects the traditional assumption of the supremacy of painting, for this essay is much more about Giacometti's sculptures than his paintings.

31. *Aesthetics and History*, p. 38.

32. "Cézanne's Doubt," *Sense and Non-Sense*, trans. Hubert L. Dreyfus and Patricia Allen Dreyfus (Evanston, Ill.: Northwestern University Press, 1964), p. 15.

33. *Feeling and Form* (New York: Charles Scribner's Sons, 1953), p. 88.

34. Ibid.

35. Ibid., pp. 89-90. Langer's visual bias is indicated further by the use throughout her aesthetics of the key term *virtual*, adopted from the science of optics.

36. *The Art of Sculpture* (New York: Pantheon Books, 1956), p. 71.

37. Ibid., pp. 49-50.

38. Ibid., p. 71.

39. James J. Gibson, *The Perception of the Visual World* (New York: Houghton Mifflin, 1950).

40. *Henry Moore on Sculpture*, ed. Philip James (London: MacDonald, 1966), p. 131. Sidney Geist surely goes too far, however, when he claims that "in most cases the palping of sculpture is a voyeurism of the hands. It makes more sense, as far as learning anything is concerned, to touch a painting." *Brancusi: A Study of the Sculpture* (New York: Grossman, 1968), p. 162. Indeed, some sculptures absolutely demand our touching; for example, Arp's marble *Figure Classique*, 1964, in the Albright-Knox Art Gallery in Buffalo, is a palpable delight. The cool, smooth, slowly undulating surfaces are not only lovely to touch but our touching is fundamental in perceiving the form. Without touching, the ghostly white of the marble is perceivd as lacking significant solidity, and without a sense of that solidity the form of the statue becomes more pictorial than sculptural.

II PERCEIVING SCULPTURE AND PAINTING

1. *Truth and Method* (New York: Seabury Press, 1975), p. 120.

2. *Philosophical Writings of Peirce*, ed. Julius Buchler (New York: Dover, 1955), p. 75.

3. My conception and use of phenomenological description is much closer to Heidegger than Husserl.

4. The Rembrandt is no longer in the Philadelphia Museum. However, the Rembrandt reproduced here (Fig. 25) is very similar.

5. However justified for protective purposes, glass guards, because of their reflections, interfere with our seeing the paintings. Thus glass should be placed with great care, especially in relation to the surrounding lights. Unfortunately, such care is not always given. For example, in both the Uffizi and the Museum of San Marco in Florence, thick glass guards have been placed several inches in front of most of the paintings. In some instances, we see less of the painting than of

235

ourselves. In all instances, the reflected interferences are unnecessary and abominable. If the glass were nonreflective, of finer quality, and placed closer to the paintings, and if the lighting were professionally handled, then at least some of the paintings could still be adequately seen.

6. E. Fry correctly observes, "If the total perception of . . . a work may be accomplished from a frontal vantage point, and this perception leads to the comprehension of the work as a two-dimensional pattern underlying and controlling any projections into space, the work is in the domain of painting." *Sculpture from Twenty Nations* (Princeton, N.J.: Princeton University Press, 1967), p. 12. That is not to deny that a narrative series of paintings such as those of the Vatican Logge, designed by Raphael, require our movement, much of it continuous. We follow those frescoes like a camera on wheels. Nevertheless, we inevitably come to rest at certain points and focus in from a privileged position.

7. *Eye and Brain* (New York: McGraw-Hill, 1966), p. 169.

8. The restraint of the privileged position from which we perceive paintings can be irritating to some people. For example, Joseph Addison notes, although his reference is to the English garden of the eighteenth century, "The mind of man naturally hates everything that looks like a restraint upon it, and it is apt to fancy itself under a sort of confinement, when the sight is pent up in a narrow compass. . . . There is nothing so distasteful to the Eye as a confined Prospect. . . . The Eye naturally loves Liberty, and . . . will not rest content with the most beautiful dispositions of Art confined within a narrow compass." *Spectator* No. 412, p. 54.

9. *The Senses Considered as Perceptual Systems* (Boston: Houghton Mifflin, 1966), p. 205.

10. *The Structure of Behavior*, trans. Alden L. Fisher (Boston: Beacon Press, 1963). p. 186.

11. Often with low relief and even sometimes with sculpture in the round, such as Michelangelo's *David* (Fig. 19), there may be a dominant memory image. Usually, however, that image will be accompanied by subordinate images.

12. John Russell, *Henry Moore* (New York: G. P. Putnam's Sons, 1968), p. 156.

13. *The Analysis of Art* (New Haven, Conn.: Yale University Press, 1926), p. 36. Cf. Edward Bullough's claim: "The circumstance that the space of a statuary is the same space as ours (in distinction to relief sculpture or painting, for instance) renders a distancing of pedestals, that is, a removal from our spatial context, imperative." "Psychical Distance," p. 382.

14. Cf. the remark of Noghuchi's: The base "frames and creates an object of importance. And yet I am bothered by it. It tends to remove sculpture from a man's own proportion and contact. It supplies a fictional horizon. This is the chief reason why I have attempted an integration of sculpture and base: bases that bite into the sculpture, sculpture that rises from the earth." *Isamu Noguchi: A Sculptor's World*, p. 39. Perhaps because most of them seem to have much more knowledge about painting than sculpture, museum professionals tend to be slavish—granting the need for protecting sculptures and the restriction of exhibition spaces—to the tyranny of the eminence of the eye.

15. Selden Rodman, *Conversations with Artists* (New York: David Adair, 1957), pp. 127-28.

III PERCEPTION

1. For some of the best criticisms of the traditional theory of perception from a phenomenological point of view, see the works of Merleau-Ponty, esp. *The Structure of Behavior*; from an experimental psychological point of view, see the works of James J. Gibson, esp. *The Senses Considered as Perceptual Systems*. For an analysis of the limitations of Gibson's theory, see Ulric Neisser, *Cognition and Reality* (San Francisco: W. H. Freeman, 1976).

2. *Language, Truth and Logic* (New York: Dover, n.d.), pp. 63–65. Or as Bertrand Russell argued: "All the aspects of a thing are real, whereas the thing is a mere logical construction." *Our Knowledge of the External World* (London: George Allen and Unwin, 1914), p. 89.

3. Alfred North Whitehead, *Process and Reality* (New York: MacMillan, 1929), Chapt. 8.

4. Cf. P. F. Strawson, *"Individuals": An Essay in Descriptive Metaphysics* (London: Methuen, 1969), p. 65: "The fact is that where sense experience is not only auditory in character, but also at least tactual and kinaesthetic as well—or, as it is in most cases, tactual and kinaesthetic and visual as well—we can then sometimes assign spatial predicates on the strength of hearing alone. But from this fact it does not follow that where experience is supposed to be exclusively auditory in character, there would be any place for spatial concepts at all. I think it is obvious that there would be no such place."

5. *The Phenomenon of Life* (New York: Harper and Row, 1966), pp. 141–42.

6. Cf. George Herbert Mead, *The Social Psychology of George Herbert Mead*, ed. Anselm Strauss (Chicago: University of Chicago Press, Phoenix Books, 1956), pp. 97–98: "The process of perceiving an object through the eyes . . . may be called the normal perception, since our perception through other organs of sense is so largely mediated through the imagery of vision itself." Similarly for Santayana, sight is perception par excellence. *The Sense of Beauty* (New York: Dover, 1955), pp. 73–75.

7. That is not to deny that in the tradition the other senses have not had their champions. For example, Bernardino Telesio in *De rerum natura juxta propria principia* (1587) defended the sense of touch as the sense of all senses. But such defenses are the exceptions that prove the rule. For a discussion of Telesio's very interesting theory of the senses, see Ernst Cassirer, *The Individual and the Cosmos in Renaissance Philosophy*, trans. Mario Domandi (New York: Harper and Row, Torchbooks, 1964), pp. 145 ff.

8. *Truth and Method*, p. 436. Cf. Merleau-Ponty: "The physical models of Gestalt theory have just as little relationship to the phenomena of life as crystallization has to karyokinesis [motion]." *The Structure of Behavior*, p. 151.

9. *The Senses Considered as Perceptual Systems*, p. 134.

10. *Cognition and Reality*, p. 24. Neisser goes on to report that the only substantial modern treatment of "active touch," for example, is Gibson's "Observations on Active Touch," *Psychological Review* 69 (1962): 477–91. Cf. the following statement by R. L. Gregory: "Other sensory information such as touch does influence how we see, but it does not determine vision. Vision seems to be to a great extent autonomous in the adult; even though, as we strongly suspect, it has its origin both in evolution and in the developing child in direct experience of objects from touch. But we need more research to know just how much visual perception can be affected and corrected by the other senses." *The Intelligent Eye* (New York: McGraw-Hill, 1970), p. 42.

11. "The Origin of the Work of Art," trans. Albert Hofstadter, *Philosophies of Art and Beauty*, ed. Albert Hofstadter and Richard Kuhns (New York: Random House, Modern Library, 1964), p. 656.

12. *The Structure of Behavior*, p. 189.

13. *Poetry, Language, Thought*, trans. Albert Hofstadter (New York: Harper and Row, 1971), p. 157.

14. Maurice Merleau-Ponty, "Eye and Mind," trans. Carleton Dallery, in *The Primacy of Perception*, ed. James M. Edie (Evanston, Ill.: Northwestern University Press, 1964), p. 167.

15. Leo Steinberg, *Other Criteria: Confrontations with Twentieth-Century Art* (New York: Oxford University Press, 1972), p. 249.

16. *Henry Moore on Sculpture*, p. 275.

17. *Signs*, trans. Richard McCleary (Evanston, Ill.: Northwestern University Press, 1964), p. 69.

18. *Metaphysical Journal*, trans. Bernard Wall (Chicago: Henry Regnery, 1959), p. 243.

19. Edmund Husserl, *Ideas: General Introduction to Pure Phenomenology*, trans. W. R. Boyce-Gibson (The Hague: Martinus Nijhoff), 1952), 2: 144.

20. See, for example, Jean Piaget and Bärbel Inhelder, *The Child's Conception of Space*, trans. F. J. Langdon and J. L. Lunzer (London: Routledge and Kegan Paul, 1956), pp. 13–17.

21. *The Senses Considered as Perceptual Systems*, p. 33.

22. *What Happens in Art* (New York: Appleton-Century-Crofts, 1967), p. 69.
23. *The Senses Considered as Perceptual Systems*, p. 101.
24. *Poems 1923–1954* (New York: Harcourt, Brace, 1954), p. 129.
25. *An Introduction to Metaphysics*, trans. Ralph Mannheim (Garden City, N.Y.: Doubleday, Anchor Books, 1961), p. 153.
26. This is Gibson's term, but he uses it to refer to both the action and the interaction of the sense receptors. Each receptor is an active mode of activity or perceptual system, and this system interacts with the other sense receptors or perceptual systems. As Gibson points out: "Just as the hand can be used for grasping and carrying or for exploring, for pointing, and for drawing pictures, so also the eyes, with the optic nerves and their internal connections, can be employed in a number of ways. The individual nerve or neuron changes function completely when incorporated in a different system or subsystem." *The Senses Considered as Perceptual Systems*, p. 56. The sense receptors, furthermore, understood as perceptual systems are not reducible to the traditional five sense organs. For my purposes, however, reference to the various and highly complex perceptual systems and subsystems is needlessly confusing. Gibson's "basic orienting system" is equivalent to my "unity of the body as a perceptual system." Gibson: "The perceptual systems, as it turns out, correspond to the organs of active attention with which the organism is equipped. These bear some resemblance to the commonly recognized sense organs, but they differ in not being anatomical units capable of being dissected out of the body. Each perceptual system orients itself in appropriate ways for the pick up of environmental information, and depends on the general orientation of the whole body [basic orienting system]." Ibid., p. 58.
27. Ibid., p. 124.
28. According to Piaget and Inhelder, the coordination of touch and sight begins with the child as early as the third month. *The Child's Conception of Space*, p. 20. For some of the complexities involved in the coordination of touch and sight in adulthood, see M. Von Senden, *Space and Sight: The Perception of Space and Shape in the Congenitally Blind before and after Operation*, trans. Peter Heath (London: Methuen, 1960).
29. *Scribbling, Drawing, Painting*, trans. Ernest Kaiser and Eithne Wilkins (London: Faber and Faber, n.d.), p.35.
30. Ibid., p. 48.

IV THE AUTONOMY OF SCULPTURE

1. For an opposing claim, see Langer's *Feeling and Form*, p. 109.
2. For experimental evidence on the visual character of the impacting between, see Colin Ware and John M. Kennedy, "Perception of Subjective Lines, Surfaces and Volumes in Three-Dimensional Constructions," *Leonardo* 10 (Spring 1978): 111–14.
3. This is an obvious and important fact. Yet because of the eminence of the eye it usually is missed. Even as acute an observer as D. W. Prall writes: "A picture or a piece of sculpture is seen ideally at one glance, all its parts held together in a momentary, and also permanent unity." *Aesthetic Judgment* (New York: Thomas Y. Crowell, 1929), p. 251.
4. Cf. Robert Morris's remark about his sculpture: "One's awareness of oneself existing in the same space as the work is stronger than in previous work. . . . One is more aware than before that he himself is establishing relationships as he apprehends the object from various positions and under varying conditions of light and spatial context. "Notes on Sculpture, Part 2," *Artforum* 5 (October 1966): 21.
5. "Where Do We Go from Here?" *Arts Yearbook* 8 (1965): 154.
6. Barnett Newman's very large so-called field paintings come close to being exceptions. After a while the edges of these paintings, as a result of retinal fatigue, waver and flicker and the

rapidly moving straight-line bands of bright color, as we see them from the "side of our eyes," continue into the surrounding space.

7. *Problems of Art* (New York: Charles Scribner's Sons, 1957), p. 28.

8. Arturo Schwarz, *The Complete Works of Marcel Duchamp* (New York: Harry N. Abrams, 1970), p. 124. Cf. Duchamp's remark about one of his paintings of 1911—*Yvonne and Magdeleine (Torn) in Tatters*—"I wanted to get out of the canvas idea, which is an organization, a very technical organization that has been accepted for centuries, and that was my torture, because the canvas itself, which is a background of everything, gets mixed up with what you are painting on it, and that was not my cup of tea." Ibid., p. 106.

9. See F. David Martin, *Art and the Religious Experience* (Lewisburg, Pa.: Bucknell University Press, 1972), pp. 73 ff.

10. Cf. Donald Judd's statement: "Actual space is intrinsically more powerful and specific than paint on a flat surface." "Specific Objects," *Arts Yearbook* 8 (1965): 79.

11. *The Sense of Beauty*, p. 29.

12. For a detailed discussion of this point, see Martin, *Art and the Religious Experience*, Chapt. 4.

13. *The Palace at 4 A.M.* was not, however, a dead end stylistically. It was a pioneering work of "Space sculpture," emphasizing in its sketetal structures an atmospheric fusion of inside and outside, stressing space rather than mass.

14. *Wassily Kandinsky on the Spiritual in Art*, ed. Hilla Rebay (New York: Solomon R. Guggenheim Foundation, 1946), p. 64.

15. Ibid., p. 65.

16. "A mirror reflection, after all, is always elsewhere. Its identity with the thing mirrored is not grasped by intuition, but inferred from relation cues." Leo Steinberg, *Other Criteria*, p. 181. Or as Gadamer describes it: "Being reflected involves a constant substitution for another. When something is reflected in something else, say, the castle in the lake, it means that the lake throws back the image of the castle. The mirror image is essentially connected, through the medium of the observer, with the proper vision of the thing. It has no being of its own. . . . The actual mystery of a reflection is the intangibility of the picture, the unreal quality of sheer reproduction." *Truth and Method*, p. 120.

17. See, for example, *Personal Knowledge* (Chicago: University of Chicago Press, 1958). For how tacit knowledge functions in the aesthetic experience, see the excellent analysis of Louis Arnaud Reid, *Meaning in the Arts* (London: George Allen and Unwin, 1969), Chapt. 9.

18. *Artists on Art*, ed. Robert Goldwater and Marco Treves (New York: Pantheon Books, 1945), p. 408.

19. Marianne W. Martin, *Futurist Art and Theory, 1909–1915* (Oxford: Clarendon Press, 1968), p. 201.

20. Richard Whelan, *Anthony Caro* (New York: E. P. Dutton, 1975), p. 120.

21. Hilton Kramer, *The Age of Avant-Garde* (New York: Farrar, Strauss and Giroux, 1973), p. 469.

22. Rainer Maria Rilke, *Selected Works*, trans. G. Craig Houston (London: Hogarth Press, 1954), 1: 137. Rilke would surely have loved Louise Nevelson's black-painted wood sculptures of Victorian furniture debris arranged in juxtaposed square and rectangular niches in wall-like frames. The quiet black, like calm water, helps settle everything into repose and stills their noise (Fig. 72).

23. *Écrits sur l'art et sur la vie*, ed. Gaston Varenne (Paris: Plon, 1955), p. 18.

24. That is not to deny the great usefulness of these visual modes. As Gyorgy Kepes says, "The visual language is capable of disseminating knowledge more effectively than almost any other vehicle of communication. With it, man can express and relay his experiences in object form. Visual communication is universal and international: it knows no limits of tongue, vocabulary, or grammar, and it can be perceived by the illiterate as well as the literate. Visual language can convey

facts and ideas in a wider and deeper range than almost any other means of communication." *Language of Vision* (Chicago: Theobold, 1944), p. 13.

25. "In Praise of Hands," trans. S. L. Faison, Jr., in *The Life of Forms in Art* (New York: George Wittenborn, 1948), p. 68.

26. No one is more articulate than Sartre about these wounds. It is noteworthy that he comments: "One of the chief motives of artistic creation is certainly the need of feeling that we are essential in relationship to the world." *What Is Literature?*, trans. B. Frechtman (New York: Philosophical Library, 1949), p. 60.

27. Sidney Geist, *Constantin Brancusi, 1876–1957: A Retrospective Exhibition* (New York: Solomon R. Guggenheim Foundation, 1969), p. 13. Cf. Nietzsche's remarks: "A man's maturity—consists in having found again the seriousness one had as a child, at play." *Beyond Good and Evil*, trans. Walter Kaufmann (New York: Random House, Vintage Books, 1966), p. 83; "Our eye finds it more comfortable to respond to a given stimulus by reproducing once more an image that it has produced many times before, instead of registering what is different and new in an impression." Ibid., p. 105. Touch is not as susceptible to habit as the eye. Touch has to shape itself to things, usually taking more time than is necessary for sight, for shape is a construct for touch that emerges additively from a multiplicity of single or continuously blending touch sensations. Thus touch cannot so easily frame things into stereotypes. Moreover, our eyes more than any of the other senses have to find stereotypes—noticing only those features of a thing which serve as clues to its identity—to help orient ourselves in our worlds. If we are caught in the dark or are blindfolded, our hands will attempt to find stereotypes of shape, taking over the practical function of sight. But normally our hands are much freer than our eyes to adapt themselves to the unique and "be surprised." Cf. Roger Fry's observation: "The needs of our actual life are so imperative that the sense of vision becomes highly specialized in their service. With an admirable economy we learn to see only so much as is needful for our purposes; but this in fact is very little. . . . In actual life the normal person really only reads the labels, as it were, on the objects around him and troubles no further." Langer, *Problems of Art*, p. 31.

V THE ARTS AND THE "BETWEEN"

1. *Truth and Method*, p. 140.

2. *The Psychology of Imagination* (New York: Philosophical Library, 1948), pp. 279–80.

3. *Film as Art* (Berkeley: University of California Press, 1958), p. 216.

4. "Aesthetic Distance and the Charm of Contemporary Art," in Lee A. Jacobus, *Aesthetics and the Arts* (New York: McGraw-Hill, 1968), p. 34.

5. "Illusion and Art," in *Illusion in Nature and Art*, ed. R. L. Gregory and E. H. Gombrich (London: Gerald Duckworth, 1973), pp. 240–41.

6. *Poetry, Language, Thought*, pp. 152–53.

7. Carola Giedion-Welcher, *Contemporary Sculpture* (New York: George Wittenborn, 1960), p. 152.

8. Although originally the light fell through a window of yellow glass, now artificial light has been substituted.

9. Robert T. Peterson, *The Art of Ecstasy: Teresa, Bernini, and Crashaw* (New York: Atheneum, 1970), p. 40.

10. One of the finest centered spaces in nature for sculpture is surely the Storm King Art Center in Mountainville, New York.

11. Giedion-Welcker, *Contemporary Sculpture*, p. 232.

12. "Life on the Mississippi," in *The Favorite Works of Mark Twain* (Garden City, N.Y.: Garden City Publishing Co., 1939), pp. 46–47.

13. *Selected Works*, 1: 158.

14. *Cathedrals of France*, trans. E. C. Geissbuhler (Boston: Beacon Press, 1965), p. 149.

15. Laurie Anderson's acoustical installation—*Quartet #I for Four Listeners*, 1978—inverts Rauschenberg's procedure by having lights trigger sounds. A small gallery room is rigged with four large loudspeakers suspended in a diagonal row along the ceiling with four spotlights installed in a corner and four cylindrical light sensors hung in line among the speakers. One's trespass blocks the sensor's eye line to the illuminated path on the floor and activates different sounds from the speaker. A spatial spread also occurs because the triggering of any one speaker produces faintly audible responses from the neighboring speaker.

16. Kenneth Coutts-Smith, *Dada* (New York: E. P. Dutton, 1970), pp. 150–51.

17. Jacques Lipchitz with H. H. Arnason, *My Life in Sculpture* (New York: Viking Press, 1972), p. 57.

VI BRANCUSI, MOORE, AND GIACOMETTI

1. Brancusi brought successful legal action in a case as important and almost as famous as Joyce's *Ulysses*, ten years later. In his memoirs Lipchitz relates the humorous story about how he and his patrons circumvented the Customs. "It ['The Harpists,' 1930] was bought from me by Madame Bucher, and she mistakenly entitled it 'Harp' instead of 'Harpistes.' She sold it to an American collector, Mr. Catesby Jones, and sent it to him in America under this title. At the time there was some rule at American customs that a work of sculpture must be made after something that is alive, so if this were a harp it might be dutiable. Fortunately, the man who bought it was a maritime lawyer and the people at customs knew him. One of them said that Catesby Jones did not buy anything that was not sculpture, so there must be a mistake. He consulted with Catesby Jones and then they got a dictionary in which they found the word 'harpy.' 'That's it,' said the customs man. 'It's a bird.' So Madame Bucher asked me a favor to go with her to the American consulate in Paris and confirm the fact that the sculpture was named 'Harpy.' I said I would do it for her, although I would not swear to it if this were required. Fortunately the consulate simply asked me the question and then asked me to make a drawing of it, which I did." *My Life in Sculpture*, p. 116.

2. *Constantin Brancusi, 1876–1957*, p. 21.

3. Virgil C. Aldrich claims that without the title this work would be a purely formal composition: "curiously *with* this title, the figure comes to life as a bird, and a bird only; options to seeing it as anything else seem eliminated." *Philosophy of Art* (Englewood Cliffs, N.J.: Prentice-Hall, 1963), p. 60. I think the point is overstated, but there is no doubt that titles, such as *Bird in Space*, may have powerful control over what we perceive. See my "Naming Paintings," *Art Journal* 25 (Spring 1966): 252–56.

4. After 1907 the materials of Brancusi's bases are almost always different from the materials of his sculptures, helping to separate the sculptures from the earth.

5. One of the earliest examples of architectural subordination to sculpture is the *Altar of Zeus* from Pergamon, begun c. 180 B.C., by Menocrates of Rhodes. One of the latest examples is the much maligned Hirshhorn Museum in Washington by Gordon Bunshaft. The circular, windowless, fortresslike walls, concrete mixed with Swenson pink granite exposed by sandblasting, are powerfully sculptural in impact, but their initial architectural effect is of WPA uniformity and Mussolini-like drabness. Gradually, however, we may begin to appreciate how fittingly this architecture makes room, both inside and outside, for the sculpture. And then the architectural form, in following the sculptural function, becomes transformed.

6. Brancusi's blue-green marble *Fish*, 1930, is displayed nearby, though intended to be alongside water and to be stirred around its massive stone drum by the wind.

7. I was told by a curator that the placement of the *Bird in Space* was determined by limitations imposed by the design of the exhibition rooms and the need to protect the bronze from the elements if placed outdoors. Yet Peggy Guggenheim has exhibited another and very similar

Brancusi *Bird* in the garden of her villa in Venice for decades without the slightest damage. Venetian air may be even more harmful to bronze than New York's, yet a weekly wiping with a cloth has prevented any damage.

8. "We have here a poetry of the actual, without illusion or compensation, without tapering or entasis. The tension between the sameness of what is *known* and the perspectival variety of what is *seen* is unique in art." Geist, *Bruncusi: A Study of the Sculpture*, pp. 124–25.

9. *The Sacred and the Profane*, trans. Willard R. Trask (New York: Harcourt, Brace, 1959), pp. 32–33.

10. Geist, *Constantin Brancusi, 1876–1957*, p. 14. Cf. Henry Moore's remark: "There are universal shapes to which everyone is subconsciously conditioned and to which they respond if their conscious control does not shut them off." Herbert Read, *A Concise History of Modern Sculpture* (New York: Praeger, 1964), p. 177.

11. It may be that Brancusi should have compromised with the engineers, for the column now inclines very slightly 7 degrees from the vertical. However, I have been told that this declination resulted from an attempt—presumably by someone who found Brancusi's work "bourgeois"—to drag the column down by means of a tractor. I have not been able to verify this report.

12. Carola Giedion-Welcher, *Constantin Brancusi* (Neuchatel: Edition du Griffon, 1959).

13. With such wood sculptures, of course, extremely careful preservation techniques are necessary.

14. *Henry Moore on Sculpture*, p. 24.

15. In the later 1960s, fortunately, a small plot of grass was grown around three sides of this *Reclining Figure*, while, unfortunately, a deep sunken court was built below the fourth side.

16. *Henry Moore on Sculpture*, p. 271.

17. Since sold by the Cranbrook Academy of Art in 1972, the wood has been carefully cleaned by Moore.

18. *Henry Moore on Sculpture*, p. 69.

19. Moore remarks that the sculptor must get "the solid shape, as it were, inside his head—he thinks of it, whatever its size, as if he were holding it completely enclosed in the hollow of his hand. He mentally visualizes a complex form from all around itself; he knows while he looks at one side what the other side is like; he identifies himself with its centre of gravity, its mass, its weight; he realizes its volume, as the space that the shape displaces in the air." Ibid., pp. 63–64.

20. "The Holes of Henry Moore," in *Toward a Psychology of Art* (Berkeley: University of California Press, 1966), p. 246.

21. *Henry Moore on Sculpture*, p..66. Cf. Lipchitz's remark about his *Man with a Guitar*, 1916, in the Museum of Modern Art, New York, one of the earliest sculptures in which the hole was used to emphasize three-dimensionality: "A peculiar and important departure is the hole in the center of the figure; it is no longer a circle indented in the surface but a hole cut right through the sculpture from front to back. The purpose of the hole is simple: I wanted it as an element that would make the spectator conscious that this was a three-dimensional object, that would force him to move around to the other side and realize it from every angle. This was an innovation that took great courage to make." *My Life in Sculpture*, p. 31.

22. *Henry Moore on Sculpture*, p. 117.

23. From 1940 until his death in 1966, Giacometti concentrated more and more upon the human figure.

24. *The Life of Forms in Art*, p. 24.

25. *Being and Nothingness*, trans. Hazel E. Barnes (New York: Citadel Press, 1965), p. 230.

26. *City Square* has been enclosed in a plexiglass cube by the management of the Museum of Modern Art, reinforcing the sealing of the perimeter of the sculpture. Usually such protections are objectionable, as with Michelangelo's *Pietà* in Saint Peter's, since they tend to weaken the force of the enlivened space, but in this instance the sealing cube seems peculiarly appropriate, helping to intensify through compression the space around the figures. The space within the cube has

somewhat the effect of refracted light through slightly cloudy water. As we move the space ripples and each figure glimmers like an apparition. On a much larger scale a similar but much more powerful effect is created by the imaginative placement in the late 1950s of one of Giacometti's *Walking Man* series in the cubelike court of the Miollis Building in Paris, part of the UNESCO complex. Utterly alone on the bare concrete pavement, tightly closed in by three-storied glass sides with a narrow sky the only apparent opening (the doors are locked except for emergencies), the light presses down with brutal force. There is "No Exit," as in Sartre's play. The Anson Conyer Goodyear Sculpture Court in the Albright-Knox Art Gallery in Buffalo provides a somewhat similar spatial context for another version of a Giacometti *Walking Man*, 1960. But exits are plentiful and the court also includes large sculptures by Lehmbruck, Maillol, Moore, Calder, Lachaise, Lipchitz, and others. Consequently the compression of space and the lonely isolation emphasized in Paris is lacking in Buffalo.

27. Reinhold Hohl, *Alberto Giacometti* (New York: Harry N. Abrams, 1971), p. 280.

28. Ibid., p. 277.

29. *Time of Need* (New York: Harper, Torchbooks, 1973), p. 177.

30. "The Quest for the Absolute," in *Essays in Aesthetics*, trans. Wade Baskin (New York: Citadel, 1963), pp. 88–89.

31. In some of his earlier works, such as *The Palace at 4 A.M.*, 1932–1933, in the Museum of Modern Art, New York City, Giacometti achieves this effect by the use of open-box structures.

32. Unless this is understood, misleading judgments about Giacometti's work are inevitable. For example, William Tucker makes the remarkable claim that "Giacometti's sensibility was always, as his post-war figurative style demonstrates, that of a painter. . . . It is more an indication of sculpture's poverty than of Giacometti's talent that his work has acquired such a reputation." *Early Modern Sculpture* (New York: Oxford University Press, 1974), p. 127.

33. George Charbonnier, *Le monologue du peintre* (Paris: Julliard, 1959), p. 164.

VII THE SUBJECT MATTER OF SCULPTURE

1. "Meditations on a Hobby Horse or the Roots of Artistic Form," in *Aesthetics Today*, ed. Morris Philipson (Cleveland: World, 1961), p. 119. A change may be occurring, however. Heidegger's "The Origin of the Work of Art," for example, is finally beginning to receive considerable attention.

2. The term *primitive* insofar as it implies crudity or low quality is surely a misleading description of much of the art of these societies as well as of prehistorical societies. An excellent case can be made, for instance, that most nineteenth-century European sculpture—"an indulgence of reminiscences," as Spengler puts it—is of lesser quality than nineteenth-century Eskimo sculpture, the obvious exceptions being the works of Rude, Carpeaux, Barye, Préault, Daumier, Rosso, Degas, Gauguin, and Rodin. Moreover, as William Barrett points out, "Our civilization today still rests on the great discoveries made by early man: how to plant seeds and till the earth, how to weave cloth, fire pottery, and smelt metals. (Also to ferment plants for alcoholic drinks, an accomplishment which for some puritanical reason anthroplogists seem sometimes to pass by.) This is a banal item of schoolboy knowledge, and therefore we do not reflect upon it. I am enormously impressed, however, because I am unable to do any of these things. If civilization were to founder, I would not even know how to set about rediscovering these arts. I have planted, but the seeds were bought in a store; imagine beginning with the grasses of the field, sifting out the proper strains until eventually one got the seeds of wheat. Walking out of doors I occasionally pick up curious stones, but I don't know which are metallic and haven't the least idea how I would go about extracting the metal if it were there. And the leap from flax to cloth is beyond my power of imagination. Dear reader, do not be blasé and underrate prehistoric man before you ask yourself whether you too could start from scratch as he had to and accomplish what he did." *Time of Need*, pp. 138–39.

3. Drawing is sometimes difficult to distinguish from painting and sculpture, for both painting and sculpture often include aspects of the technique of drawing. Nevertheless drawing, unlike painting, avoids the use of colors other than white, black, and grays; and drawing, unlike sculpture, keeps to two dimensions. Because of its lack of an enlivened surrounding space, drawing is pictorial and thus much closer to painting than sculpture.

4. *Prehistoric Painting*, trans. Anthony Rhodes (New York: Funk and Wagnalls, 1965), p. 16.

5. *The History of World Sculpture* (Greenwich, Conn.: New York Graphic Society, 1968), p. 6. Franz Boas in *Primitive Art* (New York: Dover, 1955) concludes that for the primitive artist feeling for form is inextricably bound up with technical experience. The German physician Carl Gustav Carus, on the other hand, had a different explanation: "The development of the senses in any organism begins with feeling, with touch. The more subtle senses of hearing and seeing emerge only when the organism perfects itself. In almost the same manner, mankind began with sculpture. What man formed had to be massive, solid, tangible. This is the reason why painting . . . always belongs to a later phase." *Neun Briefe über die Landschaftsmalerei* (Leipzig: n.p., 1835), p. 81.

6. For an analysis and summary of prehistoric sculpture and painting, see N. K. Sandars, *Prehistoric Art in Europe* (Baltimore, Md.: Penguin Books, 1968).

7. *The Arts and the Art of Criticism* (Princeton, N.J.: Princeton University Press, 1940), p. 231. Cf. Rudolf Arnheim's claim: "Art's reputation must be due to the fact that it helps man to understand the world and himself." *Art and Visual Perception* (Berkeley: University of California Press, 1954), p. 374.

8. A long tradition in aesthetics has supported, with varying emphases, the conception that art reveals or gives insight into values, for example, Longinus, Plotinus, Thomas Aquinas, Francis Bacon, Schopenhauer, Friedrich Schleiermacher, William James, Dewey, Heidegger, and Merleau-Ponty. For a critique of this conception as formulated here, see Ronald Roblin, "Martin on the Revelatory Nature of Art," *Journal of Aesthetic Education* 11 (July 1977): 13–24.

9. "Seeing Photographically," in *A Modern Book of Esthetics*, p. 215.

10. *Science and the Modern World* (New York: Macmillan, 1925), pp. 209–10.

11. Daisetz T. Suzuki, *The Essentials of Zen Buddhism*, ed. Bernard Phillips (London: Rider, 1962), p. xiv.

12. *The Ascent of Man* (Boston: Little, Brown, 1973), p. 18. Clarence Schmidt has constructed, on a hill near Woodstock, New York, similar structures that not only wind up and down the hill but burrow into the earth. James Hampton's *Throne of the Third Heaven* is equally remarkable. From 1950 until his death in 1964, in an unheated, poorly lit garage in a ghetto in Washington, D.C., this uneducated janitor constructed out of discarded materials 180 extremely detailed contrivances wrapped in glittering gold and aluminum foil. Working entirely alone, Hampton transformed trash by means of eccentric improvisation into a complex and monumental assemblage that is now preserved in the National Collection of Fine Art.

13. Although Michelangelo may have been the designer, Ammannati was in charge of the execution, completed in 1569. Blown up by the Germans as they retreated in 1944, the bridge was rebuilt with loving care in the 1950s.

14. This attribution has been challenged recently. Polychromed terra-cottas in fifteenth-century Florence were the purchase of mainly the middle class. Thus Rudolf Wittkower believes it unlikely that this *Lorenzo* could "really have been made for the Medici prince himself." *Sculpture*, p. 184. The extremely fine quality of the bust convinces me, however, that Verrocchio was its maker.

15. "Meditations on a Hobby Horse," pp. 14–26.

16. This otherworldliness may be another reason why theorists gave precedence to painting over sculpture in the Medieval period.

17. *Art and Illusion* (Princeton, N.J.: Princeton University Press, 1969), pp. 58–60.

18. *Other Criteria*, p. 362.

244

19. *Henry Moore on Sculpture*, p. 66.

20. For Sartre, the synthesis of percept and image seeks to combine uncombinables—the percept is posited as an existent object, whereas the image is posited as a nonexistent object, and thus the synthesis is always a degradation of consciousness. *The Psychology of Imagination*, pp. 81–104, 171–74. For Whitehead, on the other hand, the highest forms of consciousness always involve the synthesis of percepts (physical prehensions) and images (conceptual prehensions). *Process and Reality*, Part II. Whitehead's account, I believe, is much closer to the phenomena of consciousness than Sartre's.

21. *Sculpture: Process and Principles*, p. 32.

22. *Systematic Theory* (Chicago: University of Chicago Press, 1951), 1: 102. See also the distinction between "proof" and "plausibility" by Joseph Margolis, *The Language of Art and Art Criticism* (Detroit, Mich.: Wayne State University Press, 1965), pp. 85–94; and the distinction between "verification" and "validation" by Michael Polanyi, *Personal Knowledge*, p. 202. To demand experimental verification in all cases ignores Aristotle's wise dictum of long ago: "for it is the mark of an educated man to look for precision in each class of things just so far as the nature of the subject admits." *Ethics*, 1094b 24–26, W. D. Ross's translation.

VIII ALL-ROUNDEDNESS

1. *Relief Sculpture* (London: Oxford University Press, 1974), p. 1.

2. Although rarely reaching sculpture in the round, Romanesque sculpture is not an exception, for there is a general pattern of movement toward higher relief. Furthermore, Romanesque sculpture led to Gothic sculpture which moved rapidly to the round.

3. *Art and Visual Perception*, p. 169.

4. One of the best recent studies is Golomb's *Young Children's Sculpture and Drawing*.

5. R. L. Gregory observes "that babies seem to prefer simple round objects to flat representations of the same objects, suggesting that they may have some innate appreciation of depth." *Eye and Brain* (New York: McGraw-Hill, 1966), p. 201.

6. *Art as the Evolution of Visual Knowledge*, p. 31. In the eighteenth century Winckelmann, without any apparant experimental evidence, concluded, "Art commenced with the simplest shape, and by working in clay,—consequently, with a sort of statuary; for even a child can give a certain form to a soft mass, though unable to draw anything on a surface, because merely an idea of an object is sufficient for the former, whereas for the latter much other knowledge is requisite; but painting was afterwards employed to embellish sculpture." *The History of Ancient Art*, trans. G. Henry Lodge (Boston: James R. Osgood, 1872), 1:193.

7. *Scribbling, Drawing, Painting*, p. 49.

8. *Art and Visual Perception*, p. 145.

9. *The Art of Sculpture*, p. 27.

10. See Piaget and Inhelder, *The Child's Conception of Space*, Chapt. 1.

11. *Symbolism: Its Meaning and Effect* (New York: Macmillan, 1927), p. 3.

12. Bruno Adriani, *The Problems of the Sculptor* (New York: Nierendorff Gallery, 1943), p. 78.

13. *The Sculpture of Donatello* (Princeton, N.J.: Princeton University Press, 1957), 2: 69.

14. *Artists on Art*, p. 324.

15. Concerning the *Hercules and Anteus*, see above, Chapt. 1, n. 14.

16. However complex and contrapuntal the composition, Michelangelo never violated the ideal boundaries of his blocks.

17. *Sculpture*, p. 118.

18. The title was an afterthought suggested to Bologna by Rafaello Borghini. See E. H.

Gombrich, *The Heritage of Apelles* (Ithaca, N.Y.: Cornell University Press, 1979), p. 129.

19. As Heinrich Wölfflin notes: "There is an art which knows the plane, but does not let it speak distinctly in the impression." *Principles of Art History*, trans. M. D. Hottinger (New York: Dover, n.d.), p. 109.

20. Furthermore, as Rudolf Wittkower points out, Bernini's works represent the climax of an action. For example, the *David*, c. 1623, in the Borghese Gallery in Rome, "aims his stone at an imaginary Goliath who must be assumed on the central axis in space, where the beholder has to stand." *Sculpture*, p. 169. All other positions around the statue, although interesting, coordinated, and carefully carved, are completely subordinated to the one in line with the stare of David, for here alone can the meaning of the subject matter be revealed.

21. Ibid., p. 214.

22. Ibid., p. 234.

23. Ibid., p. 239.

24. Read, *A Concise History of Modern Sculpture*, p. 14.

25. *Other Criteria*, p. 349.

26. Ibid., p. 325.

27. Michel Seuphor, *The Sculpture of This Century* (New York: George Braziller, 1960), p. 313.

28. Rosalind E. Kraus has pointed out that the strategy of discontinuity was a discovery that Caro learned from David Smith. *Passages in Modern Sculpture* (New York: Viking, 1977), Chapt. 5.

29. As defined by Harold Rosenberg, Environmental art is "work that encompasses the spectator, or gives him the feeling of being encompassed, instead of confronting him with an art object or image to look at." *Artworks and Passages* (New York: Dell, 1969), p. 132.

30. *The Child's Conception of Time*, trans. A. J. Pomerans (New York: Ballantine Books, 1971), p. 283.

31. *The Poetics of Space*, trans. Maria Jolas (New York: Orion Press, 1963), p. 234.

32. Kim Levin, *Lucas Samaras* (New York: Harry N. Abrams, 1975), p. 67.

IX SCULPTURE AND THE HUMAN BODY

1. To obtain a standard size, the average size of the feet of the first twelve men leaving church on Sunday was commonly used in Medieval times.

2. *The Nude* (New York: Doubleday, Anchor Books, 1959), p. 54.

3. From the fifth to the tenth centuries there are few sculpted nudes in Christendom. In the eleventh century generally only the sinful are nude—Adam and Eve or one of the damned in the Last Judgment. The proscription of the nude led the medieval sculptors to intricate investigations of faces, hands, and drapery. By the twelfth and thirteenth centuries the body begins, at last, to become unconcealed beneath the dress, as in the *Eve* of Reims (Fig. 8). In the fourteenth century, Giotto's relief design representing sculpture on the Campanile of the Cathedral of Florence—the sculptor is shown sculpting a nude man—is one of the earliest indications of the return of the nude.

4. A fascinating exception to this exaltation of, and concentration upon, the human body. before the twentieth century is the work of the nineteenth-century sculptor Antoine Barye. Whereas his nudes seem to have succumbed to rigor mortis, his animals are usually exceptionally lively.

5. *The Principles of Aesthetics*, p. 227. See also D. W. Prall, *Aesthetic Judgment*, p. 255. Horatio Greenough, one of the first American sculptors, went into more grandiloquent detail: "the human frame, the most beautiful organization of earth, the exponent and minister of the highest being we immediately know. This stupendous form, towering as a lighthouse, commanding by its posture a wide horizon, standing in relation to the brutes where the spire stands in relation to the lowly colonnades of Greece and Egypt, touching earth with only one-half the soles of its feet—it

tells of majesty and dominion by that upreared spine, of duty by those unencumbered hands. Where is the ornament of this frame? It is all beauty, its motion is grace, no combination of harmony ever equaled, for expression and variety, its poised and stately gait; its voice is music, no cunning mixture of wood and metal ever did more than feebly imitate its tone of command or its warble of love. The savage who envies or admires the special attributes of beasts maims unconsciously his own perfection to assume their tints, their feathers, or their claws; we turn from him with horror, and gaze with joy on the naked Apollo." "Structure and Organization," in *A Modern Book of Aesthetics*, p. 267. In the final years of the last century Hermann Obrist was one of the first sculptors in practice and theory *(New Possibilities in Art, Critical Essays, 1896–1900)* to oppose what he called the "Greek prejudice," the glorification of the human body: "The fatal delusion that the human figure is the alpha and omega of sculpture has been a stumbling-block for generations. True, the human figure contains wonderful potentialities for the sculptor. But look at the Tortoise Fountain in Rome. Its basins are a riot of sculptured forms, perhaps the most luxuriant in the world, but what has the shape of their contours to do with the human nude?" Giedion-Welcher, *Contemporary Sculpture*, p. 164.

7. *The Rebel*, trans. Anthony Bower (New York: Random House, Vintage Books, 1956), p. 256.

7. *Henry Moore on Sculpture*, p. 115.

8. Paul Waldo Schwartz, *The Hand and the Eye of the Sculptor* (New York: Praeger, 1969), p. 19. Xenophanes made the same point about painting long ago: "If oxen and horses or lions had hands, and produced works of art as men do, horses would paint the forms of Gods like horses, and oxen like oxen, and make bodies in the image of their several kinds." *The Pre-Socratic Philosophers*, ed. G. S. Kirk and J. E. Raven (Cambridge, Eng.: Cambridge University Press, 1966), p. 169.

9. *Barbara Hepworth: A Pictorial Autobiography* (New York: Praeger, 1970), p. 41. Anthony Caro claims that "all sculpture in some way has to do with the body. For instance, my [abstract] sculptures . . . are partly dependent upon the spectator's height from the floor when he is standing up: on his vertical stance, his consciousness of flat ground. Sculptors . . . are necessarily conscious of the body." Whelan, *Anthony Caro*, p. 115.

10. Barbara Rose, "Claes Oldenburg's Soft Machines," *Artforum* 5 (June 1967): 32.

11. *The Art of Sculpture*, p. 25.

12. Ibid., p. 29.

13. *The Poetics of Space*, p. 184.

14. Sculptors have always found self-portraiture a fascinating subject matter. See Elsen, *Origins of Modern Sculpture*, p. 39. This is explainable in part, I believe, because self-portraiture in sculpture is so close to the underlying subject matter of sculpture: being-in-the-world. Painters, of course, also have always found self-portraiture a fascinating subject matter. Moreover, because of the greater flexibility of the medium, they usually can reveal complexities of character—for example, the self-portraits of Rembrandt—much more vividly than the sculptors.

15. *The Art of Sculpture*, p. 32.

16. Compare Pliny's notorious account of Praxiteles' *Cnidian Venus*, placed in a shrine with entrances fore and aft. "Its shrine is completely open, so that it is possible to observe the image of the goddess from every side; she herself, it is believed, favored it being made that way. Nor is one's admiration of the statue less from any side. They say that a certain man was once overcome with love for the statue, and, after he had hidden himself (in the shrine) during the nighttime, embraced the statue and that there is a stain on it as an indication of his lust." J. J. Pollitt, *The Art of Greece, 1400–31 B.C.* (Englewood Cliffs, N.J.: Prentice Hall, 1965), p. 128.

17. *The Rebel*, p. 256.

18. Herbert Christian Merillat, *Modern Sculpture* (New York: Dodd, Mead, 1974), p. 28.

19. *The Art of Sculpture*, p. 33.

20. *The Nude*, p. 24.

21. *My Life in Sculpture*, p. 124.

22. *The Construction of Reality in the Child*, p. 217.

23. A good dancer in a sense is a mobilized statue, and many statues reveal the mobility of the dance, as with Degas's sculptured dancers (Fig. 36). Thus the common concern for the moving body brings many sculptors and dancers, despite all the differences of their arts, into close relationships. For example, Rodin drew inspiration from the movements of Cambodian dancers. Isadora Duncan's dancing is reflected in Bourdelle's reliefs for the Théâtre des Champs Élysées in Paris. Diaghilev recruited Pevsner and Gabo for his ballet *La Chatte* in 1926. Noguchi has collaborated with many choreographers, especially with Martha Graham, as in the 1935 production of *Frontier*. Calder also worked for Graham's Company in 1935, and in 1939 he received a commission for a water ballet for the New York World's Fair. William Zorach relates that Martha Graham studied sculpture for expressive gestures, and that he studied dances for the same reason. *Art Is My Life* (Cleveland: World, 1969), p. 131. Maurice Béjart used one of Nicholas Schöffer's Spatiodynamic sculptures as the source of human rhythmic movement in one of his ballets of 1956, and the sculpture of Marta Pan has served as starting points for some of his choreography. László Moholy-Nagy created a *Light Prop for a Ballet*, 1923–1930, intended to function during a performance by operating as an on-stage projector, weaving around its turning core a spreading pattern of light and shadow. Sherman E. Lee observes that the dance is basic to "understanding why Indian sculpture looks the way it does." *A History of Far Eastern Art* (New York: Prentice-Hall, 1973), p. 91.

24. Originally the peepholes were obstructed by two rivets. Arturo Schwarz thinks that these rivets stand for Duchamp's and the male viewer's phalli. Thus sexual intercourse is deemphasized, for in order to enjoy the vision of the young woman the rivets must be withdrawn. He also suggests that "the rivets might symbolize those that Oedipus used to blind himself when he beheld the truth of his vision." *The Complete Works of Marcel Duchamp*, p. 560.

25. *What Is Called Thinking?* trans. J. Glenn Gray and F. Wieck (New York: Harper, Torchbooks, 1972), p. 16.

X Sculpture and "Truth to Things"

1. "Logic and Appreciation," in *Problems in Aesthetics*, ed. Morris Weitz (London: Macmillan, 1959), p. 823. John Dewey makes a similar claim: "Recognition is perception arrested before it has a chance to develop freely. In recognition there is a beginning of an act of perception. But this beginning is not allowed to serve the development of a full perception of the thing recognized. It is arrested at the point where it will serve some other purpose, as we recognize a man on the street in order to greet or avoid him, not so as to see him for the sake of seeing what is there." *Art as Experience*, p. 52. Roger Fry observes: "With an admirable economy we learn to see only as much as is needful for our purposes. . . . Almost all things which are useful in any way put on more or less this cap of invisibility." *Vision and Design* (New York: New American Library, 1956), pp. 24–25. He continues: "If we look at the street itself we are almost sure to adjust ourselves in some way to its actual existence. We recognize an acquaintance, and wonder why he looks so dejected this morning, or become interested in a new fashion in hats—the moment we do that the spell is broken, we are reacting to life itself in however slight a degree, but, in the mirror, it is easier to abstract ourselves completely, and look upon the changing scene as a whole. It then, at once, takes on a visionary quality, and we become true spectators, not selecting what we will see, but seeing everything equally, and thereby we come to notice a number of appearances and relations of appearances, which would have escaped our notice before, owing to that perpetual economizing by selection of what impressions we will assimilate, which in life we perform by unconscious processes. The frame of the mirror, then, does to some extent turn the reflected scene from one that

belongs to our actual life. The frame of the mirror makes its surface into a very rudimentary work of art, since it helps us to attain to artistic vision." Ibid., pp. 19–20.

2. *Poetry, Language, Thought*, p. 127.

3. Herschel B. Chipp, *Theories of Modern Art: A Source Book of Artists and Critics* (Berkeley: University of California Press, 1968), p. 612.

4. *The Human Condition* (Chicago: University of Chicago Press, 1958), pp. 172–73. Cf. the interesting comment of Alain Robbe-Grillet: "The world is neither meaningful nor absurd. It quite simply *is*. And that, in any case, is what is most remarkable about it. . . . All around us, defying our pack of animistic or domesticating adjectives, things *are there*. Their surface is smooth, clear and intact, without false glamour, without transparency." *Snapshots and towards a New Novel* (London: Calder and Boyars, 1965), p. 53. The showing forth of a thing's "thereness" is, perhaps, the driving impulse behind the Minimal sculpture of such artists as Robert Morris, Donald Judd, Carl Andre, and Sol LeWitt. Such sculpture is presented as a thing that does not refer to anything but itself. It is a sort of "dumb thing" that closes itself within its own self-sufficient structure and its own self-referential nature. Nevertheless, that "dumbness" inevitably is transcended in our aesthetic experience, for the "dumbness" is experienced as meaningful and thus the "closing in" is transcended.

5. Plotinus held the opposing view: "Now it must be seen that the stone thus brought under the artist's hand to the beauty of form is beautiful not as stone . . . but in virtue of the Form or Idea introduced by the art. This form is not in the material; it is in the designer before it enters the stone . . . and even that shows itself upon the statue not integrally and with entire realization of intention but only in so far as it has subdued the resistance of the material." *Ennead* V, in Frank A. Tillman and Steven M. Cahn, *Philosophy of Art and Aesthetics* (New York: Harper and Row, 1969), pp. 98–99. Brancusi would seem to agree. He believed that his sculpture when successful captured the "inner proportions" of things—the essence—that could be perceived only by insight, "seen" in some imaginative empathetic sense. Yet he also insisted: "The beauty of materials is my last concern." "Direct carving is the true path to sculpture." Geist, *Brancusi: A Study of the Sculpture*, p. 161. The inconsistency in these conceptions, as far as I can make out, was never resolved by Brancusi.

6. *Art in America* (September-October 1974).

7. Richard Whelan, *Anthony Caro*, p. 92.

8. *Brancusi: A Study of the Sculpture*, p. 158.

9. Chipp, *Theories of Modern Art*, p. 582.

10. This *Aprodite* is of such excellent quality that I suspect, despite the experts, it may be an original. When truth to materials is strongly present in a sculpture, a good copy is very difficult to produce. Since the copyist is faced with the completed image, he tends to impose that image on his materials, and when that happens he also tends to sacrifice the thingliness of his materials, the sculptural equivalent of poetry translated into a foreign language.

11. *A History of Far Eastern Art*, p. 37.

12. Rodman, *Conservations with Artists*, p. 117.

13. Felix Desruelle's *Monument to Four Hostages*, 1924, in Lille, France, is a strange exception. Badly damaged in 1941, the reconstruction of 1960 is much more effective than the prosaic original, mainly because of the subject matter of barbaric execution. For photographs see Fred Licht, *Sculpture Nineteenth and Twentieth Centuries* (Greenwich, Conn.: New York Graphic Society, 1967).

14. Because of more demanding structural necessities, truth to materials is more likely to be present in works of architecture than in sculpture, as ancient Roman works illustrate. The accretions of time on architectural materials have helped redeem many such Roman buildings which originally had minimal architectural worth, as witness also the charm of so many Victorian buildings that only a generation ago were dismissed as monstrosities.

15. *Circle: International Survey of Constructive Art*, ed. J. L. Martin, Ben Nicholson, and N. Gabo (New York: Praeger, 1971), p. 105.

16. Giedion-Welcher, *Contemporary Sculpture*, p. 300.

17. The constant introduction of new sculptural materials is one reason why sculptors in recent years have been more adventurous than painters.

18. Kenneth Coutts-Smith, *Dada* (New York: E. P. Dutton, 1970), pp. 56–58.

19. Read, *A Concise History of Modern Sculpture*, p. 192.

20. *Craft and Contemporary Culture* (London: George G. Harrap and UNESCO, 1961), pp. 19 ff.

21. Maillol is a recent noteworthy exception. He employed carvers to transfer his models into stone by means of pointing machines. Italian craftsmen have a long tradition in the use of the pointing machine and seem to be particularly gifted.

22. Auguste Rodin, *Art*, Romilly Feden (Boston: Small, 1912), p. 65.

23. Ironically, only the museum caretakers and their friends can perceive this "seething," for the sculpture is now encased in the Philadelphia Museum of Art in a plexiglass cube, presumably to prevent staining.

24. *Lectures on Art* (New York: John Wiley and Son, 1872), p. 178.

25. Barbara Hepworth describes plaster as "a dead material excluding all the magical and sensuous qualities of the sculptural idea." Seuphor, *The Sculpture of This Century*, p. 103. Yet Giacometti's work surely proves that plaster does not necessarily kill the sculptural idea. And plaster can even be sensuously appealing, as in *The Table*, 1962, by Peter Agostini, and some of the sculptures of 1935–1936 by Ibram Lassau as well as his *City Fragment*, 1956–1960.

26. See Nikolaus Pevsner, *Academies of Art* (New York: Cambridge University Press, 1940).

27. *Origins of Modern Sculpture*, p. 102, Cf. the distaste for color, especially when realistic, by Edward Bullough, hardly an "Academician": "In *sculpture*, one distancing factor of present-ment is its lack of color. The esthetic, or rather inesthetic effect of realistic coloring, is in no way touched by the controversial question of its use historically; its attempted resuscitation, such as by Klinger, seems only to confirm its disadvantages." "Psychical Distance" in *A Modern Book of Esthetics*, p. 381.

28. Oswald Spengler conjectures that the sky of Greece led the sculptors to bronze: "The Hellenes had in the end come to prefer bronze and even gilt-bronze to the painted marble, the better to express (by the radiance of this phenomenon against a deep blue sky) the idea of the individualness of any and every corporeal thing." *The Decline of the West*, trans. Charles Francis Atkinson (New York: A. Knopf, 1947), 1:253.

29. Often in both the Medieval and Renaissance periods, sculptors and painters collaborated on such works, especially in Northern Europe in the Gothic period. Roger van der Weyden, Jan van Eyck, and the Master of Flemalle, for example, were hired to paint sculptures and—another indication of the preeminence of painting—usually were paid more than the sculptors. Modern sculptors and painters occasionally work collaboratively. Germaine Richier, for instance, has worked with the painter Viera da Silva.

30. Generally Renaissance sculptors avoided painting marble because of their idolization of classical marble sculpture. Marbles were often painted during Greek and Roman times, of course, but the weathering of the centuries had worn away the color. This fact was not well known, and so the Renaissance artists had the impression that the ancient sculptors lived in a gray-and-white world.

31. "As Painting Is to Sculpture: A Changing Ratio," in *American Sculpture of the Sixties*, ed. Maurice Tuchman (Greenwich Conn.: New York Graphic Society, 1967), pp. 32–33.

32. *The Problem of Form in Painting and Sculpture*, pp. 78–79. The use of color to bring out and differentiate shapes has a long tradition, of course, going back at least to the Egyptians and the Greeks. Compare Tatiana Proskouriakoff's comments on the probable role of color in Mayan sculpture: "The over-intricacy and lack of emphasis in some Maya sculptures, particularly those of

Quirigua, have often been criticized and cited as a 'Baroque' trait. The effect is in fact confusing and poses an obstacle to the recognition of meaningful forms, but it should be remembered that these designs were probably painted, and that the use of polychrome would differentiate the individual forms and make them immediately perceptible to the eye." A *Study of Classical Mayan Sculpture* (Washington, D.C.: Carnegie Institution of Washington, 1950), p. 181.

33. *Arts Yearbook* 8, p. 152.
34. Elsen, *Origins of Modern Sculpture*, p. 106.
35. Elsen, *Purposes of Art*, p. 385.

XI SCULPTURE AND PLACE

1. For an analysis of the paintings of eighteenth-century villas and mansions, see Roland Paulson, *Emblem and Expression: Meaning in English Art of the Eighteenth Century* (Cambridge, Mass.: Harvard University Press, 1975), pp. 33–34.
2. "In contrast to a mere parallelism, the connection which I have in mind is a genuine cause-and-effect relation; but in contrast to an individual influence, this cause-and-effect comes about by diffusion rather than by direct impact. It comes about by the spreading of what may be called, for want of a better term, a mental habit—reducing this overworked cliché to its precise Scholastic sense as a principle that regulates the act. . . . Such mental habits are at work in all and every civilization." *Gothic Architecture and Scholasticism* (Latrobe, Pa: Archabbey Press, 1951), pp. 20–21.
3. *The Art of Sculpture*, p. 58.
4. "The Robin and the Saint," in *Toward a Psychology of Art*, p. 326.
5. If Arnheim is correct, then presumably Environmental sculpture is also "a vulgar aberration."
6. *David Smith*, p. 178.
7. For details see William S. Ellis, "A Sacred Symbol Comes Home," *National Geographic* (July 1974), pp. 141–48.
8. Ibid., p. 141.
9. *The Lives of the Painters, Sculptors, and Architects*, 1:25.
10. Read, *A Concise History of Modern Sculpture*, p. 196.
11. *Henry Moore on Sculpture*, p. 38.
12. *The Hand and Eye of the Sculptor*, p. 135.
13. Ibid., pp. 47–48.
14. "What Is Metaphysics?," trans. R. F. C. Hall and Alan Crick, *Existence and Being* (Chicago: H. Regnery, 1949), p. 388. Merleau-Ponty makes essentially the same point: "To return to things themselves is to return to that world which precedes knowledge, of which knowledge already speaks, and in relation to which every scientific schematization is an abstract and derivative sign-language, as is geography in relation to the countryside in which we have learnt beforehand what a forest, a prairie or a river is." *Phenomenology of Perception*, trans. Colin Smith (London: Humanities Press, 1962), p. ix.

XII AVANT-GARDE SCULPTURE

1. Geist, *Constantin Brancusi, 1876–1957*, p. 13. Minimal sculpture takes anti-anthropomorphism to one of its ultimate conclusions. Thus Donald Judd and Robert Morris favor simple geometric volumes partly because they are least likely to suggest the human body and its movements. They try to direct attention to the literal limits of nonhuman things—immobile, massive, tactile, and "just there."

2. From their "Constructivist Manifesto" of 1920, quoted by Robert Goldwater and Marco Treves, *Artists on Art*, p. 454.

3. *The Story of Art* (New York: Phaidon, 1951), p. 445.

4. Segal dips surgical gauze in plaster and wraps it around the model. Because plaster dries fast, the job has to be done quickly and in sections, each section being cut off the model as it is completed. These sections are then assembled into a hollow cast of the model.

5. Elsen, *Purposes of Art*, p. 385.

6. *American Sculpture of the Sixties*, p. 42.

7. *The Hand and the Eye of the Sculptor*, p. 231.

8. Calvin Tomkins, *The Bride and the Bachelors: The Heretical Courtship in Modern Art* (New York: Viking Press, 1956), p. 146.

9. Ibid., p. 226.

10. *My Life in Sculpture*, pp. 40–41. Cf. Victor Vasarely's statement: "Let us not fear the new tools which technique has given us. We can live authentically in our time." *Directions in Art, Theory and Aesthetics*, ed. Anthony Hill (Greenwich, Conn.: New York Graphic Society, 1968), p. 104.

· 11. *Directions in Art, Theory and Aesthetics*, p. 88. It is hardly surprising that "mechanical ideology," as Lewis Mumford names it, is most pervasive in the United States, the most technologically advanced society. The French artist Francis Picabia recalls his visit to New York City in 1915: "Almost immediately upon coming to America it flashed on me that the genius of the modern world is in machinery and that through machinery art ought to find a most vivid expression." William A. Canfield, "The Machinist Style of Francis Picabia," *Art Bulletin* 48 (September-December 1966): 309.

12. *Beyond Modern Sculpture* (New York: George Braziller, n.d.), p. 3.

13. *David Smith*, p. 123.

14. Compare the remark of Lucas Samaras in Levin, *Lucas Samaras*, p. 26: "I was using things that were partly ruined or about to be thrown away. I think I was interested in the idea that when something became useless I could rescue it and give it a dignity it never had." The United States is a culture of castoff things, and James Monte quotes a sculptor: "Why, hell, the governmental surplus stores are more valuable to me than any federal sponsorship of the arts could ever dream of being." *American Sculpture of the Sixties*, p. 36.

15. *Brancusi: A Study of the Sculpture*, p. 65.

16. Goldwater, *What Is Modern Sculpture?*, p. 113.

17. *Art and Artist* (Berkeley: University of California Press, 1956), p. 172.

18. Somewhat exceptionally for a machine sculptor, Rickey often draws upon nature for part of his subject matter, especially the rhythms of nature: "The artist finds waiting for him as subject, not the trees, not the flowers, not the landscape, but the waving of branches and the *trembling* of stems, the piling up or scudding of clouds, the rising and setting and waxing and waning of heavenly bodies; the creeping of spilled water on the floor; the repertory of the sea—from ripple and wavelet to tide and torrent." Gregory Kepes, *The Nature and Art of Motion* (New York: George Braziller, 1965), p. 110.

19. *Len Lyle's Bounding Steel Sculptures* (New York: Howard Wise Gallery, 1965).

20. For recent developments in the use of sound to shape space, see *Sound Sculpture*, ed. John Grayson and Douglas Walker (Vancouver, B.C.: A. R. C. Publications, 1975). Cf. Dani Karavan's comment: "In 1966 I began drawing lines in the wind, I made the wind go through pipe-flutes. I use the wind as I use water, sand, living plants and sunlight. I use it as a form. And as a means to create a human condition immersed in nature. Wind-line." *Due ambienti per la pace*, ed. Amnon Barzel (Florence: Il Bisonte, 1978), p. 180.

21. *New York Times*, January 23, 1972.

22. Herbert Read and Leslie Martin, *Gabo: Constructions, Sculpture, Drawings, Engravings* (Cambridge, Mass.: Harvard University Press, 1957), p. 168.

23. Elsen, *Origins of Modern Sculpture*, p. 97.

24. See Taylor, *Futurism*, pp. 131–32.

25. Compare Maholy-Nagy's remark in a letter of 1937 to Carola Giedion-Welcher: "Since light is an element of the time-space continuum, by the mere fact of devoting fresh attention to the problem of light, we enter into the domain of a new feeling for space which it would be premature to analyze today. And yet it is a thing which can be summed up in a word—floating." Giedion-Welcher, *Contemporary Sculpture*, p. 174. Dan Flavin's use of the floating effect of florescent lighting is a further development of "sculptural lighting." But whereas Gabo and Maholy-Nagy usually trap and fractionate light, Flavin allows his light to circulate freely, "an incarnation," in Otto Piene's words, "of visible energy." Like Flavin, Rockne Krebs also usually allows his light beams to circulate freely, as in his vast *Sky Bridge Green* that at times filled the night space of Philadelphia in 1973; but Kreb's light beams, made of laser, do not expand like Flavin's, knifing rather than floating through space.

26. In works outlined with metal, Gabo often uses wires or nylon strings that function in the same way as the incised lines on the plastic. Barbara Hepworth, for example, in *Pelagos*, 1946, Tate Gallery, London, and to a lesser extent Henry Moore have also used wire and strings to unify volumes, but unlike Gabo they also use wire and strings to materialize tensions implicit between masses.

27. Quoted by Archipenko in *Archipenko* (New York: Tekhne, 1960), p. 57.

28. *Henry Moore on Sculpture*, p. 119.

29. Space sculpture generally and works such as *Hudson River Landscape* specifically are disparaged by Herbert Read because of their lack of mass, a dematerialization that produces "scribbles in the air." *A Concise History of Modern Sculpture*, p. 253. Clement Greenberg, on the other hand, does not disparage what he describes—mistakenly I believe—as the pictorial tendency of recent sculpture. "Modernist sculpture itself, recognizing that it is enjoyed visually in the main, has followed painting in the trend toward the exclusively optical, becoming in its Constructivist manifestations more and more an art of aerial drawing in which three-dimensional space is indicated and enclosed but hardly filled." *Art and Culture*, p. 167.

30. There are, however, significant projections and recessions that are not evident either in the photograph or from a frontal position.

31. These pre-World War I sculptures by Picasso, according to William Rubin, were "a singular event, closer to the center of his particular genius than had been his role in the creation of Cubist painting. From the present-day perspective it is clear that Picasso changed the art of sculpture more than any carver or modeler since the cavemen." *Anthony Caro* (New York: Museum of Modern Art, 1957), pp. 15–16.

32. Mixtures of planar, radial, and nodal organizations occur frequently in twentieth-century sculpture, with one mode usually dominating. Schöffer's *CYSP I* (Fig. 63) is an exceptional example because all three modes are almost equally apparent: the flat chrome planes of geometrical, Mondrian-like shapes arranged in reinforcing patterns or at right angles to one another form a series of planar "channels" that direct energies outward; the rotary motion caused by the concealed motor gives the impression of an inner core from which all these energies radiate; and a series of nodes open up both the planes and the inner core so that space penetrates through the skeletal structure, making that enlivened space as perceptible as the mass.

33. *Other Criteria*, p. 181.

34. *New York Times*, May 17, 1975.

35. *Arp on Arp*, ed. Marcel Jean, trans. Joachim Neugroschel (New York: Viking Press, 1972), p. 211.

36. *The Hand and the Eye of the Sculptor*, p. 181.

37. Carl Andre goes even further, thinking so horizontally along the ground that there are no significant vertical dimensions to his structures, as with his *Rug Sculptures*, pieces of metal materials such as lead laid flatly and evenly on the ground or floor.

38. *Due ambienti per la pace*, p. 29.

39. In the 1930s Isamu Noguchi designed three works—*Monument to a Plow, Play Monument*, and *Contoured Playground*—that if executed would have furrowed the earth. Later on he recalls in his autobiography that while working in a large studio in the American Academy in Rome in 1962, "the floor of this studio, its coolness, fascinated me, the very idea of walking, standing, or lying on the hard cement became significant—that delicate point of contrast of bare feet on the floor. I began making things that rest on the earth." *Isamu Noguchi: A Sculptor's World*, p. 37. Noguchi's influence on Earth sculpture, if any, needs investigation.

40. Compare Richard Serra's statement about his *Shift*, 1970–1972, a set of six rectangular cement slabs, five feet high by eight inches thick, placed on slopes of a field near King City, Canada: "What I wanted was a dialectic between one's perception of the place in totality and one's relation to the field as walked. The result is a way of measuring oneself against the indeterminacy of the land. I'm not interested in looking at sculpture which is solely defined by its internal relationship." "Shift," *Arts* 47 (April 1973): 50. The totality of the sculpture cannot be properly perceived even from an airplane. It is a sculpture about walking around a field for about forty-five minutes. "The work establishes a measure: one's relation to it and the land." Ibid., p. 52.

41. *Varieties of Visual Experience* (New York: Harry N. Abrams, n.d.), p. 523.

42. *Newsweek*, November 18, 1974.

43. *Isamu Noguchi: A Sculptor's World*, p. 40.

44. The apparent exceptions, for instance, Oldenburg's soft works (Fig. 85) and Anne Healy's nylon sailcloth structures still present themselves—unlike, for instance, the ethereal laser drawings of the three-dimensional hologram—as material things.

Appendix

1. *My Life in Sculpture*, pp. 7–8.

2. *Art Is My Life*, p. 173. The book referred to, first published in 1947, is one of the few and the best—*Zorach Explains Sculpture: What It Means and How It Is Made* (New York: American Artists Group, 1974). In more recent years a few more such manuals have been appearing, for example, F. Carlton Ball and Janice Loovos, *Making Pottery* (New York: Van Nostrand Reinhold, 1965); Frank Eliscu, *Sculpture: Techniques in Clay-Wax-Slate* (Radnor, Pa.: Chilton, 1959), and by the same author and publisher, *Slate and Soft Stone Sculptures*, 1972; Mark Batten, *Direct Carving in Stone* (London: Tirenti, 1966); Dona Mellach and Donald Selden, *Direct Metal Sculpture: Creative Techniques and Appreciation* (London: Allen and Unwin, 1966); Jack C. Rich, *Sculpture in Wood* (London: Oxford University Press, 1970); Victor D'Amico and Arlette Buchman, *Assemblage* (New York: Museum of Modern Art, 1972); and John Lynch, *How to Make Mobiles* (New York: Studio Publications, 1953). For a brief discussion of the various techniques of sculpture, see F. David Martin and Lee A. Jacobus, *The Humanities through the Arts* (New York: McGraw-Hill, 1975), pp. 146 ff.

3. *David Smith*, p. 64. It is noteworthy that Smith also states: "A sculpture is a thing, an object. A painting is an illusion. There is a difference in degree in actual space and an absolute difference in gravity." Ibid., p. 82.

4. *The Hand and the Eye of the Sculptor*, pp. 172 ff.

5. From one of Barlach's letters, written in June 1889, translated by Arnheim, *Art and Visual Perception*, p. 80.

6. *Henry Moore on Sculpture*, p. 148.

7. *The Hand and the Eye of the Sculptor*, p. 63.

8. Joshua C. Taylor, *Futurism* (New York: Museum of Modern Art, 1961), p. 130.

9. Chipp, *Theories of Modern Art*, p. 562.

10. Elsen, *Purposes of Art*, p. 385. It is somewhat surprising, perhaps, that Medardo Rosso,

one of the most pictorial of sculptors, makes a similar claim: "I judge that it is impossible to see a horse with its four legs all at once, or to see a man isolated in space like a doll. I feel that this horse and this man belong to an ensemble from which they cannot be separated, to an environment which the artist must take into account." *Artists on Art*, p. 329.

11. Rodman, *Conversations with Artists*, pp. 144–45.

12. *Fourteen Americans*, ed. Dorothy Miller (New York: Museum of Modern Art, 1946), p. 39.

13. Goldwater, *What Is Modern Sculpture?* p. 107.

14. *My Life in Sculpture*, pp. 107–8.

15. Albert E. Elsen, "Lipton's Sculpture as Portrait of the Artist," *College Art Journal* 24 (Winter 1964–1965): 113.

16. Ibid., pp. 46–47.

17. "Where Do We Go from Here?" *Arts Yearbook* 8 (1965): 155.

18. George Rickey, *Constructivism* (New York: George Braziller, 1967), pp. 117–18.

19. *Arts Yearbook* 8, pp. 239–40.

20. *Selected Works*, 1:98.

21. *Paintings of D. H. Lawrence*, ed. Mervyn Levy (New York; Viking Press, 1964), p. 39.

22. *The Structure of Behavior*, p. 195.

23. *Archipenko*, ed. Donald H. Karshan (Washington, D.C.: Smithsonian Institution Press, 1969), p. 21.

24. See "Biographies of Artists," in Seuphor, *The Sculpture of This Century*.

25. From "Claes Oldenburg, Roy Lichtenstein, Andy Warhol: A Discussion," moderated by Bruce Glaser and broadcast over radio station WBAI New York in June 1964. Edited and published in *Artform* 4 (February 1966): 23.

26. *The Hand and the Eye of the Sculptor*, p. 110.

27. *Art and Visual Perception*, p. 132.

28. "Specific Objects," *Arts Yearbook* 8 (1965): 75.

29. Ibid., p. 21. Cf. Matisse's remark: "In addition to the sensations one derives from a drawing, a sculpture must invite us to handle it as an object; just so the sculptor must feel, in making it, the particular demands for volume and mass." Read, *A Concise History of Modern Sculpture*, p. 42.

30. Elsen, *Purposes of Art*, p. 448.

31. *Art Is My Life*, p. 110.

32. There are many exceptions, of course. The principle would not be very helpful, for example, with many of the Greek sculptors or Donatello or Michelangelo.

33. *Art Is My Life*, p. 110.

List of Illustrations

ILLUSTRATIONS

86. Tom Wesselmann, *Smoker, I (Mouth, 12)*

87. Michael Heizer, *Circumflex*

88. Robert Smithson, *Spiral Jetty*

89. Harold Lehr, *Ecological Structures*

90. Robert Morris, *Labyrinth*

91. Duane Hanson, *Woman with a Purse*

Index

261

Lipchitz, Jacques: on Le Corbusier, 98; as multitrack sculptor, 101; and painting sculptures, 180; on technology, 201; on Picasso, 223; on the encounter, 225; and monumentality, 229. Works: *The Harpists*, 241 n.1.—*Man with a Guitar*; and hole, 242 n.21.—*Song of the Vowels*, 168; and anthropomorphism, 169
Lipman, Matthew: on body image, 55
Lippard, Lucy R.: on sculpture and color, 181
Lipps, Theodor: on human body, 163
Lipton, Seymour: on enlivened space, 225
literature: and enlivened space, 81–82, 98
Locke, John: on touch, 58
Long, Richard: and Environmental sculpture, 160
Lorenzo the Magnificent: and Michelangelo, 20–21
Lowenfeld, Viktor: on perceptual types, 10–11
Lucian: on sculpture, 21
Lucretius: on touch, 58
Lye, Len: *The Loop* and Machine sculpture, 205–6

McLuhan, Marshall: on participation with things, 60
Magdalen Master: *Madonna Enthroned* and conventions, 132
Magritte, René: and surrealism, 68
Maillol, Aristide: on Egyptian sculpture, 76; nude of, 77; placement of sculptures, 93–94; and traditional sculpture, 197; and pointing machine, 250 n.21
Malraux, André: and photographs of sculpture, 9; and details of paintings, 129
Marcel, Gabriel: on sensations, 45; on human body, 53
Marcus Aurelius: placement of, 192
Marin, John: and imaginary space, 65
Marinetti, Filippo: on Machine sculpture, 205
Marini, Marino: on sculpture and earth, 215–16; on sculpture and painting, 224
Masaccio: and Brunelleschi's *Crucifixion*, 9; and tactility, 28
Mason, Raymond: and tableaux, 159
Matisse, Henri: and line, 68; and human body, 164; turns to sculpture, 227; on sculpture, 255 n.29
Mauclair, Camille: on Rodin, 157
Mead, George H.: on sense perception, 237 n.6

Medici, Grand Duke Francesco dei: and Bologna's *Rape of the Sabines*, 155
Menocrates of Rhodes: *Altar of Zeus* and architecture, 241 n5.
Merleau-Ponty, Maurice: and neologisms, 14; on sensations, 26–28, 45; and Degas, 27; and Cézanne, 27–28; on perspective, 36; on phenomenology, 42; and being-in-the-world, 48, 54, 67; on secondary perception, 51; on space, 66; on handshake, 171; on the visible, 226–27; on Gestalt theory, 237 n.8; on things, 251 n.14
Michelangelo: on sculpture and painting, 4, 22; and Lorenzo the Magnificent, 20–21; and Ficino, 22; and autonomy of sculpture, 22–23; and Medici Chapel, 77; and Palazzo Farnese, 98; and Giacometti, 112; and Antonio Rossellino, 151; and Agostine di Duccio, 151; architectural settings of sculpture, 151; relieflike method, 152; Wittkower on, 152; and block, 155; and Bernini, 156; and the nude, 163–64; and male body, 167; and materials, 175; and chiseling, 178; placement of Sistine frescoes, 187; and painting, 228. Works: *David*: and perception of size, 133–34; and planar organization, 151–52; and homosexuality, 167; and place, 187. —*Dawn*: and Moore's *Reclining Figure*, 109. —*Pietà*: and touchability, 30; and pedestal, 40; and subject matter, 134; and enlivened space, 152–54; and radial organization, 152–54; and planar organization, 152–54; as milestone, 162.—*Ponte di Santa Trinità*, 244 n.13
Michelis, P. A.:on drama, 85
Millard, Charles W.: on Canova, 231 n.11
Milton, John: on light, 17
Miro, Juan: turns to sculpture, 227
Miss, Mary: and Environmental sculpture, 160
Modigliani, Amadeo: and textures, 68; and sensuousness of body, 167; turns to sculpture, 227
Moholy-Nagy, László: and Machine sculpture, 205; on light, 253 n.25
Mondrian, Piet: and the tactually oriented, 11; and Chryssa, 203; on visual arts, 231 n.13
Monet, Claude: disembodying effect of paintings, 67; and sculpture, 227
Monk, Meredith: and enlivened space, 99
Monreale Cathedral: mosaic in, 189

INDEX

Raphael: and Stanze frescoes, 77; and historical painting, 187; and placement of frescoes, 187
Rauschenberg, Robert: and enlivened space, 96–97; on painting and sculpture, 97
Ray, Man: and Duchamp, 204
Read, Herbert: on autonomy of sculpture, 4, 28–32; and Berkeley, 29; and Helmholtz, 29; on sensations, 29–30; on touching sculpture, 62; on origin of sculpture, 119; on three-dimensionality, 140; on Narcissus myth, 165; on human body, 165, 167; on sexual instincts, 166; on Greek art, 189; on Space sculpture, 253 n.29
Reid, Louis Arnaud: on tacit knowledge, 239 n.17
Reinhardt, Ad: and abstract painting, 122; and sculpture, 227
Rembrandt van Rijn: description of *Portrait of Nicolaes Ruts*, 34–41; on his paintings, 37; and sensa, 67; and human body, 165
Renoir: and tactility, 73; and human body, 164; and sensuousness of body, 167; and female flesh, 227
Reynolds, Joshua: on painting and sculpture, 23; and historical painting, 187
Rickey, George: on machines, 205; *Two Lines—Temporal I* as Machine sculpture, 205; on enlivened space, 225; on nature, 252 n.18
Riegl, Alois: and Lowenfeld, 10
Rilke, Rainer Maria: on silence, 36; on secondary perception, 52; on things, 77, 221; on Rodin, 96; on sculpture and place, 185; on sculpture and things, 226
Rivera, Diego: and Picasso, 223
Rivera, Jośe de: *Brussels Construction:* and nodes, 149; and all-roundedness, 158; and machine, 205
Robbe-Grillet, Alain: on things, 249 n.4
Robbia, Luca della: and color, 71; *Cantoria* and radial organization, 150
Robertson, Seonaid: on working clay, 176–77
Rodchenko, Alexandre: and Machine sculpture, 205
Rodia, Simon: and things, 124; and improvisational sculpture, 124
Rodin, Auguste: on death of sculpture, 96; on low relief, 145; on radial organization, 148–49; and all-roundedness, 155, 157–58;

and Environmental sculpture, 157; on cubic truth, 157, 223; and sensations, 157–58; and radial expansion, 157–58; and human body, 157–58; on ruins, 174; on sculpting thingliness, 177; human body and mobility, 197; and moment of suspense, 212; and mirrors, 213. Works: *Burghers of Calais:* and placement, 157, 190; as radial, 157–58; Steinberg on, 158; Arnheim on, 190. —*La Terre*, 130; Steinberg on, 130
Rogers, L. R.: on all-roundedness, 136
Rohe, Mies van der: buildings of, 98
Rosenberg, Harold: on Environmental art, 246 n.29
Rosenquist, James: painting and sculpture, 6
Ross, Charles: and Environmental sculpture, 160
Rossellino, Antonio: and Michelangelo, 151
Rosso, Medardo: on sculpture, 254 n.10
Roszak, Theodore: turns to sculpture, 227
Rothko, Mark: and the tactually oriented, 11; and imaginary space, 65; and sensa, 67; and sculpture, 227. Work: *Earth Greens*, 40, 69; described, 69–70; and tactility, 75
Rubens: and tactility, 73; and human body, 164; and sensuousness of body, 167
Rubin, William: on Picasso, 253 n.31
Rude, François: placement of *Chant du Depart*, 192
Running Animals: planes of, 149
Ruskin, John: on sculpture and thingliness, 177–78
Russell, Bertrand: on things, 236 n.2

Saarinen, Eero: *Gateway Arch* and sculpture, 6; and Pevsner, 98
Sainte-Chapelle: and crowding, 186
Samaras, Lucas: and Environmental sculpture, 159, 211; Levin on, 161; *Mirrored Room* and enlivened space, 161–62; on things, 252 n.14
Sandler, Irving: on Chamberlain, 200
Sangallo, Antonio da, the Younger: and Palazzo Farnese, 98
Santayana, George: on painting and sculpture, 26; on sight, 26; on disembodiment, 67
Sartre, Jean-Paul: and perception, 26; on the look, 44, 111-12, 126, 169; on sensations, 45; on music, 83; on Giacometti's space, 114; on being-in-the-world, 240 n.26; on

271

Trova, Ernest: *Study: Falling Man (Wheelman)*: and human body, 169; and technology, 199–200
Tŕsar, Drago: *Demonstrators II* and technology, 200
Tucker, William: on Giacometti, 243 n.32
Tussaud, Madame: wax figures of, 127
Twain, Mark: on technology, 94–95
Tzetzes: on Pheidias, 3

Uccello, Paolo: and perspective, 189

Valéry, Paul: on looks, 44; on aloneness, 221
Van Gogh, Vincent: low relief, 5–6; and sensa, 67; on art, 122
Vantongerloo, Georges: and painting sculptures, 180
Varchi, Benedetto: poll on sculpture, 4
Vasarely, Victor: on technology, 252 n.10
Vasari, Giorgio: on Giorgione, 21; on Michelangelo's technique, 152; on Cimabue, 191
Venturi, Robert: buildings of, 98
Venus de Milo: and damage, 130; and truth to materials, 174
Venus of Laussel: compared with *Venus of Willendorf*, 137; and planar organization, 141; and low relief, 141–43
Venus of Willendorf: perceiving size of, 132–34; and radial organization, 137; compared with *Venus of Laussel*, 137; and Bologna's *Rape of the Sabines*, 154
Véron, Eugène: on touch, 234 n.23
Veronese, Paolo: sensations and painting of, 62
Verrocchio; and sculpture in the round, 150; and painting, 228; and all-roundedness, 234 n.14. Works: *Colleoni*: placement of, 192. —*Lorenzo de' Medici*: and tactility, 128; and enlivened space, 128–29; and spatial withness, 129; and color, 181; Wittkower on, 224 n.14. —*Putto*: and memory, 79
visually oriented persons: sculpture and painting, 11, 79
Vitruvius: on proportions, 3
Vuillard, Edouard: nudes of, 77

Weber, Max: and painting, 228

Weinrib, David: on sculpture and enlivened space, 64
Weitz, Morris: and theory of family resemblances, 5
Wesselmann, Tom: painting and sculpture, 6; *Great American Nude, No. 54* and enlivened space, 97; *Smoker, 1 (Mouth 12)* and enlivened space, 97
Weston, Edward: on art, 122
Whitehead, Alfred North: on perception, 43–44; and causal efficacy, 66; and negative prehensions, 73; on art, 122–23; on three-dimensionality, 140; on percepts and images, 245 n.20
Whitman, Walt: on human body, 165
Wilber, Richard: on Giacometti, 110
Wilde, Oscar: on the visible, 227
Wilfred, Thomas: and *Lumia*, 49
Wilmarth, Christopher: and works, 65
Wilson, Lanford: and enlivened space, 99
Wimsatt, W. K.: on intentional fallacy, 223
Winckelmann, Johann J.: on autonomy of sculpture, 24; formulae of, 179; on precedence of sculpture, 245 n.6
Winged Bull with Five Legs: perceptions of, 24–25
Winged Victory: and damage, 130; and truth to materials, 174
Wittgenstein, Ludwig: and theory of family resemblances, 5; on primary perception, 53
Wittkower, Rudolf: on sculpture, 134; on Michelangelo's technique, 152; on Verrocchio's *Lorenzo de' Medici*, 244 n.14; on Bernini, 246 n.20
Wölfflin, Heinrich: on human body, 163
Wordsworth, William: and time, 35–36
Wright, Frank Lloyd: ramp of Guggenheim Museum, 77; buildings of, 98

Xenophanes: on painting and human body, 247 n.8

Zadkine, Ossip: and cubism, 10; placement of *Monument to the Destroyed City of Rotterdam*, 192
Zen Buddhism: on things, 123–24, 221
Zorach, William: on sculpture manuals, 223–24; on *Affection*, 229; and monumentality, 229